For Paul Mellon

Tate Gallery

George Stubbs 1724–1806

THE EXHIBITION AND CATALOGUE SPONSORED BY UNITED TECHNOLOGIES CORPORATION

Published by order of the Trustees 1984
for the exhibition at the Tate Gallery 17 October 1984–6 January 1985
and at the Yale Center for British Art 13 February–7 April 1985
Copyright © 1984 The Tate Gallery
Published by Tate Gallery Publications
Millbank, London SW1P 4RG

Designed by Derek Birdsall RDI

Typeset in Monophoto Van Dijck, 203
and printed in Great Britain by Balding + Mansell Limited
on Parilux matt cream using Inmont inks.

ISBN 0 946590 11 7 (paperback)
ISBN 0 946590 12 5 (hardback)

CONTENTS

FOREWORD

Stubbs is one of the greatest of English painters. For too long he was undervalued by the label 'Mr Stubbs the Horse Painter', and his reputation was left in the hands of sporting enthusiasts. Their admiration was well directed, but after two hundred years we can now see that Stubbs deserves an equal place with his contemporaries Gainsborough and Reynolds in the foremost rank of British art.

He is the most original and searching of all painters of animals, the maker of unforgettable images that rank with the greatest European art. This exhibition illustrates his equal genius in the portrayal of human beings, and his sympathetic understanding of the relationship between animals and those who care for them.

A project of this kind cannot be realized without the generous support of collectors both public and private, and to them all we wish to extend our sincere thanks. We are particularly grateful to Her Majesty the Queen, and to other members of the royal family. The names of all those who have lent to the exhibition — apart from those who have preferred to remain anonymous — appear on p. 8. We owe a special debt to Mr Paul Mellon KBE for his great generosity over loans and for his personal interest in the exhibition.

This is the first comprehensive exhibition of Stubbs's work since 1957, and the largest ever devoted to him. It has been organized by the Tate Gallery in association with the Yale Center for British Art, New Haven, Connecticut, where it will be seen in a rather different form from 13 February to 7 April 1985, as it was clearly unwise for paintings on panel or on large ceramic plaques to cross the Atlantic.

The works in the exhibition have been selected by Judy Egerton, Assistant Keeper of the British Collection. Mrs Egerton has for many years made a special study of sporting art, and of Stubbs in particular. The fruits of her scholarship will be found in this richly illustrated and documented catalogue.

United Technologies have sponsored the exhibition, and have taken a special interest in this catalogue. We are most grateful to them for their enthusiasm and their assistance, which has been generously given on both sides of the Atlantic.

ALAN BOWNESS
Director, Tate Gallery

DUNCAN ROBINSON
Director, Yale Center for British Art

LENDERS

Most of us know George Stubbs as a masterly painter of
animals. That he also was an incisive portraitist is one of the
pleasant revelations in this exhibition. We are pleased to
support the scholarship that provides such fascinating insights,
and we hope visitors to the exhibition, on both sides of the
Atlantic, enjoy it thoroughly.

HARRY J. GRAY
Chairman
United Technologies Corporation

ABBREVIATIONS

GENERAL

Some paintings could be included only in one showing of the exhibition, and these are indicated as follows:
* Tate Gallery only
† Yale Center for British Art only

In all entries sizes are given with height preceding width.

Under LITERATURE, the listing is selective, including only the more useful references, but including all references in Gilbey, 1898, since this was the first attempt to catalogue Stubbs's work.

Under ENGRAVINGS, in the case of engravings after Stubbs only first issues of publications during his lifetime are noted.

EXHIBITIONS

Agnew's, 1970 — *Stubbs in the 1760s*, Thos. Agnew & Sons Ltd., 1970, catalogue by Basil Taylor

Arts Council, 1974–5 — *British Sporting Painting 1650–1850*, Hayward Gallery, 1974–5, Leicestershire Museum and Art Gallery, Leicester, 1975 and Walker Art Gallery, Liverpool, 1975, catalogue Introduction by Sir Oliver Millar

Liverpool 1951 — *George Stubbs*, Walker Art Gallery, Liverpool, 1951, catalogue by 'R.F.'

R.A. 1964–5 — *Painting in England 1700–1850 from the Collection of Mr and Mrs Paul Mellon*, Royal Academy, 1964–5, exhibition catalogue by Basil Taylor

Tate Gallery 1974 — *Stubbs & Wedgwood*, Tate Gallery, 1974 exhibition catalogue by Bruce Tattersall. Introduction by Basil Taylor

Tate Gallery 1976 — *George Stubbs, Anatomist and Animal Painter*, Tate Gallery, 1976, exhibition catalogue by Judy Egerton

V.M.F.A. 1960 — *Sport and the Horse*, Virginia Museum of Fine Arts, Richmond, Virginia

V.M.F.A. 1963 — *Painting in England 1700–1850: Collection of Mr. and Mrs. Paul Mellon*, Virginia Museum of Fine Arts, Richmond, Virginia, 1963, exhibition catalogue by Basil Taylor

Vokins 1885 — *Loan Collection of Pictures by George Stubbs and Engravings from his Works*, J. & W. Vokins, 14 & 16 Great Portland Street, London, 1885

Whitechapel 1957 — *George Stubbs*, Whitechapel Art Gallery, 1957, catalogue by Basil Taylor

Yale 1965 — *Painting in England 1700–1850 from the Collection of Mr. and Mrs. Paul Mellon*: a selection for the winter exhibition 1964–5 at the Royal Academy, using the same catalogue

Yale Center 1982 — *Noble Exercise*, Yale Center for British Art, New Haven, Connecticut; exhibition catalogue by Stephen Deuchar

LITERATURE

Constantine 1953 — H.F. Constantine, 'Lord Rockingham and Stubbs; Some New Documents', *Burlington Magazine*, XCV, 1953, pp. 236–8

Egerton 1978 — Judy Egerton, *British Sporting and Animal Painting 1655–1867: The Paul Mellon Collection*, 1978

G.E.C. — [George Edward Cokayne and others], *The Complete Peerage*, 13 vols., 1910–50

Gilbey 1898 — Sir Walter Gilbey, *Life of George Stubbs R.A.*, 1898, with notes presumed to be by Mary Spencer inserted, and with two more genteely-phrased transcripts, ? the first by William Upcott

Humphry, MS Memoir — Ozias Humphry, '. . . particulars of the Life of Mr Stubbs . . . given to the author of this Memoir by himself and committed from his own relation'; MS in the Picton Collection, Liverpool City Libraries

Longrigg 1972 — Roger Longrigg, *The History of Horse Racing*, 1972

Millar 1969 — Sir Oliver Millar, *Later Georgian Pictures in the Royal Collection*, 2 vols., 1965

Namier & Brooke — Sir Lewis Namier and John Brooke, *The House of Commons 1754–1790* (alphabetically ordered), 2 vols., 1964

Parker 1971 — Constance-Anne Parker, *Mr Stubbs the Horse Painter*, 1971

Tattersall 1974 — Bruce Tattersall, *Stubbs & Wedgwood: Unique Alliance between Artist and Potter*, exhibition catalogue, Tate Gallery, 1974

Taylor 1961 — Basil Taylor, 'Josiah Wedgwood and George Stubbs', *Proceedings of the Wedgwood Society* no. 4, 1961

Taylor 1965 — (i) Basil Taylor 'George Stubbs. "The Lion and Horse" Theme', *Burlington Magazine*, CVII, 1965, pp. 81–6
(ii) Basil Taylor 'Portraits of George Stubbs', The Paul Mellon Foundation for British Art, Notes on British Art 3, *Apollo*, LXXXI, 1965, supplement between pp. 422 and 423

Taylor 1969 — Basil Taylor, *The Prints of George Stubbs*, 1769. References under Nos. 172–190 to 'Taylor 1' etc. all prints catalogued by Taylor in this publication

Taylor 1971 — Basil Taylor, *Stubbs*, 1971

Walker 1971 — Stella A. Walker, *Sporting Art: England 1700–1900*, 1972

FORTHCOMING PUBLICATIONS

Edited by Judy Egerton and Timothy Stevens: *Ozias Humphry's MS Memoir of George Stubbs*

Judy Egerton: *Stubbs: Some Details*

Christopher Lennox-Boyd and Robert Dixon: *George and George Townley Stubbs: a review of Stubbs's life and work with a catalogue raisonné of nearly 400 prints engraved by him, his son and others*

Robert Fountain: *Stubbs' Dogs*

Constance-Anne Parker: *Art, Animals and Anatomy*

ACKNOWLEDGMENTS

Without Paul Mellon's readiness to lend, and on a generous scale, this exhibition could not have taken place. In recognition of his constant admiration for Stubbs, beginning at a time when public galleries remained indifferent to his work, and with gratitude for his unfailing kindness over fifteen years and for his generosity to the Tate Gallery, this exhibition and this catalogue are dedicated to him.

Many people have given help. Sir Oliver Millar and Sir Joshua Rowley have been invaluable allies from the earliest stages of planning the exhibition: if there had been a Committee of Honour, they would have led it. I am particularly grateful to Robert Shepherd, Ian McClure, Rupert Featherstone and Lyn Koehnline for contributing papers on the conservation of works by Stubbs. For help in research I am particularly indebted to Ian Rolfe and Tim Clarke; I should also like to thank D.G.C. Allan, John Cadman, Beverly Carter, Margie Christian, Colin Eaton, Thomas R. Forbes, Ben Harford, G. Evelyn Hutchinson, Ernest Johns, Evelyn Joll, Boris Mollo, Patrick Noon, Bill Plomer, Francis Russell, Charles Ryskamp, Timothy Stevens and Stella Walker. For help in tracing paintings, I should like to thank David Fuller, Richard Green, William Joll, Charles Leggatt, John Partridge, David Posnet, Anthony Speelman and Anthony Spink.

Within the Tate, Ruth Rattenbury has given unstinting help and encouragement far above the call of duty. David Brown MRCVS has contributed notes on Stubbs's anatomical drawings; and my colleagues Leslie Parris, Iain Bain and Elizabeth Bell have been particularly helpful.

I am grateful for the generous support for this exhibition from United Technologies, and I count myself lucky in having, in Derek Birdsall, a designer whose immediate sympathy for Stubbs underlies all his skills.

JUDY EGERTON

25 August 1724 Born in Liverpool, son of John Stubbs, currier and leatherseller, and his wife Mary. Worked at his father's trade until he was fifteen or sixteen; meanwhile drew constantly.

1741–5 After his father's death (16 August 1741), worked briefly (a few weeks only?) as pupil-assistant to Hamlet Winstanley, copying the Earl of Derby's pictures at Knowsley Hall near Liverpool. Spent the next four years at home, supported by his mother, teaching himself to paint. Humphry's note 'at Liverpool he dissected Horses and some dogs' probably belongs to this period. Painted portraits (now unknown) in Leeds and Wigan.

1745–53 At York, working as a portrait-painter and studying anatomy with Charles Atkinson at York Hospital, ?also teaching perspective at Health Academy, Wakefield. Illustrated John Burton's *Essay towards a Complete New System of Midwifery*, 1751; its 18 plates have hitherto been considered Stubbs's earliest known work. Later spent about two years portrait-painting and dissecting in Hull. The double portrait of Sir Henry Nelthorpe (d. 1746) and his second wife now appears to be Stubbs's earliest known work.

1754–6 Embarked for Italy, and was in Rome by Easter 1754, but stayed only briefly. Spent the next two years in Liverpool, painting portraits, depicting 'various animals' and occasionally dissecting.

1756–8 At Horkstow in Lincolnshire, dissecting and drawing for *The Anatomy of the Horse*. Supported himself, his common-law wife Mary Spencer and ? their son George Townly Stubbs (b. ?1756) by painting 'various portraits' previously commissioned by Lady Nelthorpe. After sixteen months at Horkstow, took his drawings to London in 1758, trying (unsuccessfully) to find a professional engraver for them. May have left Mary Spencer and his children in Liverpool until he was established in London; his daughter Mary (date and place of birth unknown) was buried in Liverpool 18 September 1759.

1760–5 Quickly established a reputation as a painter of horses and wild animals; his early patrons included the Duke of Richmond, Marquess of Rockingham, Earl Grosvenor, Earl Spencer and the Duke of Grafton. First exhibited at the Society of Artists 1762; exhibited annually there until 1775. By 1764, had settled at 24 Somerset Street, his home for the rest of his life: the site is now occupied by Selfridge's department store.

 Paintings of this period include a horse painted for Sir Joshua Reynolds (?1760); the Goodwood racing, hunting and shooting pictures (?1759–60); 'The Grosvenor Hunt', 1762; 'Whistlejacket', 1761–2; the first of his 'Mares and Foals', exh. 1762; the first 'Lion and Horse' subject, exh. 1763; 'Zebra', exh. 1763; and 'Gimcrack on Newmarket Heath'. *c*.1765.

 Meanwhile worked at engraving his drawings for *The Anatomy of the Horse*.

1766–70	*The Anatomy of the Horse* published 1766. Elected a Director (committee member) of the Society of Artists October 1766, Treasurer 1769–70, and was on the committee which invited William Hunter and subsequently John Hunter to dissect a human figure for the Society.

1766–70 *The Anatomy of the Horse* published 1766. Elected a Director (committee member) of the Society of Artists October 1766, Treasurer 1769–70, and was on the committee which invited William Hunter and subsequently John Hunter to dissect a human figure for the Society.

Paintings of this period include further versions on the theme of the lion and horse, and of mares and foals; four shooting pictures, exh. 1767–70; 'The Milbanke and Melbourne Families'; 'Nyl-Ghau', for William Hunter, 1769; 'Tiger', exh. 1769; meanwhile Stubbs experimented with painting in enamel, at first on copper, the earliest known example being 'Lion Attacking a Horse', 1769.

1771–9 Elected President of the Society of Artists 19 October 1772; held office for a year, then continued as a Director. Approached Wedgwood & Bentley in search of larger 'canvases' for enamel painting: his earliest, experimental work on Wedgwood ware is the 'Sleeping Leopard', dated 1777; his latest is dated 1795. In 1775, transferred from the Society of Artists to the Royal Academy, exhibiting there 1775–6, 1778–82, 1786–7, 1789–91, 1799–1803. In 1777 published the first of his eighteen single engravings, a 'lion and horse' subject.

Paintings of this period include 'Eclipse', 1770; 'Pumpkin', 1774; 'Shark', 1775; 'Scapeflood', 1777; 'John and Sophia Musters', 1777; 'Leopards at Play', 1779; 'Moose', for William Hunter, 1770; 'Kangaroo', for Sir Joseph Banks, exh. 1773; and 'Portrait of a Monkey', exh. 1773.

1780–9 Elected A.R.A. 1780, and R.A. 1781, but did not receive the diploma of R.A. because he refused to comply with a rule made after his election that academicians should deposit a diploma picture.

1 May 1788: published twelve single engravings, mostly wild animal subjects, and re-advertised *The Anatomy of the Horse*.

Paintings of this period include 'Phaeton with Cream Ponies', c.1780–5; 'Reapers' and 'Haymakers', 1783 and 1785; 'Lady and Gentleman in Phaeton', 1787; and 'Labourers', 1789; also many wild animal subjects and several portraits in enamels.

1790–5 Involved in a project to illustrate the history of the Turf from 1750; for this sixteen of his paintings were exhibited at the Turf Gallery, 1794, engraved by his son George Townly Stubbs and published as single issues, but the project itself failed to find support. Evidently in financial difficulties in the 1790s, and assisted by Isabella Saltonstall.

Paintings of this period include 'Brocklesby Ringwood' and 'Foxhound and Bitch in a Landscape', 1792; 'Soldiers of the 10th Light Dragoons' and 'The Prince of Wales's Phaeton', 1793.

1795–1805 In 1795, aged seventy-one, began work on his *Comparative Anatomical Exposition of the Structure of Human Body with that of a Tiger and a Common Fowl*; advertised the work for publication, 1802; published in parts, 1804–6, but never completed.

Paintings of this period include 'Hambletonian', 1800; 'Freeman, the Earl of Clarendon's Gamekeeper, with a Dying Doe and Hound', 1800.

10 July 1806 Died, aged eighty-one, at 24 Somerset Street.

'*Nobody suspects Mr. Stubs of painting anything but horses & lions, or dogs & tigers*', wrote Josiah Wedgwood to his partner in September 1780, '*and I can scarcely make anybody believe that he ever attempted a human figure.*'[1] One of the chief aims of this exhibition is to show what a perceptive observer of human beings Stubbs is, from the start to the end of his working life. The same insight into individual character, the same ability to portray it with few props and no exaggerated expressions or attitudes, are as evident in the early portraits of Sir John Nelthorpe as a boy and James Stanley at the age of thirty-three (Nos. 26 and 27) as they are in the portraits of the stable-lad and the experienced trainer in 'Hambletonian Rubbing Down' (No. 138) of some four or five decades later.

Stubbs is also a master of the art of class distinction. Members of the upper class are portrayed with an ineffable though unaggressive air of knowing that they have the largest share of this world's goods and mean to keep them: this is true of sitters as different from each other as, for instance, the gentle and self-effacing young Duchess of Richmond in No. 31 and, in No. 110, that hard-headed charmer Viscountess Melbourne, who in any other station in life might have been termed a courtesan. Stubbs is never satirical in his portraiture: his truthfulness is more penetrating than satire. The young and already dissolute Lord Melbourne, we cannot help feeling as we look at his hollow-eyed langorous face, is probably of the same character as the husband in Hogarth's 'Marriage à la Mode': bored, idle and prone to debauchery; but Stubbs is never a moralist in the sense that Hogarth is.

The servants of the great houses and stables of the period are portrayed with sympathy and without condescension. Stubbs emphasizes capability in his portraits of grooms and jockeys; his individuals take pride in what they do, but they make no statements either of the Puritan ethic of work or of the Leveller tradition of equality. The nearest Stubbs comes to caricature or satire is in the portraits of Lord Torrington's brickmakers (Nos. 47–8), but in this subject he was responding to his patron's wish to have them portrayed 'like some Flemish subject'.[2] Elsewhere, Stubbs's servants and labourers are unselfconscious and evidently skilled, but never servile. In portraits such as that of Freeman, the Earl of Clarendon's gamekeeper (in No. 137) or that of the girl who pauses silently to look out at us in the middle of hay-making (No. 126), we seem to sense that acceptance of things more or less as they are which was probably characteristic of most working-class people in the eighteenth century, but which anticipates that huge knowledge that Chesterton touches on when he writes 'We are the people of England, that never have spoken yet'.

There was however more social mobility in eighteenth-century England than perhaps meets the eye. If there are aristocrats there are also self-made men among Stubbs's patrons: I must confess that my own favourite among them is William Wildman the Smithfield meat salesman, but others include Dennis O'Kelly and John Pratt. Any 'tranquil consciousness of an effortless superiority' which members of the upper classes or of the Jockey Club (fig. 1) might be disposed to feel was tested in 1791 by the case of Burdon v. Rhodes.[3] In this case, the jury at York Assizes were asked to judge whether the stewards and the Clerk of the Course (Mr Rhodes) were justified in withholding stake money from Mr Thomas Burdon on the grounds that he had invited a member of the lower classes (Christopher Rowntree) to ride his horse in a race confined to 'gentlemen'. This case attracted so much local attention that the Guildhall where it was heard was crowded out. The plaintiff for the defendant opened his case by wondering 'What can possibly have given rise to an assembly of people and tumult like this, which more resembles the proceedings in a cock-pit than a court of

justice'. As he pointed out, 'The whole of this action turns on the construction of the word gentleman'; he must have known that there were enough people anxious to hear that definition to form a crowd not only inside Guildhall but outside it. His first witness, Sir William Foulis, Bart., of Ingleby Greenhow, was asked whether he knew Christopher Rowntree, which he said he did. The ensuing exchange of questions and answers may help to throw some light on the meaning of the word 'gentleman' in Stubbs's (and Richard Wilson's) day:

'COUNSEL: Do you regard him as a gentleman?

SIR WILLIAM: Not in the general acceptance of the word.

COUNSEL: Does he enjoy the sports of the field like other gentlemen, and kill game?

SIR WILLIAM: I suppose so. He takes out a licence.

COUNSEL: Has he long been a hunter?

SIR WILLIAM: Before I was born. I believe he is upwards of seventy years old.

COUNSEL: Do you know anything against his character?

SIR WILLIAM: I know nothing against him, but on the contrary have a good opinion of him . . . and never knew him do a dirty trick.'

Counsel for the defence opined that Christopher Rowntree, 'we doubt not, is a useful, worthy member of society in the situation in which he is placed. He may possess as much as those in a superior station in life. It is only to the character of a gentleman that we resist his claim.' Various witnesses for the defence expressed shock, horror etc. as having seen old Rowntree ride in this race. In his final speech, Counsel for the

Figure 1: Thomas Rowlandson: Members of the Jockey Club. Pen and ink and watercolour *c.*1790 *Halifax Collection*

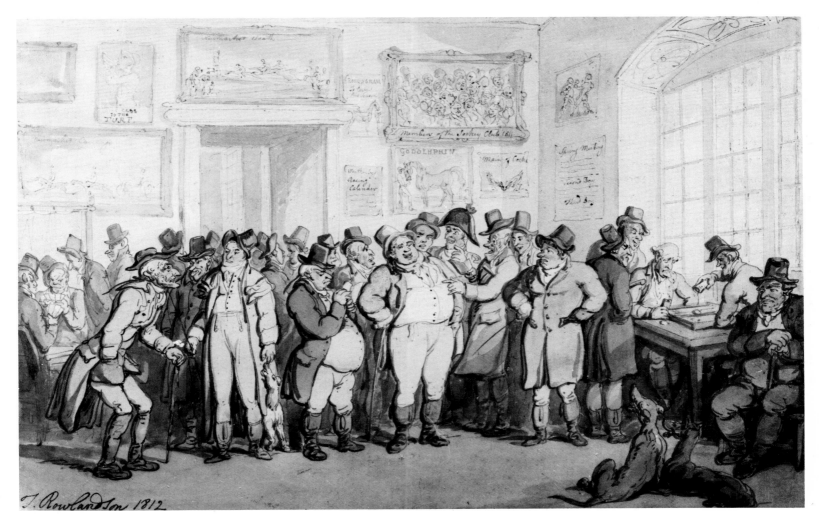

plaintiff asked 'Can it be doubted that the term gentleman is here opposed to jockey or groom: that the intention of the subscribers was that none of the horses should be rode by men whose professional skill would give them an advantage, and over-match the others in point of jockeyship?' The jury found for the plaintiff. Christopher Rowntree became, briefly, as popular a local hero as John Hampden. The verdict of the jury at York Assizes in 1791 was as revolutionary in its implications, though in its own understated English way, as the slogan *Liberté, Egalité, Fraternité* in contemporary Paris.

Racecourses were indeed perhaps the greatest force for democracy in Georgian England. If one looks at the list of subscribers to the *Racing Calendar*[4] for 1768, for example, we see that it is headed by nine dukes followed by nineteen earls, but by the time we reach the pages of the Middlesex subscribers, we find (besides the names of Mr Stubbs and Mr Wildman) publicans, saddlers, tradesmen and stable keepers: 'Mr Bowditch, at the Red Lion Livery Stables . . . Mr Cock, Stable Keeper at the Fox and Goose, London Wall . . . Mr Galley at the Goat, in Stafford Street . . . Mr Horsenail, Stable Keeper for Running Horses &c. in Mile End Road . . . Mr Payne at the Blanket Warehouse, Holborn . . . Mr Watts, Horse Doctor in Long Acre . . . Mr Wessell, at the late Dr. Walker's Patent Jesuit Drops Warehouse, Old Bailey . . . Mr Wyburn, Coal Merchant, at Tottenham . . .'. On the racecourse men met as equals; Wootton's and Tillemans' crowded Newmarket scenes show that crowds were formed from an uninhibited mixture of people from all classes.

Racing in England began with the Romans — or, as Yorkshiremen say, as soon as there were two Yorkshiremen and two horses. By 1736 it was observed that 'It is surprising to think what a height this spirit of horse-racing is now arrived at in this kingdom, where there is scarce a village so mean that it has not a bit of plate raised once a year for the purpose'.[5] Citizens of a town which held race meetings had to get used to the fact that their streets and inns would be excessively crowded during the races. If they were shrewd, they built grandstands and hotels, and opened Assembly Rooms, like those inaugurated at York in 1732 'for the evening entertainment of the nobility, gentry, etc., who usually honour our horse races with their presence',[6] the '&c.' including 'all Persons of every Rank and Degree'. Enormous crowds turned out to see matches between particularly popular racehorses, as when Gimcrack ran against Bay Ascham, or Hambletonian against Diamond. William Mason gives a hardly exaggerated (to judge from contemporary newspaper reports) view of what a country town was like on the day of the races (fig. 2). But crowds are an aspect of racing which Stubbs never portrays.

Art historians by and large have had trouble with Stubbs. Dr Waagen gave high if brief praise to 'Whistlejacket' (No. 34): 'Stubbs — A brown horse, size of Life; of great animation',[7] and also praised the Grosvenor 'Mares and Foals' (No. 90), but either was not shown or averted his eyes from works by Stubbs on his visits to Scawby Hall and Grimsthorpe. It is perhaps because Stubbs's subject-matter is straightforward and his appeal so

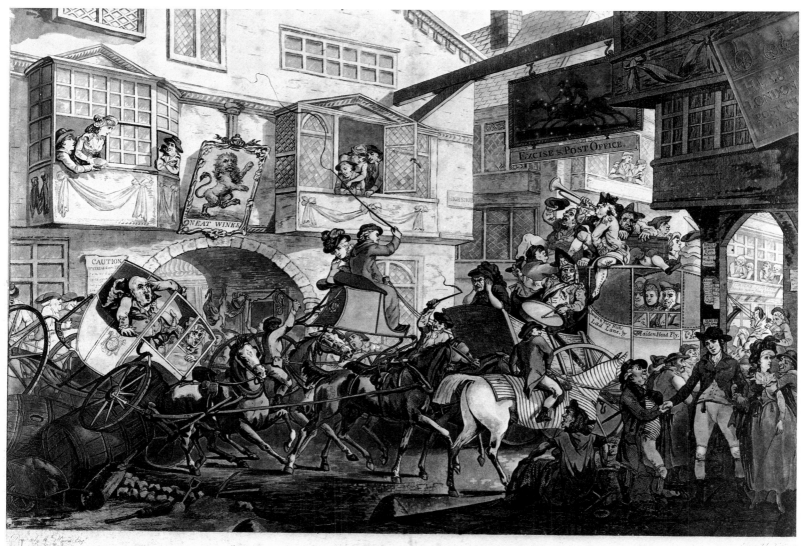

SCENE IN A COUNTRY TOWN AT THE TIME OF A RACE.

general that many art historians feel they cannot get their teeth into him, or at least not in the same way as they can tease out an allegory or ruminate over 'isms'. Yet the best writers on Stubbs (*par excellence* Basil Taylor, whose dedication to Stubbs rose above his lack of sympathy for the subject-matter, and to whom all writers on Stubbs will forever be indebted) have been art historians rather than sporting writers, who tend to concentrate on breeds, pedigrees and performances rather than design and composition. E.K. Waterhouse emphasizes that 'horse pictures form only part of his [Stubbs's] work, which embraces, in its affectionate study, man, the whole animal kingdom and nature': for this we can forgive his egregious error in saying, as if it were a saving grace, that Stubbs 'never worked at Newmarket'.[8] David Piper's broadcast talk[9] on 'The Third Duke of Richmond's Racehorses at Exercise' is the best description of a single work by Stubbs that I know of.

Taylor suggests[10] that Stubbs's work recalls that of Chardin or early Gainsborough, Waterhouse[11] that it seems to echo that of Cuyp; so it does, though I do not know where Stubbs could have seen examples of Chardin or Cuyp. The analogy with early Gainsborough is borne out by some of Stubbs's landscape backgrounds of the 1760s, particularly the sunlit distance on the right of the Metropolitan Museum's Stubbs (No. 51) or the landscape of the Grimsthorpe pictures (Nos. 44, 45 and 71). Stubbs shows no inheritance from his predecessor John Wootton, and little from Wootton's more naïve contemporary James Seymour. If any English artist influenced Stubbs, it might have been Hogarth: and of Hogarth's works, the one which seems to have the most affinity with Stubbs is the Tate's 'Heads of Six of Hogarth's Servants' (fig. 3). David Piper comments[12] that 'After Hogarth we generally see the lower classes either through patronising or hygienic eyes . . . Only Stubbs, and perhaps Ben Marshall – rather than Morland – will survey them with a clear but sympathetic eye'. But could Stubbs ever have seen in his formative years the painting of Hogarth's servants, which remained in Hogarth's collection all his life and was never engraved? Stubbs probably had little direct knowledge of Hogarth's work. Analogies seem easier to find outside the sphere of painting: Stubbs seems to have the same sort of bedrock of common sense yet the ability to soar above it that one finds in the work of George Herbert and of George Frederick Handel.

In writing about an artist whom one greatly admires, there is always the temptation to inflate his claims to greatness. I cannot support Basil Taylor's proposition that 'there is every reason to count him [Stubbs] as next to Leonardo, as the greatest painter-scientist in the history of art'. I believe that Stubbs thought of himself first and foremost as a painter of reality, and that he undertook the study of the anatomy of the horse and, later, comparative anatomy, in order to paint more realistically. His experiments with preparing enamel colours and with mixing engraving methods were undertaken because he realized that paintings on canvas and panel are liable to deteriorate, and he wished to make his works last as long as possible. Otherwise there is little 'invention' in Stubbs, apart from the ability to compose designs in a great variety of ways. His pictures are almost all of real people, with real trappings; his experiments with history painting are either rather unsuccessful (for instance, the 'Fall of Phaeton' at Saltram) or lost, like the large *Hercules* subjects once in Sir Walter Gilbey's collection. He is at his best when the ingredients of his picture are most commonplace: in

Figure 2: Scene in a Country Town at the Time of a Race: engraving after William Mason, 1789

Figure 3: William Hogarth: Hogarth's Servants *c.*1750–5. Oil on canvas *Collection Tate Gallery*

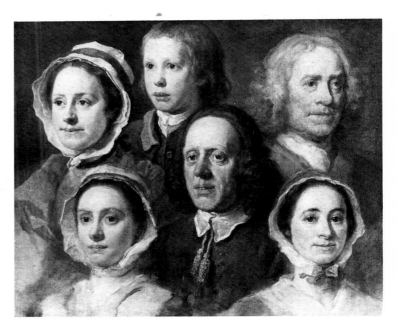

the portrait of 'Gimcrack with John Pratt up' (No. 56), for instance, when he paints a horse, a jockey, a few weeds, the corner of a rubbing down house and some clumps of trees on the horizon. As Mary Spencer remarked[13] of 'The Grosvenor Hunt' (and she, after all, knew Stubbs better than anyone else), 'Every object in the picture was a Portrait'. In the transcript of the Humphry manuscript her phrase is altered to read '. . . was painted from Nature', which is perhaps not quite what she meant. Can a milk jug be painted from nature? – for one may be sure that the jug or pitcher in the foreground of 'Reapers' was painted from a real object, and that 'portraits', in Mary Spencer's use of the word and in Stubbs's practice of his art, included still life such as tack or harness as much as it included people and animals.

We know what Stubbs weighed in 1782 (13 stone 12 lbs.[14]), the date of his self-portrait on a grey hunter (fig. 4); but knowledge of his family life remains slender. Timothy Stevens's research[15] indicates that Stubbs appears to have married in the early 1750s, to have had two legitimate children and to have carried on his father's currier business for most of that decade. Mary Spencer, who describes herself as 'Spinster' in her Will, appears to have lived with Stubbs as his common-law wife for about fifty years. She is assumed to be the mother of George Townly Stubbs (the middle name appears also as 'Townley' or even 'Towneley'), who engraved many of his father's pictures, was certified bankrupt[16] on 15 August 1785, and, perhaps because he needed some income, engraved many rather scabrous caricatures, many of them satirizing bosoms and bustles (fig. 5), as well as genteel subjects in stipple of nymphs, female personifications of the virtues, Shakespearian heroines and young ladies after Singleton; in no way can he be regarded as a chip off the old block. Robert Stubbs, described[17] as 'Relat. of the celebrated Horse Painter' on being awarded, in 1766, the Royal Society of Arts premium of ten guineas in Class 162 (landscape engraving with figures by youths under twenty-one) may have been another son; so, probably, was Richard Stubbs, who had died before Mary Spencer made her Will, which names his young daughter Louisa as a beneficiary. Stubbs's household seems to have included lodgers or probably pupils from time to time, like Miss Stewart, whose watercolour portraits are mentioned in Mary Spencer's Will (see No. 4) and who gave Stubbs's address in Somerset Street as her own when exhibiting at the Royal Academy in 1799–1800. Gilbey paraphrases a contemporary account of Stubbs's studio, but does not give his source. Otherwise all we know of Stubbs's household is that it included a white Persian cat.

The greatest gap in our knowledge of Stubbs's life is the disappearance of all except a handful of drawings (and the two major series of anatomical drawings). Stubbs's sale included numerous sketches and studies after nature: where now are the '15 sketches from Nature of Trees, in black chalk', the 'Twenty four sketches in black lead, Landscape &c.', the 'Capital Drawing, the original design for the Corn Field with Reapers' and 'Ditto, ditto, the original design for the Painting of Men loading a Cart, being a scene from nature in Lord Torrington's garden'? If these were discovered, we might learn something about Stubbs's working methods instead of having to infer that he made careful preliminary studies for all his finished pictures. Where, too, are the missing enamels? Where is the 'Portrait of Benjamin West, President of the Royal Academy'? Where is the

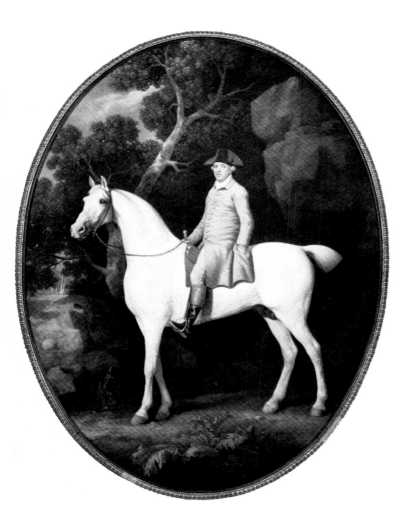

Figure 4: George Stubbs: Self Portrait on a Grey Hunter Signed and dated 1782. Enamel on Wedgwood biscuit earthenware *Merseyside County Council, The Lady Lever Art Gallery, Port Sunlight*

'portrait of a White Persian Cat, the peculiar favourite of Mr. Stubbs'?[18]

It is hoped that there is nevertheless enough in the exhibition to reveal Stubbs's genius, as a portraitist of human beings as well as of 'horses & lions, or dogs & tigers', and that those who find the anatomical drawings gruesome will find abundant solace in the grace-notes in Stubbs's work – in the details of foreground flowers, for instance, and in the beauty of weeds. Not many artists moved Horace Walpole to poetry; his verses 'On seeing the celebrated Startled Horse, painted by the inimitable Mr. Stubbs', published in the *Public Advertiser* on 4 November 1763, concluded

'*Thy pencil, Stubbs, no rival need to fear;*
Not mimic art, but life itself is here.'

Stubbs is perhaps a deceptive artist: some of his subjects seem so 'ordinary' that their extraordinary ability to move the spectator takes a second glance to manifest itself. In this his reticence is characteristically English, akin to that style which Jane Austen describes as 'burying under a calmness that seems all but indifference, the real attachment'. Stubbs's pictures speak for themselves, without the need of an interpreter; as the Editor of the *Sporting Magazine* wrote of Stubbs's portrait of 'Dungannon with a Sheep' (No. 96), 'This is really a wonderful and fine picture, and to say more of it would be to multiply encomium to impertinence.'

JUDY EGERTON

NOTES

1. Josiah Wedgwood, Stone, 25 September 1780, to Richard Bentley, Turnham Green, from transcript by Bruce Tattersall, *Stubbs & Wedgwood*, exh. cat. Tate Gallery 1974, p. 118

2. Ozias Humphry, MS Memoir of George Stubbs, Picton Collection, Liverpool City Libraries

3. There is a full account of the case in J. Fairfax-Blakeborough, *Northern Turf History*, III, 1950, pp. 96–100, from which quotations are taken

4. *Racing Calendar* is used throughout this catalogue as a shorthand reference to an annual publication which in its earlier days was entitled *A Historical List of Horse Races Run . . .* and variations on that title

5. Quoted by Roger Longrigg, *The History of Horseracing*, 1972, p. 70

6. Fairfax-Blakeborough, op. cit., p. 51

7. Dr Waagen, *Treasures of Art in Great Britain*, III, 1854, p. 339

8. *Painting in Britain 1530–1790*, 2nd ed. 1962, p. 207

9. Published in *The Listener*, 9 April 1964

10. Basil Taylor, *George Stubbs*, exh. cat., Liverpool, Walker Art Gallery, 1957, p. 8

11. op. cit., p. 207

12. *The English Face*, 1957, p. 187

13. In a note inserted in the Humphry MS Memoir, op. cit.

14. The compiler is indebted to H.B. Carter for this information, first published in *Stubbs, Anatomist and Animal Painter*, exh. cat., Tate Gallery 1976, p. 40, note 51

15. To be published in the forthcoming annotated edition of the Humphry MS Memoir by Timothy Stevens and Judy Egerton

16. P.R.O., B/6/6 f. 133: George Townly Stubbs is described as 'late of Newport Street in the co. of Middlesex printseller dealer and chapman'

17. The compiler is indebted to Mr D.G.C. Allan, Librarian of the Royal Society of Arts, for this information, recorded in the Minutes of the meeting of the Committee for the Polite Arts, MS Royal Society of Arts, and in Robert Dossie, *Memoirs of Agriculture and other Oeconomical Arts*, III, 1782

18. Missing enamels are listed in Tattersall, op. cit., p. 110 (No. 86, listed as missing, was rediscovered and is now in the collection of Mr Paul Mellon KBE. For missing drawings, see catalogue of Stubbs's sale, Peter Coxe, 26–27 May 1807: works mentioned here are lots 28 and 29 on 26 May and lots 20, 29, 67 and 73, on 27 May

Figure 5: The Go-Between or Barrow Man Embarrass'd: by and after George Townly Stubbs, 1787

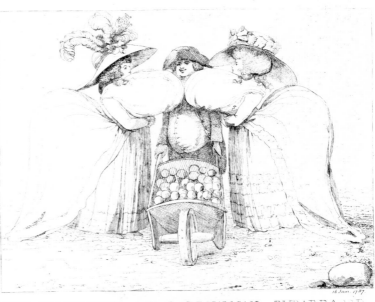

THE GO BETWEEN OR BARROW MAN EMBARRASSE

STUBBS: A CONSERVATOR'S VIEW

Since Basil Taylor stressed the need for particular care and attention in the cleaning and restoration of Stubbs's work (*Stubbs*, 1971, pp. 17–18), some attention has been paid to the problems involved. In 1980, the Scientific Department of the National Gallery published its findings on paint samples taken from the National Gallery's 'Lady and Gentleman in a Carriage', No. 132 in the present exhibition (*National Gallery Technical Bulletin*, 4, 1980, p. 64) and during the last two years, samples from four other paintings have been examined. These are 'Horse in the Shade of a Wood', dated 1780 (Tate Gallery 4696), 'Shark', dated 1775 (private collection), 'Reapers', dated 1783 (National Trust, Upton House) and 'Hambletonian', dated 1800 (National Trust for Northern Ireland, No. 138 in the present exhibition).

When addressing oneself to the problems presented by Stubbs's technique, one is really referring to those works, and especially to those painted on panel, executed after 1769, the year he began producing his enamel paintings. Pictures painted prior to this date are oil paintings on oil grounds on canvas, in which the paint is applied quite thickly and crisply. From 1770, Stubbs's materials change drastically; above all, his paint medium changes.

The results of analyses of paint from the four pictures on panel painted after this date are startling, offering a revelation which comes too late for some pictures which have already been damaged during cleaning. They are not adequately described as oil paintings. They are, rather, paintings in mixtures incorporating pine resin and beeswax and non-drying oils and fats; though one cannot tell this simply by looking at them. They defy all a restorer's expectations of an English painting of this period. Hence, the problem.

A précis by John S. Mills of the results of the analyses recently carried out at the National Gallery is of such great interest that I quote it at length.

'Lady and Gentleman in a Carriage'
'Horse in the Shade of a Wood'
'Shark'
'Reapers'
'Hambletonian'

All these paintings are on panel, except 'Hambletonian'. 'Lady and Gentleman in a Carriage' was the first picture examined. It was concluded, from gas-chromatography, to be painted in oil with an admixture of a non-drying oil or fat or stearin wax (which has a similar fatty acid composition). No beeswax or pine resin could be detected.

'Horse in the Shade of a Wood' and 'Reapers' seem to have similar media, namely a mixture of beeswax and pine resin. The second painting, however, may have a certain amount of oil, especially in the sky (only two samples were examined, from sky and foliage). There has however been much repainting in this picture, and Joyce Plesters reported that it was quite difficult to see where one finished and the other started. No drying oil was observable in the first painting.

'Shark' contained large amounts of pine resin plus a non-drying oil or fat. There was no drying oil or beeswax. Joyce Plesters found that samples of paint plus ground 'became glossy, and eventually in the temperature range 65–80°C. a clear colourless liquid flowed out, seemingly mainly from the ground or from between the ground and paint layer'.

In 'Hambletonian' the two samples differed slightly. The sky appeared to be painted essentially in drying oil, though even

here a certain amount of both beeswax and pine resin was observable. In the foliage sample there was very little drying oil and the beeswax and pine resin were both present. In both samples there seemed to be less medium than expected but this may have been because there was a good deal of ground and rather little actual paint in both of them. Of course this implies that the ground was not an oil one but I cannot be precise as to what medium it is in. Samples from both 'Hambletonian' and 'Reapers' were examined on the microscope hot stage. That from the latter was found to have paint which softened by 60°C and was more or less molten by 90°C, and a ground which was essentially unaffected by heat. In the former the paint showed only a glossiness up to about 86°C while the ground gave out some liquid by 90°C.

LIMITATIONS OF THE ANALYSES

It should perhaps be mentioned that there is at present no assurance that we would be able to detect residues of relatively volatile diluents such as oil of turpentine in the paint (though these *have* been detected in certain favourable cases in pigmented lacquers) or of 'resinified' oil of turpentine. A serious drawback in the results is the uncertainty with some samples as to the exact location of the paint structure of the materials detected. It should also be mentioned that in the case of 'A Lady and Gentleman in a Carriage', which was the first case examined, no mass-spectronomy was used and we might conceivably have missed the presence of small amounts of resin which otherwise seems to be an invariable ingredient.

It can be seen from these few results that Stubbs did not limit himself to one technique, but was continually searching for a better medium. He may simply have used whatever resins and waxes were to hand in his studio/laboratory. Only when very many more samples have been analysed will we be able to see if a pattern of experimentation emerges. What is clear now is that we should not approach any of Stubbs's pictures on panel as oil paintings, but as resin/fat or resin/wax paintings. Some of his later canvases may also prove to be of this type.

Stubbs used both mahogany and oak panels as supports. Some have a pale whitish ground, while others have no ground at all, but a very thin film of beeswax (this has not as yet been verified by the National Gallery Scientific Department, but there are several reports of this film having been found during treatments). The paint film now is very thin, almost wash-like, but with a dry shortness more akin to gouache. The juxtaposition of brush-marks, not blending or flowing together, also suggests a rather quick-drying medium, again very like gouache.

Basil Taylor's assertion that Stubbs's chemistry was perfectly sound (op. cit., p. 17) now appears slightly naïve, and his charge that damage to so many of the paintings in the past was due to careless or incompetent restorers is only partly true. The removal of a discoloured varnish from an oil painting, empirically or scientifically approached, is still a matter of exploiting the difference between solubility of oil paint and varnish, by using solvents which work differentially. The paintings in question display no such difference, since they are not in oil, nor even in a mixture of oil and resin, such as occurs in much contemporary painting. Furthermore, the substances Stubbs employed in his ground and paint (e.g. beeswax or non-drying fats) are most susceptible to attack by those solvents that the most conscientious restorer would have considered 'safe' (e.g. turpentine) and would have used to restrain the action of solvents he considered 'strong' or 'active'. Thus, unwittingly, damage was done.

The problems confronting a restorer when the paint on one of Stubbs's panels begins to lift or to flake are even more daunting. Most of the techniques for treating flaking oil paint demand the use of heat, and when dealing with a paint which melts at such low temperatures as those cited above, other remedies must be sought; and here our locker is rather bare. The water-based glues, both old and new, do not appear very effective in holding these very thin, waxy or fatty flakes of paint to their wooden supports. There are, however, one or two new types of adhesive recently introduced into conservation, which might well help to solve this problem.

Stubbs was as much an eighteenth-century 'man of science' as he was an artist. The eye and mind he brings to bear on any subject, be it a horse, a carriage, a dog or a monkey, is that of cool, objective observation and exploration, and, no doubt, he approached the technical limitations of his materials in a like manner. To what extent teaching himself the discipline of handling the materials and processes required to produce enamels influenced his approach to painting in oil is a matter for speculation. Possibly, the stimulus for his enamel paintings and for his paintings on panel was a desire to emulate the luminosity and subtle gradation of tone that he saw in some of the seventeenth-century Dutch painters, such as Cuyp and Terborch. There was a strong feeling among his contemporaries that the technique of the great masters of the past had been lost, and should be sought again.

Alas, a great number of Stubbs's pictures have suffered severely in the past, and there is no magic wand which can be waved to reverse what has happened. Happily, today, and with the help of the scientist, most restorers know a great deal more about the tools at their disposal and the materials used by the artists, and the likelihood of another Stubbs being ruined is very much reduced. We hope that we have also shown that some of the blame for the damage suffered by his pictures must be laid at Stubbs's door, for many of his wonderful images are made of stuff too frail for this rough world.

ROBERT SHEPHERD

The cleaning of Stubbs's 'Hambletonian' (No. 138)

Prior to this exhibition, the painting was cleaned at the Hamilton Kerr Institute, Cambridge. The sheer size of the picture posed problems, especially as it was feared initially that some areas executed in resinous or unconventional media might have proved vulnerable to cleaning solvents. Before cleaning the painting was obscured by several thick layers of heavily discoloured varnish which flattened the modelling of the horse and reduced the recession in the landscape.

During cleaning it became apparent that the painting was in surprisingly good condition. The paint medium did not react unfavourably to solvents, and was found to be largely drying oil with additions of a natural resin and some beeswax, especially in the landscape, where extra care in cleaning was required. The existing lining probably dates from no later than the mid-nineteenth century, and is still in sound condition. There were several small paint losses in the sky and around the edges of the picture, and the horse and figures showed considerable abrasion

of the paint surface in a few areas, possibly as a result of earlier selective cleaning using strong solvents. These abraded areas had been coarsely retouched or covered with a thick toned varnish. The thick build-up of varnish completely obscured the texture of the paint and canvas, and the signature and date were virtually invisible.

The removal of the varnish revealed the texture of the paint, showing the obvious canvas-weave pattern, visible through the thinly applied paint film. The impasto although not extensive or prominent is well preserved, and below the railings on the horizon the bright green of the distant landscape has a fluid and fused appearance, possibly attributable to the mixtures of resin and wax added to the paint medium. However there is little evidence that the lining process has deleteriously affected the original appearance of the picture, or has accentuated the canvas texture unduly.

The handling of the paint is assured and free; the stable boy's left leg for example is outlined by paint drawn from the green of the middle distance. The modelling of the horse and figures is remarkably delicate even on such a large scale, and Stubbs has not made any concessions to the size of the picture in the quality of his handling of the paint. In the horse in particular, he achieved great subtlety of effect with a simple build-up of paint, rarely more than two layers in thickness.

Several pentimenti are now visible, most clearly around the cloth in the stable-boy's hand, which was originally larger and filled with bundles of straw. The position of the trainer has been slightly altered and there is some evidence that changes were made in the position of the horse's hind legs. Otherwise, Stubbs seems to have made no other alterations to the composition on the canvas.

One intriguing but irreversible change which has occurred has been the disappearance of the outlines of the tiles on the roof of the rubbing-down house. These were executed in a resinous

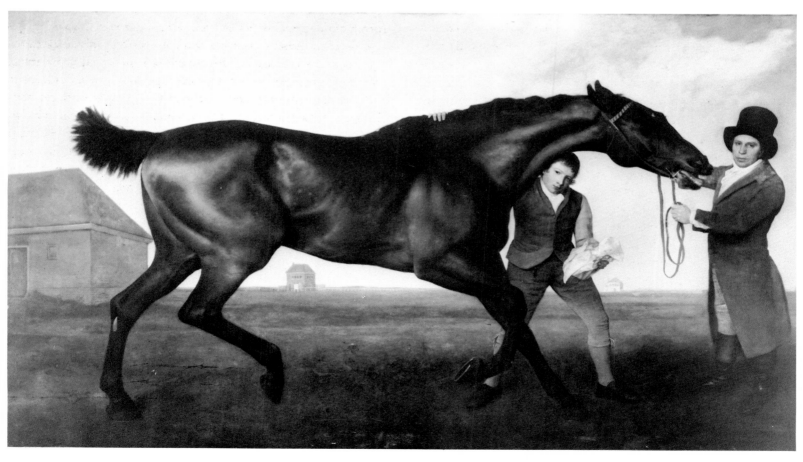

medium which is visible under ultraviolet illumination, but which cannot be seen in normal light. The most likely explanation is that Stubbs used a fugitive pigment, such as an organic red lake which has faded under the action of light leaving the lines indicated only by the medium.

After cleaning and varnishing, damaged areas were filled and retouched, and minimal glazes were applied to obvious areas of abrasion.

THE TECHNIQUES AND MATERIALS

During cleaning a technical examination of the painting was undertaken at the Hamilton Kerr Institute, both as an aid to the detection of overpaint and as an investigation into Stubbs's technique and materials. The painting was examined closely under the microscope, and minute samples of paint were taken from the edge of damaged areas to provide information on the pigments, media and the layer structure of the paint. These samples were examined in cross section under a high powered microscope, and were analysed using microchemical techniques, and an electron microprobe to reveal the elemental composition of the pigments. The following technical conclusions are distilled from the results of this research.

Stubbs used as a support a single piece of finely woven canvas, on which he applied a double ground. The lower layer is of a red brown colour and contains red and brown earth pigments (mainly ferric oxides) with lead white, carbon black and a small amount of orpiment (arsenic sulphide), while the upper ground is a paler warm grey colour and contains a larger proportion of lead white, chalk and black. The ground although relatively thick, is not smooth but follows the canvas texture, and the weave pattern acts as an integral textural component in most areas of the picture although less noticeably in the sky.

Stubbs painted the horse first, as was his normal practice, and applied the paint of the background and sky later, drawing the paint up to, and occasionally over, the outline of the horse and figures. The grey ground can be seen in places visible between adjacent regions of paint. His treatment of the horse and figures shows that he achieved subtle effects of light, shade and form through straightforward and economical means. Initially he modelled the horse in a single fairly thick opaque layer, using a mixture of red and brown ferric oxides and yellow ochre, with small quantities of black, lead white, orpiment, smalt and an organic red lake pigment. This layer was modelled while still wet, and adjacent areas of colour were smoothly merged into one another, creating almost imperceptible transitions with little overlapping of paint layers. Stubbs then applied some very thin transparent dark glazes to deepen the shadows and midtones, and scumbled pale colour over some highlight areas to emphasize the form. The lightest tones are applied quite thickly, using a heavily laden 'dry' brush to drag the paint across the canvas texture.

The treatment of the figures shows a similar freedom of approach, and the faces have been painted in thick opaque paint, modelled whilst still wet, and with details and glazed shadows added afterwards. Elsewhere, such as on the stable-boy's jacket, Stubbs has used an extremely thinly applied transparent paint layer to define the basic colour and tone, modulated with thin pale scumbles and transparent glazes in the shadows.

The most complex areas of the painting in terms of the build-up of paint are seen in the landscape and in the rubbing-down house. In the nearest foreground greens, a very thin medium layer or imprimatura underlies another thin, transparent green glaze which has flowed into the hollows of the canvas texture, and has been wiped off the tops of the threads. On top of this the signature and the details of foliage are painted in opaque paint in which coarse yellow pigment particles, of orpiment or Naples yellow, can be seen with the naked eye. Towards the horizon, thicker opaque layers are used on top of the initial green glaze to create areas of illuminated grass and the lighter tones in the distance. Finally, Stubbs applied some thin, very transparent glazes to create the more subtle modulations of tone; some of these no more than five microns thick.

The rubbing-down house shows similar use of very thin transparent layers to depict details of brickwork and tiles, over an opaque ochre paint layer. Some of these are now only detectable under ultra violet illumination due to fading of the pigment or changes in the refractive index of the medium.

Finally the sky was painted using wet-in-wet mixtures of lead white, calcium carbonate and Prussian blue. In most areas this forms a single layer on top of the ground but in one or two areas a pale pink underlayer is present, possibly as a result of some reworking.

Mention has already been made of the medium used by Stubbs, which was found to be predominantly a drying oil, with varying proportions of pine resin and beeswax. The pigments detected in Hambletonian are for the most part conventional and even conservative for a painting of this date. Stubbs made extensive use of earth pigments; iron oxides, reds and browns, yellow ochre and umbers, which are found in the horse and elsewhere. The white pigment is a mixture of lead white and calcium carbonate, and it appears that he used both bone black and a black derived from burnt wood or charcoal. Prussian blue is the most widely used blue pigment, and is also found in other paintings by Stubbs. Some smalt was also detected in small quantities. The Prussian blue, when mixed with yellow ochre, orpiment or possibly Naples yellow (not as yet confirmed in this picture, but present in earlier works by Stubbs), also creates the greens of the landscape. The use of both smalt and orpiment at this date is of interest, as both these pigments were considered to be of secondary importance by the end of the eighteenth century. In contrast, the detection of large amounts of chlorine in samples from the landscape appears to indicate the presence of Patent yellow,[1] a mixed compound of lead chloride and lead oxide, which had only become available in England since the 1780s. This use of a recently developed and relatively uncommon pigment is interesting in view of Stubbs's scientific interest in the chemistry of pigments.

IAN MCCLURE
Director
Hamilton Kerr Institute
University of Cambridge
and

RUPERT FEATHERSTONE
Trainee Restorer
Hamilton Kerr Institute

1. Rosamund Harley, Artists Pigments *c*.1600–1835. Second edition, London 1982, pp. 99–100

I

OZIAS HUMPHRY R.A. (1742–1810)
PORTRAIT STUDY OF GEORGE STUBBS
dated 1777

Black and white chalk on brown paper,
$16\frac{1}{2} \times 14\frac{3}{4}$ in. (42 × 36 cm.)
Inscribed 'Geo: Stubbs: pictor –
O:H:d!/1777' on verso of old mount
Trustees of the Rt. Hon. Olive,
Countess Fitzwilliam's Chattels Settlement,
kindly lent by Lady Juliet de Chair

PROVENANCE
. . .; Sir Kenneth Anderson, KCMG; by descent
until sold (as 'The Property of a Gentleman'),
Sotheby's 17 November 1983 (113, repr.).

This shows Stubbs at the age of fifty-three: full-faced, physically robust, temperamentally energetic and purposeful. The drawing, which has only recently come to light, is evidently a study for Humphry's finished watercolour portrait (No. 2). Dated 1777, the drawing must have been made soon after Humphry's return during October of that year from four years' work in Rome.

Stubbs's friendship with Humphry probably began before Humphry's departure for Rome; it was to be of long standing. Some twenty years after making this drawing, when Stubbs was over seventy and Humphry aged about fifty, Humphry encouraged Stubbs to talk at length about his career and various aspects of his work, then jotted down what is here referred to as the 'Humphry MS Memoir': on its first page Humphry wrote 'These particulars of the Life of Mr Stubbs were given to the author of this Memoir by himself and committed from his own relation'. The Memoir is a rambling and sometimes exasperatingly vague document – Humphry himself described it as 'much too diffusive and unimportant for the public eye' – but it is by far the fullest contemporary source of information about Stubbs.

On 2 February 1794 Stubbs sat again to Humphry, as the diarist Joseph Farington noted that day ('called on Humphry . . . Stubbs was there and sitting for his portrait'.) That portrait was presumably the 'Portrait of Mr Stubbs' which Humphry exhibited at the Royal Academy in 1794 (374); it is now in the collection of the Walker Art Gallery (pastel, 29 × 19 in., repr. page 216).

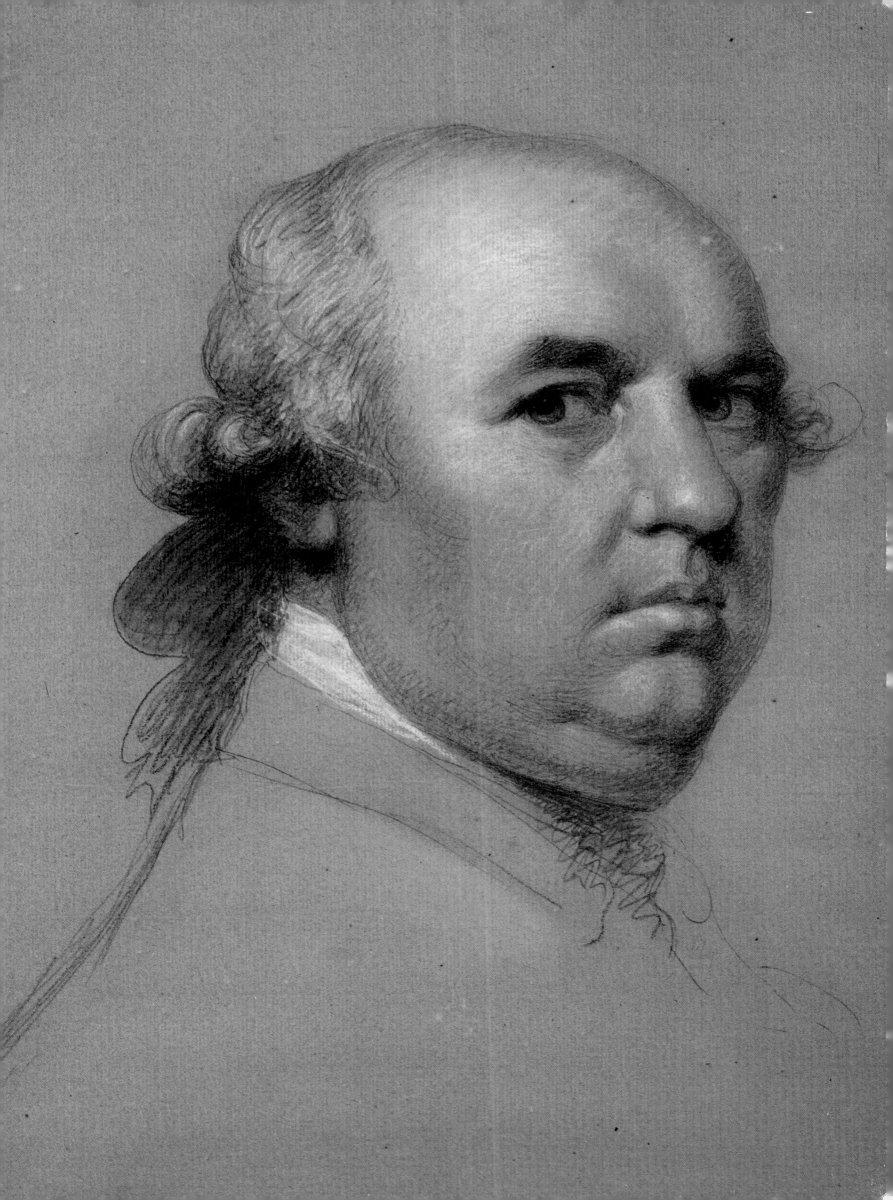

2

OZIAS HUMPHRY R.A. (1742–1810)
PORTRAIT OF GEORGE STUBBS WITH
'PHAETON AND THE CHARIOT OF THE
SUN'
probably painted 1777

Watercolour on paper, 20 × 15¾ in.
(50.8 × 40 cm.)
National Portrait Gallery, London

PROVENANCE
Presumably painted for Stubbs; Mary Spencer, in
1809; according to correspondence of *c*.1905 in
N.P.G. files, said to have been acquired direct
from G.T. Stubbs by Mr A. Stamford,
Wandsworth; sold by his widow to the National
Portrait Gallery 1905

EXHIBITED
Tate Gallery 1974 (5, repr.)

LITERATURE
Taylor 1965 (ii), pp. 3–4; Tattersall 1974,
pp. 42–3, 64–5

ENGRAVED
by W. Nicholls, published 1 December 1809 by
J. Wheble, Warwick Square, London, and in the
Sporting Magazine, XXXV, no. CCVI, November
1809, facing p. 49 ('from a picture in the
possession of Mrs Spencer')

The pose is the conventional one for an architect
displaying a plan, or an inventor his brain-child.
What is celebrated here is Stubbs's deep interest in
painting in enamel colours on hard surfaces; he is
portrayed displaying his 'Phaeton and the Chariot
of the Sun', dated 1775, his largest work in enamel
on copper (oval, 14¾ × 18 in., private collection,
repr. Tattersall 1974, p. 65), which must be resting
in its frame on an easel or some other form of
support. This 'Phaeton' was described in Stubbs's
studio sale as 'a beautiful enamel on copper, and
very highly finished; conceived with Poetic Fire,
and the action of the ethereal Coursers in their
rapid progress, highly characteristic of the
celebrated story'.

Humphry had returned to London in October
1777, after four years' absence in Rome. A study
(No. 1) for this portrait, dated 1777, must have
been made soon after his return. The fact that in
the finished portrait Stubbs displays a work in
enamel on copper makes it likely that the portrait
itself was completed before the end of the year, for
in the middle of December 1777 Stubbs received
the good news that Messrs Wedgwood & Bentley
had succeeded, after many trials, in producing the
first ceramic tablet for him to paint on. Up to that
point, all Stubbs's work in enamel was on copper
plates, whose weightiness restricted the size he
could use to 15 × 18 in. Stubbs, accustomed to
working on a larger scale, had been seeking an
alternative to copper; he was in touch with
Wedgwood & Bentley, and had been waiting, with
some impatience, for about two years for a ceramic
'canvas' (Wedgwood wrote to Bentley on 4
November 1777: 'My comp^ts to Mr Stubbs. He
shall be gratified, but large tablets are not the work
of a day'). On 11 December 1777, Wedgwood
reported to Bentley that one 'whole' and 'perfect'
tablet, 22 × 17 in., was to be sent to London for
Stubbs in a few days' time; probably Stubbs used it
for 'Lion Attacking a Stag', signed and dated 1778
(repr. Tattersall 1974, p. 97; see also pp. 17–18).

It is highly likely that during the sittings for this
portrait, Humphry asked Stubbs what progress he
had made in enamel painting during the years
when he himself was in Rome. The study (No. 1) is
of head and shoulders only; whether it was
Humphry or Stubbs who suggested that it should
be turned into a three-quarter length 'portrait of
an enamel-painter with an example of his work' is
not known, but it seems unlikely that once he had
received his first ceramic 'canvas', he would have
chosen to be portrayed with a work on copper.

A portrait of Stubbs by William Craft (exh.
1774–84), enamel on copper, 6¾ × 5¾ in. (repr.
Taylor 1965 ii, fig. 4) must be about the same date
as the Humphry watercolour.

Stubbs's 'Self Portrait' of 1781 (No. 4) is painted
in enamel on Wedgwood earthenware, as are Nos.
48, 120, 121, and 139; Wedgwood had gradually
produced larger ceramic tablets for Stubbs to work
on. Nos. 64 and 68 are examples of his earlier
work on copper. Humphry's MS Memoir includes
fairly detailed notes of Stubbs's own 'relation'
c.1797 of his experiments in producing enamel
colours and his successful works in enamel.

Mary Spencer's Will bequeaths 'a Three
Quarter Length Oil Picture, being a Portrait of the
late M^r George Stubbs, senior, painted by
Humphry' to Mrs Mary Dean, 'of Charles Street
Middlesex Hospital': did Humphry also paint a
portrait in oils of Stubbs, or is Mary Spencer
confusing this highly finished watercolour with an
oil painting? A codicil to her Will mentions 'a
Portrait of the late Mr. George Stubbs in water
colour', bequeathed to Louisa Stubbs; this may be
the Humphry watercolour, or it may be by 'Miss
Steward', presumably the Miss M. Stewart who
exhibited at the Royal Academy between 1791 and
1801, giving her address in 1799–1800 as 'at Mr.
Stubbs', 24 Somerset Street; Mary Spencer's Will
earlier mentions 'Two Small Portraits, one of
myself and the other of M^r Richard Stubbs, drawn
in water colours by Miss Steward', also bequeathed
to Louisa Stubbs. It should perhaps be noted here
that Thomas Stewart (exh. 1784–1801) exhibited a
portrait entitled 'Mr. Stubbs' at the Royal
Academy in 1801 (98); in 1795–7 his address was
given as 39 Somerset Street (but not noted in
1801): possibly he is the father of 'Miss M.
Stewart', who may have been a pupil of Stubbs's.
None of the 'Stewart' portraits are known today.

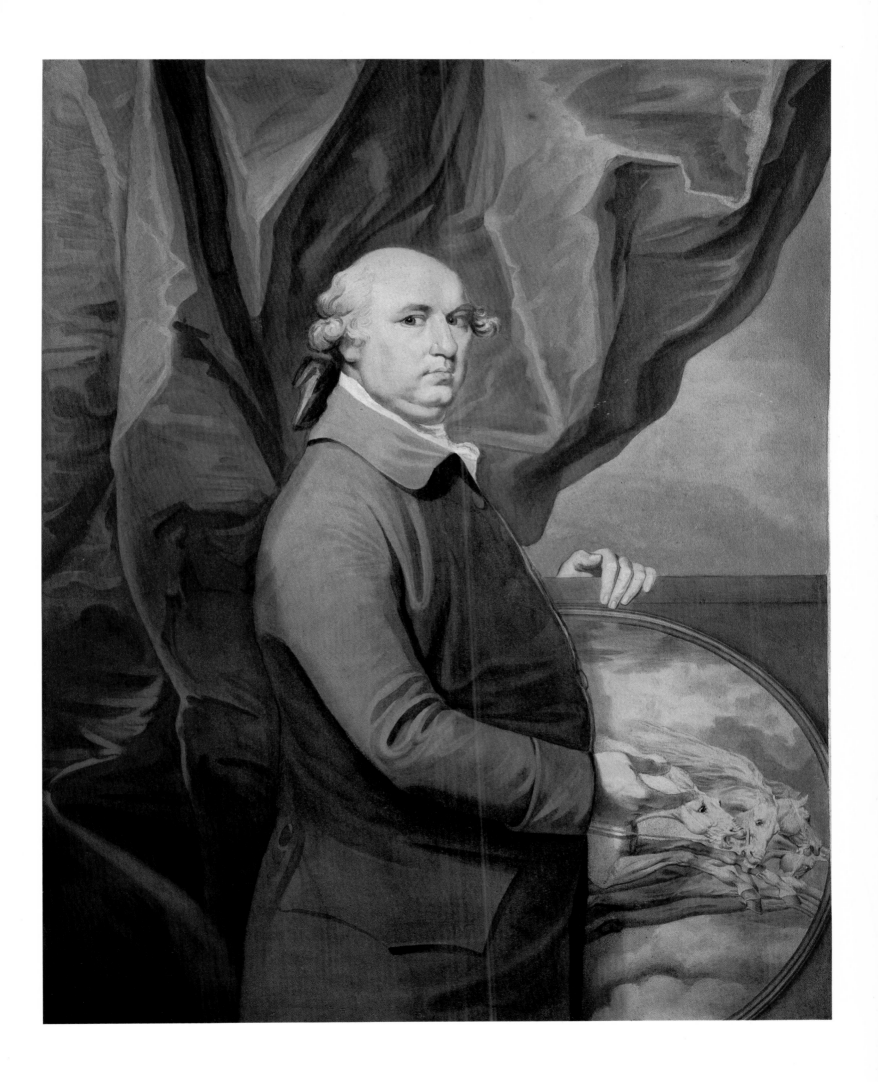

3

STUDY FOR THE SELF-PORTRAIT IN
ENAMEL
1781

Graphite on paper, 12 × 9 in.
(30.5 × 23 cm.), squared.
Inscribed 'George Stubbs' on the palette,
and on the back, in a later hand, 'This is
the portrait of George Stubbs / the
Animal Painter / and His name is to be
seen / on the palette. 5 July 1842 /
Capital drawing / by whom?'
Paul Mellon Collection, Upperville, Virginia

PROVENANCE
. . .; H.S. Reitlinger; Alistair Matthews; Ian
Fleming-Williams, from whom purchased by
Mr Paul Mellon KBE, 1962

EXHIBITED
V.M.F.A. 1963 (332); *English Drawings and
Watercolours from the Collection of Mr. and Mrs. Paul
Mellon*, Colnaghi 1964–5 and Yale University Art
Gallery 1965 (6); *English Drawings and Watercolours
1550–1850 in the Collection of Mr. and Mrs. Paul
Mellon*, Pierpont Morgan Library, New York 1972
and Royal Academy, London 1973 (31, pl. 31)

LITERATURE
Taylor 1965 (ii), pp. 3–4, fig. 1.

Taylor (op. cit.) notes that the study is 'mainly
worked in soft pencil and in a manner comparable
with that to be found in the drawings for *The
Anatomy of the Horse* and the *Comparative Anatomical
Exposition*. It seems however that a much harder and
sharper pencil has been used not only to impose the
squaring but to define the hair and neckcloth and to
reinforce the outlines of certain other features such
as the nose.' Taylor also notes that the enamel
portrait (No. 4) for which this is a study is two and
one third times the height of the drawn oval.

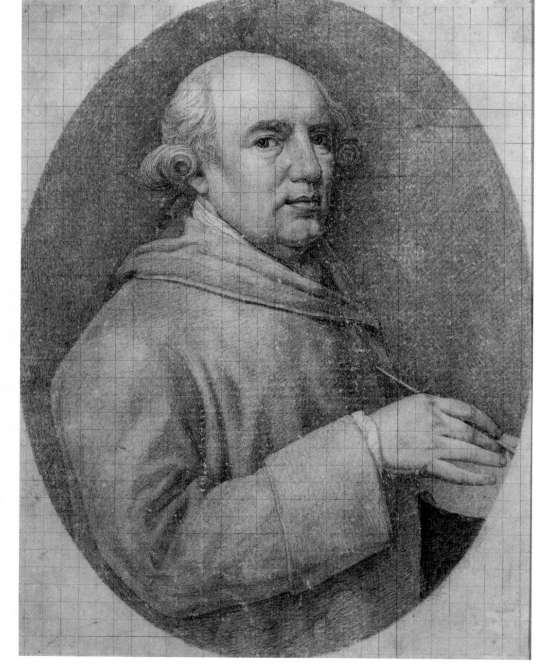

4*

SELF-PORTRAIT

Enamel on Wedgwood biscuit earthen-
ware, oval, 27 × 20 in. (68.6 × 50.8 cm.)
Inscribed 'Geo Stubbs / pinxit 1781'
lower right and on the back 'Geo. Stubbs
painted by himself for his friend Richard
Thorold / of the Inner Temple London
1781'
National Portrait Gallery, London

PROVENANCE
Richard Thorold (d. 1792); believed to have been
in the collection of the Corbett family, ? passing
into that of Sir John Dugdale Astley (who m.
Eleanor Corbett, 1858, and d. 1894), remaining at
Elsham Hall, Brigg, Lincolnshire, and in a sale
there *c.*1928 (untraced); Mrs Muriel Heely, from
whom purchased by the National Portrait
Gallery, 1957

EXHIBITED
R.A. 1782 (173, 'Portrait of an Artist'); Liverpool
1951 (27, as 'Portrait of Josiah Wedgwood');
Whitechapel 1957 (12)

LITERATURE
Humphry, MS Memoir; Taylor 1961, p. 209, fig.
C, p. 223, no. 13; Taylor 1965 (ii), pp. 3–4, fig. 2
(as in the collection of Mr and Mrs Paul Mellon)

This portrait seems to have surfaced in the late
1920s at Elsham, a few miles from Horkstow in
north Lincolnshire, its identity then lost. It was
exhibited in 1951 as a portrait of Josiah Wedgwood;
that it was in fact a self-portrait was established
in 1957 by Basil Taylor after comparison with
Stubbs's 'Self-Portrait on a White Horse' of 1782, in
the collection of the Lady Lever Art Gallery, Port
Sunlight (repr. p. 18).

Stubbs himself notes on its back that this self-
portrait was 'painted . . . for his friend Richard
Thorold' (though Humphry notes it as 'a
commission from Mr. Thorold'). A self-portrait
painted for a friend, particularly one painted in
enamel, a medium Stubbs chiefly reserved for his
favourite subjects and for portraits of people to
whom he had some special obligation, suggests a
close friendship. Stubbs's friendship with Richard
Thorold may date back to that highly interesting
but obscure period when Stubbs was working at
Horkstow on the *Anatomy of the Horse*. Richard
Thorold F.S.A. (d. 1792) was the eldest son of
Jessop Thorold and his wife Susannah, sister of the
Dr Hardy M.D. of whom Stubbs painted, according
to Humphry, an enamel portrait 'abt. half the size
of life' (present whereabouts unknown). He grew
up at Coxwold Hall, about eighteen miles south
east of Horkstow; later he acquired (?through
inheritance) an estate at Barnetby-le-Wold about
five miles from Horkstow, but lived chiefly in
London.

Though he was admitted to the Middle Temple
in 1758, Richard Thorold seems chiefly to have
been known as 'a very ingenious mechanic' (the
phrase used in the *Gentleman's Magazine* obituary
notice). His Will, which lumps together,
unspecified, 'furniture linen china pictures books',
particularizes 'all my Brass Steel Working Tools
and Engines and Prints', and also refers to a
collection of coins in cabinets. Did Stubbs ever use
his friend's services as an 'ingenious mechanic',

perhaps in the construction of tackle for his anatomy projects, in making his prints or in the making of that ingenious working model of a skeleton wired with copper and annealed iron, described in Ackermann's *Repository* after Stubb's death as 'invented by Mr. Stubbs'? If so, Stubbs may have offered to paint a subject of his choice for Thorold, rather as he had offered to do for Josiah Wedgwood, as a way of 'setting off' his indebtedness.

Richard Thorold's private life seems to have been somewhat eccentric. His Will makes generous provision for his wife Mary Thorold, adding that although he had not previously declared that he was married at all, she 'has been faithful and very attentive to me for over thirty years'. Perhaps irregular households were a bond between Thorold and Stubbs. Thorold's Will leaves £10 each ('for mourning') to Dr Richard Hardy and Mr Adrian Hardy; it does not mention Stubbs.

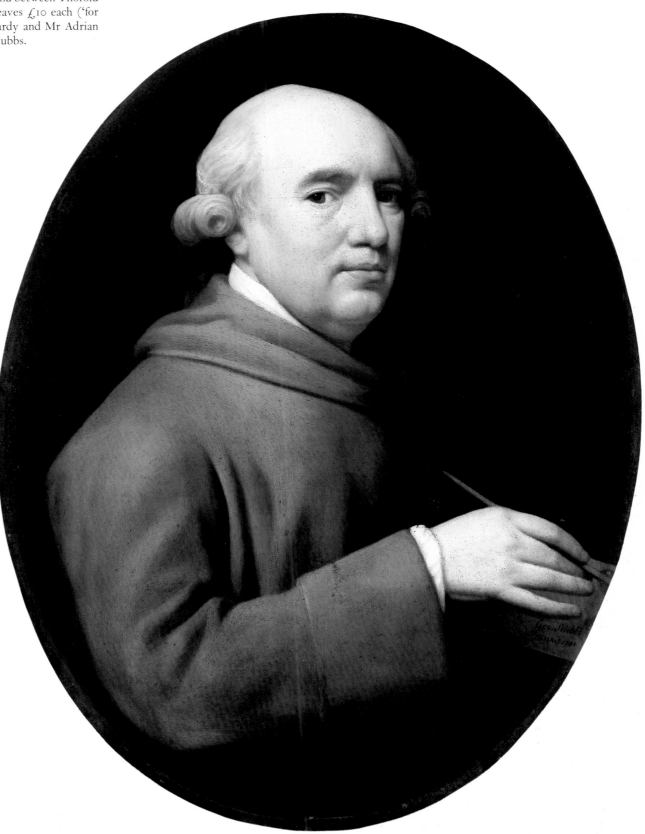

5

GEORGE DANCE R.A. (1794–1825)
GEORGE STUBBS
dated 1794

Pencil on paper, $7\frac{1}{4} \times 5\frac{3}{4}$ in.
(18.5 × 14.6 cm.)
Inscribed 'Feb? 8th 1794' b.l. and
'Geo. Dance' b.r.
Royal Academy of Arts, London

PROVENANCE
. . .; one of a collection of fifty-three portraits by
Dance acquired by the Royal Academy in an
unknown way (? presented by the artist) at an
unknown date

LITERATURE
Taylor 1965 (ii), p. 3 and note 2, p. 4

ENGRAVED
Soft-ground etching by William Daniell,
published by George Dance 1802; one of eighty-
four portraits additional to the series of seventy-
two *Portraits of Eminent Characters Sketched from Life
since the year 1793*, published in 2 vols. 1808, 1814.
William Daniell's preparatory drawing for the
soft-ground etching, in pencil and red chalk on
tracing paper, is in the collection of the Yale
Center for British Art (Noon, cit. infra, p. 127,
no. 227).

Joseph Farington recorded in his diary (cited under
No. 1) that he called on Ozias Humphry on 2
February 1794 and found Stubbs there, sitting for
his portrait (the pastel now in the Walker Art
Gallery), adding 'I encouraged him to sit for a
profile to Dance'. Perhaps Stubbs did not need
Farington's encouragement; Dance's portrait is
dated six days after Farington's visit.

Dance's portraits and Daniell's soft-ground
etchings of them are discussed by Patrick J. Noon,
English Portrait Drawings & Miniatures, Yale Center
for British Art, 1979, p. 81. Dance, by profession an
architect, was a prolific portrait draughtsman; as
Noon notes, 'this activity provided weekend
relaxation from his professional labours'. Indeed,
8 February 1794, the day on which Dance made this
drawing, was a Saturday.

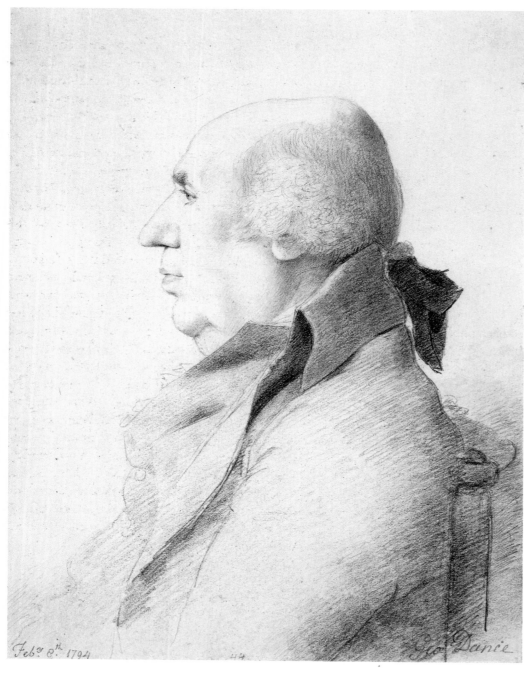

Stubbs's interest in anatomy started in childhood; it was to last all his life. It was in order to pursue a regular study of anatomy that he moved in about 1745 to York, whose County Hospital also functioned as a medical school. Here he was befriended by Charles Atkinson, a young surgeon who gave Stubbs practical instruction in human anatomy and later encouraged him to give anatomical lectures privately to students. At York Stubbs became involved with Dr John Burton (Sterne's 'Dr. Slop'), who was compiling a treatise on midwifery. Burton employed him to design the illustrations, some from Stubbs's own dissection of the body of a woman who had died in childbirth; he also persuaded Stubbs to etch the plates. To do this, Stubbs had first to teach himself the art of etching. The eighteen unsigned plates in Dr Burton's *Essay towards a Complete New System of Midwifery*, 1751, are Stubbs's first published works (No. 167).

While he was at York, Stubbs conceived the idea of research into the anatomy of the horse. No such work had been published since Carlo Ruini's *Dell' Anatomia et dell' Infirmita del Cavallo*, first published in 1598, its rather schematic woodcuts serving since then as illustrations of equine anatomy. Time, seclusion and some source of income (or savings) would be needed for the sort of project that Stubbs had in mind, and it was not until about 1756, at the age of thirty-two, that he was able to undertake it. As the place for his labours Stubbs chose the hamlet of Horkstow in north Lincolnshire, where there were tanneries nearby and where he probably enjoyed the protection of his early patroness Lady Nelthorpe (see under No. 27). He devised tackle for hauling and manoeuvring his subjects into different positions; a horse could hang for him to work on for six or seven weeks ('or as long as they were fit for use'). His only assistant was his common-law wife, Mary Spencer. Stubbs spent some eighteen months dissecting horses, stripping away layer after layer of skin and muscle until he came to the skeleton; as he dissected, he drew and made notes. Forty-one drawings have survived, from which a selection is shown here. (Nos. 6–25).

Determined to publish his *Anatomy of the Horse*, Stubbs took his drawings to London in 1758; he approached several professional engravers, all of whom declined to undertake such unfamiliar subjects. Stubbs therefore engraved the eighteen plates himself, developing a masterly technique which gives the engraved plates dignity as well as exactitude. Since commissions for paintings were abundant after his move to London, he had to work on the engravings in what leisure he had ('early in the Morning, & in the Evening and sometimes very late at Night'); not surprisingly, the work took seven or eight years to finish.

The Anatomy of the Horse (No. 168) was published in 1766. It is significant that Stubbs styles himself on its title-page 'George Stubbs, Painter.', and that he should have added that its eighteen tables were 'all done from Nature'. His research had been primarily governed by his own wish to know, as a painter, what lay beneath the skin, what contours muscles might shape and how subcutaneous veins might appear. When the great anatomist Peter Camper wrote to him in 1771, praising the book highly and hoping that Stubbs might probe further into the horse's anatomy, Stubbs replied, with no false modesty but disclaiming profound anatomical knowledge, 'What you have seen is all I meant to do, it being as much as I thought necessary for the study of Painting . . . I looked very little into the internal parts of a Horse, my search there being only matter of curiosity'.

Stubbs's interest in anatomy continued throughout his life, culminating in work in the last decade of his life on *A Comparative Anatomical Exposition of the Structure of the Human Body with that of a Tiger and a Common Fowl*; there, 'curiosity' rather than practical usefulness seems to have been his chief spur.

Twenty of the forty-two surviving drawings for *The Anatomy of the Horse*

PROVENANCE

Mary Spencer (d. 19 January 1817); ? sold (or offered), presumably by order of her executors, Thomas and Charles Ricketts, Phillips, 27–28 March 1817. No catalogue appears to have survived, and Phillips's own records were destroyed during the last war. Mr Phillips advertised, in the *Morning Post*, 18 March 1817 (p. 4), his sale, on 25 March and following day (changed in an advertisement in the *Morning Post* 25 March 1817 to '27th and following day'), of 'Works of Art by late Geo. Stubbs, Esq.', to include 'his highly distinguished work, The Anatomy of the Horse, together with a large quantity of letterpress in English and French, and copperplates pertaining to this work'.

Bought by Colnaghi; acquired from Colnaghi by Edwin Landseer R.A., reputedly in exchange for a picture (see undated letter, ? c.1860, from A.H. Cross, presumably to Joseph Mayer, Mayer Papers (Picton Collection, Liverpool City Libraries) vol. 2, f. 33: 'My friend Landseer possesses them . . . old Colnaghi bought them at a sale some years back when a sale of Stubbs's things took place and Landseer painted him Colnaghi a picture for them . . . Joseph Mayer of Liverpool evidently made an unsuccessful offer to buy the drawings from Landseer, with the intention of presenting them 'to a public institution of the native place of Stubbs': see undated letter, c.1860, from W. Cook to (?) Mayer, Mayer Papers vol. 2, f. 37)

On Edwin Landseer's death in 1873 the drawings were sold by his executors at Christie's, 15 May 1874 (seventh day, lot 1375, 'Stubbs: The Anatomy of the Horse, plates and the original drawings made for the engravings'), bought by Parsons for £1.8.0. They were then acquired by Charles Landseer, by whom bequeathed to the Royal Academy 1879.

The eighteen finished drawings, from which Stubbs engraved the plates, were used for teaching Royal Academy students. The rest, Stubbs's working drawings, lay forgotten in a parcel until they were rediscovered in 1963.

LITERATURE

Humphry, MS Memoir; Basil Taylor, 'Stubbs as Anatomist', in *Rediscovered Anatomical Drawings from the Free Public Library, Worcester, Massachusetts*, exh. cat., Arts Council, 1958, pp. 3–18, reprinted in *George Stubbs, Anatomist and Animal Painter*, exh. cat., Tate Gallery, 1976, pp. 10–19; Parker, 1971, Chap. 4, pp. 18–29; Terence Doherty, *The Anatomical Works of George Stubbs*, 1974, pp. 5–11: Doherty reproduces forty-one of the forty-two drawings (III, 1–41, omitting R.A.1) and the eighteen published plates (IV, 1–18) and provides notes on them (pp. 37–42, 84–86)

EXHIBITED

(selected drawings) Liverpool, 1951 (69–86); Whitechapel, 1957 (57–74); *Sport and the Horse*, Virginia Museum of Fine Arts, Richmond, Virginia, U.S.A. (17, A–F); Treasures from the Royal Academy, Royal Academy, 1963 (46–7, 50–1, 55–6, 59–60); Eighteenth Century Drawings, Chiswick House, 1969; Iveagh Bequest, Kenwood, 1971 (in a small exhibition around 'Whistlejacket', no catalogue); British Sporting Paintings 1650–1850, Arts Council, 1974–5 (326–7); Tate Gallery, 1976 (7–26); The Anatomy of the Horse, Royal Academy touring exhibition, 1982 (2–37)

WORKING DRAWING OF A STAGE IN DISSECTION BETWEEN THE EIGHTH AND NINTH ANATOMICAL TABLE (R.A.20)

Graphite, red chalk and ink on paper, $18\frac{3}{4} \times 12$ in. (47.6 × 30.5 cm.)
Inscribed
'Tab 9 fig 1' top left, and
with notes middle left 'A part of pectoralis inserted / with the inside of the head of humerus / and forms of a ligament that bind down the / head of the biceps. B C D what I think analogous to / the serratus minor anticus / arises at D from the sternum & / part of the first rib or / collar bone and from / the cartilaginous bindings of the / 2nd 3rd and 4th rib near their joins / to the sternum. Is inserted into the should / blade and tendinous surfaces / of the supraspinatus scapula / at C'.
The ribs are numbered, and there are other working notes within the drawing and at the right
Royal Academy of Arts, London

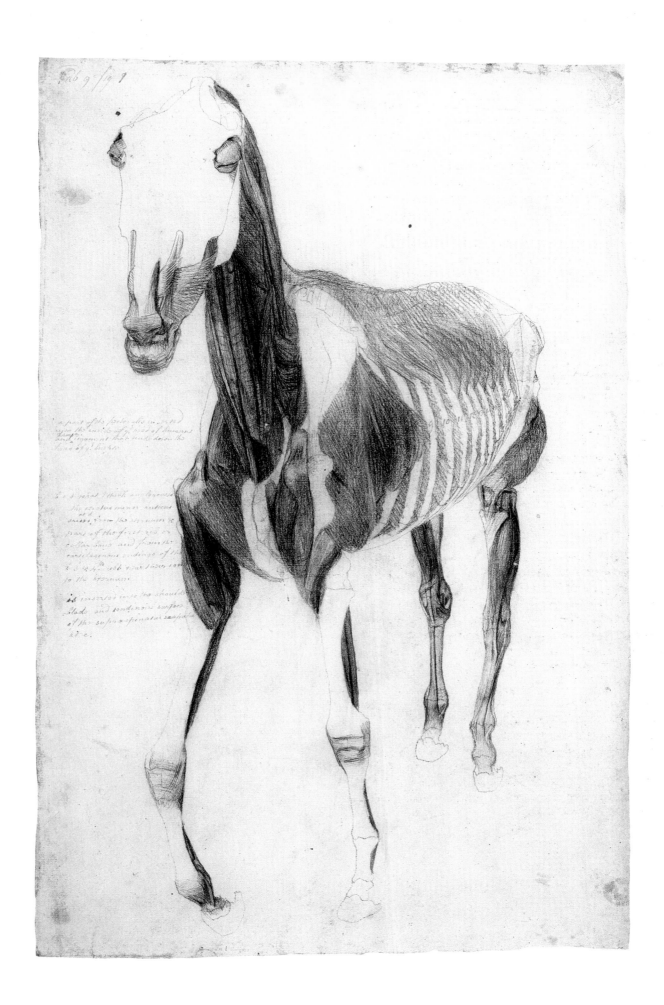

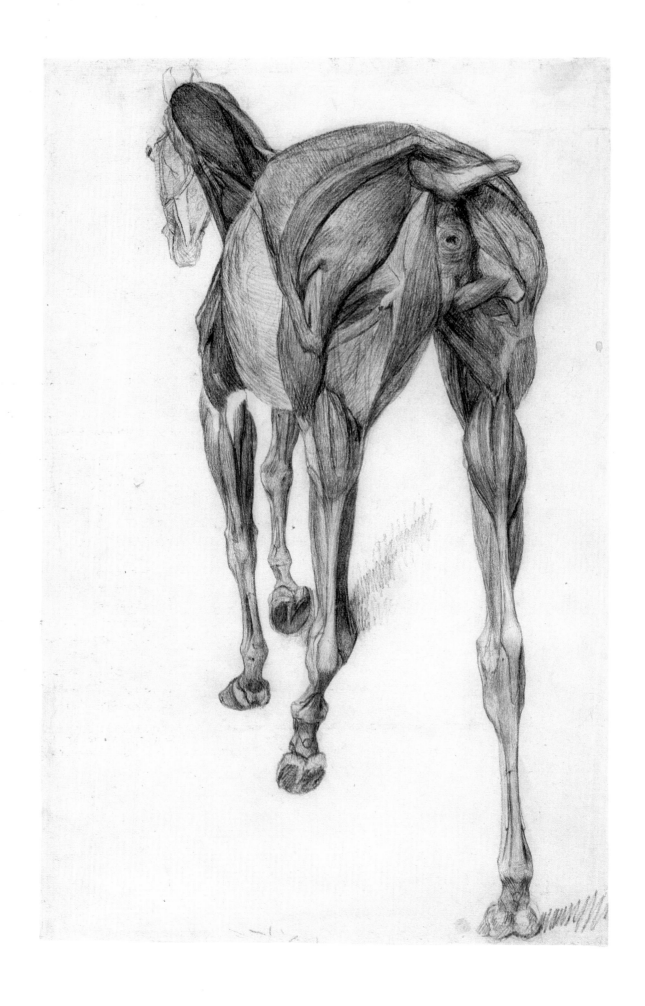

7

WORKING DRAWING OF THE MUSCLES
FOR THE THIRTEENTH ANATOMICAL
TABLE (R.A.2)

Graphite and red chalk on paper,
$18\frac{1}{2} \times 11\frac{1}{2}$ in. (47×29.2 cm.)
Royal Academy of Arts

This drawing relates most closely, though in a
slightly less advanced stage of dissection, to Table
XIV. The ligaments of the hind limbs are very
clear.

8

WORKING DRAWING OF A STAGE IN
DISSECTION BETWEEN THE THIRTEENTH
AND FOURTEENTH ANATOMICAL TABLES
(R.A.23)

Graphite, red chalk and red ink on paper
$18\frac{3}{4} \times 11\frac{1}{2}$ in. (47.6×29.2 cm.)
Inscribed 'Tab 9 fig 2' top left and on the
left:
'c a b omini
c obturator internus
d obturator externus
e quadratus
f g h adductor magnus
g g grescilis
l gluteus internus
m plantaris
n o popliteus
p iliacus internus'
Royal Academy of Arts

9

WORKING DRAWING OF A STAGE IN
DISSECTION WITH REFERENCES TO THE
THIRTEENTH AND FOURTEENTH
ANATOMICAL TABLES (R.A.24)

Graphite and red ink on paper,
$19 \times 12\frac{1}{4}$ in. (48.3×31 cm.)
Inscribed 'Tab. 10 fig 2' top left, with
numerals within the drawing, and on the
left:
'a b ye 2 gemini
c quadratus
d pectineus
e adductor brevis
f adductor longus
g the tendon of ye iliacus internus
 and psoas magnus
h illiacus internus,
i musculus parvus in articulation
j origin of ye rectus'
Royal Academy of Arts

Working drawing of the muscles probably for the
Fourteenth Anatomical Table.

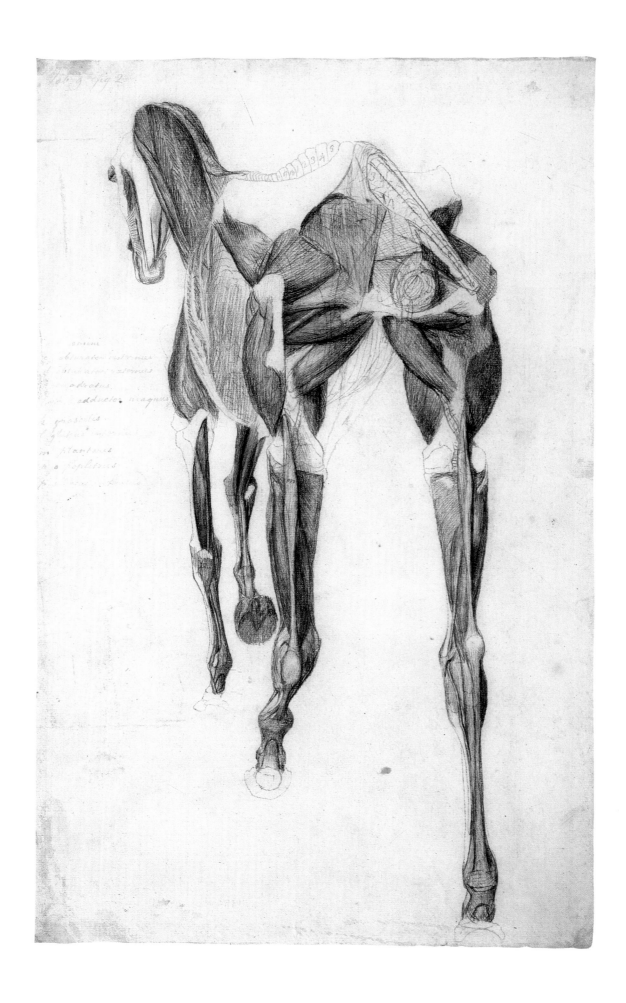

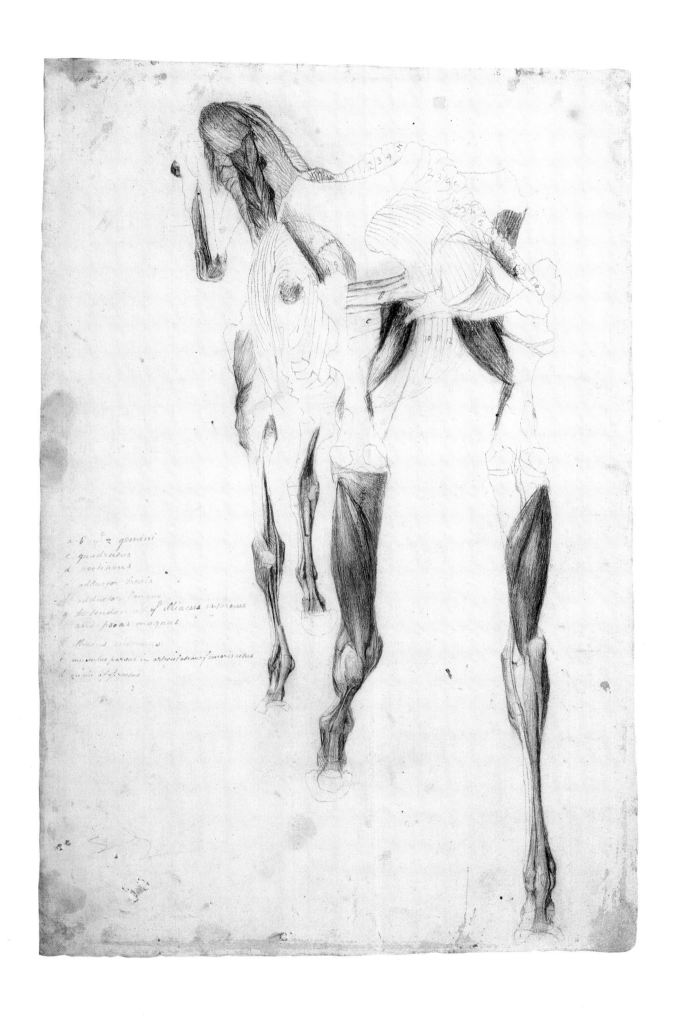

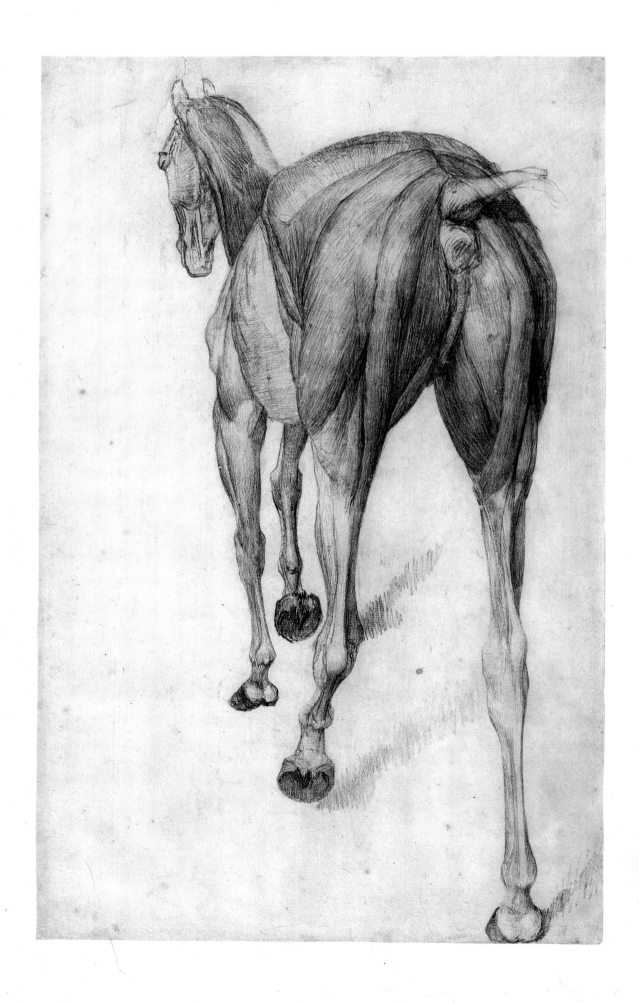

10

WORKING DRAWING FOR THE TWELFTH
ANATOMICAL TABLE (R.A.1)

Graphite on paper, $18\frac{1}{2} \times 12\frac{1}{2}$ in.
(47×29.2 cm.)
Royal Academy of Arts

In his working drawings of the hind view of the
horse Stubbs used skeleton outlines different from
those of the finished drawings and the published
illustrations. In the working drawings the right
hind limb is lengthened in relation to the other
limbs. Five working drawings of the hind view of
the dissected horse are owned by the Royal
Academy.

11

WORKING DRAWING OF THE MUSCLES
FOR THE THIRD ANATOMICAL TABLE
(R.A.27)

Graphite, red chalk and brown ink on
paper, $18\frac{3}{4} \times 23\frac{3}{4}$ in. (47.6×60.3 cm.)
Royal Academy of Arts

Left lateral view of the horse with some of the
muscles covering the neck, the shoulder and the
gluteal area removed. The abdominal muscles have
not been included. The underlying drawing of
parts of the skeleton, with the thoracic and lumbar
vertebrae and the ribs numbered, can be seen.

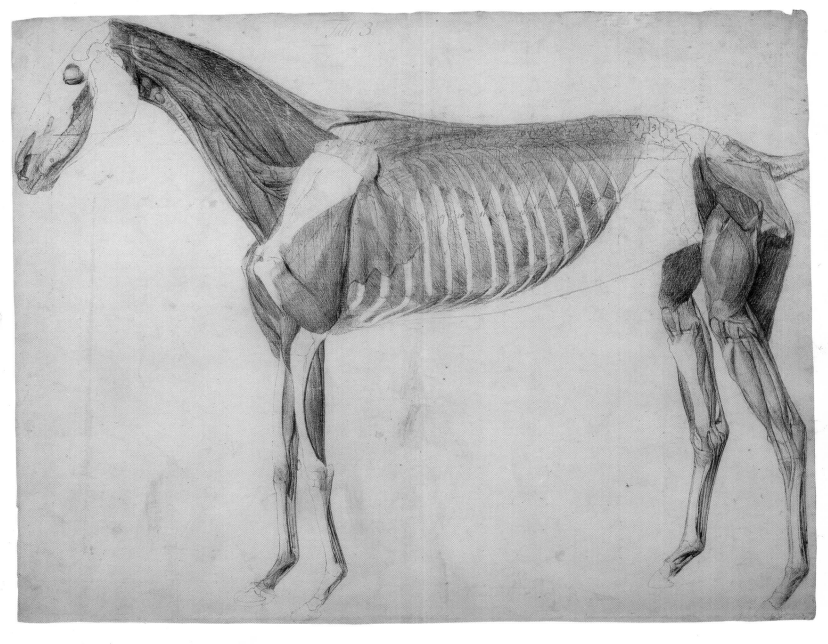

12

WORKING DRAWING CLOSE TO THE
FINISHED STUDY FOR THE SECOND
ANATOMICAL TABLE (R.A.31)

Graphite on paper, $14\frac{1}{2} \times 19\frac{1}{2}$ in.
(36.8×49.5 cm.)
Royal Academy of Arts

Working drawing of the muscles for the Second
Anatomical Table.
 Stubbs first drew parts of the skeleton over
which he then drew the muscles.

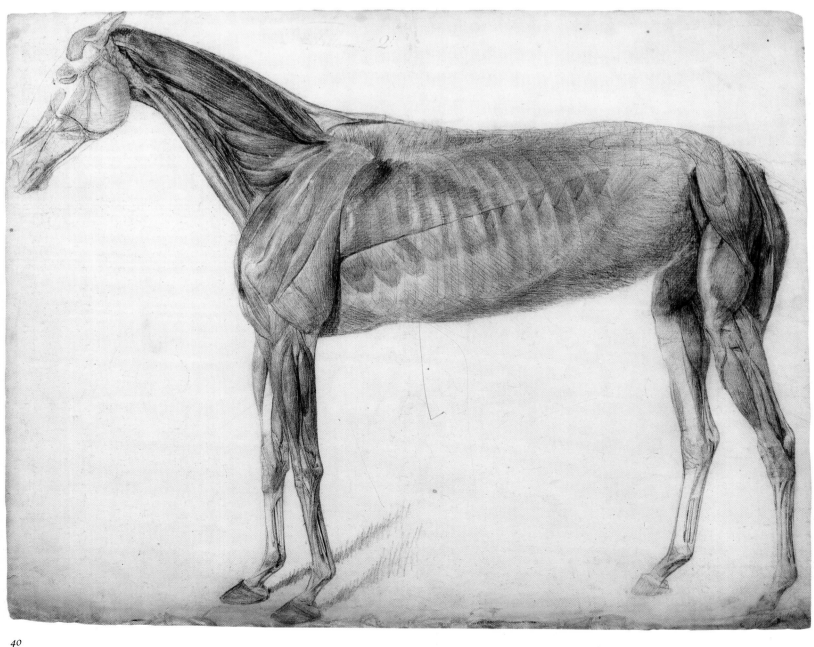

13

FINISHED STUDY FOR THE SECOND
ANATOMICAL TABLE (R.A.3)

Graphite on paper, $14\frac{1}{2} \times 19\frac{1}{2}$ in.
(36.8×49.5 cm.)
Royal Academy of Arts

Lateral view of the horse with the underlying
fascial layers removed revealing the main muscle
masses closest to the skin.

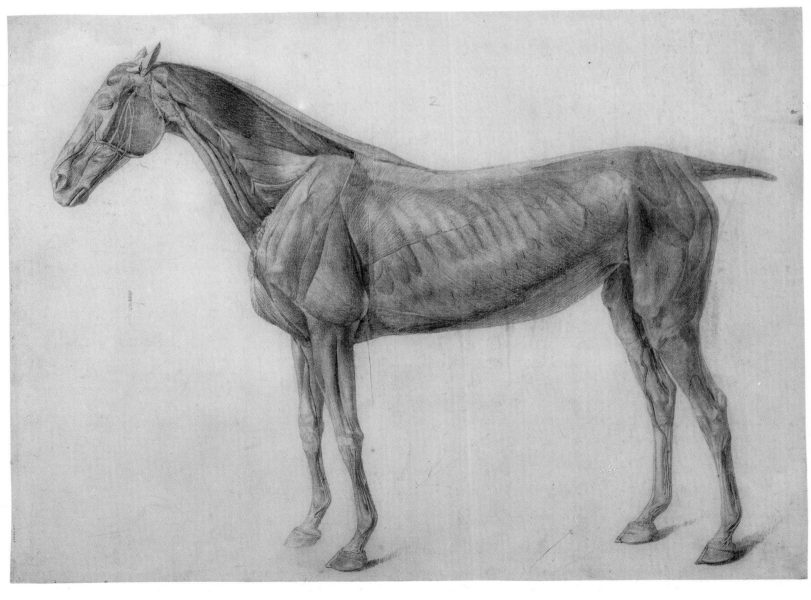

14

FINISHED STUDY FOR THE FOURTH
ANATOMICAL TABLE (R.A.29)

Graphite on paper, $14 \times 19\frac{1}{2}$ in.
$(35.6 \times 49.5$ cm.$)$
Royal Academy of Arts

More blood vessels of the neck and abdomen
exposed and many of the muscles of the neck and
upper hind limbs removed.

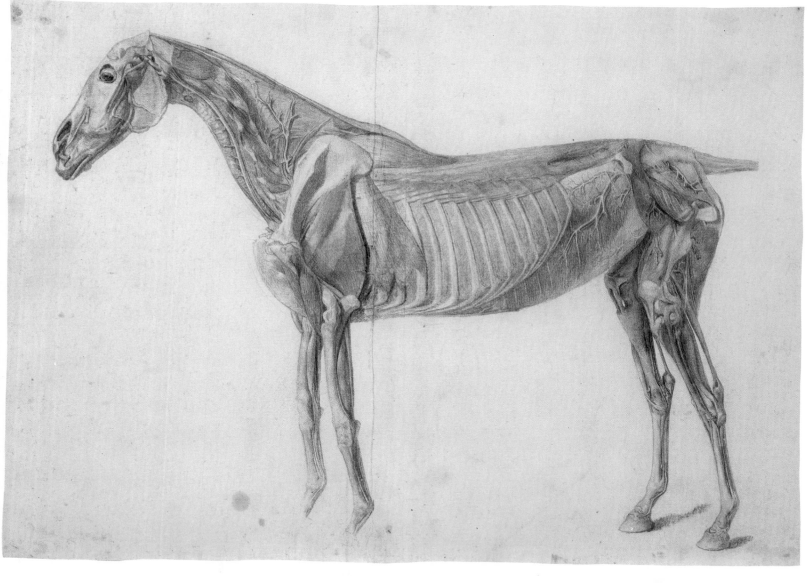

15

FINISHED STUDY FOR THE FIFTH
ANATOMICAL TABLE (R.A.30)

Graphite on paper, $14\frac{1}{2} \times 20$ in.
(36.2×50.8 cm.)
Royal Academy of Arts

The final stage of the dissection. parts of the
cervical vertebrae, the dorsal processes of the
thoracic vertebrae, the scapula, the femur, tibia
and fibula have been exposed. The main muscle
masses of the body have been removed.

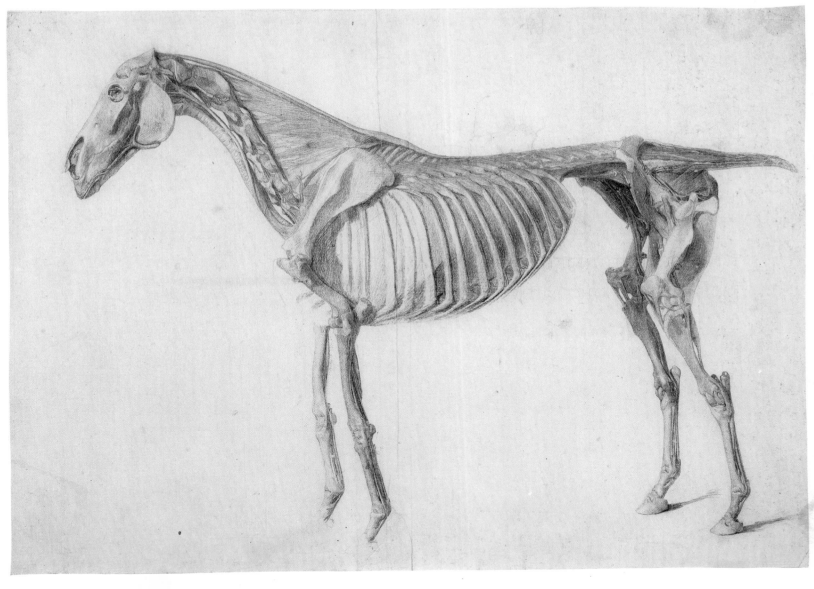

16

FINISHED STUDY FOR THE FIRST
SKELETON TABLE (R.A.5)

Graphite on paper, $14\frac{1}{2} \times 19$ in.
(36.2 × 48.3 cm.)
Royal Academy of Arts

A view of the left side of the skeleton.

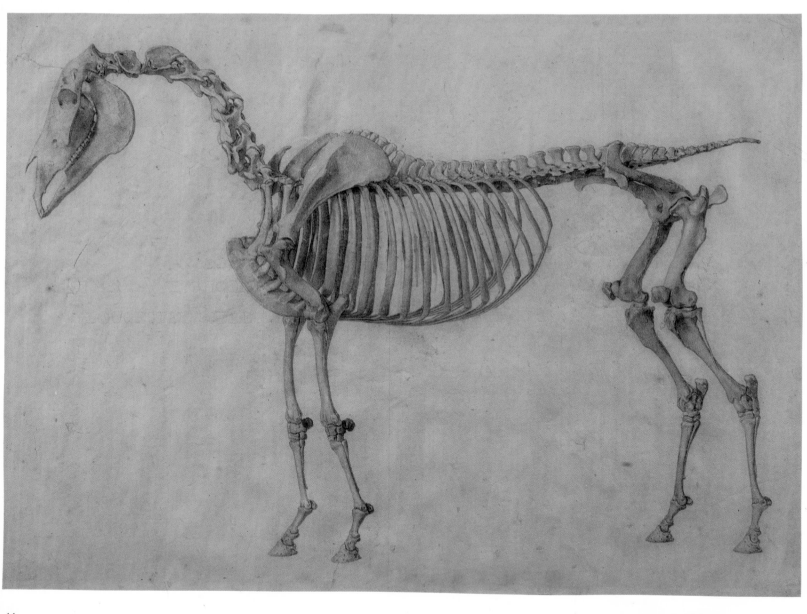

17

FINISHED STUDY FOR THE SEVENTH
ANATOMICAL TABLE (R.A.14)

Graphite on paper, $14 \times 7\frac{1}{2}$ in.
(35.6×19 cm.)
Royal Academy of Arts

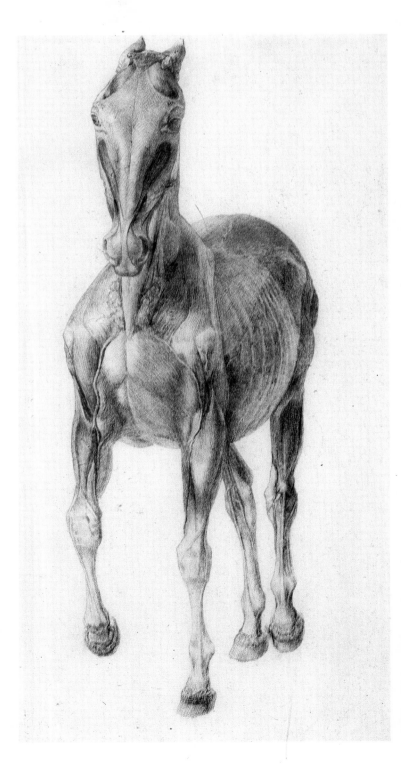

18

FINISHED STUDY FOR THE EIGHTH
ANATOMICAL TABLE (R.A.9)

Graphite on paper, 14 × 7 in.
(35.6 × 17.8 cm.)
Royal Academy of Arts

The surface muscles have been removed to show
the ribs and other parts of the skeleton, blood
vessels in the neck and fore limbs, and some of the
tendons of the legs.

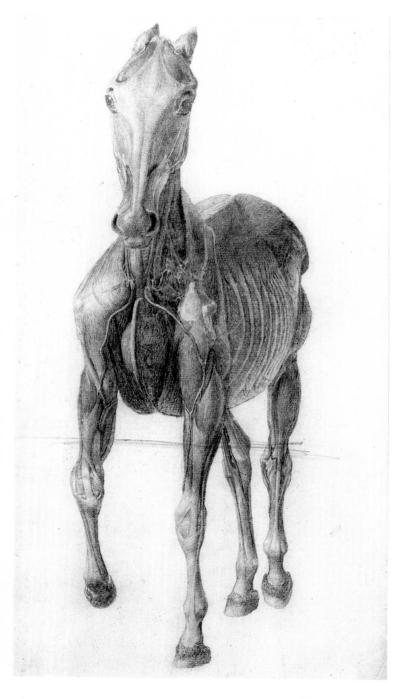

19

FINISHED STUDY FOR THE NINTH
ANATOMICAL TABLE (R.A.8)

Graphite on paper, 13 × 7 in.
(33 × 17.8 cm.)
Royal Academy of Arts

The shoulder joint and ribs have been exposed.
Only the deepest muscles are left.

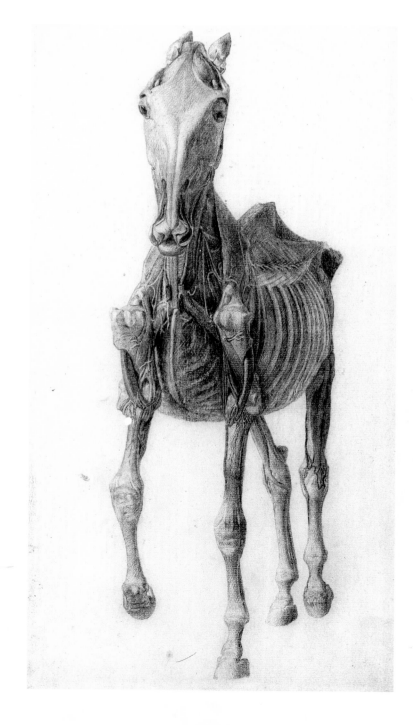

20

FINISHED STUDY FOR THE TENTH
ANATOMICAL TABLE (R.A.17)

Graphite on paper, 14 × 7 in.
(35.6 × 17.8 cm.)
Royal Academy of Arts

Few muscles and some ligaments remain. The
nervous supply to the fore limbs stands out clearly.

21

FINISHED STUDY FOR THE SECOND
SKELETON TABLE (R.A.10)

Graphite on paper, 14 × 7 in.
(35.6 × 17.8 cm.)
Royal Academy of Arts

Cranial view of the skeleton seen obliquely from
the viewer's right.

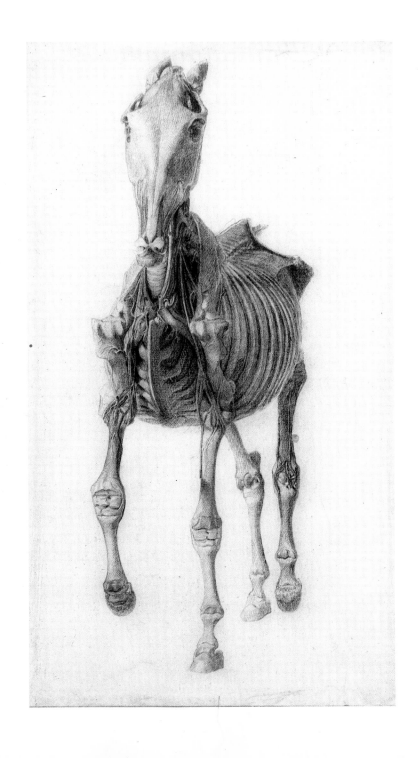

22

FINISHED STUDY FOR THE THIRTEENTH
ANATOMICAL TABLE (R.A.7)

Graphite on paper, 13 × 7 in.
(33 × 17.8 cm.)
Royal Academy of Arts

The third stage of the dissection viewed from the
rear. Some of the main muscle masses have been
removed but most remain. The sciatic nerve can be
seen in the upper hind left limb.

23

FINISHED STUDY FOR THE FOURTEENTH
ANATOMICAL TABLE (R.A.15)

Graphite on paper, 14 × 7 in.
(35.6 × 17.8 cm.)
Royal Academy of Arts

The main muscles have been removed and the
femur exposed.

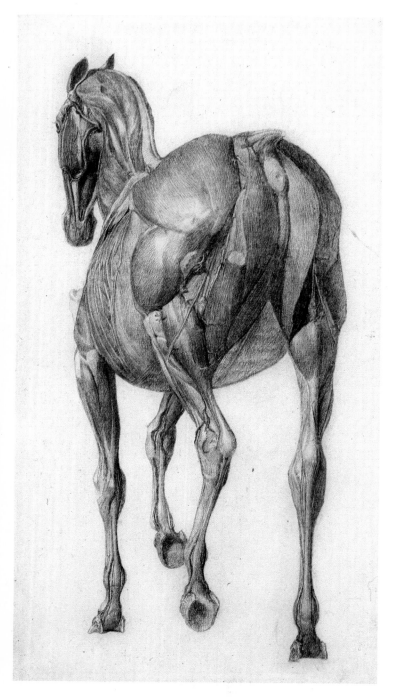

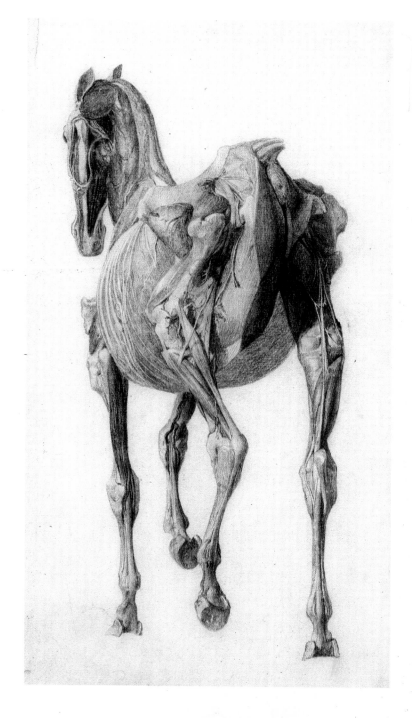

24

FINISHED STUDY FOR THE FIFTEENTH
ANATOMICAL TABLE (R.A.16)

Graphite on paper, 14 × 7 in.
(35.6 × 17.8 cm.)
Royal Academy of Arts

Only the deepest muscles remain.

25

FINISHED STUDY FOR THE SECOND
SKELETON TABLE (R.A.18)

Graphite on paper, 14 × 7 in.
(35.6 × 17.8 cm.)
Royal Academy of Arts

Caudal view of the skeleton seen obliquely from the left.

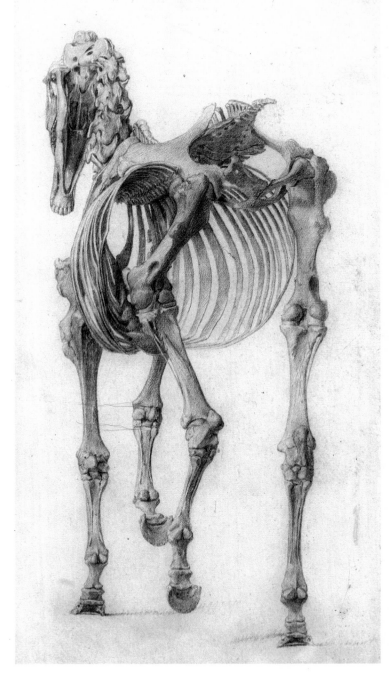

26

JAMES STANLEY AT THE AGE OF 33
dated 1755

Oil on canvas, $29\frac{1}{2} \times 24\frac{5}{8}$ in.
(72×62.5 cm.)
Inscribed on relining canvas (evidently
copied from an original inscription)
'James Stanley / An: AEtat 33. Christ.
1755 / Geo: Stubbs pinx:'
Merseyside County Council,
Walker Art Gallery, Liverpool

PROVENANCE
. . .; Mrs Y.N. China, sold Sotheby's 23 June 1971
(91, repr.), bt. Spink, from whom purchased by
Walker Art Gallery

EXHIBITED
English Paintings, Spink 1972 (19)

LITERATURE
[Mary Bennett], *Merseyside Painters, People & Places,*
Walker Art Gallery, Liverpool, *Text* vol. p. 196,
Plates vol. p. 45

Dated 1755, this portrait must have been painted
after Stubbs's return to Liverpool from his brief
visit to Rome in 1754 and before he began, prob-
ably in 1756, his eighteen months' study of the
anatomy of the horse. The portrait shows no
influence from Stubbs's first master, Hamlet
Winstanley, nor from the swaggering portraits of
English milords by Batoni which Stubbs must have
seen in Rome, nor from the elegant portraits by
Mercier who was working in York during the
previous decade, and whose work Stubbs could
have seen. Only the feigned oval in which the burly
figure is posed links this with an earlier English
portrait tradition. Otherwise nothing so strikingly
individual and honest is seen until Stubbs's
inclusion of a portrait of the groom Simon Cobb in
his picture of Whistlejacket and two other horses
(No. 33).

James Stanley has not been positively identified.
Stanley is a common Lancashire surname; it is of
course the family name of the Earls of Derby, but
this is surely a robustly bourgeois sitter. Mary
Bennett (op. cit.) notes that the Liverpool Poor
Rate Register of 1758 records a James Stanley who
lived in Ormond Street, where Stubbs had lived
earlier. In 1755 the James Stanley in the portrait
would have been approximately two years older
than Stubbs; he may well have been a boyhood
neighbour.

27*

SIR JOHN NELTHORPE, 6TH BARONET,
AS A BOY
? painted in 1756

Oil on canvas, 50×40 in.
(127×101.5 cm.)
Colonel R.S. Nelthorpe

PROVENANCE
Commissioned by Lady Nelthorpe, the boy's
mother; by descent to Colonel R.S. Nelthorpe

EXHIBITED
Vokins 1885 (15); *A Dream of Fair Children,*
Grafton Gallery 1895 (104)

LITERATURE
Humphry, MS Memoir, f.16; F. Henthorn, *The
History of Brigg Grammar School,* 1959, pp. 56–7;
Taylor 1971, p. 205, pl. 3

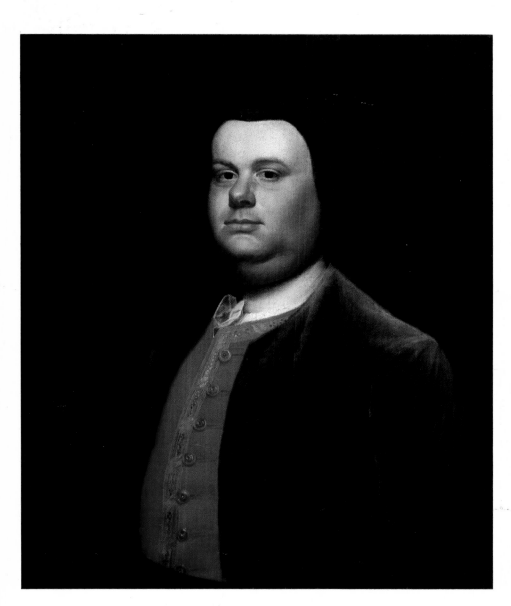

Humphry (op. cit.) relates that after his brief visit to Rome (in the spring of 1754), Stubbs returned to Liverpool where he stayed 'about two years', painting portraits (including that of James Stanley, dated 1755, No. 26) and dissecting animals, and that Stubbs then 'went from Liverpool to execute various commissions w^ch he had long rec^d [received] even before he went to Rome from Lady Nelthorpe, of various portraits'.

Stubbs had already painted a double portrait of Lady Nelthorpe and her husband, Sir Henry Nelthorpe, 5^th Baronet (first repr. Henthorn, op. cit., facing p. 96); as Sir Henry Nelthorpe died in 1746, that portrait is so far the earliest of all Stubbs's known works. It is not clear how Stubbs first attracted the patronage of the Nelthorpes, who lived near Barton-on-Humber in North Lincolnshire. But two things are certain: first, that Stubbs's reason for returning to this part of Lincolnshire to work on at least one further commission from Lady Nelthorpe was directly linked to his decision to undertake research into the anatomy of the horse in the nearby village of Horkstow; and secondly, that Lady Nelthorpe's son John, 6th Baronet, remained a faithful patron of Stubbs's in later years (see No. 113).

John Nelthorpe was born early in 1745 (Old Style 1744: baptized at St Peter's, Barton-on-Humber, 22 February 1744/5), the only son and heir of Sir Henry Nelthorpe, 5th Baronet, by his second wife Elizabeth, daughter of the Rev. Richard Branston, of Gainsborough, and widow of Joseph Woolmer, Castlethorpe, Lincolnshire. Sir Henry Nelthorpe died on 28 June 1746; his son John thus succeeded as 6th Baronet at a very tender age.

Assuming that Humphry's dating of Stubbs's return to Lincolnshire is reliable, John Nelthorpe must be portrayed here at the age of eleven, and the portrait must have been painted either just before or during Stubbs's intensive period of work dissecting and drawing the anatomy of the horse. A few signs of immaturity in this painting, such as the disproportionately large size of the boy's hands and the rather porcelain-like appearance of his white-stockinged legs, are outweighed by the mastery Stubbs already shows in the poses of the boy and dog and in the colours and textures of different stuffs – the silver satin of the waistcoat, its gold braid and the mole-coloured coat with its velvet collar and cuffs. The curve of the dog's lithe body is finely observed (as Colonel Nelthorpe points out, this is a grue dog, not a pure-bred greyhound). The background, with its Arcadian glimpse in the distance on the left and the dew-spangled plants on the right, is both fussier and less natural than the backgrounds Stubbs later painted. But the most masterly quality in this portrait is, surely, the subtlety with which Stubbs detects and conveys the essences of the boy and the baronet in one young face. If there is some consciousness of his own position in the boy's expression, there is also a good deal of natural boyishness.

That John Nelthorpe himself combined these qualities is evident from a Journal (MS, in the collection of Colonel Nelthorpe) which he kept for his mother during a visit to London, with his elder sister Charlotte and his tutor, in August–September 1754. This Journal is largely in the boy's own handwriting, though occasionally (perhaps at the end of exhausting days) evidently dictated to his tutor; and it must have been (presumably) either the tutor or Lady Nelthorpe who inscribed upon the title-page '1754. Journal of Sir John Nelthorpe. Memoirs of a Little White-headed Knight and Baronet'. It is worth quoting

from, not only as a verbal self-portrait of Stubbs's sitter but also as a rare illustration of a mid-eighteenth century boy's reactions.

John and his sister Charlotte were taken to see most of the famous sights of London, dutifully reported: the Royal Exchange, the Bank of England, the Foundling Hospital, the lions in the Tower, St Paul's, St James's Park ('saw a vast multitude of well-dressed awkward People') and Westminster Hall ('never saw so large or so dirty a Room in my Life'). Glimpses of the real boy recur: shooting Westminster Bridge en route to Vaux Hall, he 'hollo'd under its Central Arch'; walking in the park he 'pin'd for Plumb Cake' and 'saw a Boy play at Peg Top, w^ch was new to me – I wish I had one'. He had some teeth pulled out by a fashionable dentist, 'the renown'd Mons^r Laudemie [who] draws teeth in a flaming Blue & Gold Coat & a Tissue Waistcoat'. An interesting comment on what must have been his natural and broad Lincolnshire accent is his report, after a fortnight in London, that 'My Friends begin to tell me I speak Better English than I did when I first came to Town'.

The most prestigious yet most exasperating of the boy's experiences in London was on Sunday 25 August, when he attended a royal reception at Kensington Palace (quoted almost in full): 'Went in my new Strawberry Coat to the Palace at Kensington, pass'd thro' several grand Rooms full of fine Pictures saw the King, Prince of Wales Pr. Edward Duke of Cumberland & Princess Amelia pass by from Chapel, followed them into the Drawing-Room where I stayed an Hour . . . Was in great danger of being stop'd in the Ante-chamber for want of a Sword w^ch is part of the Dress of everybody that attends there Boys as well as Men. N.B. One of the little Pages look'd saucily at me & laugh'd, I wish'd I had him in a corner I'm sure I could have trip'd up his Heels. Mem^o If I come to London again next winter to beg my Mamma to let me have a Sword, for I like going to Court vastly.' (The compiler is indebted to Colonel Nelthorpe for permission to read Sir John Nelthorpe's MS Journal and to quote from this hitherto unquoted source.)

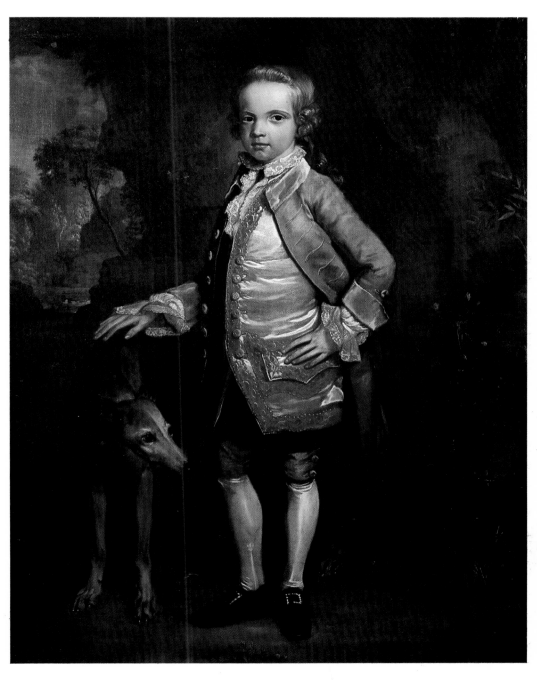

THE 3RD DUKE OF RICHMOND WITH THE
CHARLTON HUNT
? painted in 1759

Oil on canvas, 55 × 97½ in.
(139.5 × 247.5 cm.)
*Trustees of the Goodwood Collection,
Goodwood House, Chichester*

PROVENANCE
Commissioned by Charles, 3rd Duke of
Richmond, and thence by descent

EXHIBITED
British Empire Exhibition, Palace of Arts, Wembley,
1925 (v.37, repr. *Illustrated Souvenir*, 1925, p. 20);
Stubbs in the 1760s, Agnew's 1970 (1, repr.)

LITERATURE
D. Jacques, Librarian of Goodwood, *A Visit to
Goodwood . . . the Seat of His Grace the Duke of
Richmond*, 1822, p. 40, in a description of The Old
Billiard Room, 'In which we find three large
paintings, by Stubbs, one, with the third Duke of
Richmond, his Brother Lord George Lennox, and
General Jones, on horseback, with servants and
dogs . . .'; William Hayley Mason, *Goodwood, its
House Park and Grounds with a Catalogue-Raisonné of
the Pictures in the Gallery of His Grace the Duke of
Richmond*, 1839, p. 136, no. 209; Amy, Countess of
March, *Catalogue of the Goodwood Picture Collection . . .*,
1879, revised by the present Duke of Richmond,
1952, p. 51, no. 114; Gilbey 1898, p. 172, no. 3

The first important commission that Stubbs
received after his arrival in London in 1758 was
from the Duke of Richmond, for his seat at
Goodwood House, Sussex. This was for the three
big canvases (Nos. 28, 30, 31), each of which
portrays different members of the Duke's family
and circle of friends hunting, shooting and watch-
ing racehorses at exercise.

In 1758 the Duke of Richmond was twenty-
three. That year he had opened a sculpture gallery
in his London house as a study collection for the use
of artists. A graduate of Leyden, and already a
Fellow of the Royal Society, he also had scientific
interests which included the cross-breeding and
naturalization of animal species (see Nos. 82–3).
He was to develop into a statesman of radical
opinions, but at this early stage of his career he was
primarily an active military officer; as Colonel of
the 72nd Regiment of Foot he was particularly to
distinguish himself at the Battle of Minden (1
August 1759). His absence on service abroad may
partly explain his absence from all but one of the
Goodwood pictures.

This is the only one of the Goodwood pictures in
which the Duke himself is portrayed. He is the tall
figure (sometimes described as 'elongated', but it
should be noted that contemporary accounts stress
the fact that he was very tall) in the centre of the
composition. Stubbs's likeness of him is perfectly
consistent with those in his portraits by Batoni and
Reynolds, still at Goodwood. The other two
principal figures are the Duke's brother, Lord
George Lennox, advancing towards the Duke, and
General Jones (not further identified) cantering in
to join the central group.

These three wear the Goodwood blue, the livery
of the Charlton Hunt. Taking its name from
Charlton, the nearest village to Goodwood, the
Charlton Hunt was established in the reign of
Charles II; it moved to Bolton in the 1720s, but
returned to Goodwood under the Mastership of the
2nd Duke of Richmond (d. 1750) and was revived
by the 3rd Duke about 1756. The hunt kennels

were famous for their thoroughbred foxhounds,
two of whom, Charlton Richmond and Charlton
Ringwood, had gone to Brocklesby in the 1740s to
improve the breeding of the Brocklesby pack (see
No. 103).

The Charlton foxhounds were perhaps the first
thoroughbred pack which Stubbs had the chance to
observe. He portrays them with exactitude and
individuality. He may well have made individual
studies of them at the time, perhaps revising some
of these studies at a later date, for portraits of five
of the Charlton hounds reappear in Stubbs's
engravings of foxhounds published in 1788, for
which one drawing survives (No. 170). In the
engravings they seem to be sturdier and more
fleshed-out, as if Stubbs's eye for the good points of
a foxhound had meanwhile developed.

None of the three Goodwood pictures is dated,
and no records relating to them (or even to the
making of their frames, each of which incorporates
an emblem of its subject) survive in the admittedly
incomplete Goodwood archives. The dating in
Humphry's Memoir is vague, but is all we have to
go on. Humphry tells us that after Stubbs's arrival
in London in 1758, 'the first Commission of
considerable Importance' that he received was
from the Duke of Richmond, 'wch obliged him to go
and reside at Goodwood . . . at Goodwood he
continued about nine months'; Mary Spencer, in a
note added to the Memoir, tells us that Stubbs left
Goodwood in 1760, to go to Eaton Hall.

Looking at the three Goodwood pictures, it
seems apparent that the 'Hunting' and 'Shooting'
subjects are less assured than 'Racehorses
Exercising'. Can such development have been
accomplished during one stay at Goodwood of
'about nine months', in 1759–60? Stubbs may of
course have returned after 1760 for a further
working visit to Goodwood. But his talents
evidently blossomed miraculously quickly after his
move south, and it is here presumed that the
opportunity to work at Goodwood for nine months,
on a large scale and for such an encouraging patron

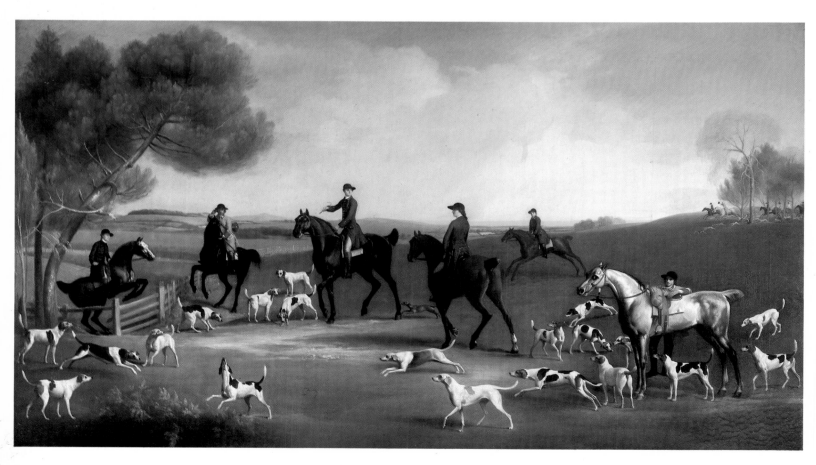

as the 3rd Duke, enabled him to progress with increasing assurance from one Goodwood subject to the next. The fact that none of the Goodwood pictures was exhibited at the Society of Artists perhaps increases the probability that all three were completed and installed at Goodwood before the Society's first exhibition in 1760, or before Stubbs first showed his work there in 1762.

In each of the Goodwood pictures, Stubbs pays as much attention to the portraiture of the servants as he does to that of their masters. Each of the servants is an individual, unmistakably drawn from life. The Goodwood Archives (vol. 229) include a 'Register of Servants at London and Goodwood', c.1727–80. In some ways this is a tantalizing volume, since more servants are included in it than are portrayed by Stubbs, yet it does offer the possibility that some of the servants can be identified. The 'Hunting' picture may include portraits of Christopher Budd, Huntsman, Henry Burch and William Freeman, whippers-in, and William Tregoze, helper to the hunt.

Echoes of Stubbs seem to recur in a series of eight sporting scenes by the Irish portraitist Robert Healey (fl. 1765–71), executed in chalk and crayon (Healey's only known medium), formerly in the collection of the Hon. Desmond Guinness and sold at Sotheby's 15 July 1983 (10–18, repr.). In particular, Healey's drawing of the Castletown Hunt (now in the collection of Mr Paul Mellon KBE) seems to echo the Goodwood hunting picture. Healey's sporting scenes were commissioned by the 3rd Duke of Richmond's sister, Lady Louisa Connolly, and her husband. Can Lady Louisa have brought Healey to Goodwood to see Stubbs's works?

29

THE COUNTESS OF CONINGSBY IN THE LIVERY OF THE CHARLTON HUNT
*c.*1760

Oil on canvas, $25 \times 29\frac{1}{4}$ in.
(63.5 × 74.5 cm.)
Inscribed 'Counteſs of Coningby / George Stubbs. Pinxit' with brush on the back of the canvas

Yale Center for British Art,
Paul Mellon Collection

PROVENANCE
. . . acquired by the Marquess of Ripon, by descent to Henry Vyner, Studley Royal, Yorkshire, sold Christie's, 18 November 1966 (117, repr.), bt. Colnaghi for Mr Paul Mellon KBE, by whom presented to the Yale Center for British Art, 1981

EXHIBITED
Yale Center for British Art, 1982 (11)

LITERATURE
Egerton, 1978, pp. 65–6, no. 66, pl. 24

Presumably painted about the same time as No. 28. Like the principal figures in that picture, the Countess wears the Goodwood blue, the livery of the Charlton Hunt. A dog of indeterminate terrier breed follows at a respectful pace. The background is Goodwood Park, with a view of Carne's Seat, a pedimented building (still standing) designed by Roger Morris in 1743 for the 2nd Duke of Richmond as a banqueting-house for the Charlton Hunt. Stubbs's studio sale, 27 May 1807, included 'Landscape with buildings, &c., View of Carne Seat, belonging to the Duke of Richmond' (one of two items in lot 56, now untraced, which may have been a study for this picture.

The Countess of Coningsby was Mary, elder daughter of the 1st Baron (later Earl) Coningsby of Hampton Court, Herefordshire, by his second wife Frances, daughter of the Earl of Ranelagh. Born *c.*1790, she succeeded on her father's death in 1729 as Countess of Coningsby in her own right (by a special act of remainder). On 14 April 1730 she married Sir Michael Newton, 4th Baronet, of Barr's Court, Gloucestershire and Culverthorpe, Lincolnshire. T.A. Cook includes her in his list of eighteenth-century ladies who owned racehorses; her roan mare Ruby won the Ladies' Plate at York in 1739 (*History of the English Turf*, 1, 1901, p. 206). Her only child John Newton died in infancy, and upon the Countess's death at the age of fifty-two in 1761, her title became extinct.

The picture has been over-painted, particularly about the horse's head. Two previously unrecorded paintings by Stubbs, 'A Bay Stallion' ($45\frac{1}{2} \times 32$ in.) and 'Mare and Foal' ($45\frac{1}{2} \times 30\frac{3}{4}$ in.) sold Sotheby's 5 July 1984 (271–2), appear to have been painted about the same time as No. 28, and are therefore among the earliest of Stubbs's known works. Their early provenance is unknown; they were believed to have been purchased by the late Pierre Jeannerat, unattributed, in a second-hand shop in Sussex. Comparison with No. 29 shows close similarity in the treatment of the landscape as well as of the horses.

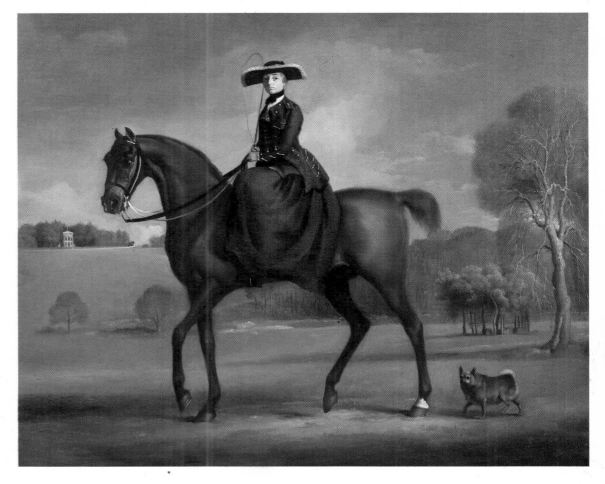

30*

HENRY FOX AND THE EARL OF
ALBEMARLE SHOOTING AT GOODWOOD
? painted in 1759

Oil on canvas, 55 × 80½ in.
(139.5 × 204.5 cm.)
*Trustees of the Goodwood Collection,
Goodwood House, Chichester*

PROVENANCE
Commissioned by Charles, 3rd Duke of
Richmond; thence by descent

LITERATURE
Humphry, MS Memoir; Jacques 1822, p. 40
('Lord Holland, the Earl of Albemarle and others
shooting'); Mason 1839, p. 135, no. 208; March
1879, revised Duke of Richmond, 1952, p. 50
(these three Goodwood catalogues are fully cited
under No. 29); Gilbey 1898, p. 172, no. 2

Henry Fox, in blue frockcoat braided with gold, in
the centre of the composition, is portrayed here at
the age of about fifty-five, and the Earl of
Albemarle, at his left in less flamboyant and far
more sensible mole-coloured shooting-dress, at the
age of about thirty-six. Henry Fox (1705–1774),
who had married Lady Georgina Lennox in 1744,
secretly and without her parents' consent, was the
3rd Duke of Richmond's uncle (and the father of
Charles James Fox). A man of jovial manners but
great public unpopularity, he sat in the House of
Commons from 1741 to 1761, holding various
cabinet posts and deriving particular benefit to
himself from the office of paymaster-general.
'Devoid of principle, and regardless of the good
opinion of others, he cared more for money than for
power' (*D.N.B.*), though George II said of him 'I'll
do him justice, I don't believe he ever did tell me a
lie', adding, 'he is the only man that ever came into
my cabinet that did not' (quoted by G.E.C.).
Henry Fox was created 1st Baron Holland in 1763.

George Keppel (1724–1772), who succeeded his
father as 3rd Earl of Albemarle in 1754, was the 3rd
Duke of Richmond's cousin, and a much more
attractive character than Fox. He was a soldier and
a favourite of the Duke of Cumberland, whose
A.D.C. he had been at Dettingen, Fontenay and
Culloden. The Humphry Memoir is evidently
muddled in stating that a portrait of Albemarle is
included in the Goodwood 'hunting piece' rather
than in the shooting picture, and also in stating
that Albemarle's portrait was 'painted from nature
whilst he was at Breakfast, the day before he
embarked upon the ever memorable and successful

expedition to the Havanna' (the date of
Albemarle's expedition to reduce Havanna, which
had surrendered the previous year, was 5 or 6
March 1762. Humphry and Stubbs, in their 1790s
conversations, perhaps confused this famous
campaign of Albemarle's with an earlier one).

This is the most unevenly-balanced of the three
Goodwood pictures, chiefly because the heavy
figure of Henry Fox looms so uncommonly large.
The picture may have been commissioned
primarily for his sake; his biographer Lord
Ilchester notes that 'Shooting was one of Henry
Fox's favourite pastimes in the country; hunting
held no charms for him' (*Henry Fox, 1st Lord Holland,
his Family and Relations*, I, 1920, p. 49). That he was a
heavily-built man is borne out by other
contemporary portraits, including two by
Reynolds, of 1762 and 1764 (repr. Lady Ilchester,
Letters of Lady Sarah Lennox, I, 1902, pl. 16; II, 1920,
frontispiece). Even so, his figure must be out of
proportion here, and he may have been the only
man ever to have intimidated Stubbs. Pentimenti
around most of the figures hint at the artist's
difficulties. The most graceful figures in the picture
are the Duke of Richmond's negro page on the left
and the groom on the right, both wearing the
yellow and scarlet Goodwood livery. The loader
and mounted keeper behind Fox, knowing their
place and the job in hand, can tentatively be
identified as Henry and William Budd, game-
keepers (from the 'Register of Servants . . . at
Goodwood' cited in No. 28). Stubbs pays as much
attention to the individual portraiture of the four
servants as he does to that of their masters.

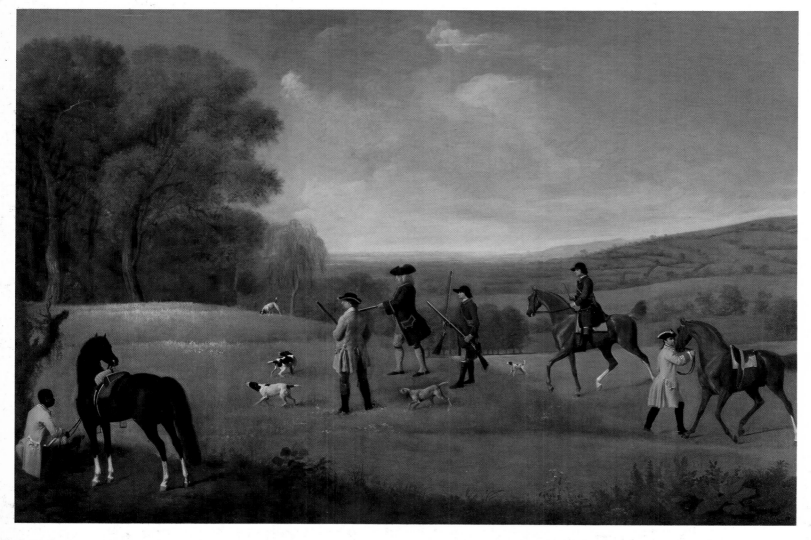

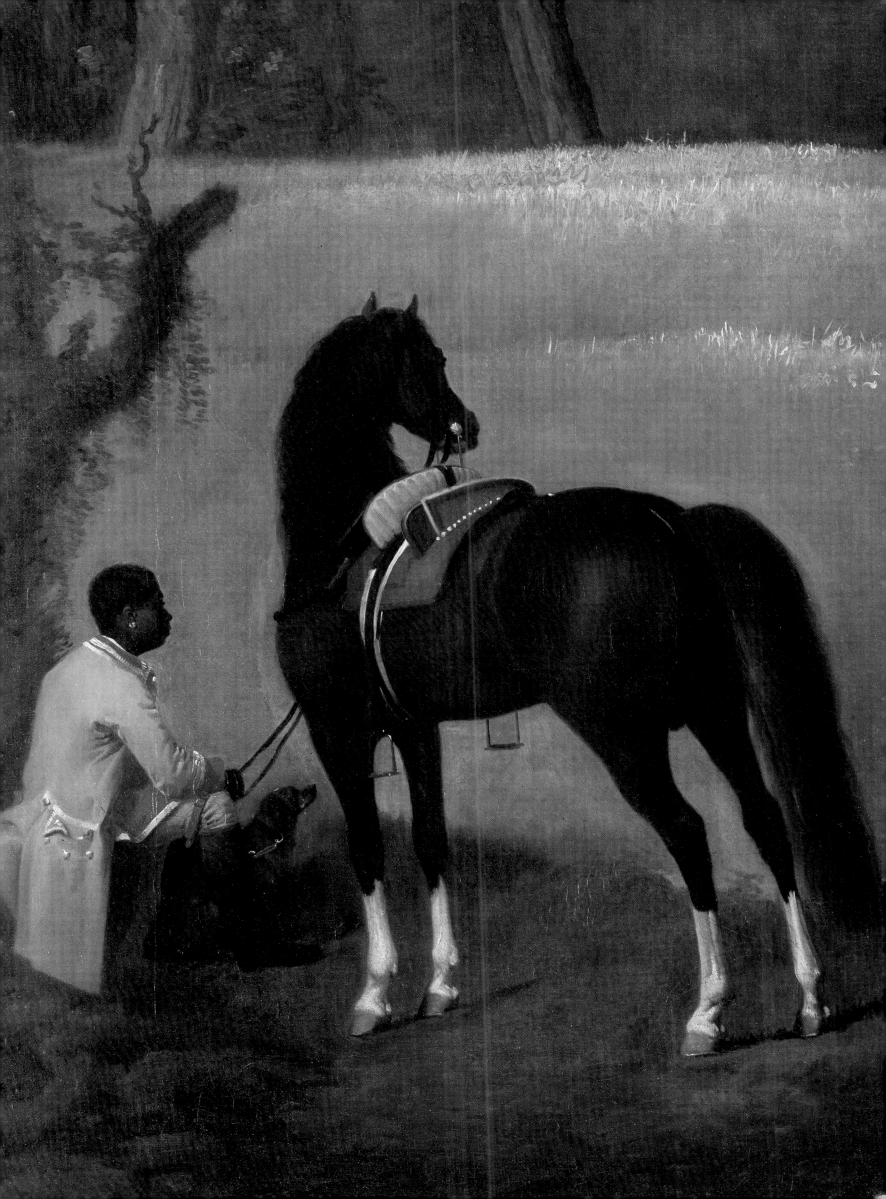

31*

THE DUCHESS OF RICHMOND AND LADY
LOUISA LENNOX WATCHING THE DUKE'S
RACEHORSES AT EXERCISE
? painted in 1760

Oil on canvas, $55\frac{1}{2} \times 80\frac{1}{2}$ in.
(139.5×204.5 cm.)
*Trustees of the Goodwood Collection,
Goodwood House, Chichester*

PROVENANCE
Commissioned by Charles, 3rd Duke of
Richmond, and thence by descent

EXHIBITED
National Portraits, South Kensington, 1868 (902);
Country Life, 1931 (131); *Old London*, Sir Philip
Sassoon's, 1938 (35); *British Portraits*, R.A.,
1956–7 (296); *Englischer Malerei der Grossen Zeit*,
1966 (5); *Stubbs in the 1760s*, Agnew's, 1970 (2,
repr.)

LITERATURE
Jacques 1822 p. 40 (as '. . . the late Duchess of
Richmond, and Lady Louisa Lennox, looking at
some horses training for the races'); Mason 1839,
p. 134, no. 207 (as 'Race Horses Training, with
portraits of the 3rd Duchess of Richmond and
Lady Louisa Lennox'); March 1879, revised Duke
of Richmond, 1952, p. 50 (as 'Race-horses
training, with portraits of the Third Duke of
Richmond, Mary his Duchess, and Lady Louisa
Lennox, all riding'; these three Goodwood
catalogues are fully cited under No. 29); Gilbey
1898, p. 171; E.K. Waterhouse, *Painting in Britain:
1730–1790*, 2nd edition, 1962, p. 208, pl. 180;
David Piper, 'A study of horses exercising, by
Stubbs', *The Listener*, 9 April 1964

This is undoubtedly the finest of the three
Goodwood pictures. Professor Waterhouse does
well to remind us of the 'novelty' of Stubbs's work:
that novelty must have been particularly striking
when Stubbs's canvases were first hung at
Goodwood in the same hall as the pictures of
racehorses and grooms commissioned by the 2nd
Duke of Richmond from John Wootton.

One factual point should be made. The 1822 and
1839 Goodwood catalogues (op. cit.) state that the
principal figures here are the 3rd Duchess of
Richmond and Lady Louisa Lennox (the Duchess's
sister-in-law, wife of the Duke's brother Lord
George Lennox). Amy, Countess of March's 1879
catalogue (op. cit.) seems to have been responsible
for the error, repeated ever since, that the 3rd
Duke of Richmond is also portrayed in the central
group. It cannot be so. For one thing, the portrait
of the swarthy man in green escorting the ladies
does not in the least resemble Stubbs's portrait of
him in 'The Charlton Hunt' (No. 28), nor the
portraits by Batoni and Reynolds of the Duke
(still at Goodwood). But even without these
portraits for comparison, we should be able to
perceive that the ladies' escort is not of their rank.
Stubbs, who was a master of (among other things)
the art of class distinction, would not have
portrayed the Duke in this subtly subordinate
position, nor mounted him on such a comparatively
undistinguished hack. The Duke's absence from
this picture is probably to be explained either by
his wish that each of the three Goodwood scenes
should portray different members of his family
circle or by the fact that he was abroad on military

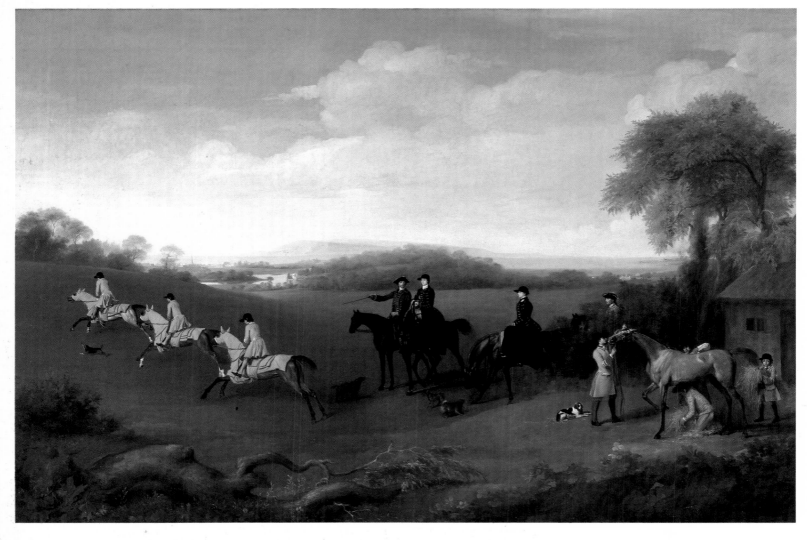

service (or both). The identity of the ladies' escort is uncertain; he may be Richard Buckner, bailiff and steward to the 2nd and 3rd Dukes, an important position in its own right, and one ably held by Buckner (the compiler is most grateful to Mr Timothy J. McCann, Assistant Archivist, West Sussex Record Office, for help over this suggested identification).

The Duchess and her sister-in-law wear the Goodwood blue, the livery of the Charlton Hunt (as does the Countess of Coningsby in No. 29). The background offers a wide view of the Sussex landscape looking from Goodwood towards Chichester, with the Isle of Wight in the distance.

To those who expect a picture to be composed centrifugally, with the heart of the action or emotion in the middle, or at least ushered towards the centre by carefully arranged wings, this composition seems to fall apart, or to consist, in Professor Waterhouse's phrase, of 'an assembly of fragmentary felicities'. What Stubbs achieves here is in fact what seems to be impossible: he places the aristocratic spectators in the centre of the picture rather than as lookers-on in the wings (as Hogarth placed spectators, for instance, in 'The Beggar's Opera' and 'The Indian Emperor'); thus the spectators within the picture and we ourselves (outside it) seem to be watching together as the racehorses enact their ritual exercise and canter off to the left. There is something almost surreal about the measured pace at which they move, and about the red-bordered yellow livery sweatcovers which they wear. A key role is played here by the little black and tan dog which runs along beside them, probably yapping excitedly, and saving them from unreality.

But the scene is almost stolen by the group on the right of the picture: a groom rubbing down a horse after exercise, the sotto voce murmurs with which he reassures the exhausted animal almost audible, while a stable-lad gathers straw for him to use as a wisp, and an even younger groom brings in fresh straw from the right. There is no parade here; the groom is a professional who goes about his duties quietly, confidently and without ostentation. The decorum with which this aristocratic household was conducted must have impressed Stubbs greatly; he would perhaps have seen something of how life was lived on a grand scale at the start of his career, when he was working at Knowlsley Hall near Liverpool, and he was to see much more of it as the decade unrolled and he received commissions to work at Wentworth Woodhouse, at Grimsthorpe, at Eaton Hall, Southill and other great houses.

The groom is probably identifiable, from the Goodwood Register of Servants (cited under No. 28) as William Budd: many of the Goodwood servants came from the ramifying Budd family of Charlton. Christopher Budd junior was a stable-lad; so were James Jordan, George Renwick and William and Robert Pickerell. It is impossible to identify them now; but clearly all the servants are portrayed from life.

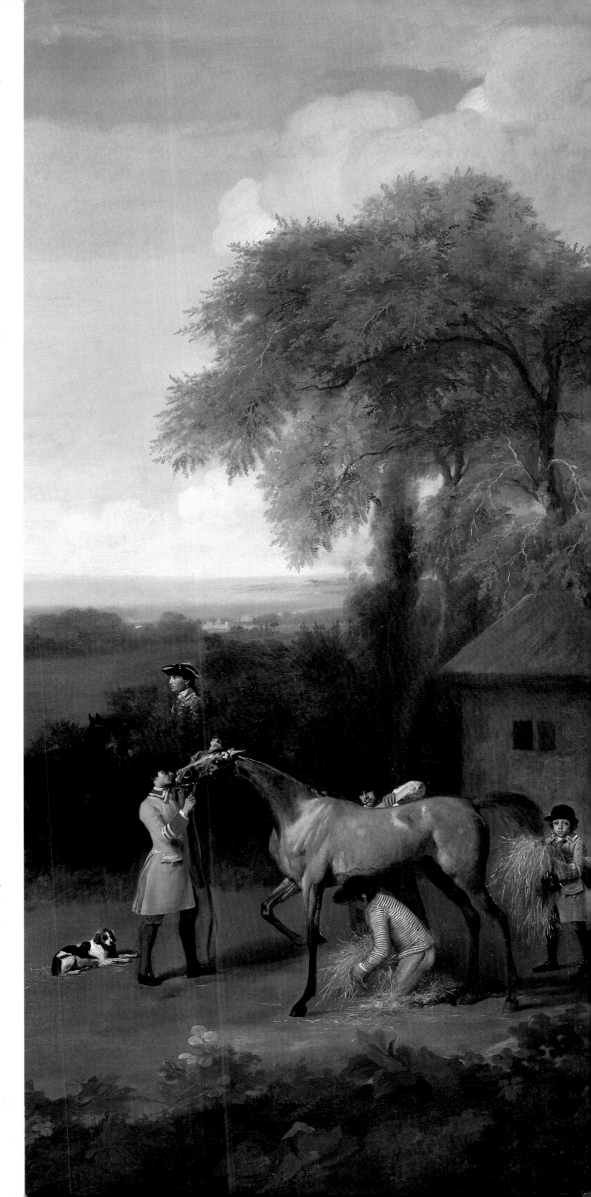

32

JOSEPH SMYTH ESQr, LIEUTENANT OF
WHITTLEBURY FOREST,
NORTHAMPTONSHIRE
*c.*1762–4

Oil on canvas, $25\frac{1}{4} \times 30\frac{1}{4}$ in.
(64.2×76.8 cm.)
Inscribed 'Joseph Smyth Esqr Lieutenant
of Wittlebury Forest Obt [sic] 1710 A et
sue 88 / by Stubbs' in ink, in a near-
contemporary hand, along lower edge of
the back of the frame, and 'Mr Joseph
Smith / Verderer of Whittlebu [ry] /
Forest' in a later hand on an old label
Dr D.M. MacDonald

PROVENANCE
Presumably commissioned by the sitter (or
possibly by the 3rd Duke of Grafton on behalf of
the sitter); reputedly later in the Selby-Lowndes
collection; purchased *c.*1938 by a Belgian private
collector, by whom sold as 'The Property of a
Nobleman', Sotheby's 9 July 1980 (129, repr.), bt.
Leggatt for Dr. D.M. MacDonald, on loan to Tate
Gallery since 1980

EXHIBITED
Tate Gallery since 1980

A tablet once visible in the parish church of St
Mary's, Whittlebury (before its floor was covered
with glazed tiles) commemorates the memory of
'Joseph Smyth Esq., Fifty Two Years Lieutenant of
Whittlebury Forest. He died April the 23d 1799 in
the Eighty Eighth year of his age' (the compiler is
indebted to Colin Eaton for tracing a record of this
inscription). Joseph Smyth was evidently born (not
'Obt', as in the inscription on the back of the frame)
in 1710, and was probably in his early fifties when
he sat to Stubbs.

Whittlebury Forest is more correctly termed
Whittlewood Forest; the village of Whittlebury
lies on its outskirts a few miles south of Towcester.
At the end of the eighteenth century Whittlewood
Forest covered '5424 acres 1 rood 11 poles': it lay
(and still lies, on a reduced scale) principally in the
south of Northamptonshire, but extending into
Buckinghamshire and Oxfordshire. Originally, as
with all forests in England, Whittlewood and the
rights to everything in it belonged to the Crown.
Charles II, while reserving the Crown's right to 'all
timber trees and saplings' (chiefly, of course, for
the use of the navy), granted other rights in
Whittlewood and nearby Salcey Forests to his
Queen and, after her death, to his three illegitimate
sons and their heirs for ever.

By 1705, the 1st Duke of Grafton (Charles II's
son by the Duchess of Cleveland), and after him his
heirs, had succeeded to all non-royal rights in
Whittlewood Forest, including possession of
Wakefield Lodge (and its 362 acres), which the 2nd
Duke of Grafton commissioned William Kent to
rebuild. The Dukes of Grafton bore the titles of
Lord Warden or Master Forester, with re-
sponsibility for the supply of timber to the Crown,
the upkeep of the forest and the administration of
forest laws, and Hereditary Keeper, with
responsibility for the custody and management of
the deer and the supply of venison to the royal
household.

In practice, since the Dukes of Grafton had
numerous other responsibilities – the 3rd Duke,

Stubbs's patron, was successively Secretary of
State for the North, Privy Councillor and 1st Lord
of the Treasury, as well as Lord Lieutenant of
Suffolk, where his principal seat of Euston Hall lay
– the day-to-day responsibility for administering
Whittlewood Forest devolved upon the Lord
Warden's Lieutenant, or Deputy Warden. It was
this office which Joseph Smyth discharged for fifty-
two years. Even with a staff of two Verderers, a
Woodward, a Purlieu Ranger, five Keepers and six
Page-Keepers, the Lieutenant's office was no
sinecure. It was in fact a complex form of estate
management, with the Duke of Grafton's interests
as well as the Crown's to look after.

Stubbs's sitter looks sturdy and vigilant, and
eminently capable of discharging his duties
efficiently and conscientiously. The green of his
greatcoat is the traditional colour worn by officers
for vert and venison. It is not clear whether the
Duke of Grafton appointed or nominated him to
office; but it was presumably at the suggestion of
the 3rd Duke of Grafton (for whom Stubbs had
already painted 'Antinous', No. 43, and a picture of
brood mares and foals) that Joseph Smyth sat to
Stubbs – whether at the Duke's or his own expense
is not known. What is clear is that Joseph Smyth
was a gentleman, his place in society being much
the same as, for instance, that of Richard Buckner,
Steward to the Duke of Richmond, who (I have
suggested) appears escorting the Duchess and her
sister to watch the Duke's racehorses at exercise in
No. 31.

Joseph Smyth lived at Sholebrook in the parish
of Whittlebury. On 21 July 1750 he married Lucy,
daughter of Lucy Knightley, lord of the manor of
Fawsley, Northamptonshire (the Christian name
Lucy was used in this family by males and females).
He became the uncle by marriage of Valentine
Knightley, who sat to Stubbs in 1776 (No. 114).
Presumably it was admiration for his uncle's
portrait that made Valentine Knightley choose
Stubbs to paint his own portrait.

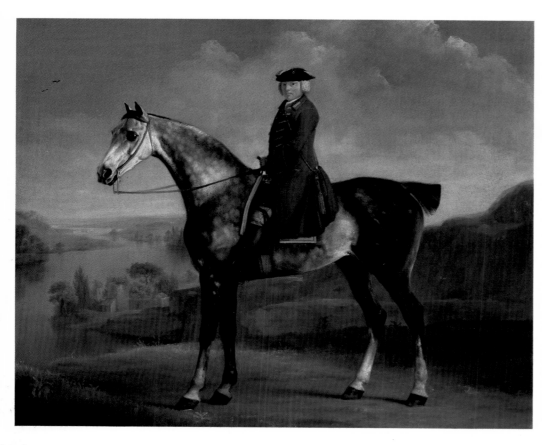

33

WHISTLEJACKET AND TWO OTHER
STALLIONS WITH SIMON COBB, THE
GROOM
1762

Oil on canvas, 39 × 74 in. (99 × 187 cm.)
Trustees of the Rt. Hon. Olive,
Countess Fitzwilliam's Chattels Settlement,
kindly lent by Lady Juliet de Chair

PROVENANCE
Commissioned by the 2nd Marquess of
Rockingham (paid for in August 1762: see note at
the end of No. 33); thence by descent

EXHIBITED
The Wentworth Woodhouse Stubbs Paintings, Ellis &
Smith 1946 (3, repr.)

LITERATURE
Constantine 1953, p. 236–7

This is the same size as the 'Mares and Foals'
painted for the Marquess of Rockingham, and may
have been painted as a pendant to it. Painting the
animals and figures first, then adding a background
(if required), seems to have been Stubbs's
invariable practice. Rockingham's decision that
three of his paintings by Stubbs – 'Mares and
Foals', this picture and the big 'Whistlejacket' –
should be left without backgrounds was courageous
and, surely, wise. The background added,
reputedly by George Barret, to Stubbs's portrait of
the Marquess's stallion 'Sampson, in three
positions' (repr. Constantine 1953, fig. 8), is
melodramatic and out of sympathy with the
subject.

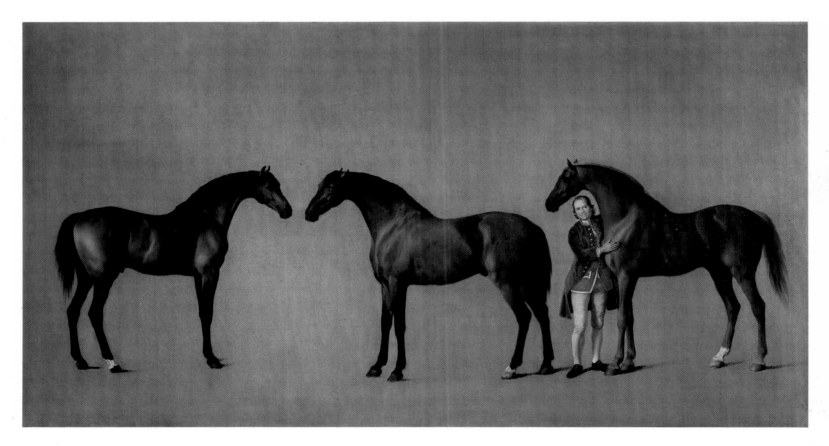

34*

WHISTLEJACKET
1762

Oil on canvas, 115 × 97 in.
(292 × 246.4 cm.)
Trustees of the Rt. Hon. Olive,
Countess Fitzwilliam's Chattels Settlement,
kindly lent by Lady Juliet de Chair

PROVENANCE
Commissioned by the 2nd Marquess of
Rockingham (paid for in December 1762, see
below); thence by descent

EXHIBITED
On loan to Kenwood, 1971–81, and as the
centrepiece of a small exhibition there, 1971 (no
catalogue)

LITERATURE
'Horace Walpole's Journals of Visits to Country
Seats. etc.', ed. Paget Toynbee, *Walpole Society*,
XVI, 1928; Humphry, MS Memoir; Dr Waagen,
Treasures of Art in Great Britain, III, 1854, p. 339;
Constantine 1953, pp. 236–8; Taylor 1971,
pp. 205–6, pl. 10

This astonishing image has never lost its power to compel attention. Its impressiveness is by no means merely a factor of size (John Wootton had painted even larger portraits of horses): it is, rather, a question of authoritativeness. There can be no doubt that the artist who modelled this horse knew the structure and function of every muscle and bone in its body.

Charles Watson-Wentworth, 2nd Marquess of Rockingham, is traditionally believed to have commissioned this life-size portrait to carry an equestrian portrait of George III, later deciding against the monarch's addition for political reasons. This tradition was already in existence when Horace Walpole (op. cit.) saw the picture ten years after it was painted: writing up his Journal after a visit to Wentworth Woodhouse on 9 August 1772, he noted 'Many pictures of horses by Stubbs, well done. One large as life, no ground done; it was to have had a figure of George 3d, till Lord Rockingham went into opposition'.

The Humphry Memoir elaborates this: 'it was intended that the present King shou'd have been painted by the best portrait painter and the Landskipp Background was to have been painted by the best Artist in that branch of the Art, hoping by the union of Talents to possess a picture of the highest excellence . . .'.

Whistlejacket's pose and place on the canvas seem to support the tradition that the picture was designed to carry a rider; and Rockingham, a decided Whig, was certainly in opposition to George III as early as December 1762 (when he resigned as Lord of the Bedchamber and temporarily forfeited his Lord Lieutenancy of Yorkshire in protest at the signing of the preliminaries of the Peace of Paris). But his decision to leave 'Whistlejacket' riderless may have been influenced as much by aesthetic as by political reasons. In commissioning the portrait of the horse, he may have been surprised to find that he got a work of superlative quality. Seeing it, he was evidently well satisfied to leave the horse as it was.

Whistlejacket was not an easy sitter: in fact he was 'remarkably unmanageable'. The Humphry Memoir includes a long anecdote about the last sitting for this picture, which incidentally gives a glimpse of Stubbs at work out of doors. A stable-boy was as usual leading Whistlejacket backwards and forwards in front of a long range of stables when Stubbs removed the picture from his easel and placed it against the stable-wall 'to view the effect of it, and was scumbling and glazing it here and there'. Whistlejacket, suddenly catching sight for the first time of his own image, began to 'stare and look wildly at the picture, endeavouring to get at it, to fight and to kick it'. Stubbs had to come to the stable-boy's aid and pummel Whistlejacket 'with his palette and Mahl stick' before the horse could be quietened and led away.

Very few accounts for works painted by Stubbs appear to have survived. Accounts for pictures painted for the 2nd Marquess of Rockingham in 1762, 1764 and 1766 (Wentworth Muniments, Sheffield City Libraries, published by Constantine, op. cit.) are extremely valuable, particularly as no dates for Stubbs's work for Rockingham are suggested in the Humphry Memoir, though it includes many anecdotes relating to such work.

It is not easy in every case to identify the Rockingham pictures from their description in the accounts; but of the pictures in this exhibition it seems clear that 'Mares and Foals' (No. 88), 'Whistlejacket and two other Stallions with Simon Cobb' (No. 33), 'Scrub, with John Singleton up' (No. 35) and 'Foxhounds' (No. 36) were all finished and paid for by August 1762, and can be identified in Stubbs's receipt: 'August yc 15th 1762 Recd of the Most Honble Marquiss of Rockingham the sum of one Hundred and ninty four pounds five shillings in full for a Picture of five brood-Mares and two foles one picture of three Stallions and one figure one picture of a figure on Horseback one picture of five Dogs and another of one Dog with one single Horse Rcd Geo: Stubbs'. Stubbs's rate at this period seems to have been 40 gns. per picture, but he may have reduced his charges for the pictures without a background.

The next two pictures painted for Rockingham, for which Stubbs's receipt dated 30 December 1762 reads 'Eighty guineas for one Picture of a Lion and another of a Horse Large as Life', appear to have been the very large 'Lion Attacking a Horse' (No. 60, for which a pendant 'Lion Attacking a Stag', No. 61, seems to have been painted a few years later) and the life-size 'Whistlejacket'. Two more pictures at 40 gns. each were paid for on 31 August 1764 (probably 'Sampson in three positions' and 'Bay Malton with John Singleton up', neither in this exhibition). On 7 August 1766, Stubbs received 40 gns. for 'A Picture of an Arabian Horse': this, the compiler suggests, was for 'The Marquess of Rockingham's Arabian Stallion', No. 72.

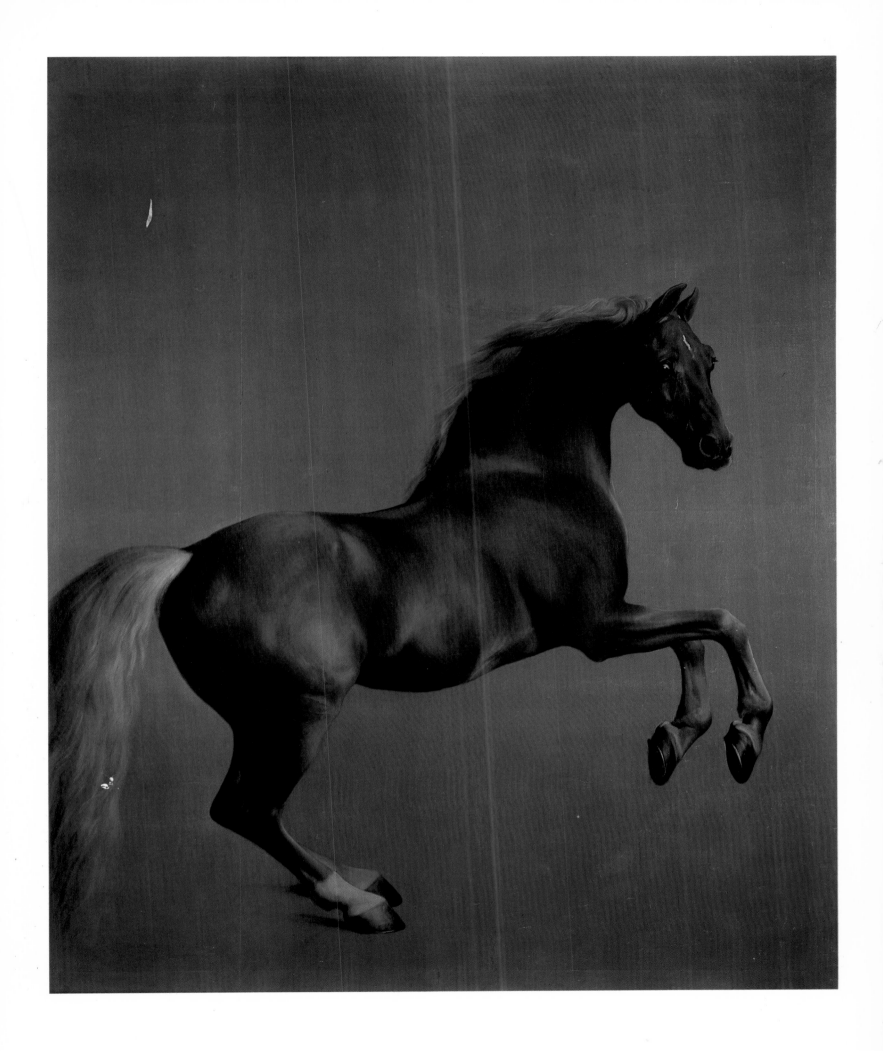

35

THE MARQUESS OF ROCKINGHAM'S
SCRUB, WITH JOHN SINGLETON UP
1762

Oil on canvas, 40 × 50 in.
(101.5 × 127 cm.)
Trustees of the Rt. Hon. Olive,
Countess Fitzwilliam's Chattels Settlement,
kindly lent by Lady Juliet de Chair

PROVENANCE
Commissioned by the 2nd Marquess of
Rockingham (paid for in August 1762: see note at
the end of No. 33); thence by descent

EXHIBITED
The Wentworth Woodhouse Stubbs Paintings, Ellis &
Smith 1946 (5, repr.)

LITERATURE
Constantine 1953, p. 236–7

Scrub was foaled at the Marquess of Rockingham's
stud in 1751, got by Blaze out of Lucretia. Between
1755 and 1761 he raced at Newmarket and York,
and later returned to Rockingham's stud as a
stallion. When he was an old horse, Rockingham
gave him to John Singleton, in whose possession he
died at Givendale, Yorkshire.

John Singleton (1715–1793), Yorkshire born and
bred, must be about forty-seven years old in this
picture: by no means uncommonly old for an
eighteenth-century jockey. He continued to ride
for Rockingham for another decade, winning his
most famous victory in 1767 on Bay Malton:
Stubbs's portrait 'Bay Malton with John Singleton
up' is in the same collection (on loan to the
National Horseracing Museum, Newmarket).

Stubbs also painted a life-size portrait of Scrub
(96 × 96 in.). According to the Humphry Memoir,
Rockingham commissioned this in connection with
that abortive project for an equestrian portrait of
George III for which he had first commissioned a
life-size portrait of Whistlejacket (though to this
compiler, the life-size 'Scrub' looks earlier than
'Whistlejacket'). 'Some dispute' arose over the life-
size 'Scrub', and Stubbs took it back. It is now in
the collection of the Earl of Halifax.

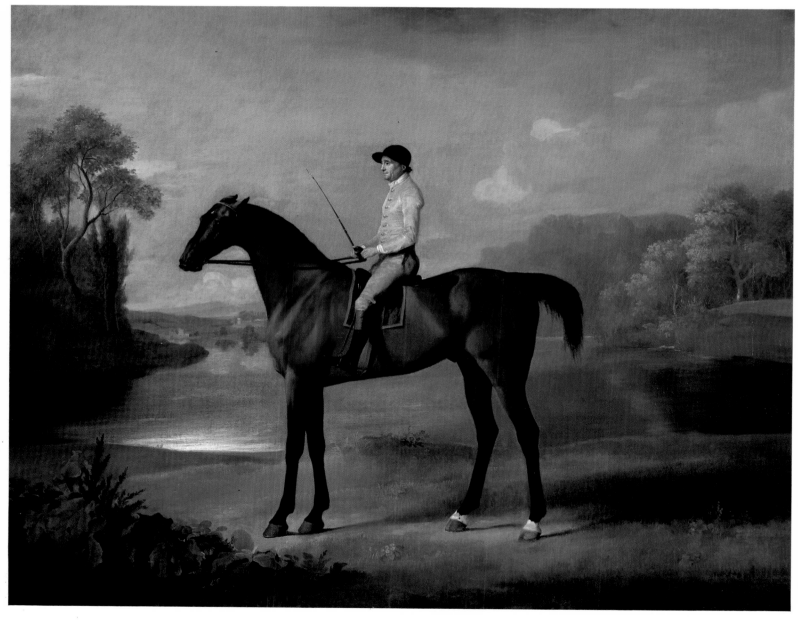

36

FOXHOUNDS IN A LANDSCAPE
1762

Oil on canvas, 40 × 50 in. (101.5 × 127)
Trustees of the Rt. Hon. Olive,
Countess Fitzwilliam's Chattels Settlement,
kindly lent by Lady Juliet de Chair

PROVENANCE
Commissioned by the 2nd Marquess of
Rockingham (paid for in August 1762 : see note at
the end of No. 34); thence by descent

EXHIBITED
The Wentworth Woodhouse Stubbs Paintings, Ellis &
Smith 1946 (7, repr.); Liverpool 1951 (47);
Graves Art Gallery, Sheffield 1952 (10);
Whitechapel 1957 (38)

LITERATURE
Constantine 1953, p. 236–7

These are evidently portraits of individual hounds
(dog, bitch, dog, bitch, dog), placed across the
picture as if posed for a judge's eye. The frieze-like
design is obviously comparable to the variations on
the theme of mares and foals, but this is the only
known work where Stubbs arranges hounds in such
a way. Thirty years later, Stubbs was to fill the
portrait of a single couple of foxhounds (No. 104)
with far more tension.

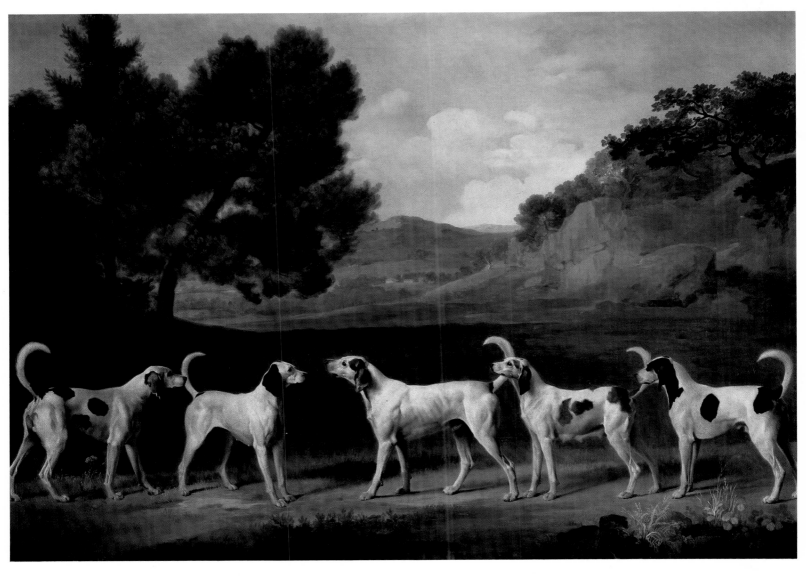

37*

MOLLY LONG-LEGS
exhibited 1762

Oil on canvas, $39\frac{3}{4} \times 49\frac{7}{8}$ in.
(101×126.8 cm.)
Inscribed 'Molly Long-legs / Geo: Stubbs / pinxit' lower left

Merseyside County Council, Walker Art Gallery, Liverpool

PROVENANCE
Unknown before its ownership by Sir Walter Gilbey, by 1885; Gilbey sale, Christie's 12 March 1910 (150), bt. Vokins, 24 guineas; Tresham Gilbey, sold Christie's 30 May 1947 (82, repr.), bt. Bernard, £1,942.10.0, by whom sold to Walter Hutchinson; his sale, Christie's 20 July 1951 (124), bt. Agnew, £1,050; Messrs. Lewis's, Ltd, by whom presented to the Walker Art Gallery, 1951

EXHIBITED
Society of Artists 1762 (112); Vokins 1885 (20); *Works of Art illustrative of and connected with Sport*, Grosvenor Gallery 1890 (47); *National Gallery of British Sports and Pastimes*, Hutchinson House, [1948] (140); *Selected Acquisitions of the Walker Art Gallery, 1945–1955*, Agnew's 1955 (25); Whitechapel 1957 (17, pl. VII); *Primitives to Picasso*, R.A., Winter 1962 (166, pl. 28)

LITERATURE
Gilbey 1898, pp. 164–5; typescript catalogue entry, Walker Art Gallery

Molly Long-legs was a bay filly, got by Babraham out of a Foxhunter mare, bred by Fulke Greville of Wilbury House, Wiltshire. She raced between 1757 and 1761 for Greville, and in 1761–2 for Lord Bolingbroke, after which she was retired from the turf and kept as a brood-mare until at least 1778.

In this portrait, Molly Long-leg's jockey wears a light blue jacket and black cap. These colours were neither Greville's nor Bolingbroke's; they are however very similar to the colours worn by the jockey in Stubbs's portrait of the Duke of Grafton's racehorse Antinöus (No. 43 in this exhibition). Possibly the Duke of Grafton owned Molly Long-legs at least for long enough for him to commission Stubbs to paint her portrait. If this is so – and there is no record of the picture ever having been at Euston Hall, or of having been sold by the Duke – it is possible that the Duke parted with the horse and her portrait together. The painting seems never to have been in either the Greville or Bolingbroke collections; its early ownership therefore remains obscure.

The first official list of 'Colours worn by the Riders of Noblemen, Gentlemen, &c.' was published in the *Racing Calendar* of 1800; this lists the 3rd Duke of Grafton's racing colours as 'Sky blue, with black cap' (the next Duke chose 'Scarlet'

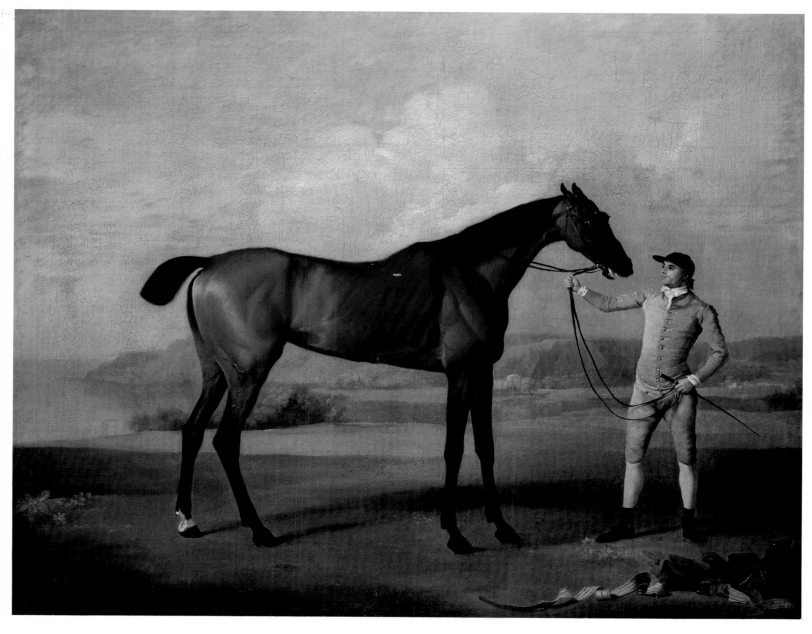

as his own colours). Colours in portraits of racehorses are by no means always a reliable guide to the horses' owners, many of whom often raced hopeful winners under other men's names and in other colours, in order to lengthen the odds by making it appear that a horse which in fact came from a well-known stable was unlikely to be a good bet – then, with luck, recouping handsomely on their own bets.

Whatever the problems posed by the racing colours in this painting, there is no doubt about its quality. The details of the striped girth and stirrup leathers, the saddle and hooded sweat-cover lying in the foreground on the right merit close attention.

In the Society of Artists exhibition of 1762, 'Molly Long-legs' was catalogued as 'Companion' to 'A Portrait of a Horse, call'd Tristram Shandy' (sold Sotheby's 14 March 1962, lot 136, repr., now in an American private collection); in that picture, the horse is accompanied not by a jockey in racing colours but by a stable-lad.

38*

A HORSE BELONGING TO THE RT. HONBLE. LORD GROSVENOR, CALLED BANDY FROM HIS CROOKED LEG
exh. 1763

Oil on canvas, 34 × 51 in. (86 × 129 cm.)
Her Grace Anne, Duchess of Westminster

PROVENANCE
Commissioned by Lord Grosvenor, later 1st Earl Grosvenor; thence by descent

EXHIBITED
Society of Artists 1763 (122)

LITERATURE
Humphry MS Memoir, note by Mary Spencer inserted opposite f. 19 v.

ENGRAVED
Published by Sayer and Bennett, 2 June 1777 (reissued 12 May 1794)

The note inserted in the Humphry MS Memoir reads 'In 1760 on his leaveing Goodwood, he went to Eaton Hall in Cheshire the seat of Lord Grosvenor, this was a prior engagement, to paint Bandy there he stayed many weeks, and painted a very large hunting piece' (No. 39). Had the 'prior engagement' been made while Stubbs was still based, not far from Eaton Hall, in Liverpool, or in London? It is impossible to say, or to date Stubbs's stay at Eaton Hall with precision.

Bandy, 'called so from one of his legs being crooked, was, notwithstanding this, one of the best horses of his day, and afterwards a capital stallion . . .' (catalogue of the Turf Gallery exhibition, 1794, ?compiled by Stubbs, published in the *Sporting Magazine*, January 1794, pp. 210–14). He was a bright bay colt, bred in Yorkshire and foaled in 1747, got by Cade out of Mr Vane's Little Partner; after a moderately successful racing career in 1752–4, he was purchased by Lord Grosvenor.

Bandy's name leads the list of over three hundred stallions and brood mares owned by Lord Grosvenor between 1753, when his interest in stud-farming began, and his death in 1802 (see No. 90).

The version exhibited at Stubbs's *Turf Review* exhibition in 1794 must have been the version in which the groom wears a broad-brimmed hat rather than a peaked cap; this version, probably painted in the early 1790s for the *Turf Review*, lacks the crisp detail and masterly highlights in the Grosvenor picture. This version, successively in Stubbs's studio, 26 May 1807 (90), in the collection of Sir Walter Gilbey (his sale, 12 May 1910, lot 151, wrongly identified as the picture exhibited in 1763) and in the collection of the 1st and 2nd Earls Beatty, has passed through the art market several times in the last decade, always wrongly stated to be the picture exhibited in 1763 and as ex-collection Lord Grosvenor. The Grosvenor picture has never left that family's collection, and has not been exhibited since 1763.

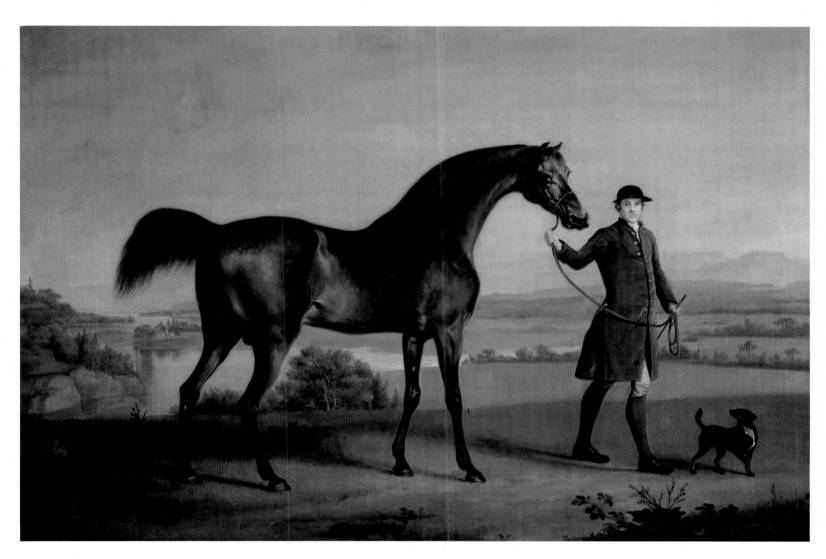

39*

THE GROSVENOR HUNT
dated 1762

Oil on canvas, 59 × 95 in. (149 × 241 cm.)
Inscribed 'Geo: Stubbs p: / 1762' near
the roots of the tree below Lord
Grosvenor's horse
His Grace The Duke of Westminster

PROVENANCE
Commissioned by Richard Grosvenor, later 1st
Earl Grosvenor; thence by descent

EXHIBITED
Society of Artists 1764 (112, 'A hunting piece';
Walpole's catalogue was later annotated by John
Sheepshanks: 'bought by Lord Grosvenor for
300 gns.'); Liverpool Art Club 1881 (94);
Vokins 1885 (26); Grosvenor Gallery 1890 (46);
Whitechapel 1957 (2, pl. XXIII); *Stubbs in the
1760s*, Agnew's 1970 (3, repr.); *British Sporting
Painting 1650–1850*, Arts Council 1974–5 (41,
repr.)

LITERATURE
Humphry MS Memoir; J. Young, *Catalogue of the
Pictures at Grosvenor House, London, with etchings from
the whole collection*, 1820, no. 2; Gilbey 1898,
pp. 33–4, 129–30

A note inserted in the Humphry MS Memoir, in
Mary Spencer's hand, describes this as 'a very large
Hunting Piece, in which the portraits of Lord
Grosvenor (on honest John) his brother Mr:G, Sir
Roger Mostyn, Mr Bell Lloyd & appropriate
Servants, together with a view of the Country,
from the Saloon of Eaton Hall. Every object in this
Picture was a Portrait . . .'.

Lord Grosvenor is the figure who turns to face
the spectator, the tree above him seeming to bow
in salutation; he was aged thirty-one in 1762, and
his brother Thomas, next to him, gesturing with a
whip, twenty-eight. The next two gentlemen are
Sir Roger Mostyn, 5th Bart. (1734–1796), of
Mostyn, Flintshire, Lord-Lieutenant of Flintshire,
and Mr Bell Lloyd (? of Pontriffith). The huntsman
winds his horn on the left of the picture; he and the
other hunt servants wear green livery.

'Every object in this Picture was a Portrait',
Mary Spencer noted, by which she meant 'drawn
from life' or 'drawn from nature'. The landscape
and particularly the skyline is 'portrayed' by
Stubbs with as much exactitude as in the view of
Eaton Hall engraved by Kip after Knyff. It includes
a wide view of the Peckforton Hills, with the
ancient fortress of Beeston Castle (barely visible at
this distance) on the hill on the left.

The hounds are portrayed in a state of great
excitement, having got the stag at bay on the bank
of the River Dee: the representation of their
splashes in the water combines intense observation
with virtuoso painting.

That 'The Grosvenor Hunt' appears to be
derived from Oudry's 'Louis XV chassant le cerf
dans la fôret de Saint-Germain', painted in 1730,
has often been commented on. The stag at bay in
the river, the hounds splashing in, the hunt
members waiting on the further bank and the

huntsman winding his horn on the left are all
details which occur in both Oudry's and Stubbs's
pictures (though Stubbs has moved the huntsman
to the near bank of the river, weighting the
composition at exactly the right point). But there
seems to be no way in which Stubbs could have seen
the Oudry, which was in the Cabinet du Roi at
Marly (unless he returned from Rome in 1754 via
Marly), and the picture seems never to have been
engraved. Stephen Deuchar suggests (in cor-
respondence) that the missing link may be John
Wootton's 'The Death of the Stag', dated 1737,
which also shows a debt to Oudry; Horace Walpole
saw it at Kew in 1761, and Stubbs could also have
seen it there (Sir Oliver Millar, *Tudor, Stuart and
Early Georgian Pictures in the Royal Collection*, 1963, no.
545, pl. 203). Wootton seems to have spent more
time abroad than Stubbs, and may have sketched
the Oudry.

Richard Grosvenor, eldest son of the 6th baronet
of Eaton Hall in the county of Chester, was one of
the richest men in England. His grandfather's
marriage with a London heiress had united the
already substantial Grosvenor fortunes (founded
on land and lead-mines) to vast estates in London,
gradually developed as Mayfair and Belgravia,
their squares echoing the names of the family's
Cheshire manors (Eaton, Eccleston and Belgrave).
Like his father and grandfather before him, he
represented Chester in the House of Commons,
where he was one of Pitt's staunchest supporters;
Pitt rewarded him with a barony in 1761. Horace
Walpole noted that Grosvenor evidently took his
elevation to the peerage less seriously than his
preoccupation with racing, noting on 17 March
1761 that Richard Grosvenor 'has been made a
viscount or baron, I don't know which, nor does he,
for yesterday, when he should have kissed hands,

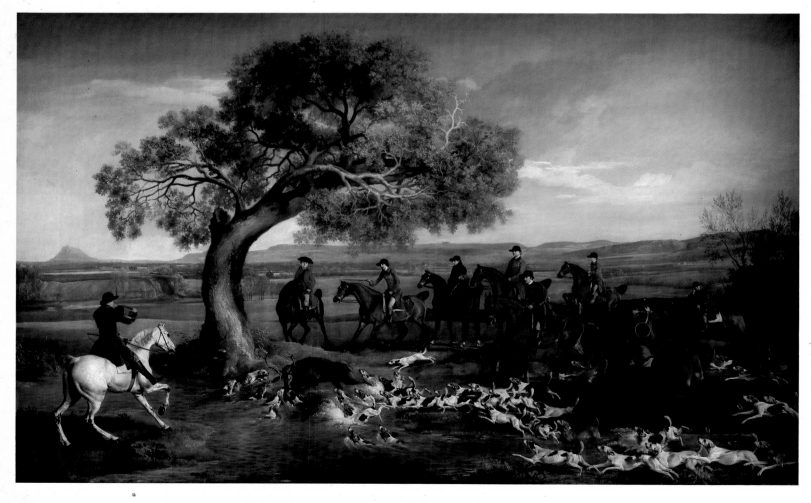

he was gone to Newmarket to see the trial of a racehorse' (ed. W.S. Lewis and others, *Correspondence*, XXII p. 490).

The chief enthusiasm in Lord Grosvenor's life was racing and the breeding of racehorses. Some account of his stud-farm is given under No. 90, a painting of some of his brood mares and foals.

While racing was Lord Grosvenor's ruling passion, collecting pictures ran it a close second. While he was still a mere baronet aged twenty-seven, Horace Walpole, his envious rival in the Old Master field, classed him among the 'boys of twenty and thirty thousand a year ... who care not what they give'. For purchases of Italian and Flemish pictures, Grosvenor largely relied on the advice of Richard Dalton, Keeper of the King's pictures. But he also patronized living British artists; Farington reported that Lord Grosvenor had told Benjamin West 'that he means to have a room furnished with English pictures only'. He bought West's 'The Golden Age' (probably the version exhibited at the Royal Academy in 1771, and possibly the picture in the Tate Gallery) and three of his large battle-pieces, including 'The Death of General Wolfe', narrowly beating George III to its purchase: the King had to be content with a replica (the Grosvenor picture is now in the National Gallery of Canada). Grosvenor was himself bitterly disappointed at missing the chance to buy Hogarth's 'The Lady's Last Stake', which he coveted both as a gambler and as a connoisseur. Hoping for something similar, he offered to buy Hogarth's next picture at whatever price the artist named, but sardonically withdrew when that work turned out to be the perverse and lugubrious 'Sigismunda weeping over the Heart of her Dead Lover Guiscardo' (now in the Tate Gallery). After Hogarth's death, he bought his 'Distressed Poet'. Grosvenor commissioned the Rev. Matthew Peters's salacious 'Girl in Bed', which caused a sensation when exhibited at the Royal Academy in 1777: a reviewer wrote that any man who had his wife or daughter with him 'must for decency's sake hurry them past that corner of the room' (the painting is now in the Rhode Island School of Design Museum; Grosvenor's own marriage ended disastrously in 1770, when he successfully sued the King's brother, the Duke of Cumberland, for adultery). Hoppner's 'The Flower Girl' was a more decorous purchase, and his commission to Richard Wilson to paint 'View on the River Dee near Eaton Hall' (now in the Barber Institute) was very sound. Grosvenor's purchase of Northcote's 'The Falconer' (still at Eaton) shows that his enthusiasm for sport was not confined to racing. From Sawrey Gilpin he commissioned portraits of his race-horses Alexander, John Bull, Justice, Meteor and that oddly-spelled son of Eclipse, Pot8os; but his favourite horse painter was undoubtedly Stubbs, by whom he was to own at least eleven works. Grosvenor was not attracted to Stubbs's dramatic subjects or exotic animals. The pictures he continued to commission from Stubbs were all of racing or stud-farm subjects. He remained a faithful patron of Stubbs for nearly twenty years, commissioning, as a last work, a portrait of 'Sweet Briar', dated 1779.

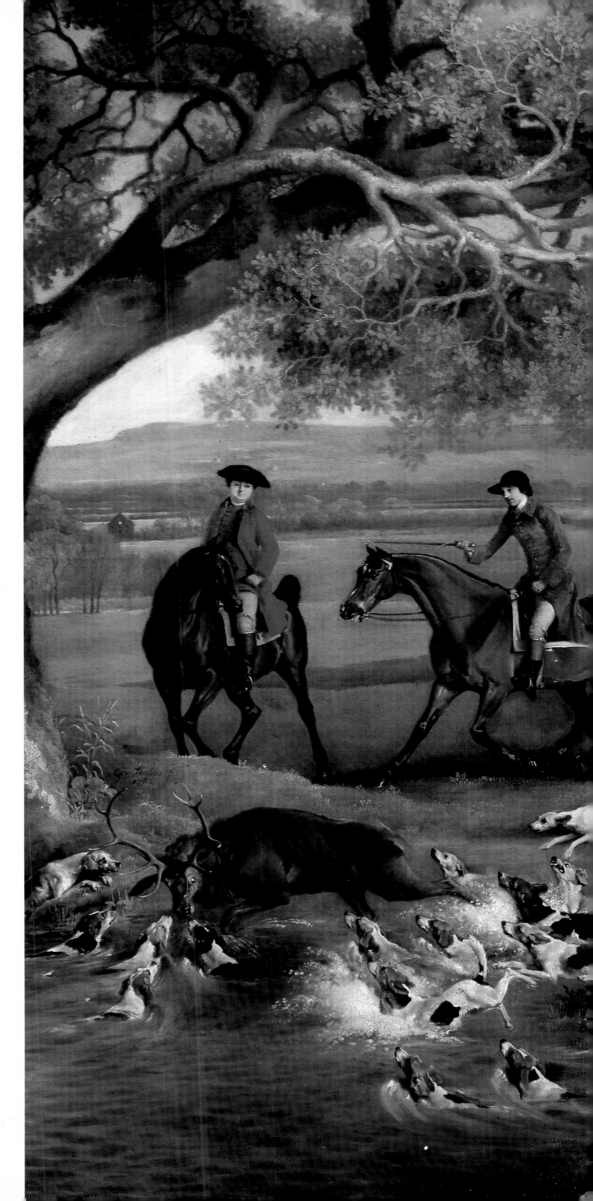

40

LUSTRE, HELD BY A GROOM
c.1760–2

Oil on canvas, 40⅛ × 50 in.
(102 × 127 cm.)
Inscribed 'Lustre [in white] / Geo: Stubbs
. Pinx:' lower right
Paul Mellon Collection, Upperville, Virginia

PROVENANCE
? commissioned by the 2nd Viscount Bolingbroke;
... ; William James, acquired 1900, by descent to
his son Edward James; sold by the Trustees of the
Edward James Foundation, East Dean, Sussex,
Sotheby's 18 November 1970 (28, repr.),
bt. Ackerman for Mr Paul Mellon KBE

LITERATURE
Egerton 1978, p. 68, no. 68, pl. 25

Lustre, foaled in 1754, by Blank, was owned first by
the 3rd Duke of Ancaster and later by the 2nd
Viscount Bolingbroke, for whom in 1760 he won a
race at Winchester and a match at Newmarket.
Bolingbroke, one of Stubbs's most important early
patrons, is noticed under the portrait of 'Turf,
with Jockey up', No. 57, which remained in the
Bolingbroke family collection, with other works by
Stubbs, until a sale at Christie's on 10 December
1943. That sale did not include 'Lustre', and the
suggestion that Bolingbroke commissioned this
picture must remain speculative.

The portrait of the groom is notably sensitive.
Alert to and in sympathy with his charge, the
groom provides a perfect example of Stubbs's skill
in portraying the unstudied, uningratiating de-
meanour of the trusted servants of the great houses
and stables of the period.

41*

JENISON SHAFTO'S RACEHORSE SNAP
WITH THOMAS JACKSON, HIS TRAINER
AND JOCKEY
c.1762–3

Oil on canvas, 38½ × 49½ in.
(97.8 × 125.7 cm.)
Private Collection

PROVENANCE
Presumably commissioned by Jenison Shafto;
believed to have been in the Fetherston family of
Packwood, Warwickshire, for several generations
before being recorded in the MS inventory of
John Fetherston c.1860 ('Portrait of a groom
holding a black racehorse'); by descent to the
present owner

LITERATURE
Mary Spencer, MS note inserted in Upcott's
transcript of the Humphry Memoir, after f. 19

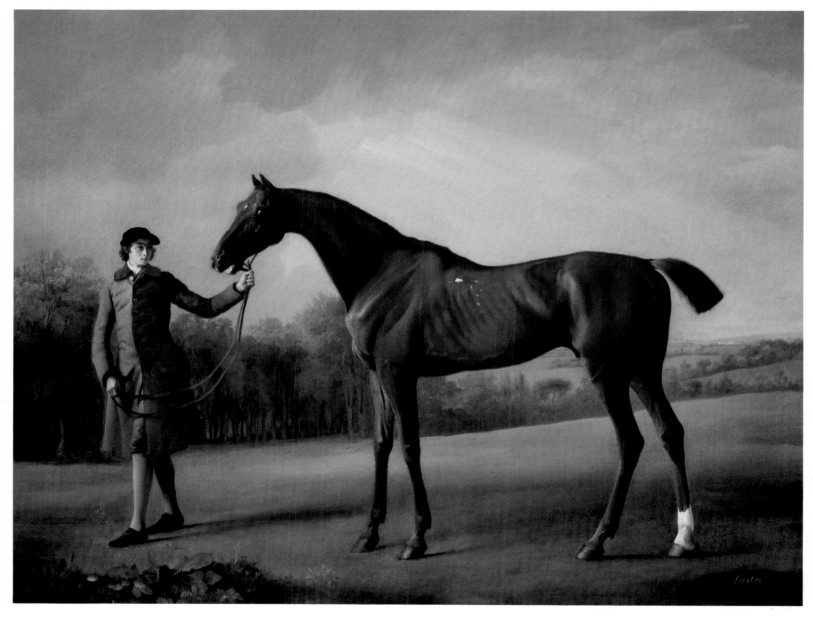

Mary Spencer (op. cit.) relates that after painting 'Bandy' (No. 38) and 'The Grosvenor Hunt' (No. 39) at Eaton Hall in Cheshire, Stubbs 'from thence went for the first time, to Newmarket, to paint Snap for Jeneson Shaft Esq.'. This picture is thus one of the earliest works which Stubbs painted after establishing himself in London, and as the first commission he received from Newmarket, it marks an important point in his career. Unlike his predecessors Wootton and Seymour, Stubbs did not, at this stage, include Newmarket landmarks in his portraits of Newmarket winners. This landscape with its gentle undulations and meandering river may represent Wratting in Cambridgeshire, where Shafto lived. Stubbs's use of soft light greens gives it a spring-like freshness, against which the velvet of the trainer's livery and the dark sheen of Snap's coat tell to strong effect. The only sign of immaturity here is that the trainer seems to be placed further behind the horse than a bridle's length would allow.

Snap was a dark bay horse by Snip out of sister to Slipby, bred by a famous breeder, Cuthbert Routh, and foaled in 1750. At the sale of Routh's stud after his death in 1752, Snap was purchased by Jenison Shafto. Snap proved a winner, both at Newmarket, where he twice beat Marske in matches over the Beacon Course for 1,000 guineas each, and later at Shafto's stud, where he sired 261

winners whose prize-money reputedly totalled £92,637. Snap died in July 1777, aged twenty-seven.

The trainer with Snap in this picture is almost certainly Thomas Jackson, who learnt his skills in Cuthbert Routh's stable; on his master's death he entered Jenison Shafto's service. Jackson frequently himself rode as jockey on horses he had trained, and continued to do so until he was sixty. Stubbs's portrait depicts a middle-aged but clearly still energetic figure. Jackson died in 1766; a memorial slab at Nunnington is lettered as follows:

Here lie the Remains
of
MR. THOMAS JACKSON,
Who was born at Thornton-le-Street,
near Thirsk,
Was bred at Black Hambleton,
And Crowned with Laurels
at Newmarket.
He died
Worn out in the service of his Friends,
Feb. 2nd, 1766, aged 62.

(quoted in C.M. Prior, *Early Records of the Thoroughbred Horse*, 1924, pp. 24–5 and 48–53, from which information about Snap and Jackson is largely taken).

Jenison Shafto (c.1728–d. 1771) was M.P. for Leominster, 1761–8, and for Castle Rising, 1768–71, but took little active part in politics. He kept a large racing stable and stud farm at Wratting, and was famous for his prodigious wagers. His luck was proverbial; Horace Walpole, remarking in 1763 on the unvarying sameness of the social round in England over the last ten years, gave as example 'The beginning of October, one is certain that everybody will be at Newmarket, and the Duke of Cumberland will lose, and Shafto win, two or three thousand pounds' (*Correspondence*, ed. Wilmarth S. Lewis and others, vol. 38, 1974, p. 272). Shafto's most successful wagers were matches against time; probably the most celebrated was his wager in 1759 that he would ride fifty miles in under two hours (he used ten different horses, and won with 43 seconds in hand) and the most profitable was his wager with Hogo Meynell in 1761, for 2,000 guineas, that one man could ride a hundred miles a day for twenty-nine days, on any one horse each day, a wager won for him by his groom Thomas Woodcock.

Shafto commissioned two other pictures from Stubbs. A later portrait of Snap in a paddock at his stud-farm, dated 1771, descended in the Shafto and Adair families until it was sold at Christie's on 17 June 1966 (92, repr.); a portrait of two Shafto mares and a foal is No. 92 in this exhibition.

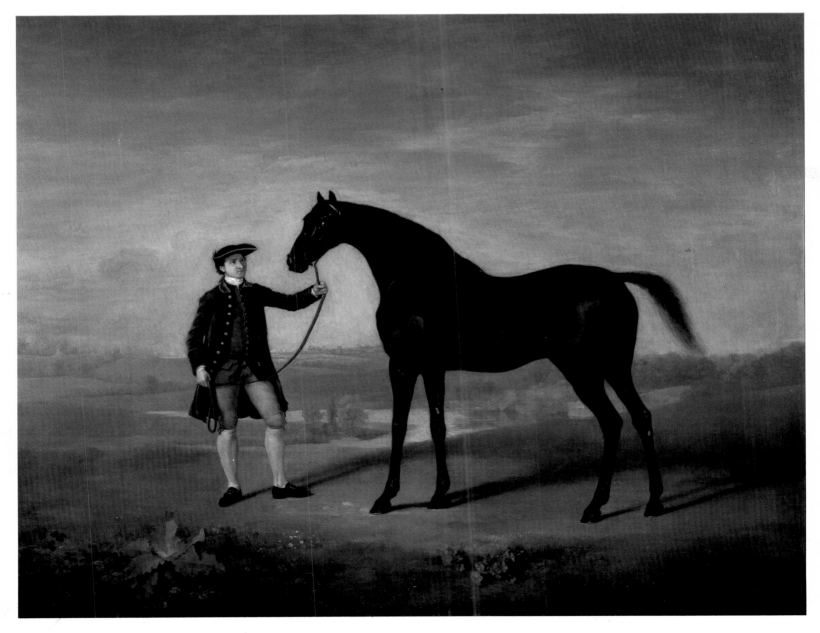

42*

HOLLYHOCK

painted by Stubbs in 1766, with later
additions of figures by Boucher and
landscape by Vernet

Oil on canvas, $15\frac{1}{4} \times 18\frac{3}{4}$ in.
(38.7 × 47.6 cm.)
Her Majesty The Queen

PROVENANCE
Commissioned by 2nd Viscount Bolingbroke from
Stubbs in 1766, and given by him that year to 'M.
(?) Monet'; . . . Colnaghi, from whom purchased
by George IV (when Prince of Wales) 16 April
1810, and thereafter in the Royal Collection

EXHIBITED
Animal Painting, Queen's Gallery 1966–7 (37)

ENGRAVED
by John Scott for publication in the *Sporting
Magazine*, XXI, January 1803, facing p. 171, as
'Colt, bred by Lord Bolingbroke' Millar 1969,
no. 1119, pl. 148

This must be the only work in which the talents of
George Stubbs, François Boucher and Claude-
Joseph Vernet are combined – to curious and, it
must be admitted, unsatisfactory effect. The
picture began as a portrait by Stubbs of the colt
Hollyhock, bred by the Duke of Cumberland,
foaled in 1765, by young Cade out of Cypron; Lord
Bolingbroke purchased the colt at Windsor and
commissioned its portrait. Millar (op. cit.) notes
that the remains of an old label on the back of the
frame record that Bolingbroke gave the picture to
'M. (?) Monet dans un dernier voyage en
Angleterre' in 1766; the label adds that the horse
was painted by Stubbs in London, the background
by Vernet and the figures, dog and sheep by
Boucher. Presumably M. Monet considered that
Stubbs's composition was dull, and had the picture
'embellished' by two of the most fashionable artists
in France.

After some successes at Newmarket, Hollyhock
ended his days at Lord Rockingham's stud, and
died while covering a mare. The painting must
have returned to England by 1802, for Scott's
engraving of it was published in the *Sporting
Magazine*'s issue of January 1803, captioned 'Colt,
bred by Lord Bolingbroke / the Horse painted by
Stubbs, Landscape by Vernet, Figures dog and
Sheep by Boucher.' The *Magazine*'s editor
commented, 'The original painting from which this
print is taken is one of the most beautiful ever
seen', a remark which must surely have
exasperated its original artist.

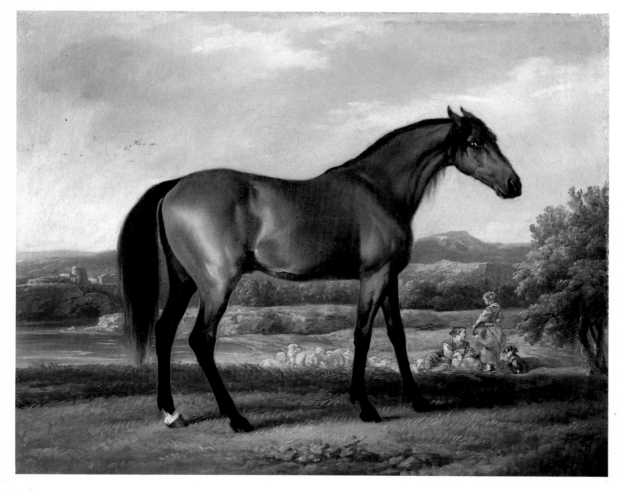

43*

ANTINOUS, A HORSE BELONGING TO HIS
GRACE THE DUKE OF GRAFTON
exh. 1764

Oil on canvas, $39\frac{7}{8} \times 50\frac{1}{4}$ in.
(101.3×127.6 cm.)
Private Collection

PROVENANCE
Commissioned by the 3rd Duke of Grafton;
thence by descent

EXHIBITED
Society of Artists 1764 (115); Vokins 1885 (32);
Sporting Pictures and Prints, Norwich 1950 (11);
European Masters of the Eighteenth Century, R.A.
1954–5 (121);
English Pictures from Suffolk Collections, Agnew's
1980 (39)

A label on the stretcher is inscribed (? in an early
nineteenth-century hand) 'Antinous / Jockey
Pilkington / By Stubbs / Landscape by Barrett'.

George Barret (1732–1784), landscape painter,
was born in Ireland but worked in England from
1763. From then until *c.*1770 he seems to have been
an occasional collaborator with Stubbs. No
documents or accounts relating to this picture have
survived, but there seems no reason to doubt the
old label's statement that Barret painted the
landscape in this picture, for it is in his style and
not in Stubbs's. Other works in which Barret added
landscape to Stubbs's animals include 'Sampson, in
three positions', painted for the 2nd Marquess of
Rockingham *c.*1764; probably the 'Portrait of a dog
belonging to Lord Edward Bentinck' exhibited
under Barret's name at the Society of Artists in
1768 (2: Walpole, 'A water spaniel who seems
pursuing a wild duck') but catalogued at Welbeck
Abbey in 1810 as 'a dog by Stubs & Barat' (now
untraced); and at least one of the 'lion and horse'
pictures (see No. 66).

When Barret added the landscape to 'Antinous',
had Stubbs already painted 'Mares and Foals by a
Stream' for the 3rd Duke of Grafton? (Taylor 1971,
pl. 18: unfortunately not available for this
exhibition.) Stubbs gave that painting a deliciously
fresh and silvery background: did the Duke prefer
Barret's more conventional autumnal tints?

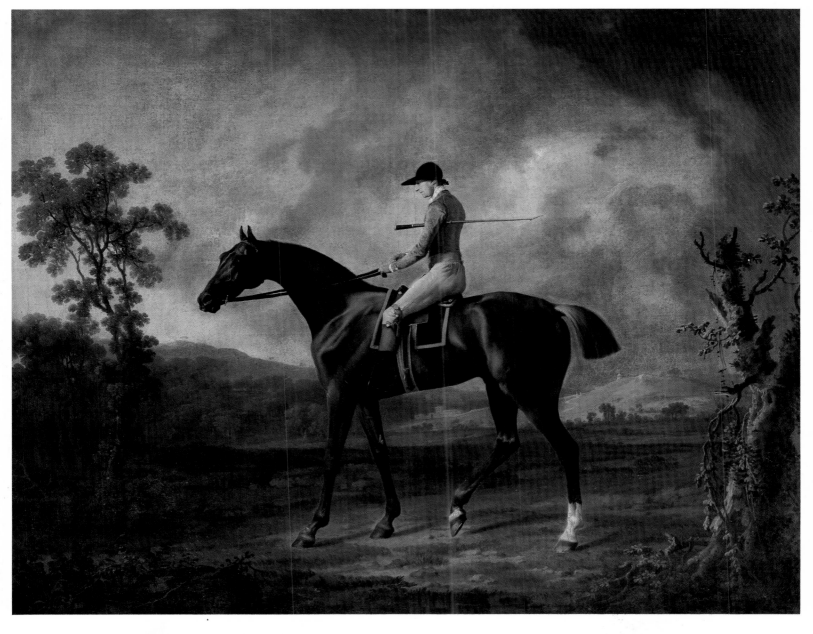

44*

THE DUKE OF ANCASTER'S BAY STALLION
BLANK, HELD BY A GROOM
? c.1762–5

Oil on canvas, $39\frac{1}{2} \times 49\frac{1}{2}$ in.
(100.4×125.8 cm.)
Lettered 'DUKE OF ANCASTER'S / BLANK'
lower right
Grimsthorpe and Drummond Castle Trustees

PROVENANCE
Commissioned by Peregrine Bertie, 3rd Duke of
Ancaster;

LITERATURE
Catalogue of Pictures at Grimsthorpe, n.d., privately
printed, no. 356

An old label on the back of the picture reads 'A bay
horse, bred 1740: bred by the Earl of Godolphin
and afterwards the property of the Duke of
Ancaster. Got by Lord Godolphin's Arabian . his
dam the famous Little Hartley Mare, out of Flying
Wig.
'Blank ran at Newmarket in April 1746 against Mr.
Panton's Sloe. He started very seldom and only
won one match at Newmarket in April 1747.
'Though Blank proved unsuccessful on the Turf as
a racer, yet he was afterwards allowed to be as
valuable a Stallion as any as ever covered in
England, as will appear from the immense number
of fine horses and mares of his get, which have not
only been allowed to be excellent racers, but their
blood valued by every eminent and successful
breeder.'

Such a description of a horse's pedigree and
performance is typical of the information desired
by racehorse breeders, forming the bases for the
advertisements of a stallion's services. Blank
evidently 'started' so seldom that he was not even
given an official racing name; yet as a stallion (and
particularly as a son of the Godolphin Arabian) he
was highly renowned.

Nos. 44 and 45 (with 72, in the next gallery)
were painted for Peregrine Bertie (1714–1778),
who succeeded as 3rd Duke of Ancaster in 1742. He
was devoted to racing and racehorse-breeding, and
was lucky enough to find a bride at Newmarket
who brought him a fortune of £60,000: she was
Mary, daughter of Thomas Panton, Keeper of the
King's Running Horses, and was waspishly
described by Horace Walpole as 'the natural
daughter of Panton, a disreputable horse jockey'.
Both the Duke and the Duchess sat to Reynolds.
The Duke of Ancaster officiated as Lord Great
Chamberlain at George III's Coronation in 1760,
and was Master of the Horse from 1766 until his
death. Lord North described him as 'a very
egregious blockhead, mulish and intractable'
(G.E.C., from which quotations are taken).

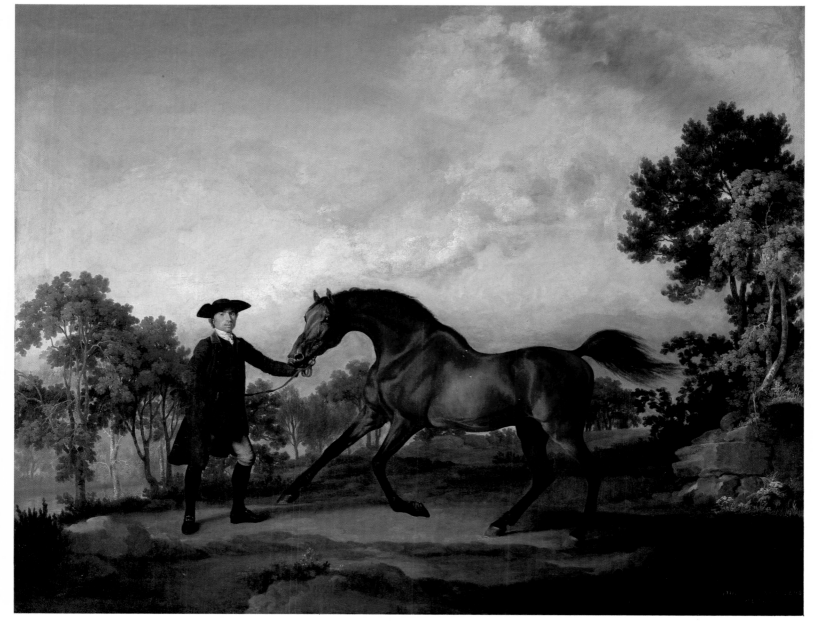

45*

THE DUKE OF ANCASTER'S BAY STALLION
SPECTATOR, HELD BY A GROOM
?c.1762–5

Oil on canvas, 39½ × 49½ in.
(100.4 × 125.8 cm.)
Lettered 'DUKE OF ANCASTER'S. /
Spectator' lower right
Grimsthorpe and Drummond Castle Trustees

PROVENANCE
Commissioned by Peregrine Bertie, 3rd Duke of
Ancaster; thence by descent

LITERATURE
Catalogue of Pictures at Grimsthorpe, n.d., privately
printed, no. 355

As with No. 44, an old label on the back of the
picture records Spectator's pedigree and
performances: 'A Bay Horse, 1749, bred by Mr.
Thomas Panton of Newmarket, and sold to the
Duke of Ancaster. Got by Mr. Panton's Crab, his
dam by Mr. Croft's Partner, out of Bonny Lass, the
dam of the Duke of Bolton's Merry Andrew . . .'.

Spectator was more successful than Blank on the
racecourse, winning at Newmarket in 1754–6 and
also at Huntingdon in 1755 and 1757. Like Blank,
he entered the Duke of Ancaster's stud, where his
progeny were very creditable, though less
renowned than Blank's. He died at Grimsthorpe in
1772.

The background, with a split-paling fence and,
beyond it, a tree-fringed meadow in sunlight,
recurs in later stud-farm scenes; an echo of it
appears in Stubbs's own print of 'Two Foxhounds
in a Landscape', published in 1788 (No. 184).

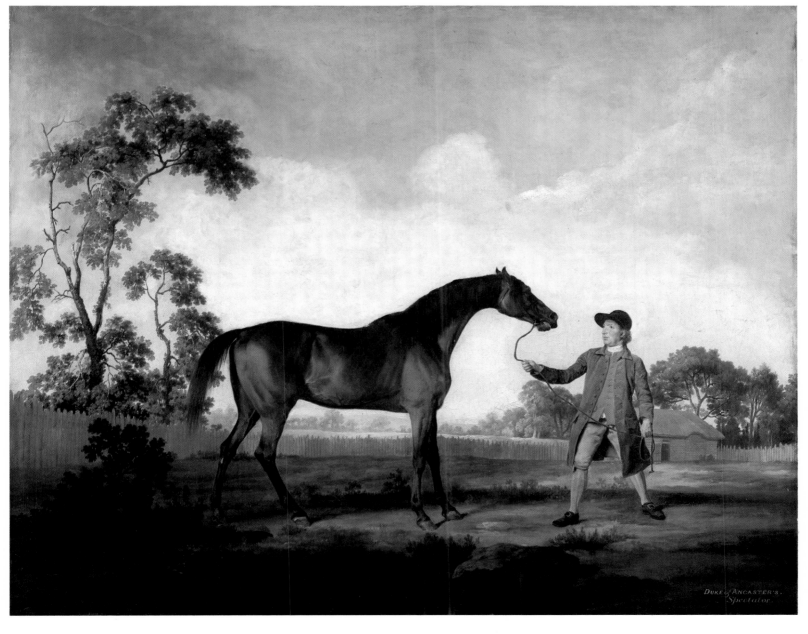

46

LORD TORRINGTON'S HUNT SERVANTS
SETTING OUT FROM SOUTHILL,
BEDFORDSHIRE
*c.*1765–8

Oil on canvas, 24 × 41½ in.
(61 × 105.5 cm.)
Private Collection

PROVENANCE
Commissioned by George, 4th Viscount
Torrington; sold (as 'The Property of a
Nobleman, Brought from his Lordship's Seat in
Bedfordshire'), Christie & Ansell 24 January 1778
(51, 'Three horses and grooms with dogs, &c.
belonging to Lord Torrington'), bt. Wildman,
15 gns.; William Wildman, sold, after his death,
Christie's 20 January 1787 (74, 'three portraits of
horses, dogs and grooms'), bt. Middleton,
£22.10.6; by descent to Rev. Frederick Matthews
Middleton, thence to his son-in-law Colonel E.F.
Hall, by whom sold, Christie's 19 July 1929 (47,
repr.), bt. Knoedler, £4,410; purchased by a
private collector, and thence by descent

EXHIBITED
Whitechapel 1957 (4); Agnew's 1970 (9, repr.);
British Sporting Painting 1650–1850, Arts Council
1974–5 (42, repr. p. 50)

LITERATURE
Humphry, MS Memoir; Francis Russell, 'Lord
Torrington and Stubbs: a footnote', *Burlington
Magazine*, CXXII, 1980, pp. 250–3

Humphry (op. cit.), recording Stubbs's recol-
lections of pictures he had painted for Lord
Torrington, describes this as 'His [Lord
Torrington's] Coachman, Grooms & Hunters, w[th]
a few dogs going out a Hunting . . . The village of
Southill forming the Background of the picture –'.
The compiler is indebted to J.F.J. Collett-White,
Bedfordshire County Record Office, for establish-
ing, by reference to contemporary maps and,
particularly, to Thomas Badeslade's bird's-eye
'View of Southill' of *c.*1727–33 (in the collection of
Bedfordshire County Record Office) that Stubbs
has painted the Southill village background with
exactitude, from a viewpoint immediately west of
the West Tower of All Saints Church; its western

face is included in the view. Lord Torrington's
servants are depicted as if they had just come out of
the east gates of Southill Park.

Francis Russell's very valuable article (op. cit.)
draws attention, for the first time, to the fact that
this picture is one of a series of three (each
approximately the same size) commissioned from
Stubbs by Lord Torrington to show the outdoor
servants and workmen of Southill. The series is
clearly set out in the Torrington sale catalogue of
1787:

lot 51 'Three horses and grooms with dogs, &c.,
belonging to Lord Torrington' (the
picture now under discussion)

lot 52 'Portrait of his steward and gamekeeper
with dogs, &c' (this painting, now in a
private collection, was unfortunately
not available for the exhibition

lot 53 'Ditto, the brickmakers with a view of
the new lodge' (No. 47 in this
exhibition, its repainted background
discussed in that entry)

As Russell comments (p. 253), 'That three of
Stubbs's most original and arresting compositions
were painted for him would alone imply that Lord
Torrington was a patron of some discernment'
(Russell proceeds to show that 'he was in fact a
connoisseur with wide interests'). Stubbs's friend
William Wildman had the good sense to buy all
three pictures at the Torrington sale; they were in
the sale of Wildman's collection after his death.

Lord Torrington's sale also included three
pictures on which 'Stubbs and Barret' are named as
collaborators: 'Portraits of two horses and a poney,
belonging to Lord Torrington, remarkably fine'
(lot 60), 'Ditto its companion' (lot 61) and 'A view
of Roach Abbey in its present state, in which is
introduced the portrait of Lady T –' (lot 63). All
three pictures were bought by 'Pierce'; none of
them has so far been traced.

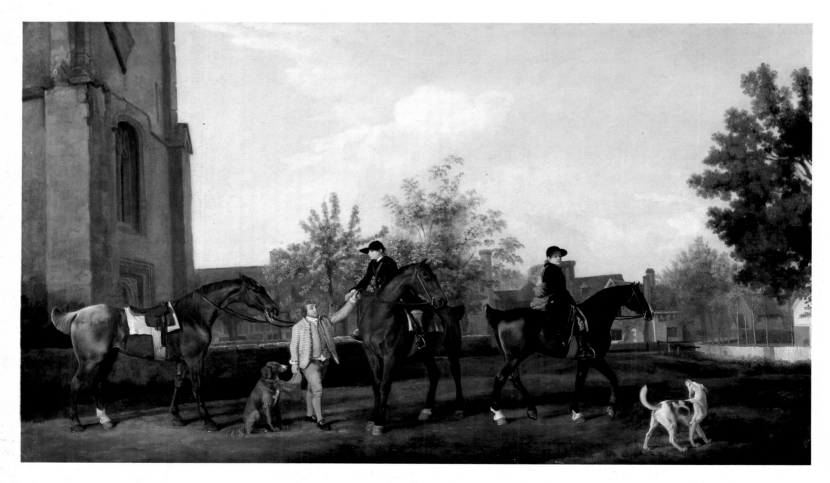

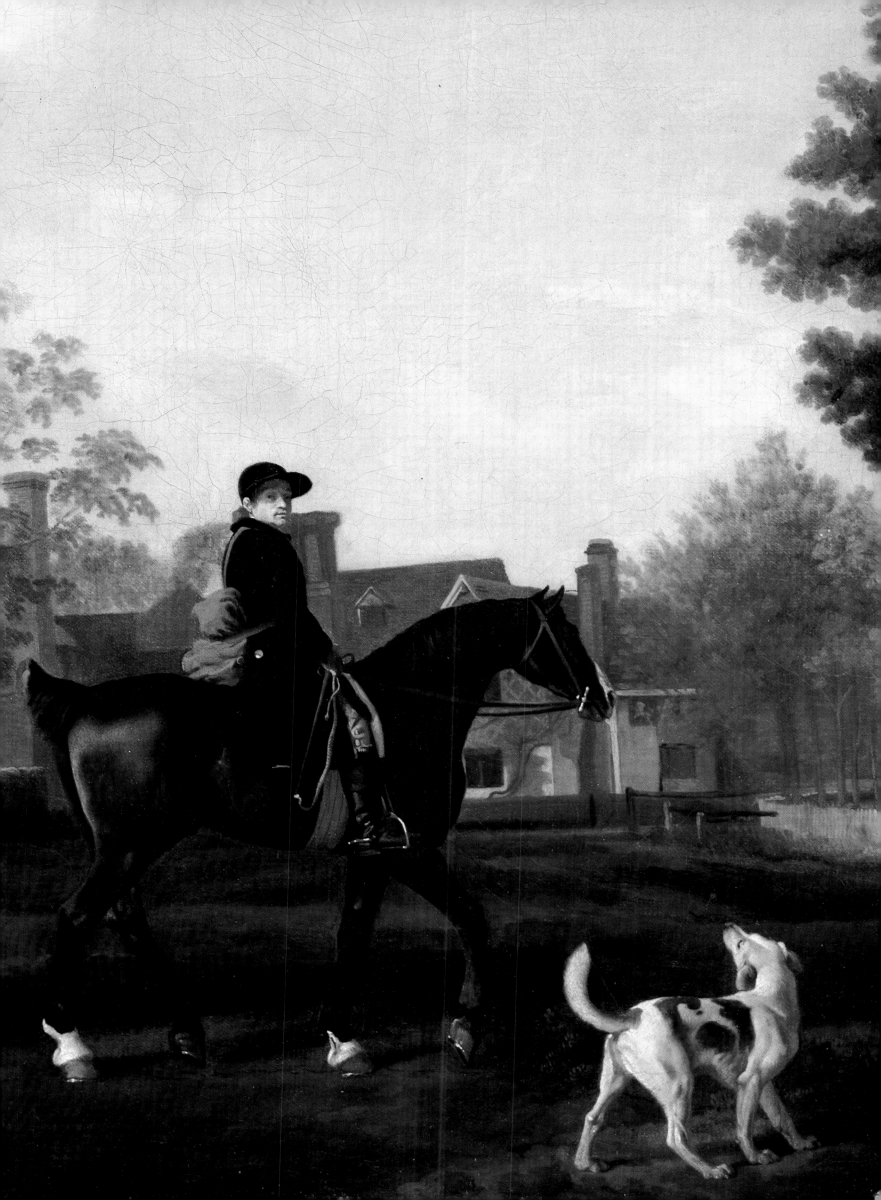

47

LABOURERS (LORD TORRINGTON'S
BRICKLAYERS AT SOUTHILL)
dated 1767: the background later
overpainted by Amos Green

Oil on canvas, $24\frac{1}{4} \times 42\frac{1}{4}$ in.
(61.5×107.4 cm.)
Inscribed 'Geo: Stubbs 1767' lower right
Philadelphia Museum of Art,
John H. McFadden Collection

PROVENANCE
Commissioned by George, 4th Viscount
Torrington; sold (as 'The Property of a
Nobleman, Brought from his Lordship's Seat in
Bedfordshire'), Christie & Ansell 24 January 1778
(53, as 'The brickmakers, with a view of the new
lodge'), bt. Wildman, 30 gns.; William Wildman,
sold after his death, Christie's 20 January 1787
(76, as 'The brick cart'), bt. Wills, £36.15.0;
Andrews Harrison, by 1790 (when engraved); . . . ;
W. Kinleside Gratwicke, sold Christie's 20 May
1905 (135), bt. Agnew, from whom purchased,
1913, by John N. McFadden (d. 1921), by whom
bequeathed to the Philadelphia Museum of Art

EXHIBITED
Old Masters, R.A. 1875 (15); *Brighton Loan
Exhibition*, Brighton Museum and Art Gallery
1884; Vokins 1885 (4); Manchester 1909 (4)
Liverpool 1951 (10); *The Romantic Era*,
Indianapolis, Herron Museum of Art 1965
(18, repr.); *Romantic Art in Britain*, Detroit Institute
of Arts and Philadelphia Museum of Art 1968 (13)

LITERATURE
Joseph Farington, *Diary*, 28 February 1814;
Gilbey 1898, p. 175, no. 1; Francis Russell, 'Lord
Torrington and Stubbs: a footnote', *Burlington
Magazine*, CXXII, 1980, pp. 250–3, figs. 31–2

ENGRAVED
by Henry Birche, published 25 March 1790,
dedicated to Andrews Harrison, pair to
'Gamekeepers'

Francis Russell points out that this is one of a series
of three pictures commissioned by Lord
Torrington to show the outdoor servants and
workmen of Southill (see No. 46). According to
Humphry, Lord Torrington had often watched his
bricklayers at work, 'appearing like a Flemish
subject'; but he evidently left the composition of
the subject to Stubbs. 'Mr Stubbs was a long time
loitering about observing the old Men without
perceiving any thing that engagd them all so as to
make a fit subject for a picture till at length they
fell into a dispute abt the manner of putting the
Tail piece into the Cart wch dispute so favorable for
his purpose lasted long enough for him to make a
sketch of the picture Men, Horse and Cart as they
have been represented –.' Humphry adds that the
men later posed for him 'in a Neighbouring Barn'
until the picture was completed. This is the fullest
account we have of Stubbs's working methods; but
the preliminary 'sketch of the picture' has not
survived.

Originally the picture included, in the
background on the right, 'a view of the new
lodge', as shown in an X-ray photograph of the
painting (Russell, op. cit., fig. 31); this view can
still be seen in the background of the enamel
version (No. 48). As Russell points out, the 'new

lodge' was presumably one designed by Isaac Ware
and erected by the very labourers whom Stubbs's
picture commemorates (but long since destroyed).
The 1778 catalogue of the sale of Lord Torrington's
three Southill pictures (op. cit.) specifies that this
picture then included 'a view of the new lodge'; but
by 1790, when Amos Green's engraving of the
subject was published, Amos Green himself had
substantially repainted the background on the
right to depict what Russell (understandably
gritting his teeth) calls 'an umbrageous woodland
scene with a rustic cottage'. This was presumably
done at the request of Andrews Harrison, owner of
the picture in 1790 (did he, a Londoner, feel uneasy
with another man's piece of property in his
picture?). The repainting, of a prettiness wildly
unlike Stubbs's own style, was pronounced 'very
unworthy' by Joseph Farington: *Diary*, 28
February 1814, with Robert Smirke, 'walked to the
house of the late Mr. Harrison, and saw two
pictures by Stubbs (the animals & figures) the
landscape by the late Mr. Green of Bath painted
over that which was executed by Stubbs, but very
unworthy of the admirably painted animals'.

Stubbs made at least two other versions of this
picture: in oil on panel, $35\frac{1}{2} \times 58$ in., signed and
dated 1779 (National Trust, Upton House, Lord
Bearsted collection), probably the version
exhibited at the Royal Academy in 1779 (322), and
in enamel, signed and dated 1781 (No. 48 in this
exhibition).

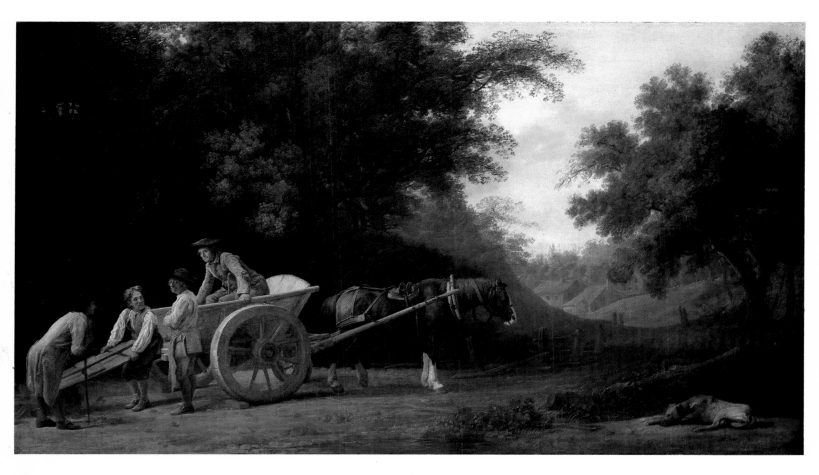

48†

LABOURERS
dated 1781

Enamel on Wedgwood biscuit earthenware, oval, $27\frac{1}{2} \times 36$ in. (69.8×91.4 cm.)
Inscribed 'Geo Stubbs pinxit 1781' lower right
Paul Mellon Collection, Upperville, Virginia

PROVENANCE
Commissioned by Josiah Wedgwood I, then by family descent until sold by Sir John Wedgwood, Bt., T.D., Christie's 23 June 1978 (147, repr.), bt. Baskett & Day for Mr Paul Mellon KBE

EXHIBITED
Tate Gallery 1974 (11, repr.), continuing on loan to the Tate Gallery until consigned to Christie's, 1978

LITERATURE
Humphry, MS Memoir; Taylor 1961, p. 223, no. 12; Taylor 1965 (ii); Tatterall 1974, pp. 54, 112

Josiah Wedgwood wrote to his partner Richard Bentley on 30 May 1779, reporting 'certainty and success' in making larger tablets, 'perhaps ultimately up to 36 inches by 24' for Stubbs's enamel paintings. He added that Mr Stubbs 'wishes you know to do something for us by way [of] setting off against the tablets'. Wedgwood had several ideas in mind, most of which Stubbs executed, including portraits of Wedgwood and his wife and a 'family picture' (all now in the collection of the Trustees of the Wedgwood Museum, Barlaston). He had already thought of asking Joseph Wright of Derby to paint the 'family picture', 'but other ideas took place, & remembering the labourers, & cart in the exhibition, with paying for tablets &c. I ultimately determin'd in favor of Mr. Stubbs' (Tattersall 1974, p. 112). 'The exhibition' in which Wedgwood had admired 'the labourers, & cart' was the Royal Academy exhibition of 1779, in which Stubbs showed (322) what was presumably the oil on panel version of No. 47. Stubbs's indebtedness to Wedgwood was still 'trifling' in 1781. Wedgwood paid for his version of 'Labourers' in two instalments of 170 guineas and £189; Stubbs's receipts for these payments are among the Mayor papers, Picton Collection, Liverpool City Libraries.

The enamel version shows the 'view of the new lodge' included in the original version (No. 47) but overpainted by Amos Green.

49

LORD GROSVENOR'S ARABIAN WITH A
GROOM
c.1765

Oil on canvas, 39⅛ × 32⅞ in.
(99.3 × 83.5 cm.)
Kimbell Art Museum, Fort Worth, Texas

PROVENANCE
Presumably commissioned by 1st Lord
Grosvenor, ? sold Peter Coxe, 2 July 1812 (24, as
'The Portrait of a celebrated Colt'), bt. anon.,
36 gns.; . . . ; inherited by a private U.S. collector;
bt. in the New York art market for a U.S. private
collector; purchased through Leggatt Brothers by
the Kimbell Art Museum, 1980

EXHIBITED
On loan to the Tate Gallery 1979–80

LITERATURE
Judy Egerton, 'The Painter and the Peer: Stubbs
and the Patronage of the 1st Lord Grosvenor',
Country Life, 22 November 1979, pp. 1892–3

ENGRAVED
by Peter Mazell (subject 14¼ × 18⅜ in.), published
by W.H. Ryland, 20 February 1771. Mazell
exhibited his print at the Society of Artists 1772
(194, as 'Lord Grosvenor's Arabian, from a
picture of Mr. Stubbs').

Lord Grosvenor's Arabian (he seems never to have
been given a more specific name, probably because
he was not a racehorse) is recorded as having sired
ten foals between 1766 and 1778. Since the painting
depicts a young stallion, still evidently nervous of
its own powers, a date of *c*.1765 is suggested; the
style of the painting itself suggests a date not far
from 'Setting out from Southill' (No. 46).
Everything in the composition and colouring is
subtly balanced to suggest the Grosvenor
Arabian's youth and high mettle. The low horizon
suggests boundless promise. There is a pearly light
in the sky, and the air is fresh: it must be early
morning.

This horse is obviously supremely well-bred. Its
distinctive white markings show off the
characteristics of the Arabian breed at its best:
small muzzle, concave profile, large eyes, ears
carried correctly pricked, high set-on tail. The way
in which Stubbs has posed the horse and
highlighted its distinctive markings reduces the
animal's bulk and enhances its air of delicacy. The
tree is a young oak, bifurcated in a way Stubbs
often found useful in composing a picture. The
branch that bends over the stallion's head is a
characteristic of Stubbs's hair's-breadth judgment
in composition, placing one thing against another
so that each is related but uncluttered.

The groom at the Arabian's head, in quiet-
coloured livery of greys and browns, holds the
stallion gently but securely with a lead-pole. His
gaze, directly meeting that of the restive animal, is
at once capable and reassuring. His steadiness
counterbalances the animal's tension, and perfectly
illustrates Stubbs's feeling for the sympathy
between the stud groom and his charge.

The 2nd Lord Grosvenor (later 1st Duke of
Westminster) was much thriftier than his father.
He was to create the Grosvenor Gallery of pictures,
acquiring the Agar collection *in toto* and most of the
Marquess of Lansdowne's collection, and adding
such items as Gainsborough's 'The Blue Boy' and
Reynolds's 'Mrs Siddons as the Tragic Muse'. To
help finance such pictures, the 2nd Earl of
Grosvenor held picture sales in 1807 and 1812.
They were partly weeding-out sales, though the
1812 sale catalogue more tactfully called this the
'separating of over-abundant specimens of the same
master's works'. It was a good opportunity for the
2nd Earl to get rid of paintings acquired by his
father which were not to his own taste (see No. 39).
Out, in 1812, went 'The Girl in Bed', 'The Golden
Age' and two of Gilpin's racehorse portraits; out,
too, went five of Stubbs's paintings for the 1st Earl
Grosvenor. Three of these were portraits of the
'celebrated Racers' Sweet William, Sweet Briar and
Protector. Lot 39 was clearly the version of
'Gimcrack on Newmarket Heath' (see No. 55) now
in the collection of the Jockey Club. Lot 24, which
fetched the highest price of the Stubbs lots (36
guineas, whereas the 'Gimcrack' picture fetched 21
guineas and the racers less) may well have been the
picture we now recognize as 'Lord Grosvenor's
Arabian'.

Mazell's engraving of the picture shows almost
an extra third of landscape on the left, prompting
some to believe that Stubbs's canvas must have
been cut down. Detailed examination by the
conservators at the Kimbell Art Museum shows no
conclusive evidence of this; 'the picture has been at
its present dimensions for some time', and as the
tacking edges have been removed on all four sides,
it is not possible to determine its original dimen-
sions. In this compiler's opinion, the canvas has not
been cut down (or not by a significant margin).
The balance on Stubbs's canvas seems perfect as it
is; the extra landscape in Mazell's engraving seems
to have little point, except that engraved portraits
of horses were invariably 'landscape' rather than
'portrait' shaped.

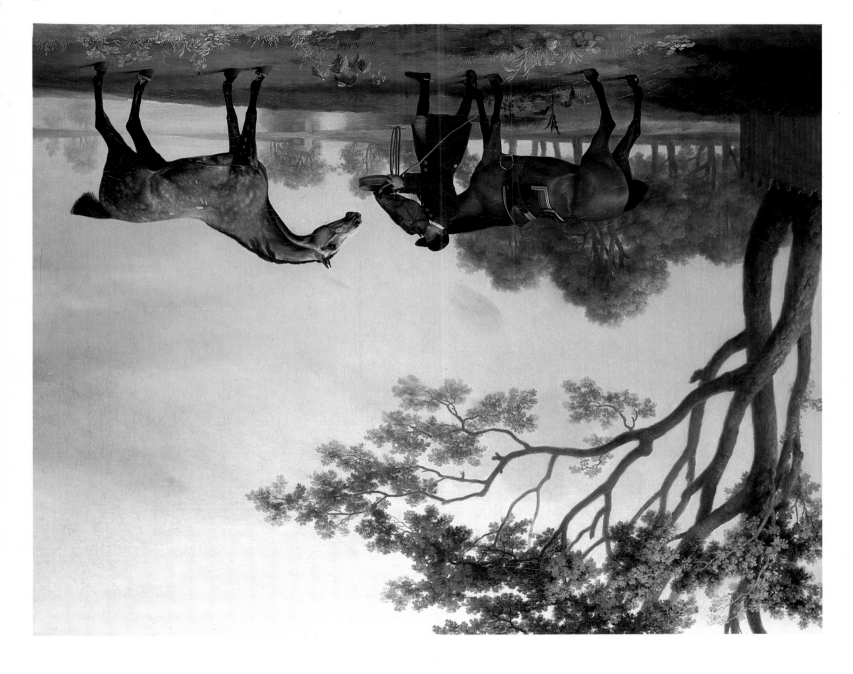

50

BAY HUNTER AND GREY ARAB WITH A GROOM

c.1763–8

Oil on canvas, 39¼ × 49 in.
(100.3 × 124.5 cm.)
Inscribed 'Geo. Stubbs / pinxit' lower
right of centre

*The Trustee of the Will of the 8th Earl of
Berkeley deceased, from the Collection at
Berkeley Castle, Gloucestershire*

PROVENANCE
Believed to have been at Berkeley Castle for
many generations before that of the late 8th Earl
of Berkeley

EXHIBITED
On loan to the Tate Gallery, January–June 1982

This painting is in exceptionally good condition,
apart from shallow craquelure. Recent cleaning by
Viola Pemberton-Piggott has revealed the
assurance with which horses and groom are
painted, the crispness of detail in the foreground
plants and the lovingly studious manner with
which Stubbs painted trees in the 1760s: in the
branches of the oak on the left, he has applied
numerous touches of impasto in subtly graduated
greens and greys, in other places lifting the paint
with his brush to admit light. The background of
trees and a river or lake with a little hut on its
further bank is repeated in 'Mares by an Oak Tree'
of c.1764–5 (National Trust, Ascott: Rothschild
Collection, repr. Taylor 1971, pl. 22).

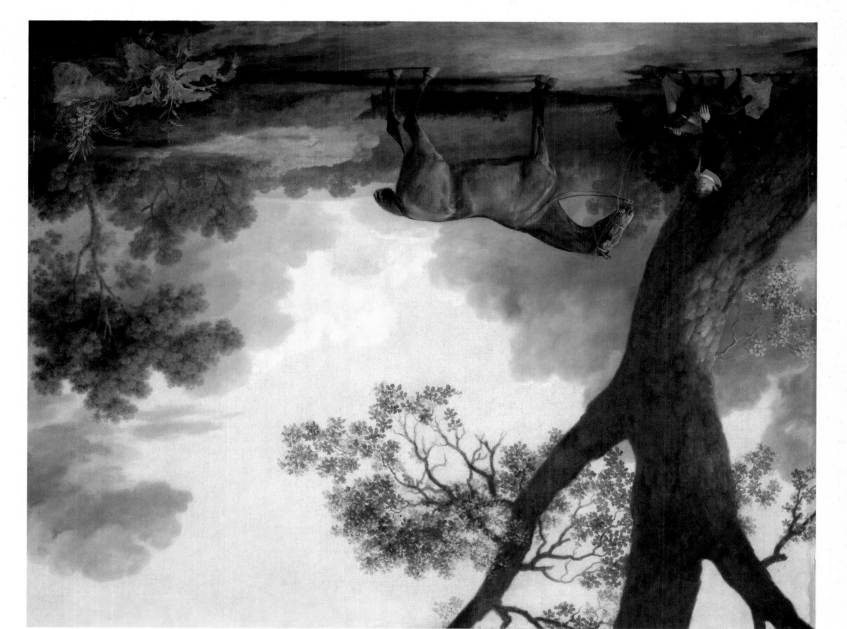

51

THE DUKE OF DORSET'S HUNTER WITH A GROOM AND A DOG

dated 1768

Oil on canvas, 40 × 49¾ in.
(101.6 × 126.4 cm.)
Inscribed 'Geo: Stubbs / pinxit 1768'
lower right

*Metropolitan Museum of Art, New York,
Bequest of Mrs Paul Moore 1980*

PROVENANCE

Commissioned either by Charles Sackville, 2nd
Duke of Dorset (d. 1769) or his nephew John
Frederick Sackville, who succeeded as 3rd Duke
of Dorset, 1769; thence by descent until sold
(? privately, ? in the 1920s) to Mrs William H.
Moore, U.S.A., by whom given to Mr and Mrs
Paul Moore, U.S.A., c.1930; bequeathed by Mrs
Paul Moore to the Metropolitan Museum of Art,
New York, 1980.

EXHIBITED

Sport and the Horse, Virginia Museum of Fine Arts,
Richmond, Virginia, U.S.A., 1960 (29),
(frontispiece)

When exhibited at Virginia in 1960, the date of
1768 inscribed on the picture had not been read. A
date of 'probably . . . 1768–1772' was suggested
(accurately enough) for the picture, and the patron
who commissioned it was stated to have been John
Frederick Sackville, 3rd Duke of Dorset; but he did
not succeed to the title (and the family fortune)
until the year after the date inscribed on the
picture, and it may rather have been commissioned
by his uncle, Charles Sackville, 2nd Duke of Dorset,
Master of Horse to Frederick, Prince of Wales, from
1747.

Which Duke commissioned it is not of primary
importance, compared with the fact that this
picture, little-known in England, belongs to
Stubbs's prime period, when his confidence in
himself as a landscape painter as well as a horse-
painter is at its highest. The realistic observation of
cloud formations and the management of light as
rain clears off is also fully assured. The portrait of
the groom is relaxed as well as sensitive. The dog is
evidently a ducal pet, for he wears a gold collar.

52

NEWMARKET HEATH, WITH A RUBBING-
DOWN HOUSE (pair to No. 53)
c.1765

Oil on canvas, $11\frac{15}{16} \times 16\frac{1}{2}$ in.
(30.4 × 41.9 cm.)
Tate Gallery

PROVENANCE
As for No. 53, until 1957; sold by Agnew to B.N.
Mavroleon, 1958; 'The Property of a Lady', sold
Sotheby's 18 July 1979 (140, repr.), bt. Baskett &
Day for the Tate Gallery

EXHIBITED
Landscape in Britain c.1750–1850, Tate Gallery
1973–4 (99); *Painting from Nature*, Arts Council,
Fitzwilliam Museum, Cambridge, and Royal
Academy, 1980–1 (15, repr.)

LITERATURE
Taylor 1971, pp. 42, 208, pl. 34; *The Tate Gallery
Illustrated Catalogue of Acquisitions 1987–80*, 1981,
pp. 45–6

53

NEWMARKET HEATH, WITH A RUBBING-
DOWN HOUSE (pair to No. 52)
c.1765

Oil on canvas, 12 × 16 in.
(30.5 × 40.5 cm.)
Paul Mellon Collection, Upperville, Virginia

PROVENANCE
Stubbs's studio sale, 27 May 1807 (59,
'Landscapes with Buildings, &c a pair, Views on
the Race Ground at Newmarket'), perhaps bt. by
James Ward R.A. for Thomas Garle (entries
dated 1807–8 in James Ward's MS Account Book
indicate that Ward repaired, relined and framed
these and other 'small pictures of Stubbs' for
Garle; the compiler is grateful to Anthony Reed
for bringing these entries to her notice); sale of
Thomas Garle, deceased, Christie's 24 May 1862
(1, 'Two views of the stables at Newcastle';
corrected by hand in Christie's own copy of the
sale catalogue to '. . . Newmarket'), bt. Watson,
£2.10.0; . . .; anon. sale, Christie's 25 October
1957 (156), bt. Agnew; sold by Agnew to Ian
Askew 1958, bt. back from him 1961, and sold the
same year to Mr Paul Mellon KBE

EXHIBITED
V.M.F.A. 1963 (318, pl. 176); R.A. 1964–5 (153,
pl. 55); Yale 1963 (171, pl. 55)

LITERATURE
Taylor 1971, pp. 42, 208, pl. 33; Egerton 1978,
p. 77, no. 76, pl. 29

This pair of small landscapes recording views from
different angles of one of the rubbing-down houses
on Newmarket Heath are the only pure landscape
studies by Stubbs to survive. Both were probably
made for the two different portraits of Gimcrack,
c.1765 (see below). They remained in Stubbs's
studio for the rest of his life, and were frequently
referred to for later compositions.

Most of the details of No. 52 are incorporated in
the large picture of 'Gimcrack on Newmarket
Heath, with a Trainer, Jockey and Stable-Lad' of
c.1765 (No. 55) and in 'Laura with a Jockey and
Stable-Lad', dated 1771 (private collection, repr.
Taylor 1971, pl. 69); the same details appear, with
variations, in 'Baronet with Sam Chifney up', dated
1791 (Private Collection) and, finally, in
'Hambletonian being rubbed down, with a Trainer
and Stable-Lad', dated 1800 (No. 138).

No. 53 was used for 'Gimcrack on Newmarket
Heath, with John Pratt up' (No. 56), for 'Turf, with
Jockey up' (No. 57), both *c*.1765, and for 'Eclipse at
Newmarket with a Groom and a Jockey', dated
1770 (No. 54).

Four rubbing-down houses stood on Newmarket
Heath in the eighteenth century (one survives,
near the Running Gap). They were used for
'rubbing down', with wisps of straw, or with rough
cloths such as the stable-lad holds in
'Hambletonian' (No. 138), horses which inevitably
sweated profusely after exercise or racing. This
rubbing-down house seems to have been reserved
for horses belonging to royalty and to members of
the Jockey Club. In John Bodger's pictorial map of
the racecourse and buildings on Newmarket
Heath, published in 1787 (repr. Frank Siltzer,
Newmarket, 1923, facing p. 62) it can be identified as
'the King's Stables'. The two spectators' stands in
the background of No. 52 are 'the King's stand', on
the left, and 'the Duke's stand', still further distant
on the right, with a (movable) betting-post
between them; the railings stretching obliquely
away border 'the Duke's course'. Stubbs's
viewpoint for this study must have been the south-
west (or Suffolk) edge of Newmarket Heath
(information kindly provided by Canon Peter May,
of Newmarket, and Captain Lees, Clerk of the
Course at Newmarket).

52

53

Each painting powerfully suggests that Stubbs first carefully selected his viewpoint, then intently scrutinized his subject and transcribed it as truthfully as possible, making no concessions to picturesque formulae; but the high degree of control and finish in both makes it unlikely that they were actually painted on the spot. They are more likely to have been worked up in the studio from preliminary drawings which were made on the spot. Stubbs's studio sale included many items (e.g. lots 18–30 on 27 May 1807, grouped under the heading 'Drawings, Drawing Books, Studies from Nature, Sketches, &c.') which suggest a regular practice of preliminary sketching, in chalk, pencil, or pen and ink on paper, directly from nature; the disappearance of all such sketches and studies deprives us of a full understanding of Stubbs's working processes.

54*

ECLIPSE AT NEWMARKET, WITH A
GROOM AND A JOCKEY
? 1770

Oil on canvas, $39\frac{1}{2} \times 51\frac{3}{4}$ in.
(100.3×131.5 cm.)
The Stewards of the Jockey Club

PROVENANCE
Presumably commissioned by William Wildman and sold, with the horse itself, to Dennis O'Kelly

EXHIBITED
Derby Day 200, Royal Academy, 1979 (7.1, repr.)

ENGRAVED
in mezzotint by T. Burke, published by Robert Sayer 1 October 1773

A study for this painting is shown as No. 94, under which details of the performances and progeny of Eclipse, arguably 'the most famous racehorse of the English Turf', are given. In this finished picture, Eclipse is shown with a jockey who wears the racing colours of William Wildman, red jacket and black cap. Wildman had bought Eclipse for £75 at the sale of the Duke of Cumberland's stud, and it was he who, presumably, commissioned this painting. By the time it was engraved in 1773, Eclipse was the property of Dennis O'Kelly (see No. 94); as the engraving states that the painting was then in the possession of Dennis O'Kelly, he must have bought the painting as well as the horse itself from Wildman.

Eclipse is portrayed in the same pose in a painting which also includes portraits of William Wildman and his two young sons, in the collection of the Baltimore Museum of Fine Art, repr. Walker, 1972, pl. 56: that painting, alas, has been very heavily restored and is generally in poor condition.

55*

GIMCRACK ON NEWMARKET HEATH,
WITH A TRAINER JOCKEY AND A
STABLE-LAD
*c.*1765

Oil on canvas, 40 × 76 in.
(101.6 × 193.2 cm.)
Private Collection

PROVENANCE
Commissioned by the 2nd Viscount Bolingbroke,
by descent to 6th Viscount Bolingbroke, sold
Christie's 10 December 1943 (48, repr.), bt. Ellis
& Smith; Walter Hutchinson, sold Christie's
20 July 1951 (122, repr.), when purchased for a
private collection

EXHIBITED
National Gallery of British Sports and Pastimes,
Hutchinson House [1948] (133); *European Masters
of the Eighteenth Century*, Royal Academy, 1954–5
(107)

Gimcrack, a grey horse foaled in 1760, by Cripple,
the Godolphin Arabian's son, out of a Partner
mare, was one of the most famous racehorses of
eighteenth-century England. He made his debut at
Newmarket in the spring of 1765, winning his first
victory there in the colours of William Wildman
(see No. 56); he was purchased a few weeks later
by the 2nd Viscount Bolingbroke, whose black
racing colours he wears here.

It was for Bolingbroke that Gimcrack won his
most celebrated victory: a match for 1,000 guineas
against Sir James Lowther's Ascham on 10 July
1765; and it is that victory which this picture
celebrates. Betting on this 'grand match' (odds 5 to
4 on the winner) was reputedly over £100,000.
Even the sedate pages of the *Gentleman's Magazine*
carried a report of the match, immediately after the
other big news story, a major government
reshuffle. Though her husband thereby lost a
valuable sinecure, Lady Sarah Bunbury could
hardly contain her rapture at having been at
Newmarket 'to see the sweetest little horse that
ever was; his name is Gimcrack, he is delightful'. 'I
must say', she added, 'I was more anxious about the
horse than the ministry.'

In October 1765 Gimcrack suffered his first
defeat, in a match against Bay Malton; Bolingbroke
promptly sold him to the Comte de Lauraguais, an
Anglomaniac racing addict (Gimcrack was to
return later to England: see No. 56). Bolingbroke
had owned him for just over three months only:
luckily he had the sense to commission Stubbs to
record Gimcrack's greatest victory. Lord
Grosvenor, a later owner of Gimcrack, evidently
admired this picture so much that he commissioned
Stubbs to paint a replica; almost the same size, it
was in the Grosvenor sale of 2 July 1812 (39), after
the first Earl's death, and is now in the collection of
the Jockey Club at Newmarket.

The picture makes use of the study (No. 52) of
the Rubbing Down House and the spectators'
stand on the skyline. It also makes use (uniquely, it
seems, for Stubbs) of the by now rather antiquated
device of representing the race in progress in the
background, where Gimcrack is seen to be winning
against a bay, a chestnut and a grey horse. As
always with Stubbs, there is no crowd: the victory
is almost a private affair between the horse, his
jockey, his trainer and the stable lad who lifts his
gaze in respectful wonder. The trainer at the
horse's head holds the reins in a beautifully judged
pose which is at once natural and celebratory.

56

GIMCRACK WITH JOHN PRATT UP, AT
NEWMARKET
*c.*1765

Oil on canvas, 39½ × 50 in.
(100.4 × 127 cm.)
*Syndics of the Fitzwilliam Museum,
Cambridge*

PROVENANCE
Commissioned by William Wildman; his sale
(after his death on 25 December 1784), Christie's,
20 January 1787 (2nd day), lot 71, bt. Woodburn,
£17.6.6.; Sir Walter Gilbey by 1898, sold
Christie's, 11 June 1915, lot 391, bt. Dean, £231;
Sir William Pierrepont Wilson-Todd, Bart, of
Halnaby Hall, Croft, Yorkshire (d. 1925);
presented by his widow to the Yorkshire Club,
12 May 1925; sold October 1958 to Agnew's,
from whom bt. by Lady Robert Adeane; by
descent to her son, from whose family the picture
was purchased through Michael Tollemache by
the Fitzwilliam Museum with aid from the
National Art-Collections Fund, the British
Sporting Art Trust and others 1982.

EXHIBITED
On loan to Fitzwilliam Museum 1958–1982;
International Art Treasures, Victoria and Albert
Museum, 1962, no. 37; *English Pictures from Suffolk
Collections*, Agnew, February–March 1980, no. 41

LITERATURE
Gilbey, 1898, pp. 161–2; Judy Egerton, 'Racing
to Save a Stubbs Masterpiece', *Country Life*,
13 May 1982, pp. 1397–8, adapted, with the
Editor's permission, for *National Art-Collections
Fund Review*, 1983, pp. 96–7

ENGRAVED
in mezzotint by William Pether, published
(according to Siltzer) 17 May 1766

Here Gimcrack's jockey wears the red jacket and
black cap which were the racing colours of William
Wildman, a wealthy and astute Smithfield meat
salesman who built up a very profitable business
acting as middleman between noblemen's farms
and the London meat market. His name recurs as
the owner of racehorses; he seems to have been a
racing partner or confederate of Lord Bolingbroke.
Gimcrack is stated to have belonged to Wildman
when he won his first victory at Newmarket on
9 April 1765; presumably Wildman asked Stubbs
to celebrate that victory with this painting.

Hitherto it has been assumed that Stubbs's
patrons were all noblemen or at least landed
gentry; it is refreshing to discover, from this
picture's early provenance, a self-made man
amongst them. The *Gentleman's Magazine*, reporting
the death in Clerkenwell, on Christmas Day 1784,
of 'Mr. Wm. Wildman, formerly an eminent

butcher and salesman, and since well-known to the
gentlemen of the turf', added that he left 'a
considerable fortune'. But his son and heir
evidently did not care for pictures, for Wildman's
collection was consigned to Christie's, where it
occupied two days' sale on 19–20 January 1787.
This sale included fifteen paintings by Stubbs
(including the set of four 'Shooting' pictures, Nos.
73–6, which may include a portrait of Wildman)
and eleven engravings – almost certainly the
largest single holding of the artist's work to be
formed during his lifetime.

When the engraving of No. 56 was published, it
bore the title 'Gimcrack, mounted by Mr. John
Pratt, Riding Groom to the R^t·Hon^ble· Lord Visc^t
Bolingbroke' (probably he also rode for William
Wildman, but there is and always has been more
publicity value in a peer's name than in a
butcher's). The term 'Riding Groom' at this period
covered anyone who worked in a gentleman's
stables and wore his livery or his racing colours –
jockeys, grooms and trainers. But the 'M^r' prefixed
to John Pratt's name alerts us to the fact that he is
no ordinary jockey. The compiler is indebted to
Miss Marie Hartley of Askrigg, Yorkshire, for
pointing out that he can be identified as the John
Pratt who, during the course of a career which
included not only riding and training racehorses
but also ownership of them, progressed from the
stables to election as a member of the Jockey Club:
'the first instance of a man of plebian origin being
elected' (J. Fairfax-Blakeborough, *Northern Turf
History*, III, 1950, p. 224). Pratt acquired landed

estates in his native Wensleydale. He died in 1785; a broadsheet records that though he was 'often hard pressed, whip'd and spurred by that jockey, Necessity, he never swerved out of the course of Honour'.

Gimcrack's career ended in Lord Grosvenor's stud farm. Lord Bolingbroke, who had commissioned No. 55 from Stubbs, sold Gimcrack after his first defeat to the Comte de Lauraguais; who subjected Gimcrack to a ruthless match against the clock, in which Gimcrack reputedly ran twenty-two and a half miles in one hour. The collective British memory has not forgiven Lauraguais; but, astonishingly, Gimcrack took the ordeal in his stride. Once home at Newmarket, he won most of his races in 1767–8. In October 1768 he was purchased by Sir Charles Bunbury; a year later, Lord Grosvenor purchased him for 1,200 guineas. In the spring of 1770 Gimcrack won the coveted Whip at Newmarket; but soon afterwards his racing career collapsed, and Lord Grosvenor retired him to stud near Newmarket, where Stubbs portrayed him, with a groom, for the third time (the original version is still in the Grosvenor family collection; a replica painted for the Turf Gallery is in the collection of Lord Halifax). For a few years Gimcrack's services were advertised at the top rate of thirty guineas per mare ('and five shillings to the groom: the money to be paid before taking the mare away'), but he was not a great success as a sire, and his death passed unrecorded. It is as a racehorse, not as a stallion, that Gimcrack's name lives on.

57

TURF, WITH JOCKEY UP, AT NEWMARKET
c.1765

Oil on canvas, 39 × 49 in.
(99.1 × 124.5 cm.)
Inscribed 'Turf' lower left
Yale Center for British Art,
Paul Mellon Collection

PROVENANCE
Commissioned by Frederick St. John, 2nd Viscount Bolingbroke; by descent to 6th Lord Bolingbroke, sold Christie's 10 December 1943 (49, repr.), bt. Ellis & Smith; Walter Hutchinson, sold Christie's 20 July 1951 (126), bt. Leggatt; Ivor Grosvenor, 2nd Viscount Wimborne; by descent to 3rd Viscount Wimborne; Somerville & Simpson, from whom purchased by Mr Paul Mellon KBE; presented to the Yale Center for British Art

EXHIBITED
National Gallery of British Sports and Pastimes, Hutchinson House 1948 (111); Yale Center 1982 (43, repr. p. 31)

LITERATURE
Egerton 1978, pp. 78–9, no. 76A, colour plate 12

Turf was a bay colt, foaled in 1760, by Matchem out of the Duke of Ancaster's Starling mare. Owned by the 2nd Viscount Bolingbroke, he had a successful racing career, chiefly at Newmarket, until his retirement through lameness in 1767, the peak of his success being beating King Herod in a match for 1,000 guineas over the Beacon Course at Newmarket on 4 April 1766.

It will at once be obvious that the portraits of 'Turf' and of 'Gimcrack, with John Pratt up', are closely similar compositions, based on the landscape study which is No. 53 in this exhibition. There are numerous differences, notably in the placing of the horse and jockey (almost centrally, in 'Turf', and in the left-hand half of 'Gimcrack') and in the angle at which the rubbing-down house is seen. This compiler finds it impossible to say which picture was painted first, and invidious to suggest which is the better.

The name of Turf's jockey is not recorded. His expression is shrewd and assessing; it is a remarkable portrait.

OTHO, WITH JOHN LARKIN UP
dated 1768

Oil on canvas, $39\frac{7}{8} \times 50$ in.
(101.2×127 cm.)
Inscribed 'Geo: Stubbs pinxit / 1768'
lower left (beneath frame) and 'Otho'
below the horse; 'Otho' is also lettered
on the lintel of the door
Tate Gallery

PROVENANCE
Presumably commissioned by John Fitzpatrick,
2nd Earl of Upper Ossory (d. 1818); probably
purchased by the 6th Baron Monson until sold to
Mallet & Son (Antiques) Ltd., 1964; Leggat
Brothers, from whom purchased by Mr Paul
Mellon KBE, 1965; presented by him to the Tate
Gallery through the British Sporting Art Trust,
1979

EXHIBITED
Lincolnshire Art Treasures, Usher Art Gallery,
Lincoln 1946 (100); *Somerset House Art Treasures
Exhibition*, Somerset House 1979 (L.3, repr. p. 15)

LITERATURE
Egerton 1978, p. 80, no. 78, pl. 30; *The Tate
Gallery Illustrated Catalogue of Acquisitions 1978–80*,
1981, pp. 44–5

ENGRAVED
? by John Scott, 'from a . . . painting . . . in the
possession of . . . the Earl of Upper Ossory',
published in the *Sporting Magazine*, 9 October
1796, facing p. 64

The performances on the racecourse and at stud of
Otho, foaled in 1760, bred by Richard Vernon and
got by Moses out of Miss Vernon, were certainly
creditable – his racing career included winning a
match against Lord Bolingbroke's Turf (portrayed
by Stubbs in No. 57) at Newmarket in 1764; he was
at stud from 1768, and within a decade the success
of his most famous son Comus ensured that Otho's
services commanded high fees – but Otho was not
as renowned as, for instance, Gimcrack or Eclipse.
It is his portraitist rather than the horse himself
who has ensured that Otho cannot be forgotten,
waiting alertly and obediently in a fitful gleam of
sunlight, the moist and shadowed turf beneath his
hooves seeming to reach fruition in the apple-green
of his jockey's jacket.

Little has so far been traced about John Larkin,
except that his name appears among Cambridge-
shire subscribers to the racing calendar and as the
owner of racehorses between 1769 and 1780. He
was probably a gentleman-jockey who occasionally
rode for his friends. Stubbs himself tells us, through
Larkin's self-assured pose and high-held head, that
he is not of the same class as the artist's less self-
regarding, more level-gazing professional jockeys.

The two gentlemen who successively owned Otho exemplify the variety within the class to which Stubbs must chiefly have looked for patronage. Otho's breeder and first owner was Richard Vernon (1726–1800), who began his career in the army but resigned a captaincy in the 1st Foot Guards at the age of twenty-six to help his friend the Duke of Bedford to manage his estates; in 1759 he married Bedford's sister, the widowed Countess of Upper Ossory, one of Horace Walpole's favourite correspondents. Vernon represented various constituencies in the House of Commons from 1754 to 1790, though there is no record of his having spoken in the House in the thirty-six years he sat in it. Some of his energies were devoted to horticulture, but more to racing; he was a founder member of the Jockey Club, a breeder of racehorses on a large scale and so astute a better that he is said to have 'converted a slender patrimony of three thousand pounds into a fortune of a hundred thousand'. Vernon was sometimes called 'the father of the Turf' and sometimes, less reverently, 'Jubilee Dicky' (D.N.B.).

Early in 1767 Vernon sold Otho to his stepson, John Fitzpatrick, 2nd Earl of Upper Ossory (1745–1818), who was described by Horace Walpole as a man 'who has all the passions of youth without its ridicules; who loved gaming without making or losing a fortune, and Newmarket without being a dupe or a sharper' (letter of 7 October 1773; ed. W.S. Lewis and others, *Horace Walpole's Correspondence*, XXXII, 1965, p.154). The 'passions of youth' included an affair with the wife of the 3rd Duke of Grafton (Stubbs's patron); the Graftons were divorced in 1769, after the birth of the Duchess's daughter by Lord Ossory, whom she then married. Lord Ossory sat in the House of Commons (more actively than his stepfather Richard Vernon) for Bedfordshire, 1767–94, and was Lord Lieutenant of that county from 1771 until his death. He was a member of the Jockey Club, but more interested in breeding racehorses (and other animals: he had a menagerie as well as a stud at Amptill Park, his Bedfordshire seat) than in betting on them. Lord Ossory was a cultivated man who bought paintings by contemporary British artists as well as by old masters; he was elected F.R.S. in 1780 and F.S.A. in 1793. Farington described him in 1808 as 'a conversible man, a lover of the arts, and a great friend of Sir Joshua Reynolds' (*Diary*, 6 February 1808; he sat to Reynolds in 1767–71. The sale of Lord Ossory's pictures after his death (Christie's 8 April 1819) does not include this Stubbs, which may have been inherited by one of his daughters.

Newmarket provides the background for No. 58. The same rubbing-down house which appears in Nos. 52–3 is here seen from the opposite viewpoint, so that St Mary's church and Newmarket town appear in the middle distance.

The theme of a lion attacking a horse preoccupied Stubbs for over thirty years, inspiring seventeen known works. These are mostly paintings in oil or enamel, but include two of Stubbs's own engravings and a relief model in Wedgwood clay. They have been the subject of a brilliant and detailed study by Taylor (1965 i). Largely discounting a posthumous anecdote that Stubbs, returning from Italy, made an otherwise unrecorded visit to the African coast and there witnessed a lion attacking a Barbary horse, Taylor convincingly argues that Stubbs's original inspiration for the theme was an antique marble sculpture of a lion attacking a horse which Stubbs could easily have seen in the Palazzo dei Conservatori on his visit to Rome in 1754 (repr. Taylor 1971, fig. 14; Francis Haskell & Nicholas Penny, *Taste and the Antique*, 1981, p. 251, fig. 128). This sculpture, as Haskell & Penny note, had been admired since the late Renaissance as a work of great expressive power; it was said to have been particularly admired by Michelangelo, whose reported views 'reached the standard guidebooks'. The sculpture had provided Panini and Richard Wilson with motifs for paintings, and Giambologna with inspiration for bronzes. Such was its fame that it would have been surprising if one of Stubbs's fellow-artists in Rome, knowing his interest in horses, had not drawn his attention to it.

Humphry's Memoir records that 'it does not appear that whilst he [Stubbs] was in Rome he ever Copied one picture or ever design'd one subject for an Historical composition, nor did he make one drawing or Model from the antique either Bas Relief or single Figure . . . so much had he devoted himself to observe & to imitate particular objects in Nature'. It may be true that Stubbs did not actually draw the antique sculpture while he was in Rome, though it is difficult to believe that the image did not remain engraved in his mind. The actual source he used may have been an indirect one, especially as the effect of repairs to the antique sculpture in 1694 had been to reconstruct the horse's head as drooping forwards, whereas in Stubbs's treatment of the subject, the horse's head is turned backwards to its attacker. The backwards turn of the horse's head is shown in Ghisi's engraving of the subject (Taylor 1965 i, fig. 42), which seems to predate the statue's repair, in the free variations of Giambologna and in two copies of the sculpture which Stubbs may have known in England: the life-size copy in stone made by Peter Scheemakers for Rousham in 1743 and a reduced marble version acquired by Henry Blundell (No. 59). The sculpture in Rome is pre-Hellenic; it presumably provided the inspiration for many later Roman works of art including mosaics as well as sculpture, and probably inspired some Roman legionary to carve out of stone the Corbridge lion (attacking a lamb) discovered during excavations of the Roman station at Corbridge, Northumberland (it is on view in the museum on the site). Animals as predators upon each other also recur in eastern art, notably in the borders of 'Turkey' carpets.

Stubbs's general subject of the lion attacking a horse can be divided into four distinct episodes (Taylor suggested three, but his 1965 article was written before the reappearance of No. 63). In the first, or episode A, the horse scents the emergence of the lion from its cave, and rises up in terror (No. 62 is an example). In episode B, the horse stands, as if mesmerized, in the same terror-struck attitude, despite the much closer approach of the lion (No. 66). In episode C, the lion has leapt upon the horse's back and sunk its teeth in the horse's withers (Nos. 60, 64, 65 and 67 are examples). In episode D (of which No. 63 is the only known example) the horse has collapsed under the weight of the lion, whose teeth are in the horse's flank and whose paws are forcing the horse to roll on its back in an exposed and defenceless position. Stubbs's various versions of the general subject (listed in Taylor's Appendix) were not made in this narrative order. Episode D may have been his earliest treatment of the theme, stirring in the artist's imagination the idea of a drama to be worked out in episodes or scenes.

Humphry's MS Memoir relates that Stubbs made numerous studies of a lion in Lord Shelburne's menagerie at Hounslow Heath (see p. 92). The Memoir relates that 'The White Horse frighten'd at the Lyon was painted from one of the Kings Horses in the Mews w^ch M.^r Payne the Architect procur'd for him – The expression of this was produced, repeatedly, from time to time by pushing a brush upon the Ground towards him'. The horse varies in colour from white to chestnut with flaxen or white (palomino) mane and tail.

Stubbs's 'frightened horse' proved a popular subject in engravings, some of them introducing a melodramatic flavour which is foreign to Stubbs; and it was probably from engravings that the subject was copied by unknown artists. There is some evidence that engravings after Stubbs were known in France: M. Huber, in his *Notices Generales des graveurs divisés par nations . . .* 1787, lists *Le cheval en presence du lion, Le cheval en presence de la lionne* and *Le cheval saisi par le lion*. It influenced Sawrey Gilpin's paintings of horses frightened by a storm, and James Ward's horses frightened by serpents and even sunsets. Could John Trumbull have seen Stubbs's 'Horse Devoured by a Lion' (No. 63) when he was in England? His studies for 'The Death of General Mercer at the Battle of Princeton, January 3 1777' (repr. Helen A. Cooper, *John Trumbull*, exh. cat., Yale University Art Gallery, 1982, pp. 64–7) appear to be derived from No. 63 (? or from the sculpture), though in Trumbull's finished painting he changes the pose of General Mercer's horse.

More curiously, Stubbs's image of the lion attacking the horse provided some unknown sculptor with models for three reliefs for a mantlepiece in a stately home in Yorkshire, and some unknown craftsman with a motif for the top of a gold-mounted cameo vinaigrette (in the collection of Ivor Mazure, who kindly brought it to the compiler's notice).

59*

Italian School, eighteenth Century
HORSE ATTACKED BY A LION

Marble, $16 \times 28 \times 19\frac{3}{4}$ in.
($40.6 \times 71.1 \times 50.2$ cm.)
Merseyside County Council,
Walker Art Gallery, Liverpool

PROVENANCE
. . .; ?2nd Earl of Bessborough, sold Christie's
7 April 1801 (87), bt. Hurd; Henry Blundell
(1724–1810); by descent to Col. Joseph Weld,
who presented it to Liverpool Corporation 1959

LITERATURE
Taylor 1965 (i), p. 86 n. 12, fig. 41; *Walker Art
Gallery, Liverpool, Foreign Catalogue*, 1977, text vol.,
pp. 316–17.

As noted above, Stubbs's treatment of the lion and
horse theme was indebted to the celebrated
antique sculpture in Rome, which he may have
known not only in the original but also from copies
such as this one. Although its early history is not
recorded, No. 59 later belonged to Stubbs's patron
Henry Blundell of Ince Blundell Hall, who also
owned one of Stubbs's paintings of the theme.

60†

HORSE ATTACKED BY A LION (Episode C)
?1762

Oil on canvas, 96 × 131 in.
(243.7 × 333 cm.)
Yale Center for British Art,
Paul Mellon Collection

PROVENANCE
Commissioned by the 2nd Marquess of
Rockingham (? paid for in December 1762: see
note at the end of No. 34); by descent to Earl
Fitzwilliam, Wentworth Woodhouse, Yorkshire,
sold Christie's 11 June 1948 (57); Walter
Hutchinson; Partridge from whom purchased by
Mr Paul Mellon KBE, 1960, and presented to the
Yale Center for British Art, 1977

EXHIBITED
National Gallery of British Sports and Pastimes,
Hutchinson House 1948 (340); Partridge 1960
(60, repr.) V.M.F.A. 1963 (335, pl. 174); R.A.
1964–5 (270, pl. 52); Yale 1965 (182); National
Gallery of Art, Washington, on loan 1966–76

LITERATURE
Humphry MS Memoir; Gilbey 1898, p. 168;
Constantine 1953 (fully cited under No. 34);
Taylor 1965 (i), p. 81, fig. 44, Appendix no. 1;
Taylor 1971, p. 209, Egerton 1978, pp. 71–2,
pl. 26

This is by far the largest of Stubbs's lion and horse
paintings, and is one of the earliest. It is probably
the first item in Stubbs's receipt dated 30 December
1762 for the Marquess of Rockingham's payment of
'Eighty guineas for one Picture of a Lion and
another of a Horse Large as Life' (the second item
being 'Whistlejacket'). Stubbs later painted 'Lion
Attacking a Stag' (No. 61) as a pendant. Both were
painted in London, not at Wentworth Woodhouse.

The background, with its rather improbable
palm-tree on the left, appears to be an imaginary
'African' one. Presumably this picture was painted
before Stubbs found, in Creswell Crags, a real
landscape better suited to the 'lion and horse'
theme.

The Humphry Memoir includes a graphic
account of Stubbs's preliminary studies, and the
manner in which he made them: 'Mr Stubbs
painted also several pictures in London for the
Marquis — the most considerable of which, were
two pictures the Size of Life. — one of a Lyon
devouring a Stag, the other of a Lyon devouring a
Horse. The studies for the former of these animals
were made from a Lyon of Lord Shelbournes at his
villa on Hounslow Heath, by the permission of his
Lordships Gardner. — The Lyon was confin'd in a
Cage, like those at the Tower of London. — after
having often view'd and consider'd the Lyon well,
he made a design, and prepared his Materials for
painting the picture from Nature: but as the
posture of the animal was a given one for the
purpose he wanted, it could seldom be seen in the
position; therefore as the progress of the picture
was often suspended, it afforded our author an
opportunity of making many other studies from the
Lyon, wᶜʰ he did wᵗʰ Black lead pencil sometimes,
but generally with Black & White Chalks upon size
paper. — These Drawings from the animal were
very slight; often outlines only — and never more
than sketchy Black & White Studies — some of
these designs were from the Lyon walking, others
resting, some sleeping others eating &c &c &c.
Whilst he was executing these drawings many
opportunities occur'd of observing the disposition
of this animal: of the manner in particular in wᶜʰ
they watch & spring upon their prey . . .'.

619

LION ATTACKING A STAG

? painted 1765
Oil on canvas, 96 × 131 in.
(243.7 × 333 cm.)
Yale Center for British Art,
Paul Mellon Collection

PROVENANCE
Commissioned by the 2nd Marquess of Rockingham (no receipt traced); by descent to Earl Fitzwilliam, Wentworth Woodhouse, Yorkshire, sold Christie's 11 June 1948 (58); Walter Hutchinson; Partridge, from whom purchased by Mr Paul Mellon KBE, 1960, and presented to the Yale Center for British Art, 1977

EXHIBITED
? Society of Artists 1766 (164); National Gallery of British Sports and Pastimes, Hutchinson House 1948 (339); Partridge 1960 (61, repr.); National Gallery of Art, Washington, on loan 1966–76

LITERATURE
Humphry, MS Memoir: *The Works of James Barry Esq.*, 1809, I, p. 23; Gilbey 1898, p. 169; Taylor 1965 (1), p. 81, fig. 36; Egerton 1978, pp. 74–5

This was painted as a pendant to the equally large 'Lion Attacking a Horse' (No. 60). 'Lion Attacking a Stag' was probably painted in 1765 and may have been exhibited in 1766. A comment in a letter from the artist James Barry (undated, but datable 1765; published in *The Works of James Barry*) seems to describe the Rockingham picture exactly: 'he [Stubbs] is now painting a lion parting and out of breath lying with his paws above a stag he has run down: it is inimitable'. Stubbs exhibited 'A lion and stag' at the Society of Artists in 1766 (164). Walpole's comment on the exhibited picture — 'indifferent, no spirit' — while at variance with Barry's, is not wholly unjust to the Rockingham picture.

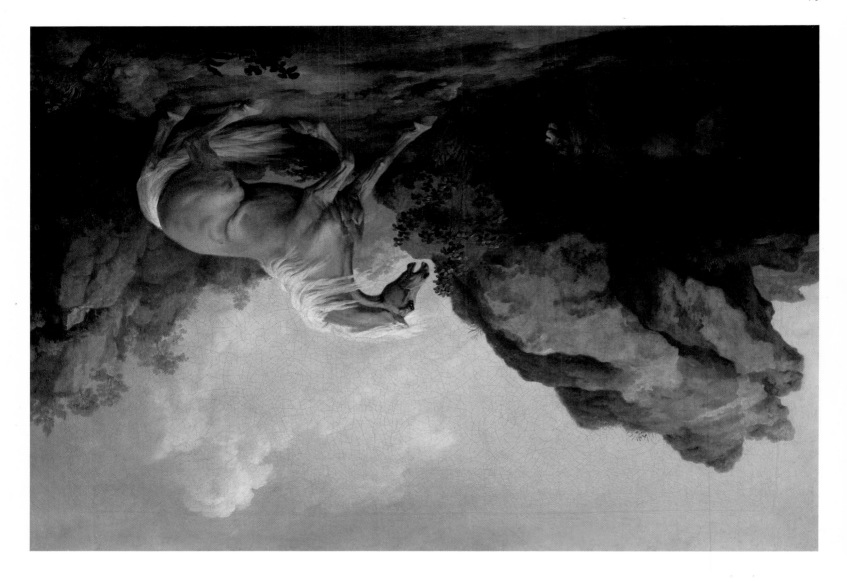

62

HORSE FRIGHTENED BY A LION
(Episode A)
? exh. 1763
Oil on canvas, 27¾ × 40⅛ in.
(70.5 × 101.9 cm.)
Private Collection

PROVENANCE
. . . ; private collection for many years

EXHIBITED
? Society of Artists 1763 (119); on loan to Tate
Gallery since 1973

LITERATURE
Taylor 1965 (1), p. 86, ? Appendix no. 9

ENGRAVED
Taylor 1, some differences (see No. 172)

Stubbs's earliest exhibits of works on the Lion and
Horse theme were at the Society of Artists in 1763,
where he showed two pictures entitled 'A horse
and a lion' (119) and 'Its companion' (120).
Against 'A horse and a lion', Horace Walpole
noted in his exhibition catalogue 'The horse rising
up, greatly frightened'. The picture so impressed
Walpole that he composed a poem entitled 'On
seeing the celebrated Startled Horse, painted by
the inimitable Mr. Stubbs', which was published in
the *Public Advertiser*, 4 November 1763 (it is
reprinted in Walpole's *Anecdotes of Painting in
England*, ed. 1969, IV, pp. 110–12). The poem
paints a vivid word-picture of the frightened horse,
'rooted' to the spot by 'apprehension, horror,
hatred, fear', with 'ears shot forward' and 'stiff,
projected mane'. Such details make it clear that no.
119 in the 1763 exhibition must have been the
frightened horse of episode A or B. In episodes C
and D the horse is not merely 'startled' or
'apprehensive', but is under violent attack and
fighting for its life; its ears are back and its mane
streams backwards.

It seems very likely that the picture exhibited
in 1763 as 'A horse and a lion' was No. 62 and that
'Its companion' was No. 63. Both pictures seem to
date from the early 1760s; they are similar in size,
style and colouring, and in both the setting is an
accurate representation of the shapes and forms of
particular rocks and crags in Creswell gorge. Their
exhibition as a pair in 1763 would have made (and
now makes) narrative as well as visual sense, for
they show the first and last episodes in the
encounter between the horse and the lion.

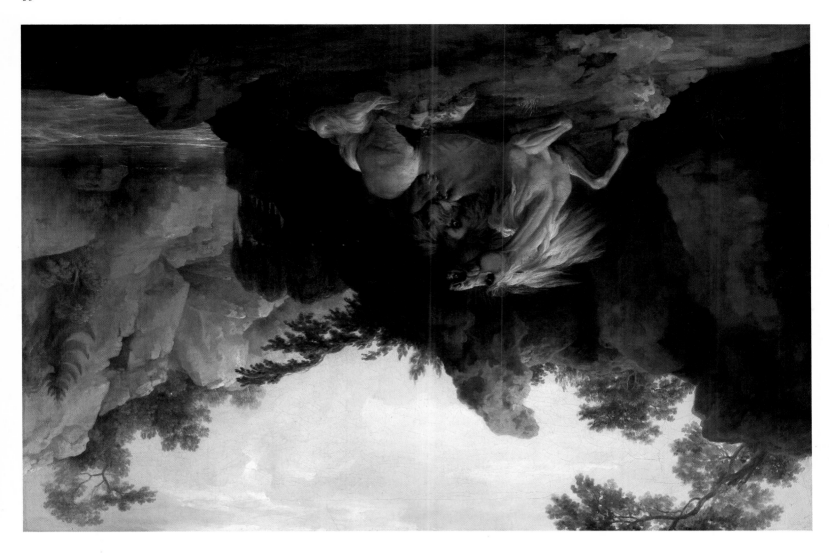

63

HORSE DEVOURED BY A LION
(Episode D)
? exh. 1763

Oil on canvas, 27¼ × 40¾ in.
(69.2 × 103.5 cm.)

Tate Gallery

PROVENANCE
. . . ; Horatio Miller by 1876; Sir Walter Gilbey,
sold Christie's 11 June 1915 (400), bt. Algernon
Dunn Gardner; Mrs H.C. Leader, sold Sotheby's
3 April 1968 (142, repr.), bt. Ackermann for Mr
Paul Mellon KBE; lent to the Tate Gallery from
February 1973; given to the Yale Center for
British Art 1975, continuing on loan to the Tate
Gallery until (an export licence having been
refused) its purchase in 1976

EXHIBITED
? Society of Artists 1763 (120); Old Masters, R.A.
1876 (35)

LITERATURE
Gilbey 1898, p. 156; Taylor 1971, p. 34, fig. 17;
*The Tate Gallery 1976–8, Illustrated Catalogue of
Acquisitions*, pp. 16–17.

This subject is closest of all to the antique sculpture
which, as Taylor suggested, was Stubbs's original
inspiration for his variations on the lion and horse
theme. It is the only representation by Stubbs of
this episode so far known. As suggested under No.
62, it appears to be a companion piece to that work,
and to have been exhibited with it in 1763.

64*

LION ATTACKING A HORSE (Episode C)
dated 1769

Enamel on copper, octagonal,
$9\frac{9}{16} \times 11\frac{1}{8}$ in. (24.3 × 28.2 cm.)
Inscribed 'Geo: Stubbs pinxit 1769' lower
right and, on the back, 'N⁰ J [? for '1']'
Tate Gallery

PROVENANCE
Purchased by Peniston Lamb, 1st Viscount
Melbourne; his daughter, firstly Lady Cowper,
secondly Lady Palmerston; her son, Lord Mount
Temple; Lord Wallis Talbot Kerr, sold Foster's
8 March 1923 (318, as 'on porcelain'); Sir George
Buckston Brown, by whom presented with Down
House to the British Association for the
Advancement of Science, by whom handed over
in 1962 to the Royal College of Surgeons; sold
1968 to Speelman; sold to a British private
collector, from whose executors purchased,
through the Maas Gallery, with the aid of the
Friends of the Tate Gallery, for the Tate Gallery,
1970

EXHIBITED
Society of Artists 1770 (135, 'A lion devouring a
horse, painted in enamel'); Whitechapel 1957
(51); Tate Gallery 1974 (15, repr.)

LITERATURE
The Tate Gallery 1968–70, 1970, pp. 67–9

This is the earliest known enamel by Stubbs. The
Humphry Memoir relates that 'an Octagon within
a Circle of 12 Inches upon Copper of a Lyon
devouring a Horse was sold to Lord Melbourne for
100 Guineas being the first picture in Enamel that
our Author sold'.

Horace Walpole annotated his copy of the 1771
Society of Artists exhibition catalogue 'Very
pretty': an odd adjective to choose, but probably it
describes the workmanship rather than the subject
– Walpole had already enthused in verse over 'On
seeing the Celebrated Startled Horse by Mr.
Stubbs' (see No. 62). Though small, No. 64 is (in
this compiler's opinion) perhaps the most
successful of all Stubbs's work in enamel. The
design of the lion upon the horse's back is tightened
up considerably from No. 60 and now makes a
forceful cameo-like group, commanding all the
space available; cutting the corners to make an
irregular octagon makes the lion and horse group
even more forceful.

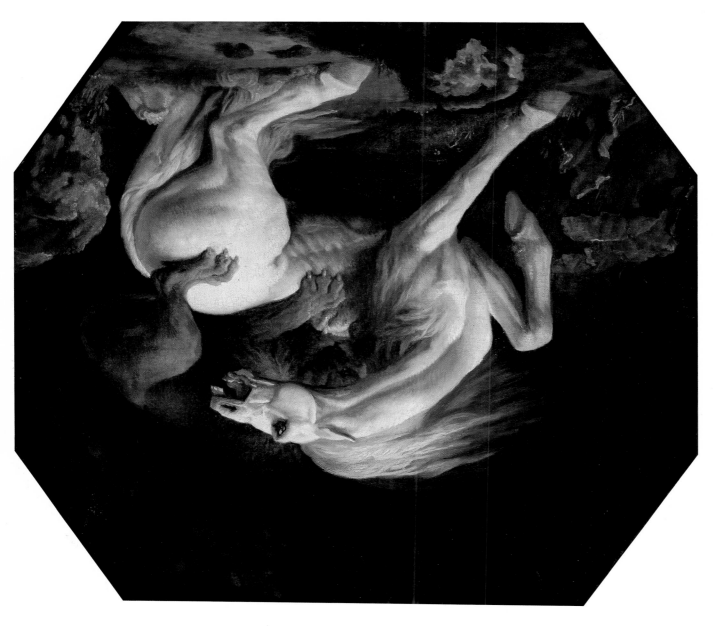

65

HORSE ATTACKED BY A LION (Episode C)

c.1768–9

Oil on panel, octagonal, 10⅛ × 11⅞ in.
(25.7 × 29.5 cm.)

Paul Mellon Collection, Upperville, Virginia

PROVENANCE
Benjamin West P.R.A., sold, after his death,
Christie's 23 June 1820 (6, as 'The Lion and
Horse, small, octagon, panel, 10 in. by 11¾'), bt.
Pinney £23.2.0; Humphry Ward by 1885; bt. (?
through Vokins) by Sir Walter Gilbey, sold, after
his death, Christie's 11 June 1915 (411), bt.
Hagger; Lord Norrie; . . . ; Partridge, from
whom purchased, 1962, by the present owner

EXHIBITED
Vokins 1885 (42, lent by Humphry Ward);
V.M.F.A. 1963 (334); R.A. 1964–5 (263); Yale
1965 (175)

LITERATURE
Gilbey 1898, p. 157, no. 20; Egerton 1978,
pp. 72–3, no. 71

This is likely to have been one of Stubbs's first
paintings on panel, and may well have been a try-
out for the almost identical version painted in
enamel on copper and dated 1769 (No. 64, q.v.).

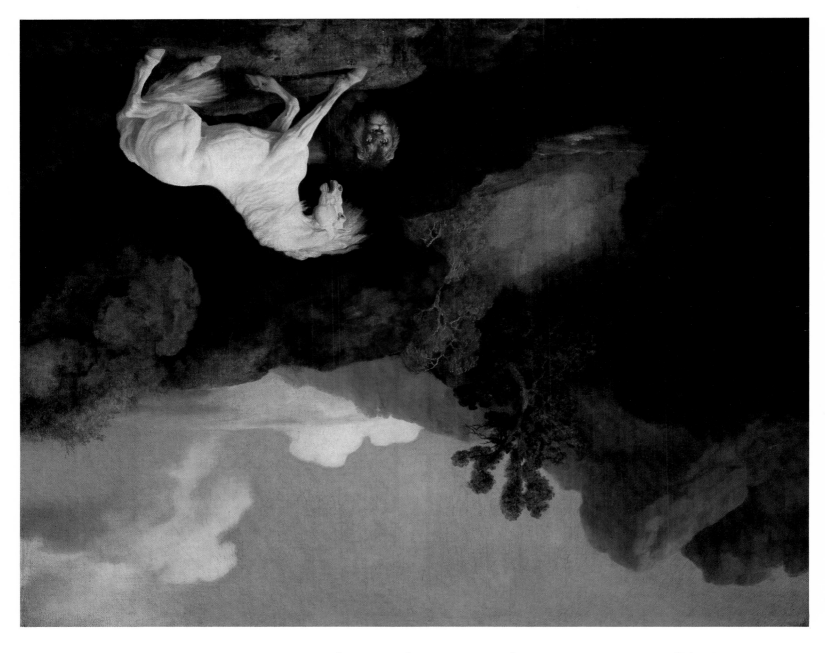

*99

WHITE HORSE FRIGHTENED BY A LION
(Episode B)
dated 1770
Oil on canvas, 40 × 50¼ in.
(101.6 × 127.6 cm.)
Inscribed 'Geo: Stubbs / pinxit 1770'
lower right
*Merseyside County Council,
Walker Art Gallery, Liverpool*

PROVENANCE
. . . ; Sir Walter Gilbey, by 1885, sold Christie's
12 March 1910 (149), bt. Wallis for the Walker
Art Gallery

EXHIBITED
Vokins 1885 (3); *The Liverpool School of Painters,*
Harrogate 1924 (26); *British Art,* Manchester
1934 (25); *British Painting 1730–1850,* British
Council, Scandanavia 1949–50 (90); Liverpool
1951 (11, repr.); *Le Paysage Anglais,* Orangerie,
Paris 1955 (65); *European Masters of the Eighteenth
Century,* R.A. 1954–5 (119); *The Romantic
Movement,* Tate Gallery and Arts Council Gallery,
1959 (336); *British Painting 1700–1960,* British
Council, U.S.S.R. 1960 (25)

LITERATURE
Gilbey 1898, pp. 156–7, no. 18; Geoffrey Grigson,
'George Stubbs, 1724–1806', *Signature,* no. 13,
1940, p. 24; Robert R. Wark, 'A Horse and Lion
Painting by George Stubbs', *Bulletin of the
Associates in Fine Arts at Yale University,* XXII, no.
1, 1955, pp. 1–6; Taylor 1965 (i), p. 86, Appendix
no. 7; Taylor 1969, p. 22

ENGRAVED
in mezzotint by George Townly Stubbs (horse
and lion only, against their immediate
background), published 20 September 1770

Nos. 66 and 67 were evidently painted as pendants
to each other. Each is dated 1770; in each the horse
is white, and painted to the same scale, on a canvas
of similar size.

In contrast to the earlier pair (Nos. 62 and 63),
the backgrounds here are more generalized and
romantic, probably inspired by recollection of
Creswell Crags rather than drawn from actuality.
In the earlier pair, the drama is acted out in the
centre of the composition, and in a noonday light;
in the later pair, Stubbs moves the lion and horse
group from the centre of the stage, and his
treatment of light has become much more
dramatic. In the Liverpool picture, light falls on the
centre of the middle distance, as if that were some
fortunate country where once the horse ranged
freely; in the New Haven picture, the sky darkens,
and the light shifts to the edge of the picture, as if
foreshadowing the inevitable extinction of the
horse's life.

Grigson's suggestion (op. cit.) that George
Barret painted the landscape in No. 66 cannot be
supported. It is based on a passage in a letter from
John Hunter to his pupil Edward Jenner, undated,
but in *Letters from the Past* (the Royal College of
Surgeons' edition of letters from Hunter to Jenner,
1976, p. 21) placed within the year 1778: 'I have a
picture of Barret & Stubbs. The Landscape by
Barret, and a Horse frightened at the first seeing of
a Lion by Stubbs. I got it for five guineas. Will you
have it? I have a dearer one [presumably the 'Lion
devouring a stag' in Hunter's sale, 29 January 1794,
lot 73, bt. Lowndes, present location unknown] and
no use for two of the same master's, but do not have
it excepting you would like it or I can get my
money for it.' It is not entirely clear whether
Hunter refers to a picture by each artist or a
picture painted by them in collaboration; if the
latter, the picture cannot now be identified. In No.
66 there is only one hand at work, and that is
Stubbs's; Barret's foliage is more finicky and his
colouring is yellower in tone. Having decided that
in this picture the horse is to be white, Stubbs
heightens its effect by making the background
dark; his colouring and his landscape forms in this
picture can be compared with those in the painting
of the moose (No. 82, also painted in 1770).

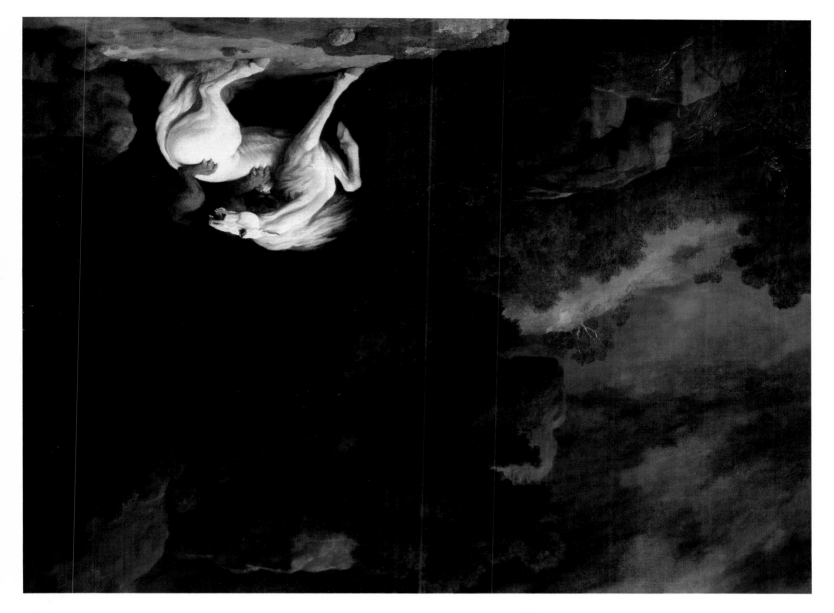

WHITE HORSE ATTACKED BY A LION
dated 1770

Oil on canvas, 40⅜ × 50¼ in.
(101.9 × 127.6 cm.)

Inscribed Geo: Stubbs pinxit 1770 lower
right

Yale University Art Gallery, Gift of the
Yale University Art Gallery Associates,
New Haven, Connecticut

PROVENANCE
. . . ; ? Sir William Knighton (1st Bart.,
1776–1836); Sir William W. Knighton, Bart., sold
after his death, Christie's 23 May 1885 (448) bt.
Vokins, 22 gns.; Sir Walter Gilbey, sold Christie's
12 March 1910 (148), bt. Guillet, 22 gns.; A.P.
Guillet, sold Christie's 23 October 1942 (158);
£94.10.0, bt. Percy Moore Turner, from whom
purchased as a Gift of the Associates in Fine Arts
at Yale University to Yale University Art Gallery

EXHIBITED
Liverpool 1951 (8); *Sport and the Horse*, Virginia
Museum of Fine Arts, Richmond, Virginia 1960
(19, repr.); *Romantic Art in Britain: Paintings and
Drawings 1760–1860*, Detroit Institute of Arts and
Philadelphia Museum of Art 1968 (14, repr.);
currently on loan to the Yale Center for British
Art

LITERATURE
Gilbey 1898, p. 157, no. 19; Robert R. Wark,
'A Horse and Lion Painting by George Stubbs',
*Bulletin of the Associates in Fine Arts in Yale
University*, XXII, no. 1, 1955, pp. 1–6; Taylor
1965, p. 86, Appendix no. 8; A. C. Ritchie &
K. B. Neilson, *Selected Paintings and Sculpture from
the Yale University Art Gallery*, 1972, no. 49, repr.,
and pl. 10.

Painted as a pendant to No. 66, q.v.
Yale University Art Gallery's collection also
includes the 'Capriccio of Roman Ruins and
Sculpture with Figures' by Panini, signed and
dated 1741, which includes a representation of the
antique sculpture of a lion attacking a horse which
Stubbs presumably saw in Rome (see Taylor 1971,
pp. 33–4, details repr. figs. 14–15; Ritchie &
Neilson, no. 54, repr.).

LION AND LIONESS
dated 1770

Enamel on copper, octagonal, $9\frac{1}{2} \times 11$ in.
(24.1 × 28 cm.)
Inscribed 'Geo: Stubbs / pinxit 1770'
lower right
Paul Mellon Collection, Upperville, Virgina

PROVENANCE
Stubbs's studio sale, 27 May 1807 (79); . . . ;
Pierre Jeannerat by 1951 and by whose executors
sold Sotheby's 14 March 1984 (119 repr.),
bt. Baskett & Day for Mr Paul Mellon KBE

EXHIBITED
Liverpool 1951 (19); Whitechapel 1957 (50);
Tate Gallery 1974 (8, repr.)

LITERATURE
Taylor 1961, p. 223, no. 2; Tattersall 1974, no. 8,
repr.

A picture entitled 'A lion and lioness' was exhibited
at the Society of Artists in 1771 (153). Stubbs
usually added 'in enamel' to his exhibited enamels;
as it is not stated to be in enamel, the exhibited
picture may have been an oil.

69

LIONESS AND LION IN A CAVE
*c.*1770

Oil on canvas, $35\frac{1}{2} \times 53\frac{1}{4}$ in.
(90.2 × 135.8 cm.)
Private Collection

PROVENANCE
(either this or the Philadelphia picture)
Stubbs's studio sale 26 May 1806 (68, 'A LION
AND LIONESS reposing under a venerable oak,
stripped from Age of all Foliage; admirably
drawn and coloured throughout'); . . . ; H.N.
McKenzie, sold Christie's 27 June 1980 (bt.
Richard Green, from whom purchased for a
private collection)

The tree appears to have been blasted by winter,
or in some way fossilized. In the 1770s Stubbs
composed numerous scenes with lions and
lionesses, usually seen in or at the mouth of caves.
The caves of Creswell Crags may well have
inspired them.

There is a closely similar version of the picture
in the Philadelphia Museum of Art.

Stubbs's lion and tiger subjects, in parti-
cular, were copied by Edgar Ashe Spilsbury
(*c.*1773–1838), a surgeon, who is said to have
'studied Animal Painting under Stubbs' during his
apprenticeship at Chelsea Hospital, and to have
owned 'several Sketch Books which contained
numerous spirited sketches and studies of Lions,
Tigers &c. – Mr Spilsbury expressed much
attachment to and value for these remains of his old
master, as they were presents from him'. Thomas
Landseer's *Twenty Engravings of Lions Tigers Panthers
& Leopards*, 1823, includes engravings after
Spilsbury as well as after Stubbs, Rubens,
Rembrandt, Ridinger and Edwin Landseer, so he
must have enjoyed some fame in his day. His style
is rather melodramatic, and his animals have
exaggeratedly expressive faces, with a touch of Paul
de Vos about them which never enters Stubbs's
style, but was also to affect Landseer's.

At some point in the 1760s, Stubbs discovered a real yet little-known landscape whose aspect and whose mystery aroused his deep interest. This was the landscape of Creswell Crags, two opposing ranges of high limestone cliffs, irregularly shaped, deeply fissured and overhung with trees and plants. The Crags lie about two miles from Welbeck Abbey, on the Nottinghamshire-Derbyshire border; the shallow Wellow river runs between them. In the eighteenth century, the Crags lay very much off the beaten track; there was no road between them, and they appear to have been quite unknown to travellers in pursuit of the picturesque like the Rev. William Gilpin, who contented himself with raptures over the more accessible Matlock ('Every object here is sublime, and wonderful'). Any gentleman who rode this way was more likely to be looking for game than 'views'.

In the title of the first of the 'Shooting' pictures (No. 73), Stubbs alerts us to the fact that the landscape is 'A view of Creswell Crags, taken on the spot'. Once this clue is followed, aspects of the same landscape can be recognized in many of Stubbs's works, including Nos. 62 and 63. Stubbs portrays various features of the crags with considerable accuracy. The compiler is indebted to Dr Rogan D.S. Jenkinson for pointing out that Creswell Crags have a distinctive feature – a localized thickening in the bedding planes of the magnesium limestone, producing a 'notched' effect – which enables them to be recognized in Stubbs's work with certainty.

It is likely that Stubbs first explored the landscape of Creswell Crags several years before the 'Shooting' pictures – perhaps as early as 1762, when he was working for the Marquess of Rockingham at Wentworth Woodhouse, twenty-one miles from the Crags. What is certain is that during the 1760s Stubbs drew on the landscape of Creswell Crags increasingly, both for real and imaginary subjects. In that background he found a landscape particularly apt to the theme of the wild horse imagined in a state of nature as the prey of the lion; and he began to devise subjects with leopards, lions and lionesses in or near the mouths of caves.

The most tantalizing question about Creswell Crags is whether Stubbs could have known that in prehistory these caves were in fact the haunt of wild animals – not only of the horse, bison, woolly rhinoceros and hyaena but also of the cave lion and the spotted leopard. Professional excavation of the caves did not begin until 1874; then many of the initial finds were in shallow soil. If Stubbs did explore the caves, it would have been with the anatomical knowledge he had gained at Horkstow; he may have come across sufficient evidence to believe that that encounter between a horse and a lion which had probably first fired his imagination in the form of a marble sculpture must in fact have occurred, many times, in just such a landscape as Creswell Crags.

There is now a Visitor Centre at Creswell Crags, with a museum; visitors can walk round the crags, but may not enter the caves.

LITERATURE
W. Boyd Dawkins, 'On the distribution of the British Post Glacial Mammals', *Geological Society quarterly*, XXV, 1869, pp. 192–217; do. 'On the mammalia and traces of Man in Robin Hood's Cave, *Geological Society quarterly*, XXXII, 1876, pp. 240–59; Rogan D.S. Jenkinson, *The archaeological caves and rock shelters in the Creswell Crags area*, 1978

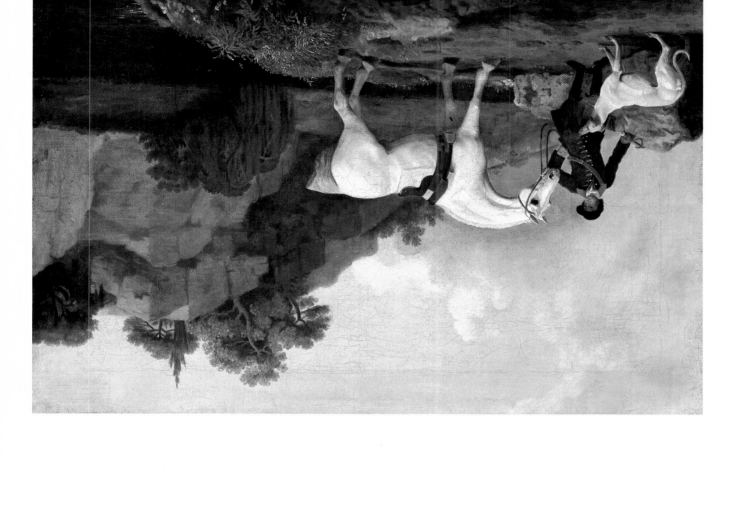

70

A GREY HUNTER WITH A GROOM AND A GREYHOUND AT CRESWELL CRAGS

c.1762–4

Tate Gallery

Oil on canvas, 17½ × 26¾ in. (44.5 × 68 cm.)

PROVENANCE
. . . ; bought in a lumber shop and sold to Lord Clifden (see Davies, cit. infra); executors of 4th Viscount Clifden, sold 25 May 1895 (676), bt. Davis for the National Gallery; transferred to the Tate Gallery c.1898, reclaimed by the National Gallery 1955, re-transferred to the Tate 1961

EXHIBITED
Huddersfield 1946 (85); Liverpool 1951 (as 'Landscape, with a gentleman holding his horse')

LITERATURE
Gilbey 1898, p. 128; Martin Davies, *National Gallery Catalogues: The British School*, 1959, pp. 93–4 (as 'A Horse with a Man and a Dog, in a Landscape')

This may be the first painting in which Stubbs represents a subject of his own times against a background of Creswell Crags (Nos. 62 and 63, in which he depicts the timeless combat of the lion and horse in the same setting, probably precede it). The chief subject here is the grey horse, presumably some nobleman's or gentleman's favourite mount for this sort of terrain: its stocky build and short legs make it ideally suited to picking its way over rocks and across moorland,

following the greyhound in pursuit of the hare. The status of the man has been variously interpreted, Martin Davies terming him merely 'a man', the Stubbs exhibition of 1951 promoting him to 'a gentleman' and the Tate (wisely, in my opinion) demoting him since then to 'a groom'. His attitude, while graceful enough, is subservient to that of the horse, and it is to the horse rather than to the spectator that he turns his gaze: the pose indicates that he is a groom on duty rather than a gentleman taking his ease, and his costume – dark blue coat with red collar and red buttonholes – is presumably the livery worn by the servants of some now unidentified owner. The greyhound is the precursor of many a dog in Stubbs's paintings whose natural curiosity engages the tolerant attention of a horse; the way in which they eye each other is, of course, as useful a linking thread in such animal 'conversation pieces' as it is in those depicting humans.

A date of c.1762–4, a little earlier than the second half of the 1760s to which some of Stubbs's most brilliant canvases belong, is proposed here because there is still something less than completely assured about the handling; the horse is rather too heavily modelled, particularly about the jaw and neck (as is, too, the huntsman's grey horse in 'The Grosvenor Hunt', No. 39, which is dated 1762); there is also some ungainliness about the greyhound, though this may be due to the fact that it, like the young John Nethorpe's dog in No. 27, is not pure-bred. Such slight weaknesses are outweighed by the powerful sense of place which this picture emanates. The setting is unmistakenly a stretch of the southern range of Creswell Crags. Stubbs paints the limestone cliffs, caves and crannies so convincingly that there can be little doubt that he observed this horse, this groom and

this greyhound against the looming background of those very crags. No. 70 thus almost certainly precedes No. 72, which we know was paid for either in 1764 or 1766; it must surely also precede No. 71, in which the representation of an exotically dressed 'Arabian' groom with a horse in the same setting lacks the feeling of real creatures observed in a real place.

This was the first painting by Stubbs to enter a public collection in England. The National Gallery's withdrawal of it in 1955 left the Tate with no adequate representation of Stubbs's work (it owned only the worn and rather dull 'Horse in the Shade of a Wood', purchased in 1933), prompting that active search for a fine example of Stubbs's work which led directly to the acquisition of 'Mares and Foals' (No. 89) and, more indirectly, to the steady increase in the number and quality of the Tate's works by Stubbs. No. 70 was re-transferred to the Tate in 1961.

A replica of No. 70, 18 × 27 in., with Agnew's in 1977, and now in a private collection, is virtually identical. A version of the subject, 25 × 29½ in., sold at Christie's 6 February 1931, (exh. *Art Treasures*, Christie's 1932 and at Ackermann 1970, no. 2, repr. on cover), now in a private collection, is in this compiler's opinion the work of a copyist; it is more coarsely painted, and the copyist, evidently ignorant of the towering appearance of Creswell Crags from this view point, has sought to 'improve' Stubbs's precisely judged composition by extending his picture, upwards to increase the amount of sky, thus reducing the crags to the semblance of a rockery, and on the left, adding an inappropriately conical contour to the age-weathered rocks behind the groom. Stubbs's copyists invariably give themselves away by their incomprehension of the reality underlying Stubbs's designs.

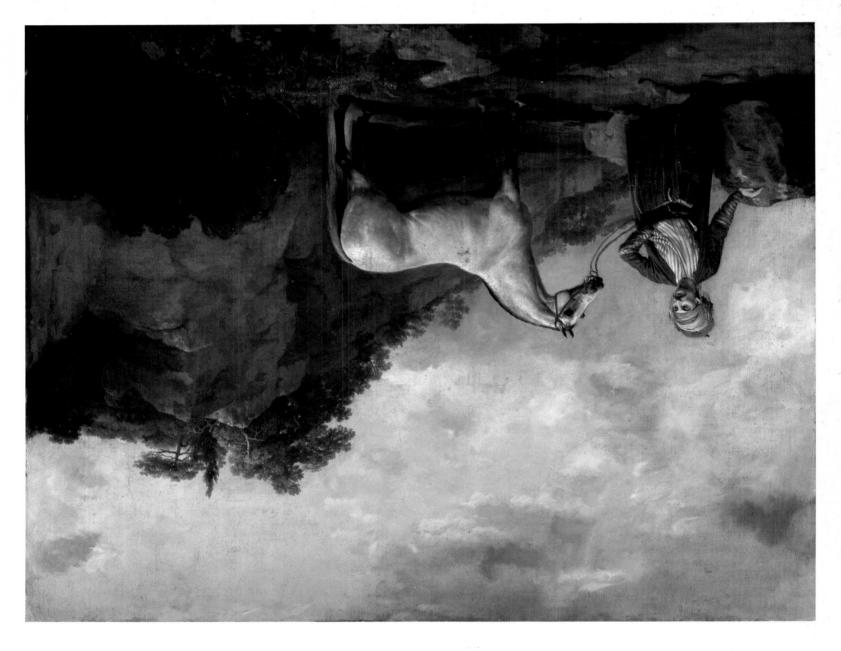

71*
A GREY HORSE WITH AN ARABIAN
GROOM AT CRESWELL CRAGS
c.1763–4

Oil on canvas, 35½ × 44 in.
(90.2 × 111.8 cm.)

Grimsthorpe and Drummond Castle Trustees

PROVENANCE
Peregrine Bertie, 3rd Duke of Ancaster; thence by descent

LITERATURE
Earl of Ancaster: *Catalogue of Paintings*, privately printed, n.d., no. 364

Here the setting is closely similar to that in Nos. 70 and 72. In this painting it is the Arabian groom who steals the scene; the horse is a neatly made (presumably Arabian) young grey whose portrait lacks the weight of his attendant's. The Arabian groom, who strikes, though with more flamboyance, the same pose as the groom in No. 70, is wonderfully exotic. The painting of his turban, with its intertwined strands of pink, blue and gold, the striped silk of his shirt and the voluminous blue stuff of his trousers deserves close scrutiny; Stubbs's brushwork here is as masterly as in the costume of the Indian attendants in the more impressive composition 'Cheetah with Two Indian Attendants' (No. 79). The idea of alluding to the Arabian blood of a horse by portraying it with an evidently Arabian groom goes back at least to Wootton (e.g. in such pictures as 'The Byerley Turk with a Groom', repr. Roger Longrigg, *The History of Horse-Racing*, 1972, p. 59).

No. 71 has not hitherto been exhibited or reproduced.

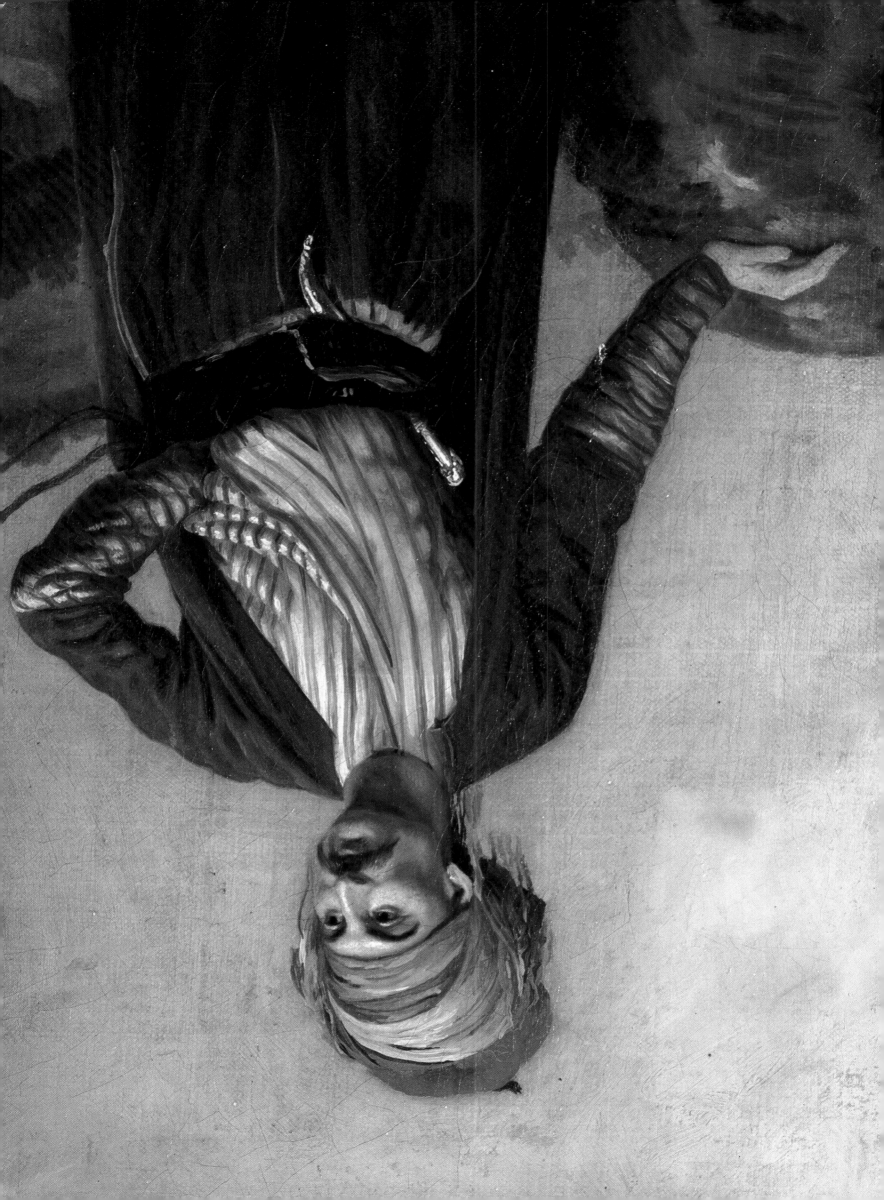

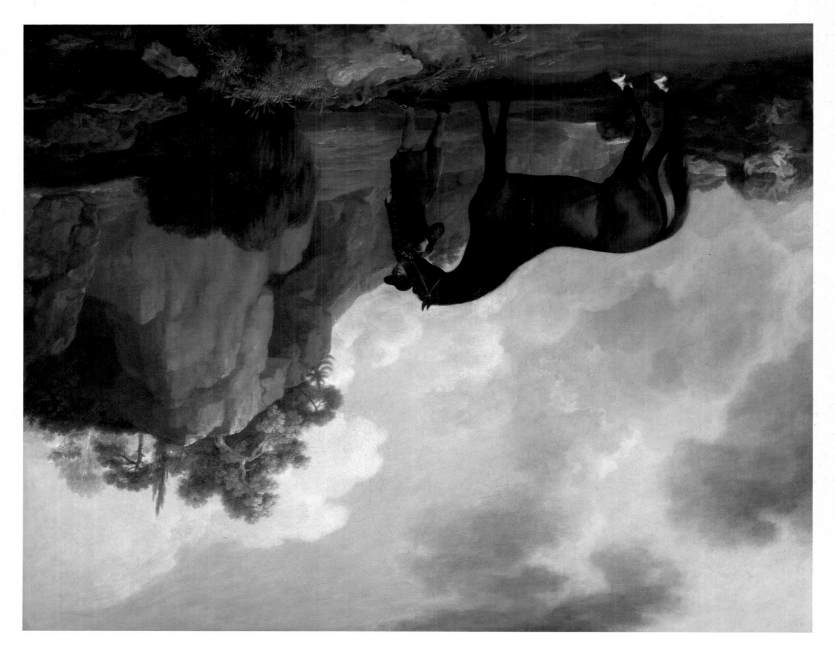

72

**THE MARQUESS OF ROCKINGHAM'S
ARABIAN STALLION LED BY A GROOM AT
CRESWELL CRAGS**

? exh. 1766

Oil on canvas, sight size, 38½ × 48½ in.
(97.8 × 123.2 cm.)

*Trustees of The Rt. Hon. Olive,
Countess Fitzwilliam's Chattels Settlement,
kindly lent by Lady Juliet de Chair*

PROVENANCE

Commissioned by the 2nd Marquess of
Rockingham (? paid for in August 1776); thence
by descent

EXHIBITED

? R.A. 1766 (166, 'An Arabian Horse'); *The
Wentworth Woodhouse Stubbs Paintings*, Ellis &
Smith 1946 (4, as 'Racehorse and Groom in a
Rocky Landscape'); *The Anatomy of the Horse:
George Stubbs*, Gainsborough's House, Sudbury,
Suffolk, in association with the Royal Academy,
1982 (39, as *do.*, repr. on a small scale)

LITERATURE

E.K. Waterhouse, 'Lord Fitzwilliam's Sporting
Pictures by Stubbs', *Burlington Magazine*,
LXXXIII, 1946, p. 199; Constantine 1953,
pp. 236–8, fig. 10 (as *do.*)

This comparatively little-known painting was not
included in either of the two previous Stubbs
exhibitions of 1951 and 1957, and has rarely been
reproduced; this is surprising, for it is a picture of
high quality in a very well-known collection. It
must surely date from around 1765–6, when
Stubbs, seemingly effortlessly, was producing a
whole series of different but equally fine works.
Constantine notes that Stubbs's original percep-
tion and rendering of delicate aqueous light is
masterly, adding (and here he is writing more
generally about the pictures painted by Stubbs for
Rockingham), 'indeed in looking at these pictures
we can readily appreciate that independence of
outlook which lifts him above so many of his
contemporaries'.

The background is the same stretch of the
southern face of Creswell Crags as in No. 70, but
here the crags loom less large, as if the viewpoint
were further away from them; this feeling of being
slightly distanced from the crags, perhaps in time
as well as in space, coupled with the advance in
painterliness which this picture has over No. 70,
suggest that this must be the later picture.

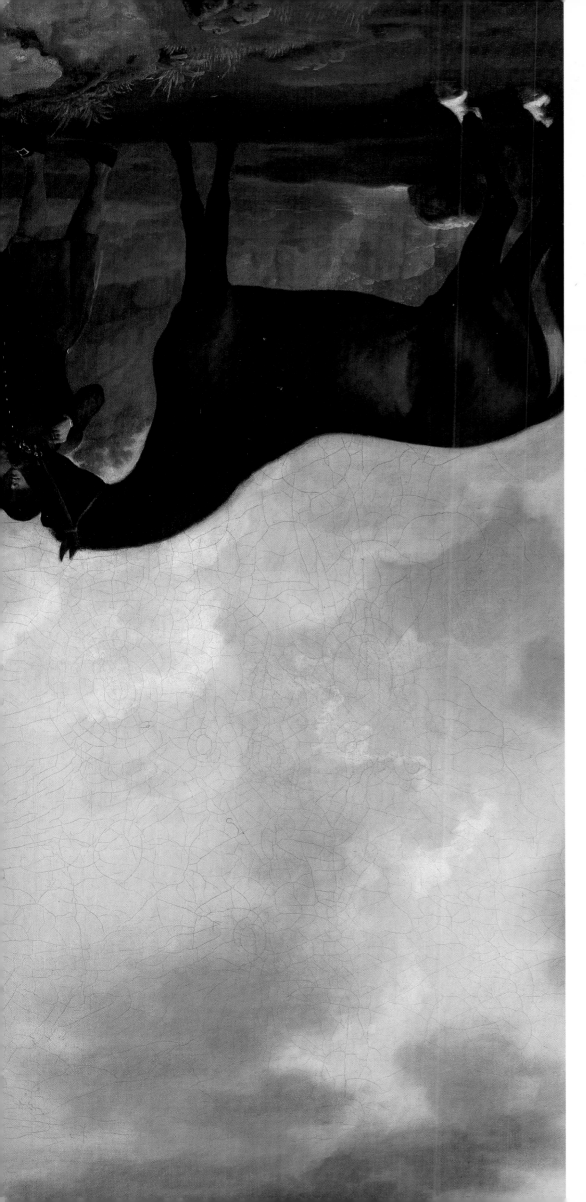

The 'new documents' published by Constantine are entries in the 2nd Marquess of Rockingham's account books which record payments to Stubbs, with some receipts from the artist. While Stubbs's first commissions from Rockingham (e.g. for 'Mares and Foals', 'Five Foxhounds' and 'Whistlejacket', Nos. 34, 36 and 88) are readily identifiable from the account books, this picture is not so easily identifiable from subsequent entries. Constantine believed it must be one of two pictures (the other being 'Sampson, in three positions', Constantine fig. 8, not in this exhibition) covered by one payment to Stubbs of £70.15s. on 31 August 1764. The compiler believes it to be the picture paid for in the next recorded payment to Stubbs, of 40 guineas, on 7 August 1766, for 'A Picture of an Arabian'. Constantine equates this with the painting now called 'Bay Malton with John Singleton up'; but to this compiler it seems more likely that No. 72 is the picture paid for as 'Picture of an Arabian', since the horse depicted here has most of the qualities of the pure-bred Arabian, which are not remarkable in the portraiture of 'Bay Malton' (who, incidentally, had a white sock on only one hindleg, not on both, as this horse has). If No. 72 can indeed be identified as 'A Picture of an Arabian', then it may very well have been the picture exhibited at the Royal Academy in 1766 (166) as 'An Arabian Horse' – and payment in August (1766) on receiving, in Yorkshire, a painting that had been exhibited in London in May and June would make sense.

In Ellis & Smith's exhibition of 1946, this picture was entitled (and has been ever since, until now) 'Racehorse and Groom in a Rocky Landscape'; and it was suggested that the horse was *probably* Cato', a racehorse belonging to the 2nd Marquess of Rockingham; but since his ownership of Cato was in fact only very brief (in 1756–7), this seems most unlikely. 'Racehorse and Groom in a Rocky Landscape' is in any case an inept title for this picture. It certainly posed a puzzle for E.K. Waterhouse (op. cit.) who, although he would vaunt no claim to be an expert on sporting pictures, detected an apparent anomaly which no writer on sporting art had noticed; reviewing the 1946 exhibition, he observed that 'the rocky landscape is one to which no groom in his senses would ever take a racehorse'. Waterhouse was driven to suggest that after publishing *The Anatomy of the Horse*, Stubbs was 'perhaps at his most exalted phase in his notions about that noble creature', and that posing a racehorse amongst rocks must be 'an attempt, as it were, to "houyhnhnmize" his horses'.

Once one realizes that the background is no fiction but a real place, the 'puzzle' ceases to exist. Creswell Crags are only 21 miles distant from Wentworth Woodhouse, Lord Rockingham's seat; Rockingham himself may often have ridden this way, in search of game, or to visit the Duke of Portland at Welbeck or Sir George Savile at Rufford, both of whom were his friends. Rockingham may have seen and admired one of the earlier paintings in which Stubbs used Creswell Crags as a background and have asked for its inclusion in this picture; or Stubbs may have judged that Rockingham would appreciate a noble background which he would certainly recognize. In either case, the horse in this picture should be seen not as a racehorse (for his background would then certainly be unsuitable), but as a noble and evidently progenitive representative of an ancient breed, depicted in a timeless but in fact real setting.

73

TWO GENTLEMEN GOING A SHOOTING,
WITH A VIEW OF CRESWELL CRAGS:
TAKEN ON THE SPOT
exh. 1767

Oil on canvas, 39 × 49 in.
(99 × 124.5 cm.)

Inscribed (No. 73) 'Geo. Stubbs / pinxit
17–– [?1768]' lower right
Yale Center for British Art,
Paul Mellon Collection, given in memory
of his friend James Cox Brady,
Yale College, Class of 1929

PROVENANCE
? commissioned by William Wildman; his
executors' sale, Christie's 20 January 1787, in two
pairs (85, 'A pair of shooting pieces', bt.
Woodburn, £48.16.6; 86, 'Ditto', bt. Tassaert,
£48.16.6); evidently reunited as a series of four,
purchased *c.*1787 by General Giles Stibbert,
Portswood House, near Southampton (the *Sporting
Magazine,* noted in November 1809 that General
Stibbert 'possesses Mr. Stubbs's four pieces of
shooting, with Mr. Woollett's copies, fine
impressions, all in the same room'); his sale,
Stewart 30 May 1811 (140, 'Those celebrated chef
Douvres, the shooting pieces . . .'), bt. anon.,
£105; anon. sale, Christie's 2 December 1899
(36–39), bt. H. Taylor, ? for Vokins, by whom
sold to Sir Walter Gilbey; sold through Vokins,
1909, to Agnew's; W. Lockett Agnew;
Ackermann; James C. Brady, New York, 1968,
from whom purchased by Mr Paul Mellon KBE
and presented to the Yale Center for British
Art, 1976

EXHIBITED
Society of Artists (No. 73) 1767 (157); (No. 74)
1768 (167); (No. 75) 1769 (177); (No. 76) 1770
(134); Yale Center 1982 (20)

LITERATURE
Sporting Magazine, XXXV, no. CCVI, p. 50;
W. Shaw Sparrow, *George Stubbs and Ben Marshall,*
1929, p. 21, (1) repr. facing p. 20 (3) following
p. 20; Taylor 1971, pp. 41–2, 209, pls. 47–52;
Egerton 1978, pp. 81–3, no. 79, (1) colour plate
13, (4) pl. 31; Stephen Deuchar, *Noble Exercise,*
Yale Center for British Art, 1982, pp. 10–11, 21
note 3, 34, (10 repr. p. 41)

ENGRAVED
in line by William Woollett, numbered 'Plate 1st'
– 'Plate IV', without titles but with anonymous
verses (quoted by Snelgrove, 1981, pp. 180–1),
published by Thomas Bradford, 132 Fleet Street,
London, (No. 73) 1 August 1769; (No. 74)
30 August 1770; (No. 75) 30 September 1770;
(No. 76) 25 October 1771

74

TWO GENTLEMEN GOING A SHOOTING
dated and exh. 1768

Oil on canvas, 39 × 49 in.
(99 × 124.5 cm.)
Yale Center for British Art,
Paul Mellon Collection, given in memory
of his friend James Cox Brady,
Yale College, Class of 1929

In his phrasing of the exhibited title of the first of his four shooting scenes, Stubbs alerts us to the fact that its background is 'a view of Creswell Crags: taken on the spot', thus providing the clue which has enabled the background to many of his pictures to be identified with certainty. For 'Horse Frightened by a Lion' and 'Horse Devoured by a Lion' (Nos. 62–63), probably painted four or five years earlier than the first shooting scene, it is suggested that Stubbs's choice of Creswell Crags for the backgrounds was inspired by his probable knowledge of the fact that the caves within the crags had long ago served as the dens of wild animals. In the first of the shooting scenes, the background is as any contemporary might have seen it; the view is of the end of the range of the Derbyshire face of the crags, where a water-mill stood, facing a small inn that served the needs of local travellers and sportsmen. Stubbs uses a very similar background, though further distanced, in his painting of mares and foals for Colonel Parker (private collection), shown, in reverse, in the engraving 'Brood-Mares' published in 1786 (repr.). A distant view of the crags appears in the fourth shooting scene, 'A Repose after Shooting', in the background on the left (the ruined abbey (?) in the background of the third shooting scene has eluded all attempts at identification). The countryside around Creswell Crags was good shooting country,

TWO GENTLEMEN SHOOTING
exh. 1769

Oil on canvas, 39 × 49 in.
(99 × 124.5 cm.)
*Yale Center for British Art,
Paul Mellon Collection, given in memory
of his friend James Cox Brady,
Yale College, Class of 1929*

particularly for hares, which are included, with a cock-pheasant, snipe etc. in the day's bag in 'A Repose after Shooting'.

Creswell Crags were on the estate of the Duke of Portland, a mile or so from Welbeck Abbey, where Stubbs was working *c.*1766–7 for the Duke of Portland; his portrait of 'A nobleman on horseback', identifiable through Walpole's catalogue annotation as the picture of the Duke of Portland outside the riding school at Welbeck (repr. Parker 1971, p. 169), was exhibited at the Society of Artists in 1767 (156), next to the first of the shooting scenes, and his portrait of the Duke of Portland's brother Lord Edward Bentinck (repr. Taylor 1971, pl. 37) was presumably painted at the same time. George Barrett was evidently working at Welbeck at the same time as Stubbs; his 'View in Creswell Crags, Nottinghamshire, with a waterfall' (untraced) was shown at the 1767 Society of Artists exhibition (2) with other views in and around Welbeck Park. Stubbs and Barrett seem to have been friends and occasional collaborators (as noted under the portrait of 'Antinous and Jockey', No. 43), and probably collaborated in the 'Portrait of a dog belonging to Lord Edward Bentinck', exhibited under Barrett's name at the Society of Artists in 1768 (2, Walpole: 'a water spaniel, who seems to be pursuing wild duck'), but catalogued at Welbeck Abbey in 1810 as 'a dog by Stubbs and Barat' (Goulding & Adams, 1936, p. xxxiv, no. 13).

Stubbs may have painted the first of the shooting scenes as a picture in its own right, only later developing the idea of a series of four. The four paintings were probably painted, and certainly exhibited, in four successive years, and the four engravings after them were published one at a time. It is difficult to be sure that the same two sportsmen are portrayed in each picture, though in each the fuller-faced man who faces us in (1) and reclines on the ground in (4) seems older than the other man. The two pointers seem to have the same markings in each picture, but that likeness would have been easier to achieve than in the portraiture of the humans.

But who are these two men? The fact that they seem well content to go 'a shooting' on their own, without the expense of loaders, beaters, shooting ponies etc. suggests that they are without social pretension and would not object to the undistinguished verses which accompany each engraving ('Plate 1st' includes the lines 'Lo! the keen sportsmen rise from beds of down / And quit th'Environs of the smoky town . . .'). They are certainly not the Duke of Portland and his brother; nor (attractive though the idea may be) Stubbs and Barrett. Is one of them, as Taylor suggests, the patron who commissioned the series? (That that patron was General Stibbert, as Shaw Sparrow asserts, is contradicted by the fact that Stibbert did not acquire the paintings until some twenty years

after they were painted). Did Thomas Bradford, publisher of the engravings, commission all four of the paintings? The engravings state that the 'Original Pictures' were 'in his Possession', but that may have been only temporarily, while they were being engraved.

It is possible that at least the first of the four was commissioned by Stubbs's patron William Wildman (c.1715–1784), meat salesman and middleman between many great estates and Smithfield, that Thomas Bradford commissioned the next three with the intention of publishing a set of engravings, and that after publication of the engravings all four were in William Wildman's collection. Certainly all four were in his sale in 1787. The full-faced man in (1) might then be a portrait of Wildman; there is at least some likeness to the only certain portrait of him, in Stubbs's 'William Wildman and his sons with Eclipse' (in the collection of the Baltimore Museum of Art), though that is a much-restored picture, and the suggested identification must remain speculative.

76

A REPOSE AFTER SHOOTING
dated and exh. 1770

Oil on canvas, 39 × 49 in.
(99 × 124.5 cm.)

Inscribed 'Geo: Stubbspinxit / 1770'
lower right
Yale Center for British Art,
Paul Mellon Collection, given in memory
of his friend James Cox Brady,
Yale College, Class of 1929

ZEBRA
exh. 1763

Oil on canvas, $40\frac{1}{2} \times 50\frac{1}{4}$ in.
$(103 \times 127.5$ cm.)
Yale Center for British Art,
Paul Mellon Collection

PROVENANCE
Stubbs's studio sale, 27 May 1807 (88); . . . ; Sir
Walter Gilbey, by 1898, ? sold Christie's 25 May
1891 (one of two in lot 348, 'Portrait of a Zebra' –
but was this another version, now untraced ? –
and 'A Boy on a Pony'), bt. Capt. M. Fitzgerald;
Vokins; Sir Walter Gilbey, sold Christie's
12 March 1910 (147), bt. Agnew; W. Lockett
Agnew, sold by his widow's executors, Christie's
15 June 1923 (58), bt. Smith; S. Ben Simon, sold
Sotheby's 16 May 1928 (130), bt. Leggatt;
Ackermann; A.K. Macomber; M.A. Hall,
Connecticut, U.S.A.; Col. J.B. Donnelly, sold
Harrod's 19 October 1960 (278), bt. Colnaghi for
Mr Paul Mellon K.B.E., by whom presented to
the Yale Center for British Art, 1981

EXHIBITED
Society of Artists 1763 (121); *English Sporting
Paintings*, 1960 (not in cat.); V.M.F.A. 1963 (315,
pl. 164); R.A. 1964–5 (267, pl. 53); Yale 1965
(179, pl. 53); Yale Center for British Art 1983
(77)

LITERATURE
Gilbey 1898, p. 167; Taylor 1971, p. 30, pl. 56;
Egerton 1978, pp. 74–5, no. 74, Colour Plate 11;
Stephen Deuchar, *Noble Exercise*, Yale Center for
British Art 1983, pp. 31, 34

ENGRAVED
by George Townly Stubbs, titled 'The Sebra, or
Wild Ass . . .', printed for Carington Bowles, n.d.

Stubbs's purpose here is quite different from that in
subjects such as the lion and horse pictures on
which he allowed his imagination to brood,
portraying animals as protagonists in a drama of
savage combat. Here he wishes to record an
accurate likeness of the first zebra ever seen in
England; he takes that likeness with an exact eye
for conformation and markings, observing the
animal with the same scientific detachment as he
brings to the portraits of the rhinoceros, blackbuck
and moose (Nos. 87, 81 and 82–3). For this
purpose, the beautifully painted landscape
background is in a sense unnecessary; and indeed,
although the dappled light hints at the purpose of
the zebra's stripes, the setting is more suggestive of
English woodland than African plain.

Stubbs painted the zebra from life, from a female
animal brought from the Cape of Good Hope by Sir
Thomas Adams in H.M.S. *Terpsichore* and presented
to Queen Charlotte in 1762. The zebra was
installed in the royal menagerie at Buckingham
Gate. 'Some Account of the Zebra, or painted
African Ass, lately brought over and presented to
her Majesty' was published in the *London Magazine*,
XXXI, July 1762, with an anonymous engraving of
the zebra and its groom facing it. The magazine
noted that thanks to Her Majesty's good-natured
indulgence, 'numbers of people' had been to see the
zebra, 'one of the most beautiful creatures of the
world . . . now generally feeding in a paddock near
her majesty's house'. A description of the zebra
followed. Both the *London Magazine* engraving and
the engraved 'Portraiture of the Zebra or Wild Ass
Drawn from Life' by and after James Roberts (repr.
R. Lydekker, 'On Old Pictures of Giraffes and
Zebra', *Proceedings . . . of the Zoological Society of
London*, II, 1904, fig. 89) look very naïve compared
with Stubbs's painting; both engravings make the
zebra look more like a painted donkey.

78

LEOPARDS AT PLAY
*c.*1763–8

Oil on canvas, 40 × 50 in.
(101.5 × 127 cm.)
Private Collection

PROVENANCE
Presumably commissioned or purchased by the
3rd Viscount Midleton (d. 1765) or 4th Viscount,
thence by descent (offered at Christie's
26 October 1945, lot 00, bt. in at £68.5.0) until
sold by the 2nd Earl of Midleton, through Oscar
& Peter Johnson, 1962, to the present owners

EXHIBITED
Pictures and Drawings from Yorkshire Houses, Oscar &
Peter Johnson 1963 (15)

LITERATURE
Taylor 1969, p. 24; Taylor 1971, p. 208, pl. 39;
Leslie Parris, *George Stubbs A.R.A. 'Leopards at
Play' and 'The Spanish Pointer'*, 1974, pp. 8–11, repr.
(in reverse) p.9

ENGRAVED
by Stubbs, but probably from the Fitzwilliam
version of the subject, titled 'Tygers at Play',
published 25 February 1780 by Stubbs (No. 173
in this exhibition)

Parris (op. cit., pp. 10–11) notes that there are four
painted versions of this subject: (1) the painting
exhibited here, which shows the animals in an open
rocky landscape with palm trees on the right,
whereas the other three paintings, and the print,
show the animals at closer range in an enclosed
cave-like setting; (2) oil on panel, 38 × 53⅝ in.,
signed and dated 1779, in the collection of the Earl
of Yarborough, differing from the print in the
disposition of the foremost leopard's tail and
hindlegs; (3) oil in canvas, 54 × 71½ in., in the
Marquess of Rockingham's collection by 1782 (and
thence by descent), which Parris considers to be
the version closest to the print; (4) oil on canvas,
35 × 52½ in. Parris describes the latter version
(exh. Liverpool 1951, no. 55, as 'Panthers') as 'a
very worn painting and, if originally by Stubbs,
subsequently altered: one of the nearest leopard's
hind legs has been misread as the end of the other
leopard's tail'. But this version, presumably
acquired by Stubbs's patron the 2nd Earl of
Clarendon (and thence by descent) was praised by
Dr Waagen when he visited the Earl of Clarendon's
seat at Grove Park in 1854: he noted there that 'A
series of pictures by the admirable English animal-
painter Stubbs are distinguished by great truth of
nature – especially two leopards' (*Treasures of Art in
Great Britain*, II, 1854, p. 458). If the picture has
indeed suffered from restoration at the hands of

someone who did not understand those com-
plexities of Stubbs's technique which are noted
here on pp. 20–21, that restoration was pre-
sumably later than Dr Waagen's visit.

Parris notes (pp. 8–10) that although the subject
depicts two leopards, Stubbs called his print
'Tygers at Play', and moreover advertised his
prints of a tiger and sleeping leopard, a recumbent
leopard and a cheetah (Nos. 176, 177 and 179 in this
exhibition) indiscriminately as 'Tygers', ignoring
the distinctions between the species readily
available in the published works of such
contemporary authors as Pennant (whom Stubbs
would almost certainly have known) and
Goldsmith. Parris makes the point that Stubbs's
works themselves show that there was no confusion
in his mind between the different animals, and
comments that 'An explanation of Stubbs's
indiscriminate use of the word 'tyger', which he
seems to have employed in some generic sense, is
still needed.' The *Oxford English Dictionary* points
out that the word 'tiger' was commonly used
indiscriminately for animals of the same genus as
Felis tigris as late as 1785, to include, for instance,
jaguar and puma in America and panther and
leopard in South Africa. Stubbs may have
mistrusted attempts to differentiate between the
various members of the cat family, and preferred to
stick to the general word 'Tiger'.

79*

CHEETAH AND STAG WITH TWO INDIANS
exh. 1765

Oil on canvas, $71\frac{1}{8} \times 107\frac{5}{8}$ in.
(180.7×273.3 cm.)
City of Manchester Art Galleries

PROVENANCE
Commissioned by Sir George Pigot, thence by
descent until sold by the Trustees of Sir George
Pigot's Will Trust, Sotheby's 18 March 1970
(30, repr.), bt. Agnew for Manchester City Art
Gallery, with grants from H.M. Treasury and the
National Art-Collections Fund

EXHIBITED
probably the picture exhibited at the Society of
Artists, 1765 (126, 'Portrait of a hunting tyger');
Empire of India Exhibition, Earl's Court, London,
1895 (55); Liverpool 1951 (35); Whitechapel 1957
(48, pls. VIII–IX); *British Painting 1700–1900*,
British Council, Pushkin Museum, Moscow and
Hermitage, Leningrad, 1960 (24); *La Peinture
Romantique Anglaise et les Préraphaélites*, Petit Palais,
Paris 1972 (251, repr.); *Eighty Years On: The
National Art-Collections Fund*, Manchester City Art
Gallery 1983 (45)

LITERATURE
Gilbey 1898, p. 176; Sir George Clutton, 'The
Cheetah and the Stag', *Burlington Magazine*, CXII,
1970, pp. 539–40; Basil Taylor, 'George Stubbs's
painting of a Cheetah with two Indians', in *Art at
Auction 1969–70*, 1970, pp. 10–19; Mildred
Archer, *India and British Portraiture 1770–1825*,
1979, p. 413 (repr.)

The cheetah was presented to George III by Sir
George Pigot (portrayed in No. 106), presumably
soon after his return in May 1764 from his first
period of service as Governor-General of Madras;
very sensibly, Pigot had arranged for two trained
Indian handlers to accompany the animal.

That princes should be presented with gifts of
exotic animals, especially those associated with the
chase, was a long-standing tradition. Mogul
emperors had kept cheetahs trained to hunt gazelle
and antelope. Many later European rulers owned
cheetahs; Taylor notes their portrayal in such
works as Stradamus's *Venationes* engravings, in
Pisanello's drawing in the Louvre and in Titian's
'Bacchus and Ariadne' (National Gallery); but this
cheetah seems to have been the first ever seen in
England.

George III gave the cheetah into the care of his
brother the Duke of Cumberland, Ranger of
Windsor Forest, who kept a menagerie. At twelve
o'clock on Saturday 30 June 1764 the Duke staged
an experiment in Windsor Great Park. According
to newspaper reports quoted by Clutton, he
wished to discover how cheetahs attacked their
prey. After creating an arena with nets, he
arranged for one of the Windsor Forest stags to be
placed within it. The cheetah was then let loose
within the arena. It immediately attacked the stag
and tried to seize it by the flank: the stag drove it
off with its antlers. The cheetah again attacked and
was again driven off. On its third attempt, the
cheetah was tossed away by the stag, took to its
heels and escaped to the woods, where it attacked
some fallow deer and killed one at once. While it
was devouring its prey, the Indian attendants
caught it, covered its head with a hood, put on its

collar and secured it. Though the incident was anti-climactic, the Duke at least had the satisfaction of observing how the cheetah attacks its prey: Clutton quotes a report that 'the motions of the cheetah were somewhat like those of a cat creeping slowly on the ground till within reach of its prey, and then by a spring, leaping on it'.

Taylor (op. cit.) is at some pains to insist that Stubbs was 'not interested in the treatment of events, let alone being true to the actuality of them'. If Stubbs had attempted to depict the reality of that experiment in Windsor Park, he would not have painted the stag standing impassively within reach of the cheetah's spring (a later Pigot had the stag painted out because its pose was so unnatural: the picture was exhibited in 1951 with no stag visible). Instead, Taylor stresses Stubbs's 'noble and formal' design. 'Here is the cheetah marvellously presented in all its physical power, energy and grace. It wears the accoutrements of a creature trained for hunting, the hood used to cover its eyes and the sash by which it could be held before release. Here are the Indian servants who manage it, portrayed without a trace of superstition or European condescension; they are among his finest portraits. The landscape has a slightly exotic appearance, as well as being constructed with a sufficient largeness of design to contain the monumental group at its centre. Confronted by this splendid subject and perhaps influenced somewhat by Pigot's expectations, Stubbs here created the most ambitious of all his wild animal paintings, if we except the largest version of the subject which shows a lion attacking a horse. It had no precedent in the history of English art.'

Mildred Archer (op. cit.) singles out Stubbs's portrayal of the two Indians as 'the only portraits which depict Indians with true authenticity . . . They are perhaps the finest renderings of Indians in British painting and reflect the deep sincerity of Stubbs's own nature free from all preconceived literary notions of the Indian character'. In correspondence with the Keeper of Paintings at Manchester City Art Gallery during 1974, a natural historian from India pointed out that unlike the cheetah, the stag cannot have been painted from life: 'it has the three-pronged antlers of the Indian Sambar (cervus elaphus) but the body and ears of the British red deer'.

It is uncharacteristic of Stubbs to 'invent' an animal, but it would have been characteristic of him to have asked the Indian attendants what sort of deer the cheetah was accustomed to trace, and then attempted to represent it, with antlers which seemed to correspond with the description.

The collection of natural history prints and drawings bequeathed by Sir Thomas Banks to the British Museum includes a study in gouache of the cheetah by Peter Paillou, inscribed verso in Banks's hand 'copied from a painting by Stubbs taken from the living animal in L^d Pigot's possession' (1914-5-20-230).

80

HOUND COURSING A STAG
*c.*1762–5

Oil on canvas, 40 × 50 in.
(101.6 × 127 cm.)
Inscribed 'Geo. Stubbs / pinx (. . .)' lower
right
Philadelphia Museum of Art; purchased for
the W.P. Wilstach Collection and with the
John D. McIlhenny Fund and gift (by
exchange) of Samuel S. White, 3rd, and
Vera White, Mrs R. Barclay Scull and
Edna M. Welsh

PROVENANCE
Presumably commissioned or purchased by
George Brodrick, 4th Viscount Middleton, then
by descent until sold by the 2nd Earl of
Middleton, sold Christie's 26 October 1945 (35),
bt. Agnew; Stevens & Brown; Henry L. Straus,
U.S.A., sold Sotheby Parke-Bernet, New York,
8 November 1950 (52); E.J. Rousuck, New York;
Edgar Thom, from whose estate sold Christie's,
New York, 18 January 1984 (170, repr.), bt.
Leger, from whom purchased by the Philadelphia
Museum of Art

EXHIBITED
Liverpool, 1951 (23, as 'The Monarch o' th'
Moor')

LITERATURE
Taylor 1971 pl. 46 (as dated '1769', evidently
misreading of the almost illegible 'pinx . . .'

The stag appears in a very similar pose and with
seemingly identical antlers in 'The Grosvenor
Hunt' (No. 39); evidently Stubbs worked from the
same study for both finished works. This picture
may be very close in date to 'The Grosvenor Hunt',
which is dated 1769. Stubbs's studio sale included
'Landscape with a Stag, a Scene from Nature in
Goodwood Park' (Lot 51, with 'A Sea View . . .' on
26 May 1807), which may have been this picture. If
so, Stubbs presumably made studies for it while he
was working for the Duke of Richmond at
Goodwood, and took them with him when he
moved on to Eaton Hall.

The landscape is particularly fine, painted in
clear silvery tones, and the picture is in very good
condition. It was exhibited in 1851 as 'The
Monarch o' th' Moor', a wildly unsuitable title for
any work by Stubbs, and thought to have been
invented by E.J. Rousuck.

81*

BLACKBUCK
? *c*.1770–8

Oil on canvas, 24 × 28 in. (61 × 71.1 cm.)
Hunterian Art Gallery,
University of Glasgow

PROVENANCE
? Commissioned by William Hunter; included in
his bequest to the University of Glasgow, 1783

EXHIBITED
Liverpool 1951 (18, as 'Pygmy Antelope')

LITERATURE
J. Laskey, *A General Account of the Hunterian
Museum*, Glasgow, 1813

The following note has kindly been contributed by
Dr W.D. Ian Rolfe, Deputy Director, Hunterian
Museum, University of Glasgow.

The subject of this painting was previously
thought to be the 'Pygmy antelope', a foot-high
animal with minute horns, now known as the Royal
antelope (*Neotragus pygmaeus*). It was re-identified
in 1980 as the blackbuck (*Antilope cervicapra*) by
Dr D. Houston of Glasgow University's Zoology
Department, who also suggested that the animal's
deformed horns indicate that it was badly fed while
in captivity, probably in some unidentified
gentleman's menagerie.

The Latin name *Antilope cervicapra* for the
blackbuck echoes the ancient belief that the species
lay somewhere between the deer and the goat.
Such animals of 'middle nature' were of great
interest to William Hunter; his interest in the
nylgau antelope, halfway between black cattle and
deer, and the moose, halfway between horse and

deer, has already been noted. John Hunter also had
several specimens in his museum (one a present
from Queen Charlotte) which are thought to be a
blackbuck. There was much experimental cross-
breeding of fertile hybrids, termed 'mules' at this
time, in the hope of deriving new and valuable
strains of animal.

Buffon (1764) had made a valiant attempt to
distinguish the various antelopes that had been
'confounded with each other by travellers', but had
to acknowledge 'that the labour overbalances the
produce'. Contemporary medical interest in
antelope derived partly from the tradition that one
particular species yielded the stomach-stones or
bezoars much valued as antidotes to poison or for
ridding victims of the stone. Buffon concluded that
in fact all antelope, indeed probably all
quadrupeds, could yield such bezoars. William
Hunter had a large collection of bezoars, and
worked on them actively between at least 1764 and
1778; this may partly account for his interest in
acquiring a painting of the blackbuck.

Unlike the 'Nylghau', 1769 (Hunterian Art
Gallery) and 'The Duke of Richmond's First Bull
Moose', 1770 (No. 82), this study of the blackbuck
is not a finished painting, and was evidently not
commissioned, as the other two were, because
Hunter wanted an 'exact representation' which
would be sufficiently 'faithful and expressive' not
only to provide him with a permanent record of a
particular animal in which he was keenly interested
but also to furnish an engraver with material to
illustrate a published paper. Evidently Hunter's
interest in the blackbuck was sufficiently limited
for this study (which he may have seen in Stubbs's
studio rather than directly commissioned) to
satisfy him. William Hunter's collection of
drawings includes two watercolours of a springbok
(*Antidoreas marsupialis*), by Frederick Birnie, dated 4
December 1778 (University of Glasgow, Hunterian
Library, HF 184-1-2).

82*

THE DUKE OF RICHMOND'S FIRST BULL
MOOSE
dated 1770

Oil on canvas, 24 × 27¾ in.
(61 × 70.5 cm.)
Inscribed 'Geo: Stubbs pinxit / 1770'
lower r.
Hunterian Art Gallery, University of Glasgow

PROVENANCE
Commissioned by William Hunter; bequeathed
by him to the University of Glasgow 1783

EXHIBITED
National Gallery of Scotland 1950;
Liverpool 1951 (22); *The Hunterian Collection*,
Kenwood 1952 (36); *Glasgow University's Pictures*,
Colnaghi 1973 (6, pl. V); Tate 1976 (32).

LITERATURE
J. Laskey, *A General Account of the Hunterian
Museum*, 1812, p. 87, no. 7 in List of Pictures;
W.D. Ian Rolfe, 'William Hunter (1718–1783) on
Irish "elk" and Stubbs's *Moose*', *Archives of Natural
History*, 1983, XI, 2, pp. 263–90; W.D. Ian Rolfe,
'A Stubbs drawing recognised', *Burlington
Magazine*, CXXV, 1983, pp. 738–41.

ENGRAVED
by Peter Mazell, exh. Society of Artists 1783
(163), repr. Thomas Pennant, *Arctic Zoology*
[1785], pl. VIII, facing p. 17, entitled 'Moose
Deer'.

The Duke of Richmond's first bull moose arrived in
England from Quebec in September 1770; it was a
yearling, sent as a present from the Governor-
General of Canada to a nobleman who, with others
of his circle, was evidently interested in the
possibilities of breeding and domesticating the
species. This moose was, in William Hunter's
words, 'the first male I believe that ever was seen in
Great Britain'. Females of the species had already
arrived, and other bull moose were to follow in
1772–3. That it was the Duke of Richmond's first
bull moose which Hunter commissioned Stubbs to
paint (and not, as has been suggested in previous
exhibition catalogues, the moose which Horace
Walpole saw at Lord Orford's in 1773), has been
conclusively proved by Rolfe (op. cit.), who throws
a brilliant light on Hunter's interest in the animal
and on his purpose in commissioning Stubbs to
paint it. It is from Rolfe's articles, with his
permission, that these notes, much condensed, are
drawn.

Soon after the arrival of the Duke of Richmond's
first bull moose, Hunter went to observe the
creature. He then obtained 'leave to have a Picture
of it made by Mr. Stubbs, in the execution of which,
no pains were spared by that great Artist to exhibit
an exact resemblance both of the young animal
itself, and of a pair of Horns of the full-grown
Animal, which the General had likewise brought
from America and presented to the Duke'. Since
Stubbs's painting is dated 1770, it must have been
made within four months of the moose's arrival.

Hunter's keen interest in the moose derived
from his continuing interest in the probability that
certain animal species had become extinct.
Acceptance of such a probability was anathema to
most of his contemporaries, to whom it seemed like
doubting divine providence. Hunter had already
proved, at least to his own satisfaction, that the
creature now known as the mastodon was extinct,
concluding, in a Royal Society paper of 1768, that
'though we may as philosophers regret it, as men
we cannot but thank heaven that its whole
generation is probably extinct'.

Hunter was also inclined to think that the Irish
'elk', known only by excavations of its gigantic
fossil horns, was also extinct, but had first to satisfy
himself that the young Canadian moose would not
develop antlers of similar size, and thus prove itself
the living representative of the same species. He
therefore embarked upon a systematic in-
vestigation, beginning with detailed observation of
the Duke of Richmond's first bull moose,
continuing with all other available specimens, and
including an attempt to discriminate the moose
from the European 'elk' (a term used as
indiscriminately as the term 'tiger'). In this latter
research he experienced considerable frustration;
he considered earlier representations of the
European 'elk', in the works of such authors as
Aldrovadus, Gessner, 'the French Academicians'
and Buffon were largely fanciful, and certainly
useless as scientific records: 'It is much to be
questioned if any of the Authors above mentioned
would have known an Elk if they had seen one'.
What Hunter needed from Stubbs was 'an exact
resemblance' which would provide a permanently
reliable record of the particular animal presently
under his own scrutiny.

Hunter recorded the results of his research in a
manuscript entitled 'The Original [Canadian
French term for the moose] from Quebec', which he
intended for publication in the Royal Society's
Philosophical Transactions. Because he could not
satisfy himself on the future antler development of
the Canadian moose (all the animals available for
his first-hand study were too young), he judged his
case for providing that the Irish 'elk' was extinct
was insufficiently established, and refrained from
publishing his paper (it is published in Rolfe,
Archives, op. cit., pp. 263–76).

Probably Hunter intended to have Stubbs's
painting on display if and when he read his paper to
members of the Royal Society, and to include an
engraving of it with the publication of his paper: he
was to follow such procedures in his paper on the
Nylghau, read and published the following year
(1771). 'Good paintings of animals give much
clearer ideas than descriptions', he commented in
that paper. He was evidently well satisfied with the
'exact resemblance' of Stubbs's painting to the
Duke of Richmond's first bull moose, announcing
that his own description (which is in fact
meticulously detailed) would mention 'only such
things as cannot be understood by seeing the
Picture itself, or an accurate engraving'. It should
be emphasized that this description, like Stubbs's
painting, is of one particular animal presented to
the Duke of Richmond in 1770; any difference
between that animal and others of the species could
and would (see No. 83) then be detected. For
permission to quote the following extracts from
Hunter's paper on 'The Original from Quebec'
(Hunter Papers, H150, Glasgow University
Library, as published by Rolfe, *Archives*, op. cit.,
pp. 265–6) we are grateful to the Librarian,
Glasgow University Library, and to the Society for
the History of Natural History.

'*Proportion.* The peculiarity in this animal which predominates and first strikes the Eye is his height, or stilt-like length of legs, with a disproportional shortness of Neck . . . This uncommon proportion among the parts of his body shews that he is made for feeding on Trees and on the rank herbage of marshy grounds, which we are assured in fact furnish his favourite pasture . . .

'*Colour and Hair.* His colour in general is between grey and brown – in some situations with regard to the light the colour is more yellow, in others more red. The lower parts of his legs are of a very light brown, or dirty white colour. His hair is loose or shaggy upon his body, especially over his buttocks as in a horse that is casting his coat; upon the fact and legs it is short, and lies flat or sleek.

'*Mane.* His mane is characteristic. It begins at once behind the summit of his head, & terminates at once beyond the hump over his shoulders. It consists of long, bristly, erect hairs, inclining a little backwards.

'*Head.* His head has likewise a peculiar character, especially in the convexity of the Nose, and in the length of the upper lip . . .

'*Guttural Caruncle.* This is a pendulous piece of flesh, of the size of a man's finger, covered with skin and hair, hanging down from the throat, exactly in the angle between the head & neck.

'*Food.* He was very fond of Apples, of bread, of Bran, of some herbs, particularly clover, both fresh and dry, and of the leaves of most trees and shrubs. He would eat, but did not much relish Otes; and would not taste grass not Hay, nor straw. He drank slowly. He ruminates . . .

'*Motion.* His walk was grave & slow; his Trot swift or rapid, and attended with a smart cracking noise, either from his hoofs or joints . . .

'*Manners.* He appeared to be more intelligent, more grave, & docile than a Horse of the same Age, and less apt to be offended. He knew his keeper, and there was a very sincere and mutual friendship between them: but he was so little shy of strangers, that he would follow anybody who would shew him a piece of bread or an Apple.

'When he is a little teized with stroaking or rubbing, or only touched by a stranger, he makes a whining or moaning noise through his Throat & Nose, exactly like the sound of a sick or peevish child.

'The Heat of the weather was supposed to oppress him; & therefore his keeper had been instructed to throw a Pale-full of water over him now & then to cool him. He appeared to be pleased with it, and always shook himself after it exactly as a horse does when wet or dirty.'

83

THE DUKE OF RICHMOND'S SECOND BULL MOOSE
datable 1773

Pencil, $7\frac{3}{8} \times 8\frac{5}{8}$ in. (18.8 × 22 cm.)
Glasgow University Library

PROVENANCE
Presumably commissioned by William Hunter; included in his bequest to the University of Glasgow, 1783

LITERATURE
W.D. Ian Rolfe, 'William Hunter (1718–1783) on Irish "elk" and Stubbs's *Moose*', in *Archives of Natural History*, 1983, XI, 2, pp. 263–90; Martin Kemp, 'Glasgow University, Bicentenary Celebrations of Dr. William Hunter (1718–83)', *Burlington Magazine*, CXXV, 1983, p. 383; W.D. Ian Rolfe, 'A Stubbs drawing recognised', *Burlington Magazine*, CXXV, 1983, pp. 738–41, repr. fig. 13.

ENGRAVED
(detail) by Peter Mazell. His line-engraving of the moose's head and shoulders, in a mountainous landscape, oval, above writing-engraving 'G Stubbs Del' (left) and 'P. Mazell Scul', was published in Thomas Pennant, *Arctic Zoology*, I [1785]; it is repr. in Rolfe, *Archives*, 1983 (op. cit.), p. 269, fig. 4, and in Rolfe, *Burlington*, 1983 (op. cit.), p. 740, fig. 14.

For the Duke of Richmond's first bull moose and William Hunter's continuing research into the species, see No. 82. Rolfe's papers (op. cit.) again provide the information for this entry, and for the attribution of No. 82 to Stubbs.

The Duke of Richmond's second bull moose had arrived in England by 4 October 1773; that day Hunter went to see it, accompanied by 'Dr. Solander and several of his friends, carrying with us Mr. Stubbs's picture'. Hunter had already pronounced that painting (No. 81) to be 'an exact resemblance' of the Duke of Richmond's first bull moose; now he intended to use it to observe the 'principal differences' between the first bull moose, a yearling, and the newly arrived creature, which was considerably more fully grown' and aged about two and a half years.

As Rolfe comments, 'Here then we see Stubbs's picture being used as an accurate visual record, as a working tool' of the eighteenth-century natural historian (*Burlington*, 1983, p. 738). Hunter's particularization of the 'principal differences' he observed in the Duke of Richmond's second bull moose included the distinctive feature of the pendulous 'bell' or 'caruncle' hanging from the throat, 'whose extremity when the hair was burned off was round'; maturing antlers 'dividing into an ascending and descending broad branch – and each of these into an inner and outer branch'; and 'remarkably long and awkward hoofs on the forefeet'.

These 'differences' are clearly delineated in this pencil drawing, unsigned and undated, which Rolfe convincingly attributes to Stubbs. Evidence that the drawing is by Stubbs lies in the writing-engraving 'G Stubbs Del' below Peter Mazell's engraving of this particular moose's head, antlers and shoulders, reproduced on the title-page of Thomas Pennant's *Arctic Zoology*, I [1785]; apart from the engraver's addition of 'arctic mountains' in the background, the physical features of the moose are faithfully reproduced from the drawing. Martin Kemp (op. cit.), perceiving 'weak articulation' in the newly discovered drawing, expresses doubt as to whether it can be Stubbs's original. Neither Rolfe nor this compiler would claim that No. 83 is a particularly distinguished drawing. It is a documentary record, which is presumably what Hunter wanted; it is certainly more assured than drawings of the same animal made by John Frederick Miller for Sir Joseph Banks (noted in Rolfe, *Archives*, 1983, p. 280, no. 23). Though No. 83 lacks the expressive vitality of the drawings of lemurs made by Stubbs for Sir Joseph Banks (No. 84), the only surviving drawings by Stubbs which can certainly be dated to around 1773, No. 83 appears to be stylistically consistent with some of the less finished drawings which Stubbs made for his *Comparative Anatomical Exposition* in the 1790s. Comparison with such drawings in this exhibition should help to authenticate No. 83.

84

MARMADUKE TUNSTALL'S MOUSE LEMUR: THREE SHEETS OF STUDIES
1773

(i) Two studies, in different attitudes
Pencil, $7\frac{3}{4} \times 10\frac{1}{8}$ in. (19.7 × 25.7 cm.)
Inscribed verso, ? by Sir Joseph Banks, 'From an animal alive in the possession of M. Tunstal Esqre 1773 by Mr. Stubbs 3 papers / of sketches / Lemur murinus'

(ii) Study of the lemur walking to the left, toes clenched
Pencil, $7\frac{13}{16} \times 12\frac{3}{16}$ in. (19.8 × 30.8 cm.)
Inscribed 'Lemur murinus' lower centre and, in a different hand, 'Stubbs' lower left

(iii) Six studies, in different attitudes
Pencil, $7\frac{3}{4} \times 12\frac{9}{16}$ in. (19.7 × 32 cm.)
Inscribed 'Lemur murinus' lower centre and, in a different hand, 'Stubbs' lower right
Trustees of the British Museum

PROVENANCE
Presumably commissioned by Sir Joseph Banks, and in the collection of 811 natural history drawings and prints bequeathed by him to the British Museum

EXHIBITED
(i)–(iii) Walker Art Gallery 1951 (95–97); (iii) Whitechapel 1957 (75); (i)–(ii) Tate 1976 (35, ii repr. p. 54)

LITERATURE
Jonas Dryander, MS Catalogue of Drawings of Animals in the Library of Sir J. Banks (British Museum, Natural History), p. 5: '+ L. Murinus Penn. Ad viv. Stubbs'; W.D. Rolfe, 'A Stubbs drawings recognised', *Burlington Magazine*, CXXV, 1983, p. 738, note 2

Rolfe (op. cit.) notes that the mouse lemur which provided Stubbs's subject was kept alive for a long while in Welbeck Street, London, where it formed part of an extensive collection of living animals kept by Marmaduke Tunstall F.R.S., F.S.A. (1743–1790), in order that he might 'study their habits, manners and economy'. Sir Joseph Banks, who was 'familiar with Tunstall's collections' (ed. W.R. Dawson, *The Banks Letters*, 1958, p. 634), presumably asked Stubbs to accompany him to Welbeck Street in 1773 to make drawings of the lemur. Rolfe (in correspondence with the compiler) suggests that the inscription on the verso of (i) is in Banks's hand, while the inscription 'Stubbs' on (ii) and (iii) is in the hand of Banks's librarian, Dr Dryander.

A hitherto unfamiliar animal such as Marmaduke Tunstall's mouse lemur quickly attracted the attention of natural historians. Thomas Pennant, who called the animal 'the Little macauco', published the following description of

the same lemur that Stubbs drew: 'head and body of an elelgant light grey: inside of the ears white: orbits rufous: tail far exceeds the body in length: bushy at the end, and of a bright rust colour: nails flat and rounded: size about twice that of a mouse' (*History of Quadrupeds*, 1781, p. 217). Rolfe notes that an etching of the same lemur was published by Peter Brown, Botanical Painter to the Prince of Wales, in his *New Illustrations of Zoology*, 1776, pl. XLIV.

Marmaduke Tunstall later moved to Wycliffe, Yorkshire, where he established his collections in a house inherited from an uncle; the collections were later purchased by George Allan, and eventually passed with Allan's collections to the Library and Philosophical Society of Newcastle-on-Tyne; the mouse lemur was among the specimens noted there in 1827 (G.T. Fox, *Synopsis of the Newcastle Museum, late the Allan, formerly the Tunstall, or Wycliffe Museum*, 1827, p. 10).

Sir Joseph Banks commissioned at least two other works from Stubbs. Stubbs's painting of a kangaroo, studied (unlike the lemur) not from life but from a drawing by Sydney Parkinson, the draughtsman who accompanied Banks on Captain Cook's *Endeavour* voyage, was exhibited at the Society of Artists in 1773 (318, as 'The Kongouro from New Holland, 1770'; repr. Taylor 1981, fig. 10); an engraving of this subject by Issac Taylor is in the Banks Collection in the British Museum. Stubbs's painting of 'A Dingo Dog' (? brought back alive by Banks) was also exhibited in 1773 (319). Both paintings are now in the collection at Parham Park. Stubbs's studio sale included a painting there described as 'A Horse in a spirited action with the Portrait of a celebrated Dog, Carlo, the Property of Sir Joseph Banks' (27 May 1807, lot 74); this work, evidently not commissioned by Banks, has not been traced.

(i)

Lemur murinus

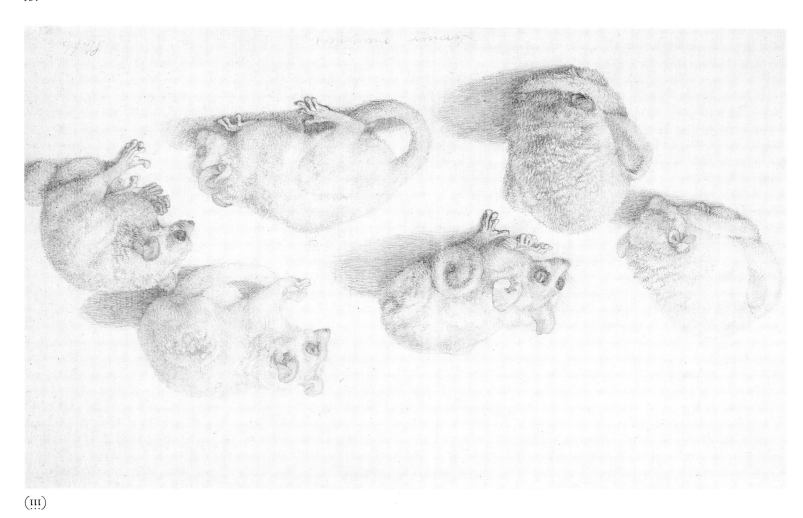

(iii)

(ii)

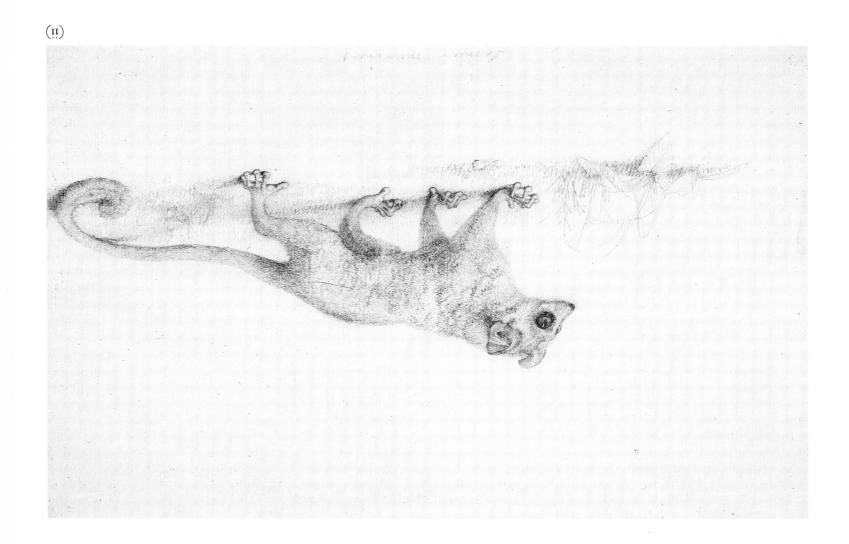

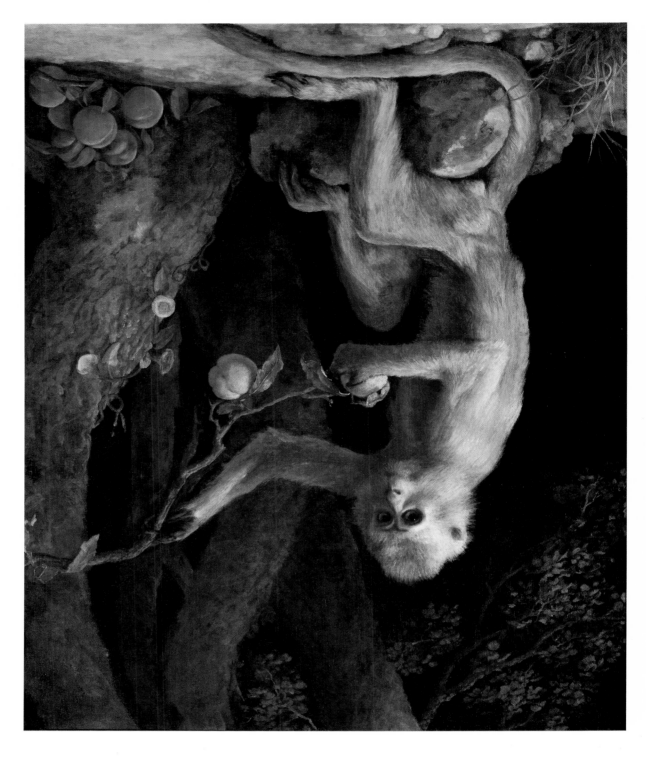

85

PORTRAIT OF A MONKEY
dated 1774

Oil on panel, 27¾ × 23¾ in.
(70.5 × 60.3 cm.)
Inscribed 'Geo: Stubbs / 1774' lower left

Private Collection

PROVENANCE
Unknown before 1971; anon. sale, Sotheby's
13 October 1971 (41, as Stubbs, After. *A
Monkey plucking peaches from a branch, bears
signature . . .*'), bt. by the present owner

EXHIBITED
R.A. 1775 (304); on loan to Walker Art Gallery,
Liverpool, July–September 1972; *The Eye of
Thomas Jefferson*, National Gallery of Art,
Washington 1976 (123, as 'Green Monkey',
repr.); Tate 1976 (34, repr. p. 53)

A later version, signed and dated 1798, in the
collection of the Walker Art Gallery, Liverpool
(repr. Taylor 1971, pl. 129), was shown in the two
previous *Stubbs* exhibitions, at Liverpool in 1951
(66) and at Whitechapel in 1957 (56). When the
painting now exhibited here appeared at Sotheby's
in 1971, it was generally presumed to be a copy of
the Walker picture, although the Royal Academy
exhibition catalogues record that Stubbs exhibited
'A Portrait of a Monkey' in 1775 and 'A Monkey' in
1799 (177), and he would not have exhibited the
same picture twice. The versions dated 1774 and
1798 are the same in composition and virtually the
same in size, but there is a far more powerful sense
of immediate observation from life in the earlier
version.

As noted in the Tate's 1976 exhibition
catalogue, the subject has often been entitled 'The
Green Monkey', but Prue Napier and Daphne
Hills, of the Mammals Section, Department of
Zoology, British Museum (Natural History), point
out that this is an incorrect identification, as the
green monkey is distinguished not only by the
greenish tinge of its soft outer hairs but also by its
black face. They identify Stubbs's monkey as
'probably a young specimen of the crab-eating
macaque (*M. fascicularis*) from South-East Asia',
and point out that it is unlikely to have been
instinctively disposed to eat the peaches it is here
portrayed with. *M. fascicularis* is quite an ordinary
little monkey, probably not uncommon in England
in the eighteenth century. Stubbs's subject may
have been observed in a patron's private menagerie
(or among his household pets) or in one of the many
commercial menageries in and around London.

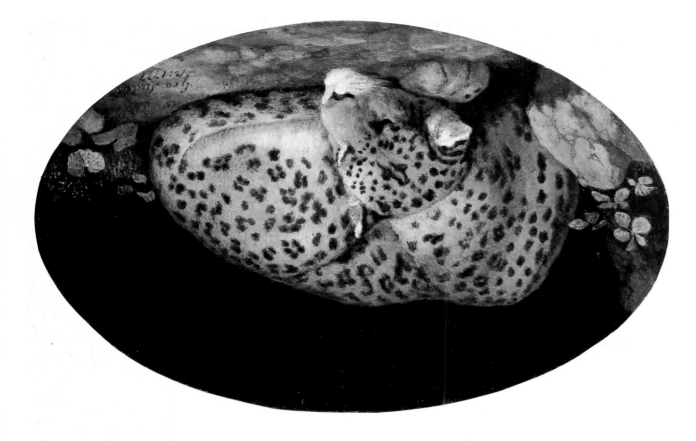

98

SLEEPING LEOPARD
dated 1777

Enamel on Wedgwood biscuit earthen-
ware, 4¼ × 6⅝ in. (13 × 16.8 cm.), oval
Inscribed 'Geo. Stubbs / pi: 1777' lower
right, and impressed 'WEDGWOOD'

Paul Mellon Collection, Upperville, Virginia

PROVENANCE
? Lot 64 in the first day of the artist's sale,
26 May 1807, 'SLEEPING TIGER – in enamel';
purchased (? at the sale) by William Hoare,
Principal of Burlington House Academy,
Hammersmith, London, and in his collection by
c.1820; thence by descent to Janet Faurschou,
Manitoba, Canada, from whom purchased by
Mr Paul Mellon K.B.E., 1974

LITERATURE
Bruce Tattersall, 'A Sleeping Leopard by George
Stubbs', *Burlington Magazine*, 1976, fig. 93; Bruce
Tattersall, cat. entry no. 87, pp. 90–1, in Egerton
1978

ENGRAVED
by Stubbs as a detail of a print published 1 May
1788 (No. 189). In the engraving the sleeping
leopard appears in the same pose as in the enamel
(though in reverse direction), curled up behind a
tiger.

This enamel is the earliest recorded example of
Stubbs's work upon Wedgwood Queen's Ware. It is
likely to have been painted before the potter had
begun to manufacture 'canvasses' for the artist.
Unlike all Stubbs's other enamels on Queen's Ware,
this painting is upon an already glazed oval
which were painted on once-fired unglazed biscuit,
fragment. Rather than having been deliberately
manufactured for the artist, the oval was probably
cut out of the bottom of a dish with a grinding
wheel. The position of the impressed mark
Wedgwood, at the very edge, where all the lower
sections of the letters are lost, further indicates
that the oval was cut out of a larger dish; the
nature of the mark and the colour of the glaze
indicate a date in the late 1760s for its manufacture.
The smallness of this oval also makes it unlikely
to have been purposely made by Wedgwood for
Stubbs, since one of Stubbs's principal intentions in
asking Wedgwood to make plaques for him was
that he wished to secure larger panels for his
enamels than was possible with copper. All the
evidence suggests that the 'Sleeping Leopard' was
painted by Stubbs as a *morceau de reception* to
demonstrate the possibilities of painting in enamel
on Queen's Ware.

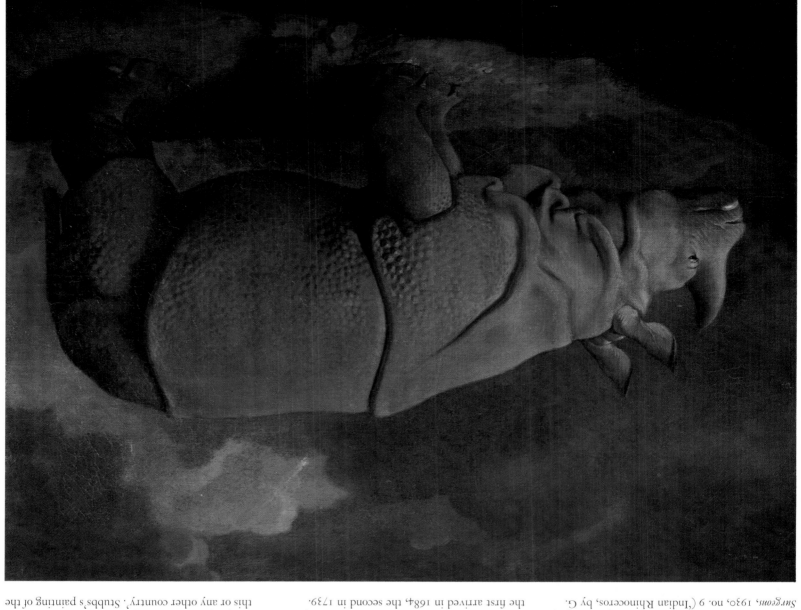

RHINOCEROS

? painted in 1790 or 1791

Oil on canvas, 27½ × 36½ in.
(69.9 × 92.7 cm.)

Private Collection

PROVENANCE
Presumably commissioned or purchased by John Hunter for his Museum, which was later entrusted to The Royal College of Surgeons of England by Parliament

EXHIBITED
Liverpool 1951 (57); Whitechapel 1957 (53); *The Eye of Thomas Jefferson*, National Gallery of Art, Washington 1976 (122, repr.)

LITERATURE
William Clift, 'A List of Paintings and Drawings numbered according to the situation in which they were placed . . .' in Mr Hunter's Museum in Castle Street, Leicester Square', MS, 1816, p. 5, no. 7; do, 'Pictures delivered May 3rd 1819', MS, no. 5; 'List of Portraits in the Court Room of the College', MS, 1820, no. 31 (these manuscripts are in the collection of the Royal College of Surgeons); Sir Arthur Keith, *Hunterian and other pictures in the Museum Collection of the Royal College of Surgeons*, 1930, no. 9 ('Indian Rhinoceros, by G. Stubbs'); Basil Taylor, *Animal Painting in England*, 1955, pp. 36, 63; Taylor 1971, pp. 30, 210, pl. 72; Parker 1971, p. 86; T.H. Clarke, 'The Iconography of the Rhinoceros from Dürer to Stubbs', *Connoisseur*, CLXXXV, 1974, repr. p. 115 as 'c.1790'; Egerton 1976, p. 31; William Gaunt, *Stubbs*, 1977, p. 7; Richard D. Altick, *The Shows of London*, 1978, p. 39

The foremost authority on the rhinoceros in art is Mr T.H. Clarke. The compiler is extremely grateful to Mr Clarke for allowing her to read the relevant chapter in his forthcoming book *The Rhinoceros from Dürer to Stubbs 1515–1799*, and to use his research for this entry.

Mr Clarke asks two key questions about this picture: when was it painted, and how can we be sure that it is by Stubbs? In the 1957 Stubbs exhibition catalogue the picture was stated to have been painted 'circa 1772' from an animal then on show in London, and all subsequent references (except for Mr Clarke's 1974 article) have accepted that dating uncritically, since it seemed to accord with a statement in Loisel's pioneer work on European menageries that 'at the end of the century . . . the London public had the opportunity of seeing two rhinoceroses, one that was exhibited in 1770 and the other in 1799'. But as Mr Clarke points out, there was no rhinoceros in London in 1770; Loisel's '1770' must be an error (possibly a printer's error) for '1790', when there certainly was a rhinoceros. It was the third to be seen in England; the first arrived in 1684, the second in 1739.

In the summer of 1790 a rhinoceros, apparently a young animal, arrived in an East Indiaman as a gift to Mr Dundas, who either gave or more probably sold it to Thomas Clark, lessee of Exeter 'Change and the Lyceum in the Strand, where he mounted exhibitions of curiosities, not merely animal. The rhinoceros was on view at the Lyceum by 26 July 1790, when the *Morning Herald* reported 'We hear Mr. Clark of Exeter Change is singular in his possessions, having perhaps what no Englishman before has had, the supporters of the King's Arms alive, a Lion and Male Unicorn . . . a greater living curiosity has never appeared in this country'. Clarke quotes what is evidently a first-hand account of the rhinoceros, recorded by the Rev. W. Bingley in 1805: 'He exhibited symptoms of no ferocious propensity, and would even allow himself to be patted on the back or sides by strangers. His docility was about equal to a tolerably tractable pig . . . He was very fond of sweet wines, of which he would often drink three or four bottles in the course of a few hours'. His voice was not much unlike the bleating of a calf. It was most commonly exerted when the animal observed any person with fruit or other favourite food in his hand, and in such cases it seems to have been a mark of his anxiety to have it given him.'

Over the next year, the rhinoceros continued on show at the Lyceum, where it was joined in December 1790 by 'three stupendous Ostriches' and by 'The Royal Lincolnshire Ox, allowed by best judges to be the largest and fattest cow bred in this or any other country'. Stubbs's painting of the

*87

Lincolnshire Ox is in the collection of the Walker Art Gallery, Liverpool.

From June 1791 until early in 1793 there were no advertisements for the rhinoceros, which may have been on tour. On 7 February 1793 Gilbert Pidcock announced that 'having purchased the principal part of Mr. Clark's collection, in addition to his own, he flatters himself that it is the largest collection of the Animal and Feathered Creation ever exhibited to the Public'. There followed a period of exuberant advertising, in which Pidcock issued handbills, posters and even token halfpennies bearing the rhinoceros's image. On 3 June 1793 the rhinoceros appeared by royal command at Windsor: 'This Day Her Majesty sent to Mr. Pidcock the Exhibitor of the Rhinoceros, for that Animal to be brought to the Queen's Lodge, for the Queen and Princesses to view it. It was of course immediately drawn in the Machine before the Lodge, the appearance of which highly gratified them and the KING'. A few days later it was on show at Ascot Races, and then began a western tour; but it sustained an injury to one of its forelegs in the summer of 1793, and soon afterwards at Corsham near Portsmouth, the rhinoceros died.

This compiler has little doubt that the painting of the rhinoceros is by Stubbs; the realism with which it is observed is consistent with that in other paintings by Stubbs for John and William Hunter, and the manner in which its solid bulk fills the canvas, the colouring and the handling of foreground shadow and distant light all seem characteristic of Stubbs. Hunter was particularly interested in the *rhinoceros unicornis* and there is no doubt that the painting was in his Museum when he died on 16 October 1793. What is undoubtedly odd, as Mr Clarke notes, is that in the lists of Hunter's pictures drawn up by William Clift (op. cit.), he leaves a blank where the name of the artist should be, although he correctly names Stubbs as the artist of two other paintings in Hunter's collection, 'A Male and Female Monkey' of c.1770 and 'The Yak, or Tartar Ox', dated 1791. Stubbs is not named as the artist of 'Rhinoceros' until Keith's catalogue of 1930 (op. cit.), and then with no explanation. William Clift started work as John Hunter's assistant on 14 February 1792, at the age of seventeen. If after that date a painting of a rhinoceros had entered Hunter's collection, Clift would surely have known who the artist was (though it is fair to say that in Hunter's museum, subject-matter was probably more important than connoisseurship). The probability therefore must be that Stubbs painted the rhinoceros before Clift entered Hunter's service, in 1790 or 1791 (his interest in exotic animals making the earlier date likelier) and that Hunter hung the picture unlabelled in his museum and that the subject of who painted it was never discussed.

Stubbs's studio sale on 26 May 1807 included 'Nine studies of the Rhinoceros, in different attitudes (lot 15, in a section headed 'Drawings, Studies from Nature, Sketches & c', all presumably by Stubbs himself); they were sold, with lot 16 ('A pencilled Drawing of a Lion, 3 ditto of Pointers, and a study of a Cow') for one shilling and sixpence. Like all the drawings in Stubbs's sale, they have disappeared. The presence in Stubbs's studio of 'nine studies of the Rhinoceros' would seem to support his authorship of the painting – if indeed the drawings were by Stubbs. A drawing of a sleeping rhinoceros, in black and white chalk on blue paper, formerly attributed to Stubbs (repr. Taylor 1971, pl. 71) is now, with a similar drawing in the collection of the late Sir John Witt, generally accepted as being by Ridinger.

Stubbs's 'Mares and Foals' paintings are perhaps the best-known and best-loved aspects of his work. He exhibited five paintings at the Society of Artists under the titles of 'A Brood of Mares', 'Brood Mares and Foals' and 'Brood Mares', in 1762, 1764, 1765, 1766 and 1768, and one entitled 'Mares and Foals' at the Royal Academy in 1776. There was thus ample opportunity for would-be patrons to think of commissioning such works themselves. The Marquess of Rockingham commissioned one of them (No. 88, probably the earliest), Lord Grosvenor two (Nos. 89 and 91), Lord Midleton and Mr. Jenison Shafto one each (Nos. 90 and 92), and Lord Bolingbroke, The Duke of Grafton, Colonel George Parker and John Musters one each. Not all these paintings could be lent to this exhibition. Parker (op. cit.) very usefully reproduces ten 'Mares and Foals' subjects on one page, as well as separately.

To the general spectator, the 'Mares and Foals' paintings seem to offer a lyrical picture of the English countryside adorned by the noblest and least menacing of its creatures. But those who commissioned the paintings would expect in addition the accurate portraiture of their own animals. Much thought and considerable expense would have gone into selecting a stallion to cover a mare, and among the foals, future racing winners and good breeders would be looked for. For the moment, however, mares and foals are seen as if in a state of nature, free from the bridles, saddles and spurs of the racecourse.

The original idea for the frieze-like arrangement of the earlier 'Mares and Foals' paintings may have been suggested by engravings by Mathem after Collaert and others, which show animals as if on a stage in the foreground, against generalized backgrounds. But Stubbs almost certainly drew all his mares and foals from life, perhaps first making numerous studies and then (for each finished picture is very carefully designed) arranging them into an ideal composition; if such studies did exist, they are now lost.

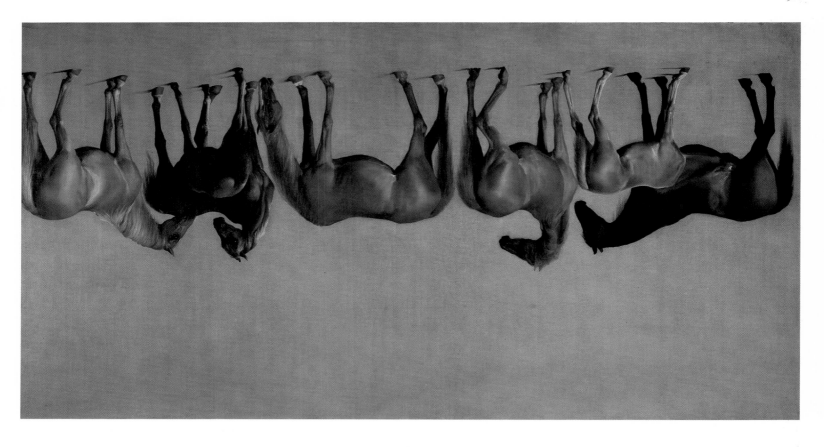

88

**MARES AND FOALS WITHOUT A
BACKGROUND**
paid for in August 1762

Oil on canvas, 39 × 75 in.
(99 × 190.5 cm.)

*Trustees of The Rt. Hon. Olive,
Countess Fitzwilliam's Chattels Settlement,
kindly lent by Lady Juliet de Chair*

PROVENANCE
Commissioned by the 2nd Marquess of
Rockingham; thence by descent

EXHIBITED
Probably Society of Artists 1762 (110, 'A Brood of
Mares'); *Old Masters,* R.A. 1879 (223); *La Peinture
Anglaise, XVIIIe & XIXe Siècles,* Palais du Louvre,
Paris, 1938 (137, repr.) *The Wentworth Woodhouse
Stubbs Paintings,* Ellis & Smith 1946 (2, repr.);
Liverpool 1951 (31); Whitechapel 1957 (30);
Sport and the Horse, Virginia Museum of Fine Arts,
Richmond, Virginia 1960 (18, repr.)

LITERATURE
H.F. Constantine, 'Lord Rockingham and Stubbs;
Some New Documents', *Burlington Magazine,*
XCV, 1953, p. 237, fig. 10; Taylor 1971, pp. 14,
26–7, 206, pl. 20; Parker 1971, chap. 8, 'The
Mares and Foals Series', pp. 55–71 *passim,* repr.
p. 58 (and, with other 'Mares and Foals' pictures,
p. 57).

Constantine (op. cit.) publishes a receipt which he
traced among the Wentworth Muniments,
Sheffield City Libraries: 'August Ye 15th 1762
Recd of the Most Honble ye Marquis of
Rockingham, the sum of one Hundred and ninty
four pounds five shillings in full for a picture of five
brood-Mares and two foles one picture of three
Stallions and one figure and one picture of a figure
on Horseback and a picture of five Dogs and
another of one dog with one single Horse.
R[eceived] Geo: Stubbs'. The picture of 'one dog
with one single Horse' cannot now be traced. The
other pictures paid for here are Nos. 33, 35 and 36
in this exhibition.

It is not known whether the decision to leave
this picture without a background was Stubbs's or
Lord Rockingham's, but evidently Lord
Rockingham was content to pay for it as it was in
August 1762. Benjamin Killingbeck's copy of the
three right hand mares and foal, set in a landscape,
evidently commissioned or purchased by Lord
Rockingham, is repr. Constantine, op. cit., fig. 7.

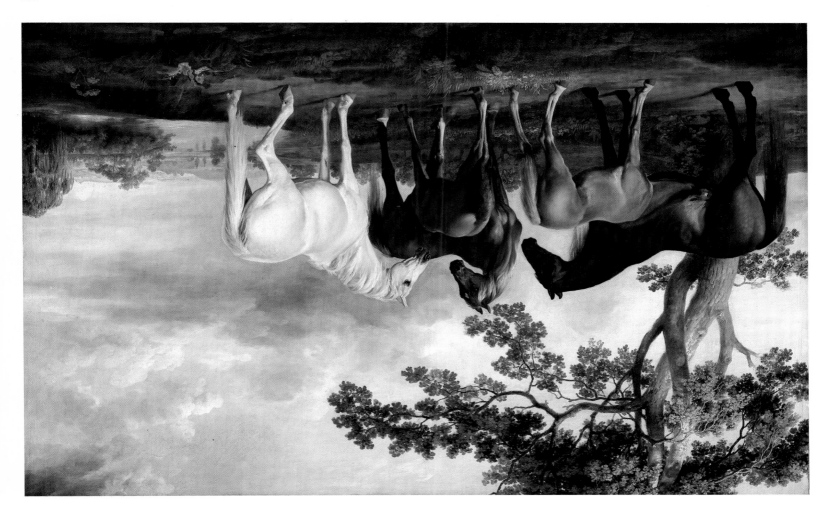

68

MARES AND FOALS IN A RIVER
LANDSCAPE
c.1763–8

Oil on canvas, 40 × 63¾ in.
(102 × 162 cm.)

Tate Gallery

PROVENANCE
Presumably commissioned or purchased by the
3rd Viscount Midleton (d. 1765) or 4th Viscount,
thence by descent until sold by the 2nd Earl of
Midleton, through Oscar & Peter Johnson, to the
Tate Gallery 1959

EXHIBITED
Liverpool 1951 (36, repr.); Whitechapel 1957 (32,
pl. XIII); Tate Gallery 1976 (28)

LITERATURE
Tate Gallery Report 1959–60, p. 29; Taylor 1971
and Parker 1971 (cited under No. 88)

Largely adapted from 'Mares and Foals without a
background' (No. 88), but with the omission of the
two central mares from that picture, and the
translation of the chestnut mare on its right into a
grey (and an alteration in the pose of its hindleg).
Given the enormous amount of work which Stubbs
achieved in the 1760s, it is not surprising that he
should borrow from one of his earlier compositions,
but it is odd that the patron who commissioned this
picture (? Viscount Midleton) should not want his
own horses portrayed. The inference is perhaps
that he did not have brood mares of his own, but
liked the subject.

90*

MARES AND FOALS BENEATH LARGE OAK
TREES
*c.*1764–8

Oil on canvas, 39 × 74 in. (99 × 187 cm.)
Her Grace Anne, Duchess of Westminster

PROVENANCE
Commissioned by Lord Grosvenor (later 1st Earl
Grosvenor); thence by descent

EXHIBITED
Old Masters, British Institution 1817 (65): this
picture or No. 91; *Old Masters*, British Institution
1843 (128): this picture or No. 91; Wrexham
1876 (252); Whitechapel 1957 (31); *Stubbs in the
1760s*, Agnew's 1970 (4, repr.); *British Painting
1600–1800*, Art Gallery of New South Wales and
National Gallery of Victoria, Australia 1977–8
(40, repr.)

LITERATURE
John Young, *A Catalogue of the Pictures at Grosvenor
House*, £821, no. 9; G.F. Waagen, *Works of Art and
Artists in England*, II, 1838, p. 318; Gilbey 1898,
p. 130, no. 3; Taylor 1971 and Parker 1971 (cited
under No. 88)

The painting hung for many years in the Gallery of
the Grosvenors' London house, Millbank, where
privileged visitors could see it; until the National
Gallery's acquisition of No. 70 in 1895, this was
probably Stubbs's best-known painting, and would
of course have confirmed his label 'Mr. Stubbs the
horse-painter'.

It is pleasant to be able to quote high praise for
this picture from Dr Waagen, who generally
averted his eyes from all English horse-painting.
He recorded after his visit to the Grosvenor
Gallery: 'GEORGE STUBBS. – I was very glad to
see here a picture by this master, with whose
merits I had been made acquainted by copper-
plates, and his work on the Anatomy of the Horse.
It represents horses at the foot of enormous oaks in
an extensive flat country. Independently of the
great truth, and perfect understanding of the
horses, it is treated with ability, and the tone of the
air is very good.'

Taylor (op. cit.) dates the picture to 1760–2,
implying that it was painted very soon after
'Bandy' and 'The Grosvenor Hunt' (Nos. 38–9).
To this compiler, it seems more likely to belong to
the middle or later 1760s, when Stubbs's command
over landscape is seemingly most relaxed, and
when he uses impasto quite liberally, as here, to
dapple leaves and heighten the effect of sunlight on
the paling fence.

Details of Lord Grosvenor's stud-farm were
published in two parts in the *Sporting Magazine*,
XXXI, January 1808, pp. 186–91, and February
1808, pp. 221–8. Lord Grosvenor began racing
('commenced upon the turf') in 1753, and began his
stud-farm the following year. 'His Lordship
regularly kept several stallions, and a very large
number of brood mares, in his stud, and was the
greatest breeder of racing stock of any gentleman

in England.' A list of the 306 stallions and brood
mares from 1754 until Lord Grosvenor's death in
1802 begins with Bandy (whose portrait with a
groom is No. 38, and ends in 1802 on a magnificent
note with 'Violante, got by John Bull out of sister to
Skyscraper; by Highflyer, out of Everlasting, by
Eclipse'. As well as the 306 horses listed by name,
Lord Grosvenor 'was owner and breeder of an
unaccountable number of blood horses, &c., many
of whom were trained and raced, but the greater
part thereof had no particular name given to them,
and from whom his Lordship selected his hunters,
hacks, &c. and disposed of the remainder'.

A pity he did not name all his horses, for Lord
Grosvenor had nice taste in the naming of horses.
He particularly liked flower and vegetable names;
listed among his stallions and brood mares are
Daphne, Primrose, Cowslip, Snapdragon (by Snap,
No. 41), Laurel, Bramble (out of Sweetbriar),
Marigold, Honeysuckle and Polyanthus;
Cauliflower, Parsley, Radish, Asparagus and
Turniptops. The names are worth noting since
Stubbs often included some allusion to a horse's
name in his portrait, as he does when he depicts
Sweet-William and Sweet-briar blossoming in the
foreground of their namesakes' portraits;
conversely, it may be that the unidentified
chestnut horse in the picture sold from the Dick
collection at Sotheby's on 23 April 1975 (138, repr.)
is in fact Lord Grosvenor's Polyanthus, since a
beautifully painted clump of polyanthus appears in
the foreground of this portrait.

Lord Grosvenor is said to have spent over
£300,000 on his stud-farms at Eaton and Oxcroft
near Newmarket. He incurred some substantial
gambling losses, but reaped such rewards as
winning the Derby three times, in 1790, 1792 and
1794, and the Oaks five times between 1781 and
1799.

91*

MARES AND FOALS UNDER AN OAK TREE
dated 1773

Oil on panel, $32\frac{1}{2} \times 40$ in. (82×101 cm.)
Inscribed ('Geo: Stubbs pinxit' lower
right in front of the bay mare's nearside
hindleg and '1773' behind it.
Her Grace Anne, Duchess of Westminster

PROVENANCE
Commissioned by Lord Grosvenor (later 1st Earl
Grosvenor); thence by descent

EXHIBITED
Old Masters, British Institution 1817 (65): this
picture or No. 89; *Old Masters*, British Institution
1843 (128): this picture or No. 89; Vokins, 1885
(16); *Works of Art Illustrative of and Connected with
Sport*, Grosvenor Gallery 1890 (97, date misread
as 1770); British Empire Exhibition, 1924 (v. 20);
Stubbs in the 1760s, Agnew's 1970 (8, repr.)

LITERATURE
Gilbey 1898, p. 130, no. 4; Taylor 1971 and
Parker 1971 (cited under No. 88)

A watercolour version attributed to George
Townly Stubbs (? signed) is repr. in W. Shaw
Sparrow, *British Sporting Artists*, 1922, facing p. 136;
then in the collection of Oswald Magniac, it is now
untraced.

92*

TWO SHAFTO MARES AND A FOAL

dated 1774

Oil on panel, $31\frac{1}{2} \times 39\frac{1}{2}$ in.
(80 × 100.3 cm.)
Inscribed 'George Stubbs pinxit 1774'
lower right

Private Collection

PROVENANCE

Presumably commissioned by Robert Shafto; by
descent through Sir Robert Shafto Adair, 5th
Bart., until sold by The Adair Trust, Christie's
17 June 1966 (93, repr.); br. Marshall Spink;
Mr & Mrs Jack R. Dick, sold Sotheby's 26 June
1974 (89, repr.); Richard Green, from whom
purchased by the present owner

The mares and foal were described in the 1966 sale
catalogue as 'the property of Jenison and Robert
Shafto'; but the picture is dated 1774, and Jenison
Shafto, a famous sportsman and breeder, for whom
Stubbs had worked earlier (see No. 41) had died in
1771. Presumably his stud at West Wratting near
Newmarket was carried on by his brother Robert,
or moved to the latter's home at Benwell, Co.
Durham. All the Shaftos in the eighteenth century
seem to have been devoted to horses, including the
Rev. John Duncombe Shafto, who thought it
prudent to race his horses under other men's
names.

Stubbs's 'Mares and Foals' subjects became
increasingly realistic in the 1770s. The mares here
are shown, naturally enough, with dropped backs,
sagging bellies and little youthful charm, but there
is still the interposition of a slim long-legged
dependent foal to add grace to the composition.
The degree of realism is still further increased in
the picture of 'John Musters's Brood Mares at
Colwick Hall', dated 1777, sold from Colwick Hall
in 1888, for a while in the collection of Mr Paul
Mellon KBE, sold Sotheby's 18 November 1981
(104) and now in a private collection.

93

STALLION AND MARE
? exh. 1769; engr. 1776
Oil on canvas, 37½ × 48 in.
(95.3 × 122 cm.)
Inscribed 'Geo Stubbs pinxit' lower right
Sir Martyn Beckett, Bt.

PROVENANCE
Purchased by Willoughby Lacy, by 1776; ? sold
by him by c.1800; Sir Walter Gilbey, by 1885,
sold Christie's 11 June 1915 (392, as 'Portrait of
Jupiter with a mare near a shed, dated 1789'),
bt. Goslett, 10 guineas; F.G. Cundall, from whom
purchased by Agnew's and sold to Hon. Sir
William Gervase Beckett, M.P., 1922; by descent
to the present owner

EXHIBITED
? Society of Artists 1769 (178, as 'A horse and
mare'); Vokins 1885 (22, as 'Jupiter and Mare,
dated 1789'); *Works of Art illustrative of and
connected with Sport*, Grosvenor Gallery 1890 (234,
as do.); Burlington Fine Arts Club 1934 (as do.);
Masterpieces from Collections of Yorkshire and Durham,
Leeds Art Gallery 1936 (24, as do.); Liverpool
1951 (48, as 'Jupiter and Mare', not dated);
Whitechapel 1957 (27, as do.); *English Pictures*,
Petit Palais, Paris

LITERATURE
Gilbey 1898, pp. 146–7 (as 'Jupiter and Mare,
dated 1789'); Taylor 1971, p. 29, fig. 6 (as
'Jupiter and a Mare. 1779')

ENGRAVED
in mezzotint by George Townly Stubbs, from an
Original Picture in the Possession of Willoughby
Lacy Esqre, entitled 'Stallion and Mare', ? first
published 1 December 1776, reissued several
times in Stubbs's lifetime

Problems over the dating of this picture and the
identity of the stallion have arisen, all seemingly
due to repetition (from Gilbey in 1898 onwards) of
the error that the canvas is itself dated.

We should look first at what the picture
portrays – and that is a fully adult chestnut stallion
advancing towards a mare, with a finely painted
landscape background. It is this compiler's belief
that the picture may be the work exhibited as 'A
horse and mare' at the Society of Artists in 1769
(178). Obviously with such an imprecise title one
cannot be sure of this. It should however be noted
that Horace Walpole annotated his exhibition
catalogue at this point: 'very fine, tho the muscles
exaggerated', and that no other picture of a single
horse and mare can readily be equated with this
title and description. This picture has all the high
qualities, both in the portraiture of the horses and
in the landscape background, which one would look
for in a work by Stubbs of 1769. There is no doubt
that this is the picture which was engraved in 1776;
the lapse of seven years between the painting's
exhibition and the engraving's publication is not
uncommon: its owner may not have made it
available to the engraver for some years, and in any
case G.T. Stubbs had a great deal of work on hand
in these years.

So far so good: we postulate an undated painting
of an unnamed (and unidentified) stallion and mare
which could have been exhibited in 1769 and of
which the engraving was certainly published in
1776.

Confusion over the picture has developed first because Gilbey (op. cit.) recorded that the painting was dated 1789, and secondly because he appears to have jumped to the conclusion that the horse was Colonel Thornton's celebrated chestnut horse Jupiter (Gilbey comments, oddly enough, 'The chestnut has changed to a bright cream; he has a black mane and tail . . .'). The real problem here is that Jupiter was not foaled until 1774; in 1778 (two years after the publication of the engraving of Stubbs's picture) he won his most famous victory at Newmarket (a stake of 1,000 guineas) and did not retire to stud until much later. But Stubbs's picture, as its present owner points out, portrays a rampant stallion who cannot possibly be a two-year-old. There must therefore be a mistake in its previous identification as Colonel Thornton's Jupiter.

The fact that the picture was purchased by a theatrical proprietor rather than a racehorse-breeder increases the probability that Stubbs's purpose in painting 'Stallion and Mare' was to represent animal passion rather than to portray individual horses. Willoughby Lacy (c.1750–d. after 1813) was the illegitimate son of James Lacy, Garrick's partner in the ownership of Drury Lane Theatre; when James Lacy died in 1774, he left his moiety to his son, who for a few years was flush with money. Willoughby Lacy is summed up by Cecil Price as 'a wildly extravagant but pleasant person' (*Letters of Richard Brinsley Sheridan*, I, 1966, p. 96, note 1). His extravagances were such that he had to mortgage his share in the theatre to Garrick and sell his house at Isleworth to Sir Edward Walpole; it is likely that he also had to sell 'Stallion and Mare' not long after acquiring it. He was finally bought out of Drury Lane Theatre by Sheridan, who considered him 'utterly unequal to any Department in the Theatre' (*ibid*, p. 99). Willoughby Lacy seems to have disappeared from the London scene early in the nineteenth century, and is last heard of playing Hamlet in Cork.

Stubbs is the first artist to have essayed, in 'Stallion and Mare' (and in his 'Lion and Horse' subjects), the portrayal of emotion in horses. Few of his 'romantic' subjects seem to have been commissioned by his regular patrons (with the notable exception of Lord Rockingham, who commissioned the very large 'Horse Attacked by a Lion' and 'Lion Attacking a Stag', Nos. 60–1). Sawrey Gilpin and James Ward later painted their own versions of the subject-matter of 'Stallion and Mare': Gilpin's 'Grey Arab and a Mare' is in the collection of the Fitzwilliam Museum, Cambridge, and Ward's 'L'Amour de Cheval', dated 1827, is in the collection of the Tate Gallery (both repr. Taylor 1971, figs. 7 and 8). H.B. Chalon expanded the idea with a series of lithographs depicting joy, rage, courage, terror etc., published in 1827 as *The Passions of the Horse*.

94

ECLIPSE
? painted in 1770

Oil on canvas, $25\frac{1}{2} \times 30\frac{3}{4}$ in.
(64.7 × 78 cm.)
Paul Mellon Collection, Upperville, Virginia

PROVENANCE
H.A.J. Munro of Novar, Ross-shire,
(? bequeathed) to Col. the Hon. Henry Butler Johnstone, sold Christie's, *The Final Portion of the Celebrated Novar Collection formed by the late H.A.J. Munro*, 1st day's sale, 19 March 1880 (105, as 'Portrait of a chestnut horse'), bt. Vokins; Sir Walter Gilbey, sold Christie's 11 June 1915 (399), bt. Algernon Dunn Gardner; by descent to Mrs G.S.M. MacRae, Denston Hall, Newmarket, sold Sotheby's 18 March 1970 (76, repr.), bt. Ackermann for Mr Paul Mellon KBE

EXHIBITED
Old Masters, R.A. 1882 (not in catalogue: exhibition label on back of frame); Vokins 1885 (3); *Works of Art illustrative of and connected with Sport*, Grosvenor Gallery 1890 (86); *Historical Exhibition of Liverpool Art*, Walker Art Gallery, Liverpool 1908 (115); *Loan Exhibition of Sporting Paintings*, Viscount Allendale's, 144 Piccadilly 1931 (17); *British Art*, R.A. 1934 (398, Commemorative Catalogue, no. 163); Yale Center 1982 (44)

LITERATURE
Gilbey 1898, pp. 154–5; Egerton 1978, pp. 85–6, no. 82, pl. 32

Eclipse was bred in the Duke of Cumberland's stud at Windsor, got by Marske out of Spiletta, and so named because he was foaled during the great eclipse of 1 April 1764. At the sale of the Duke of Cumberland's stud after his death the following year, Eclipse was purchased by William Wildman and sent to train at Epsom. Colonel Dennis

O'Kelly, the well-known gambler, bought a half-share in him in 1769, after seeing the horse win one heat and making his famous prediction for the next race, 'Eclipse first, the rest nowhere'. Eclipse's racing career lasted only two years, 1769–70, but was spectacularly successful; he won eighteen recorded races, and was never beaten. Having bought Wildman out, O'Kelly retired Eclipse in 1771 to his stud at Cannons, near Edgware, Middlesex, where Eclipse is said to have sired 334 winners before his death in 1789. Eclipse was 'immeasurably the greatest racehorse of his century, and if his predominating influence on the breed be taken into consideration, of all time'; over 100 of his descendants have won the Derby' (*Summerhays' Encyclopaedia for Horsemen*, 6th ed., 1975).

This is a study, without the bridle, saddle and plaited mane for No. 54. A comparable study of a racehorse without a background is 'Rufus', $23\frac{1}{2} \times 30\frac{1}{2}$ in., in the collection of the Indianapolis Museum of Art, exh. *Sport and the Horse*, V.M.F.A. 1960.

Dennis O'Kelly (?1720–1787) was a self-made man. Born about 1720 in Co. Carlow, Ireland, he began his career in England as a 'chair-man' (a porter of sedan-chairs), and made his fortune by buying, breeding and betting on racehorses. His most famous 'property' was Eclipse, whom he bought from that other self-made man, William Wildman (see No.56). O'Kelly married a famous courtesan, Charlotte Hayes, improved his social position by buying a commission in the Middlesex Militia, in which he reached the rank of Colonel, and consolidated it by buying Cannons, formerly the home of the Duke of Chandos. Membership of the Jockey Club, however, eluded him. Not the least of O'Kelly's claims to fame was ownership of a talking parrot which could whistle the 104th Psalm. O'Kelly bequeathed Eclipse, Dungannon and several important brood mares to his brother, and the rest of his stud to his nephew Andrew (a less colourful character who did attain membership of the Jockey Club). Determined that his fortune should not go as it had come, O'Kelly inserted a clause in his Will that his heirs should forfeit £400 for every wager they made.

95*

MAMBRINO
dated 1779, ? painted *c*.1790

Oil on canvas, $34\frac{5}{8} \times 46$ in.
(88 × 117 cm.)
Inscribed 'Geo: Stubbs p: / 1779' lower
left of centre
Halifax Collection

PROVENANCE
Stubbs's studio sale, 26 May 1807 (82); . . . ; Mrs
Courtenay by 1885; ? Vokins; 5th Earl of
Rosebery, by 1897, thence by descent to the Earl
of Halifax

EXHIBITED
Turf Gallery 1794 (VII); Vokins 1885 (38);
*Paintings by George Stubbs and Ben Marshall from the
Durdans Collection*, Ackermann 1966 (4, repr.); on
loan through the British Sporting Art Trust to
the Tate Gallery, 1980–1, and to York City Art
Gallery, 1981–2 (no catalogues)

LITERATURE
Sporting Magazine, III, 1794, pp. 210–14

ENGRAVED
(1) by C.H. Hodges, published 1 September 1788
by John & Josiah Boydell
(2) by George Townly Stubbs, published 20 May
1794 by Messrs. Stubbs

Mambrino, by Engineer out of a mare by Old Cade, was foaled in 1768; he was purchased by Lord Grosvenor, raced with some success for him between 1773 and 1778 and then became one of the most important stallions in the Grosvenor stud. The original version of this picture, painted on panel for Lord Grosvenor, is dated 1779 (repr. Taylor 1971, pl. 85). No. 95 is also dated 1779, but was probably painted in the early 1790s for the Turf Review project; it seems to have been Stubbs's practice, when repeating subjects for the Turf Review, to inscribe a second version with the first's date, which would in most cases have been the date at which the horse itself was in its prime.

In or about 1790, Stubbs became involved in a project to publish, periodically and by subscription, '*A Review of the Turf*, or An accurate account of the performances of every horse of note that has started, from the year 1750, to the present time; together with the pedigrees, interspersed with various anecdotes of the most remarkable races, the whole embellished with upwards of ONE HUNDRED AND FORTY-FIVE PRINTS, engraved in the best manner, from original pictures of the most famous racers, painted by G. Stubbs R.A. at immense expense, and solely for this work'. Stubbs's paintings were to be engraved by his son, George Townly Stubbs, in two sizes: twenty inches by sixteen, and a smaller size as embellishment to the letter-press.

The Humphry MS Memoir states that 'in 1790 a Gentleman came to Mr. Stubbs who must be distinguish'd by the name of Turf', proposed the scheme and offered to deposit £9,000 with bankers as a fund for Stubbs to drawn on. Stubbs began work on the project, painting new versions of some pictures painted years earlier (e.g. Shark, Gimcrack, Gnawpost and Mambrino), some new subjects (e.g. Dungannon, Volunteer and Baronet) and one picture, of a famous early horse called The Godolphin Arabian, which Stubbs must either have invented or copied from some earlier work: it is perhaps the only instance of Stubbs not working direct from life.

Sixteen paintings were completed, most of the subjects were engraved and one volume of letter-press was published (No. 169). A house (alas, unnumbered) in Conduit Street was taken for the display of Stubbs's sixteen finished paintings; it was renamed for the occasion 'The Turf Gallery', and there on 20 January 1794, with full coverage in the *Sporting Magazine* (January 1794, pp. 210–14) the exhibition opened of the sixteen paintings and those prints which were ready. The *Sporting Magazine*'s comment on the painting of Mambrino was that Mambrino 'was chosen by Mr. Stubbs, not only as a capital horse, worthy to be inserted in this work, but from his being so beautiful and animated a subject for the painter'.

The project failed. Few subscribers volun-

teered; as Humphry remarked, the war with France had affected 'the sale of works of art of every description'. The promised funds were withdrawn. All the pictures painted expressly for the Turf Review ended up in Stubbs's studio sale.

It has been suggested that the anonymous backer ('Turf') for the project was the Prince of Wales, to whom the only volume of letterpress is dedicated. This is unlikely, since the Prince was invariably in dire straits for money, and found it difficult to get any loans. On 22 December 1792 Thomas Coutts wrote to him as follows: 'I hope his Royal Highness will rigidly adhere to the system of never asking me for any further sums of money . . . I beg leave most humbly to suggest that unless his Royal Highness goes *heartily firmly* and decidedly into the plan of reform, and will obstinately persevere in it for years to come, he will do himself an injury instead of any good' (Aspinall, V, 1970, pp. 320–1).

96*

DUNGANNON, THE PROPERTY OF
COLONEL O'KELLY, PAINTED IN A
PADDOCK WITH A SHEEP
dated 1793

Oil on canvas, $39\frac{1}{8} \times 49\frac{5}{8}$ in.
$(99 \times 126$ cm.)
Inscribed 'Geo: Stubbs pinxit / 1793'
lower right
Halifax Collection

PROVENANCE
Stubbs's studio sale, 26 May 1807 (81); . . . ; 5th Earl of Rosebery, thence by descent to the Earl of Halifax

EXHIBITED
Turf Gallery 1794 (IV); *Paintings by George Stubbs and Ben Marshall from the Durdans Collection*, Ackermann 1966 (6, repr.); on loan through the British Sporting Art Trust to the Tate Gallery 1980–1, and to York City Art Gallery 1981–2 (no catalogues)

LITERATURE
Gilbey 1898, p. 134; *Sporting Magazine*, III, 1794, pp. 210–14

ENGRAVED
by George Townly Stubbs, published 20 May 1794 by Messrs. Stubbs

Dungannon, Volunteer and Anvil, three of the sixteen horses which Stubbs painted for the Turf Review project, each belonged in his heyday to Colonel O'Kelly, who is noticed under No. 94 and whose initials are branded on Dungannon's companion, the sheep. The *Sporting Magazine* published what it called 'a catalogue of the pictures' (whether a separate catalogue was published is not known); according to its notes on the portrait of Dungannon, 'The great attachment of this horse to a sheep, which by some accident got into his paddock, is very singular'. Dungannon's sire was Eclipse.

97

WHITE POODLE IN A PUNT
*? c.*1780

Oil on canvas, 50 × 40 in.
(127 × 101.5 cm.)
Paul Mellon Collection, Upperville, Virginia

PROVENANCE
. . . ; Mrs Esme Smyth, Ashton Court, near
Bristol, Somerset; Lord de Mauley, sold Christie's
8 July 1949 (131), bt. F.T. Sabin; 21st Earl of
Shrewsbury and Waterford, Ingestre Hall,
Staffordshire, 1951, sold Sotheby's 23 March 1960
(63, repr.), bt. Colnaghi for Mr Paul Mellon KBE

EXHIBITED
Works of Art from Midland Houses, Birmingham
City Museum and Art Gallery 1953 (72);
Whitechapel 1957 (40, pl. XXII); *Age of Rococo*,
1958, British Council, Munich 1958 (192, pl. 118);
V.M.F.A. 1963 (314, pl. 172); R.A. 1964–5 (275,
pl. 56)

LITERATURE
Anthony Crofton, *Catalogue of Pictures at Ingestre
Hall, Staffordshire*, 1953, no. 46; Christopher Neve,
'The Dog beneath the Skin: Stubbs's Dog
Portraits', *Country Life*, 6 February 1975, p. 315,
fig. 1; Egerton 1978, pp. 100–1, no. 98, pl. 36

This is a difficult picture to date. In the catalogue of
the V.M.F.A. exhibition, 1963, Basil Taylor
assigned this 'on stylistic grounds' to the 1760s,
which seems to this compiler too early for a picture
with such a featureless background; but her own
suggestion of *c.*1800, in the Mellon catalogue, 1978,
now seems too late. A date of '*c.*1780' is now
suggested, chiefly because the dog's coat seems to
be painted in much the same way as the water
spaniel's in No. 101, and because Stubbs often uses
the weeping willow as a background in paintings of
around 1780.

Christopher Neve notes how subtly Stubbs
catches 'the very faintest suggestion of precarious-
ness, the air of apprehension that even a water-dog
exhibits when balanced on a floating object over
which it has no control'.

A WATER SPANIEL
dated 1769

Oil on canvas, $35\frac{1}{2} \times 46$ in.
(90.2 × 116.7 cm.)
Inscribed 'Geo: Stubbs pinxit 1769' lower
centre below the dog's forepaws
Yale Center for British Art,
Paul Mellon Collection

PROVENANCE
. . . ; Ackermann, 1949; C.B. Kidd; Partridge,
from whom purchased by Mr Paul Mellon KBE,
1962, and presented to the Yale Center for British
Art, 1981

EXHIBITED
Whitechapel 1957 (39); V.M.F.A. 1963 (317);
R.A. 1964–5 (269); Yale 1965 (181)

LITERATURE
Egerton 1978, p. 83, no. 80

Taylor notices in the V.M.F.A. catalogue (op. cit.)
that 'no other portrait of a dog with an unfigured
background is known' in Stubbs's work.
 The English Water Spaniel, now extinct, was
part ancestor of several sporting breeds; it was
formerly an immensely popular shooting dog,
especially in East Anglia.

99*

PORTRAIT OF A SPANISH DOG BELONGING
TO MR COSWAY
dated 1775

Oil on panel, $21\frac{1}{4} \times 27\frac{1}{2}$ in.
(54×69.9 cm.), sight size
Inscribed 'Geo: Stubbs / 1775' lower
right
Private Collection

PROVENANCE
Painted for Richard Cosway, R.A.; sold, after his
death, by Stanley 9 March 1822 (13, as 'Dog
Chacing a Butterfly'); . . . ; William Darby;
Jocelyn Feilding, by whom sold *c.*1971 to the
present owner

EXHIBITED
R.A. 1775 (303, title as above)

ENGRAVED
by E. Fisher, titled 'A Spanish Dog', published
12 July 1782

The dog is of the breed known as Papillon, so-called
because the oblique set of its fringed upstanding
ears resembles the outspread wings of a butterfly.
Pet dogs of this breed appear, over several
centuries, in paintings by Italian, French, Dutch,
Flemish and English painters. Stubbs's inclusion of
a butterfly in his picture is a gracefully flitting
allusion to the dog's 'Papillon' breeding. A rather
curious villa set on a hill in the background on the
left may be designed as a reference to this dog's
reputed Spanish origin.

This is perhaps one of the few paintings by
Stubbs to which the word 'charming' can be readily
applied. It was one of the four works with which
Stubbs, having decided to leave the Society of
Artists, made his debut at the Royal Academy; the
three other pictures Stubbs showed in its
exhibition of 1775 were 'A Portrait of a Horse,
named Euston, belonging to Mr. Wildman' (i.e. to
Stubbs's friend and constant patron William
Wildman; the picture is untraced since Wildman's
sale of 1787); 'A Portrait of a Pomeranian Dog,
belonging to Earl Spencer' (this is a less charming
picture, still at Althorp, of a heavier breed of dog
now known as the keeshond or Dutch barge dog);
and the outstandingly fine 'Portrait of a Monkey',
No. 85 in the present exhibition.

The portraitist Richard Cosway R.A.
(1742–1821) lived not far from Stubbs at 20
Stratford Place, Oxford Street. Though both his
work and his way of life were very different from
Stubbs's (Cosway is summarized, in Waterhouse's
Dictionary of British Eighteenth Century Painters, 1981,
p. 90, as 'the smartest and one of the most elegant
miniature painters England has produced': he held
fashionable soirées, some of which were attended
by the Prince of Wales, who appointed Cosway his
Principal Miniature Painter), Cosway and Stubbs
were to some extent friends. According to
Humphry, it was Cosway who, discussing with
Stubbs some 'loose and amorous Subjects' which he
himself intended to paint in enamels, first
suggested to Stubbs that he too should try working
in that medium. Stubbs's first dated enamel
painting is the 'Lion Attacking a Horse', dated
1769 (No. 64 in this exhibition). As Basil Taylor
asks (1971 p. 16), 'From whom, if not Cosway
indeed, did Stubbs get his first instruction in the
craft, for the earliest dated examples show a full
control of it?'. Stubbs may have painted this
portrait of Cosway's dog as a gesture of thanks for
such instruction.

100*

KING CHARLES SPANIEL

Oil on panel, 23 × 27 in. (58.5 × 68.6 cm.)
Inscribed 'Geo: Stubbs / 1776' lower
right
Private Collection

PROVENANCE
. . . ; unknown until sold Christie's 23 November
1973 (56) bt. Speelman, from whom purchased by
a private collector

The picture has much charm, but no sentimen-
tality. One measure of the difference between
Stubbs and Landseer is comparison of this portrait
with Landseer's 'King Charles Spaniels', exhibited
in 1845 (in the collection of the Tate Gallery).

101†

BROWN AND WHITE NORFOLK OR
WATER SPANIEL
dated 1778

Oil on panel, $31\frac{3}{4} \times 38\frac{1}{4}$ in.
(80.7 × 97.2 cm.)
Inscribed 'Geo. Stubbs Pi . . . / 1778'
lower right
Paul Mellon Collection, Upperville, Virginia

PROVENANCE
. . . ; Harold Davies, King Street, St James's,
*c.*1930; Leggatt Brothers; Lady Forteviot;
Ackermann, from whom purchased in 1960 by the
present owner

EXHIBITED
V.M.F.A. 1963 (326, pl. 173); R.A. 1964–5 (221);
Yale 1965 (183)

The dog is probably a Norfolk Spaniel, used to
spring and retrieve game from water as well as on
land. The dog's crisply curling coat calls for a
thicker use of paint than in most panels of the
period. The foreground plants are all water loving,
in allusion to the water spaniel. The compiler is
indebted to Dr Bernard Vedcourt of the Library
and Herbarium, Kew Gardens, for identifying them
as *Butomus umbellatus L.* (flowering rush), *sagittaria
sagittifolia L.* (arrow-head) and *Tussilago farfara L.*
(coltsfoot).

102*

PORTRAIT OF A HOUND BELONGING TO
WILLIAM PITT, 1ST EARL OF CHATHAM
dated 1788

Oil on panel, $32 \times 39\frac{1}{2}$ in.
(81.3 × 100.3 cm.)
Inscribed '*Geo Stubbs* pinxit / 1788' lower
left and, as if engraved on the brass plate
on the dog's collar, '*William Earl of
Chatham* / *Hayes 1777*'
Private Collection

PROVENANCE
Presumably commissioned by John Pitt, 2nd Earl of Chatham (possibly following his father's wish). The present owner is not sure how the picture entered his family, but believes it was a gift, probably from the 2nd Earl of Chatham, to one of his Rowley or Conway ancestors.

EXHIBITED
Treasured Possessions, Sotheby's in conjunction with the Historic Houses Association, December 1983–January 1984 (75)

The dog is evidently a foxhound. Stubbs has dated his portrait 1788, but inscribed '1777' on the dog's collar; presumably the year it was bred. There is no record of the elder Pitt's interest in fox-hunting; probably the dog was given as a puppy to him the year before he died, and was kept as a household dog. Stubbs's portrait of the dog at the age of eleven years, dated 1788 (ten years after the 1st Earl of Chatham's death) was presumably commissioned by Pitt's elder son, John, 2nd Earl of Chatham.

William Pitt (1708–1778), statesman, war minister, Prime Minister and one of the greatest orators of all time, was raised to the peerage as 1st Earl of Chatham in 1766. 'Il faut avouer', declared Frederick the Great, 'que l'Angleterre a été longtemps en travail, et qu'elle a beaucoup souffert pour produire M. Pitt; mais enfin elle est accouchée d'un homme.'

This is not the place to attempt a resumé of Pitt's public career. The private life of the man is less well-known, and more relevant here. In this private life, Pitt's country house at Hayes, near Bromley, in Kent, purchased in 1756 from Mrs Montague, was of indispensable importance to him. Hayes, then a tiny village, was near enough to Westminster to provide him with an ideal retreat. Hayes seems to have been to Pitt what his 'castle' at Walworth was to Mr Wemmick: an intensely private place, where he could refresh his spirits and recoup his energies. Though he held the lease of 10 St James's Square (now called Chatham House), Pitt's real home was at Hayes. There, as he told Grenville, he liked to 'draw the village air', if only 'by snatches'; there most of his children were born (including his second son William, known as 'the Younger Pitt', 1759–1806) and there his beloved wife Hester spent most of her time. When separated, Pitt and his wife exchanged notes almost daily, keeping a mounted groom continually posting between St James's Square and Hayes. On two occasions – in 1765, having inherited an estate in Somerset, and in the early 1770s, when he was in financial difficulties – Pitt considered selling or letting Hayes, but found he could not bear to part with it.

Pitt's private life is mentioned here not only because it makes Frederick the Great's 'enfin . . . un homme' un homme human, but also because it offers an insight into how Pitt shared the sort of pleasures which most Englishmen have ideally sought in domestic life: gardening (in Pitt's busy day, it often had to be 'gardening by torchlight'), pottering about the village, keeping a dog, watching the children grow up in fresh air. The tone of Pitt's relish – indeed, his positive hunger – for such things is perfectly caught in a little-known letter to his wife, written perhaps in 1759, shortly after his son William's birth: 'I wait with longing impatience . . . after much Court and more House of Commons, for the groom's return with ample details of you and yours. Send me, my sweetest life, a thousand particulars of all those *little-great* things which, to those who are blessed as we are, so far surpass in excellence and exceed in attraction, all the *great-little* things of the restless world . . .' (quotations are from Basil Williams, *Life of William Pitt, Earl of Chatham*, 1913, I, p. 349 and II, p. 128).

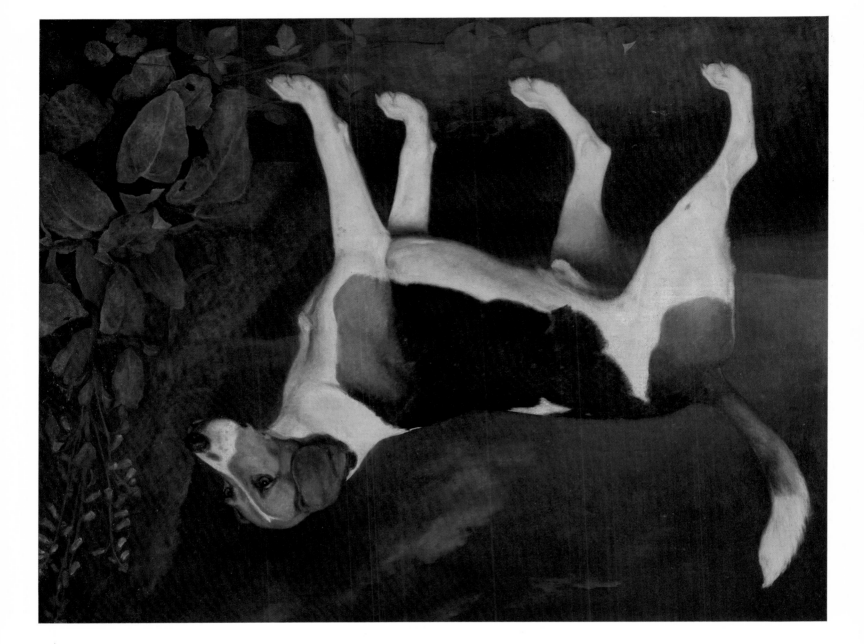

103

RINGWOOD, A BROCKLESBY FOXHOUND
dated 1792
Oil on canvas, 39½ × 49¾ in.
(100 × 126 cm.)
Earl of Yarborough

PROVENANCE
Commissioned by Charles Anderson-Pelham
(later 1st Baron Yarborough); thence by descent

EXHIBITED
British Art, R.A. 1934 (381), *Commemorative Catalogue* no. 173); Liverpool 1951 (41); *The Prints of George Stubbs*, Aldeburgh and Victoria and Albert Museum 1969 (34); *British Sporting Painting 1650–1850*, Arts Council 1974–5 (51)

At the beginning of the eighteenth century, hounds in general were a pretty scratch lot, consisting, as Roger Longrigg notes, of 'Northern and Southern hounds, a few Talbots, beagles, greyhounds and lurcher and terrier crosses'. The Pelhams of Brocklesby were foremost among those who devoted enthusiasm (and, necessarily, large expenditure) to selective breeding, producing a hound which was recognizably a foxhound. Hounds had been kept at Brocklesby since 1700, certain; but they think considerably longer'. Beginning in 1713 with 'sixteen couple of hounds, three horses and a boy', three north Lincolnshire neighbours – Charles Pelham, Roger Vyner and Sir Robert Tyrwhitt – combined their packs; Vyner and Tyrwhitt later retired from hound-breeding, and Pelham continued alone. By the middle of the eighteenth century, Brocklesby hounds had become the most influential in improving and standardizing the breed throughout England. There had been select imports of blood into the Brocklesby pack, notably from Charlton Richmond, bred in 1741 by the 2nd Duke of Richmond, (some of Charlton Richmond's progeny must appear in 'The Charlton Hunt', No. 29).; but from Charlton Richmond onward, the Pelhams concentrated on inbreeding and line breeding, which 'fixed the type and the prepotence to transmit it', That type, in Longrigg's phrase, had 'absolute quality'.

Charles Anderson-Pelham (1749–1823, created 1st Baron Yarborough, 1796), Master of the Brocklesby Hounds, 1763–1816, was as dedicated a breeder of foxhounds as his great-uncle Charles Pelham had been. Ringwood was the leading hound in his pack in the 1790s, and a prepotent sire. Born in 1788, by Neptune out of Vestal, he had at least forty lines of descent from Charlton Richmond (these notes are drawn from Roger Longrigg, *The History of Foxhunting*, 1975; quotations are from pp. 60–1, 69 and 73; see also G.E. Collins, *History of the Brocklesby Hounds*, 1902).

That the presence of a foxglove beside the foxhound is deliberately allusive is a good point made by David Coombs, *Sport and the Countryside*, 1978, p. 74.

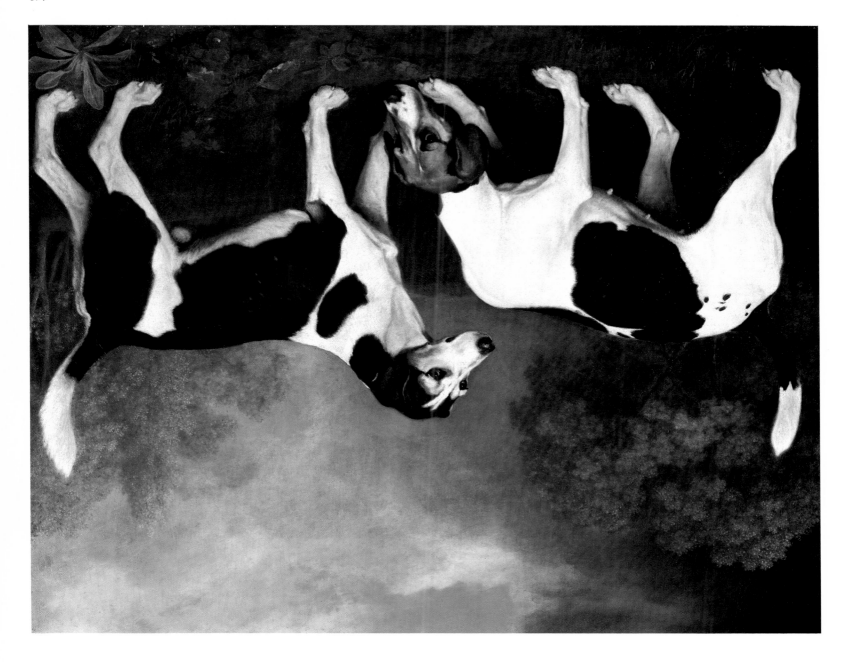

104*

A COUPLE OF FOXHOUNDS

dated 1792

Oil on canvas, 40 × 50¼ in.
(101.5 × 127.5 cm.)

Tate Gallery

PROVENANCE

Presumably commissioned by a member of the Vyner family (? Rev. Thomas Vyner, d. unmarried 1804); taken to New South Wales, Australia, by a member of the Vyner family (? by one of his nephews, Frederick Wheeler Vyner, b. 1818, emigrated 1839, or his elder brother Commander Arthur Vyner R.N., emigrated 1851, both settling in New South Wales); bt. from a later member of the Vyner family by an Australian dealer, by whom sold 1972 to a London dealer, from whom sold 1972 to Spink & Son, from whom purchased by the Tate Gallery, with assistance from the Friends of the Tate Gallery and a Special Government Grant, 1973

EXHIBITED

English Painting, Eighteenth and Nineteenth Centuries, Spink & Son, November–December 1972 (18, repr.); *Fanfare for Europe: The British Art Market* 1973, Christie's, January 1973 (30)

LITERATURE

Basil Taylor, 'A Stubbs Discovery', in *Octagon*, IX, no. 4, 1972, p. 5, repr.; *The Tate Gallery 1972–4, Biennial Report and Illustrated Catalogue of Acquisitions*, 1975, pp. 64–5; Roger Longrigg, *The History of Foxhunting*, 1975, p. 102, repr.

Painted the same year as 'Ringwood', the leading hound in the Brocklesby pack, this probably portrays a couple of foxhounds of the same breeding. It may have been painted for the Rev. Thomas Vyner (1753–1804), a keen sportsman, 'the intimate friend and companion of the first Lord Yarborough, passing the hunting season at Brocklesby for many years . . . He was considered not only a first-rate judge of breeding hounds and everything connected with their management in the kennel and in the field, but one of the most accomplished horsemen that ever steered a hunter across country' (Anon., *Vyner, A Family History*, 1885, pp. 90–1).

The three north Lincolnshire families of Vyner, Pelham (Earls of Yarborough) and Nelthorpe were closely linked, through intermarriage and through landowning and sporting interests. Stubbs worked for all three families on his return to Lincolnshire in 1776 and again in 1792. The Vyners evidently owned (and later moved to Australia) more than one painting by Stubbs. His portrait of a chestnut horse, dated 1776, inscribed 'Julius Caesar, the property of Sir J.N. Bart' [? Sir John Nelthorpe], reputedly taken to Australia by Robert Thomas Vyner, inherited by his son Charles James Vyner and sold by his widow at Christie's, 25 November 1977 (24, a damaged picture, repr.), last appeared at Sotheby's, New York 17 June 1982 (93), bt. in.

How and when 'A Couple of Foxhounds' reached Australia is not known; it may have been taken out by one of the Rev. Thomas Vyner's emigrant nephews or it may have been taken out by, or sent out to, one of the quickly ramifying Australian Vyners after the Vyner estate of Fairthorpe was finally sold up in 1858. The picture enjoyed, undamaged, over a century of obscurity in Australia, only to have its canvas ripped by a fork-lift truck on its return to England (damage impeccably restored by John Brealey).

105*

FINO AND TINY

dated (?) 1791

Oil on canvas, 40 × 50 in.
(101.6 × 127 cm.)
Inscribed 'Geo: Stubbs / Pinxit 179[?]1'

Her Majesty The Queen

PROVENANCE
Presumably painted for George IV when Prince of
Wales, and thereafter in the Royal Collection

EXHIBITED
R.A. 1791 (7), as 'A Pomeranian Dog'; Liverpool
1951 (51); *Animal Painting*, The Queen's Gallery
1966–7 (21, pl. 6)

LITERATURE
Gilbey 1898, p. 114; Millar 1969, no. 1124, pl. 125

Millar (op. cit.) notes that the dogs' names are
recorded as Fino and Tiny in 1816. Fino is the black
and white Spitz dog, Tiny the small chestnut
spaniel. The bleak mountainous landscape with its
misty lake or ford perhaps alludes to the far
northern origins of the Spitz breed. Fino appears
again in the painting of 'The Prince of Wales's
Phaeton' of 1793 (No. 135).

106

LORD PIGOT OF PATSHULL

engr. 1769

Canvas, 40 × 50 in. (101.5 × 127 cm.)

Inscribed 'Geo: Stubbs pinxit' lower right of centre, below horse's hooves (almost hidden by frame)

Private Collection

PROVENANCE
Commissioned by Lord Pigot; acquired c. 1775–7, during Lord Pigot's imprisonment or after his death, by the Hon. Edward Monckton, and thence by descent

LITERATURE
Basil Taylor, 'George Stubbs's painting of a Cheetah with two Indians', *Art at Auction . . . 1969–70*, Sotheby's, 1970, p. 11 (as 'present whereabouts unknown')

ENGRAVED
in mezzotint by Benjamin Green, in reverse direction, first published 10 May 1769, re-issued 1777 (repr. Taylor, op. cit., p. 12, fig. 1)

George Pigot, born in London in 1719, first went to India as a writer in the East India Company's service in 1737. By 1755 he had risen to the rank of Governor and Commander-in-Chief of Fort St George, Madras, where he proved an able but autocratic administrator. Like many another Englishman before and after him, he determined to make money in India. When he returned to England in 1764, having resigned as Governor of Madras, he brought with him the so-called Pigot diamond, eventually sold for £30,000; it was said that 'his great fortune was acquired by lending money to Mohammed Ali [the Nawab of Arcot] and the *Zemindars* at two and three per cent per month' (quotations are from Namier & Brooke, 1754–1790, iii, 1964).

Back in England, Pigot purchased the Staffordshire estate of Patshull, reputedly for £100,000, secured a seat in the House of Commons and began 'performing the eastern adoration of that rising star, Lord Rockingham', who obtained an Irish peerage for him. Henceforth he was known as Lord Pigot of Patshull.

Stubbs's portrait of Pigot, dated 1769, seems to accord with a judgment of Pigot recorded in 1776: 'a man of great spirit, and . . . in general honourable, but of excessive vanity and overbearing despotism'. The pastoral background is presumably Pigot's newly purchased estate of Patshull; no doubt it is his vanity that has

prompted his wish to be depicted as if he were still Governor and Commander-in-Chief, riding a long-haired charger which is probably the flashiest animal in the whole of Stubbs's work. There is no missing the autocratic nature of the man. Stubbs's portrait is much less flattering than Tilly Kettle's portrait of Pigot, begun a few years earlier and finished in 1769 (repr. Mildred Archer, *India and British Portraiture*, 1979, fig. 21).

By 1774, Pigot was evidently in financial difficulties, and returned to India for a second term as Governor of Madras. His determination to reverse the East India Company's recent policies and to override his own council provoked a *coup de main*: Pigot's councillors seized him and placed him in confinement in which, somewhat mysteriously, he died on 11 May 1777.

The circumstances of Pigot's death produced some controversy in England; an attempt to indict his enemies for murder however failed. George III, who was by no means always mad, remarked that both sides had clearly been actuated by the desire for gain. In some way which is not wholly clear, Stubbs's portrait of Pigot was acquired by his private secretary, the Hon. Edward Monckton. Since Pigot, though dead, was news again, the publishers of the engraving of the portrait took the opportunity to re-issue it in 1777.

The painting has not been exhibited or reproduced before.

107

**CAPTAIN SAMUEL SHARPE POCKLINGTON
WITH HIS WIFE PLEASANCE AND (?) HIS
SISTER FRANCES
dated 1769**

Canvas, 39⅜ × 49¾ in. (100.2 × 126.6 cm.)
Inscribed 'Geo: Stubbs/pinxit 1769' lower
right
National Gallery of Art, Washington, gift of
Mrs Charles S. Carstairs in memory of her
husband Charles Stewart Carstairs 1949

PROVENANCE
Commissioned by Samuel Sharpe Pocklington; his
elder son, Colonel Sir Robert Pocklington, who
had married Catherine Blagrave, and thence by
descent to the Blagrave family; John Blagrave of
Calcot Park, Berkshire, by whom sold at Foster's
28 June 1911 (102, as 'Colonel Pocklington and his
Sisters', bt. F. Howard, £252); Knoedler, by
whom sold to Charles Stewart Carstairs,
Lockport, New York, by 1927; The National
Gallery of Art, Washington, gift of Mrs Charles S.
Carstairs in memory of her husband, 1949

EXHIBITED
*Meisterwerke Englischer Malerei aus drei
Jahrhunderten*, Wiener Secession, Vienna 1927 (54,
repr.); *Conversation Pieces*, Sir Philip Sassoon's,
25 Park Lane, London 1930 (47); *British Art*, R.A.
1934 (395, *Commemorative Catalogue*, no. 165); on
loan to the Tate Gallery 1936–47

LITERATURE
G.C. Williamson, *Conversation Pieces*, 1931, p. 13,
pl. XXXV; Sacheverell Sitwell, *Conversation Pieces*,
1936, p. 59, pl. 60; David Fincham, 'The Sporting
Room at Millbank', *Apollo*, XXIII, 1936, repr.
p. 149; Mario Praz, *Conversation Pieces*, 1971,
p. 134, pl. 95 (and repr. in colour on cover); Taylor
1971, pl. 57, with details, pls. 58–9; Ronald
Paulson, *Emblem and Expression*, 1975, p. 165, pl. 96

Family portraits, even those which remain (as this
one did) in the family for a century and a half, often
acquire, with the passage of time, rather vague and
muddled titles. 'We think it's So-and-So' is all too
familiar a remark even in the stateliest of homes;
and suggested identifications are almost always
linked to those members of the family who were
rather more prominent in the public eye than
others.

In this case, the portrait has been exhibited and
reproduced as 'Colonel Pocklington and his Sisters'
since at least 1911, with no attempt to verify or
elaborate on this identification. But it cannot
portray a Colonel Pocklington, since no
Pocklington attained that rank until the Robert
Pocklington who was born one year after this
portrait was painted.

The picture itself offers at least three clues. It is
dated 1769: it is evidently a marriage portrait,
since the lady in the centre of the group is dressed
from top to toe in wedding clothes and holds a
bouquet of flowers which she offers to her
husband's horse; her husband wears the uniform of
the 3rd Regiment of Foot Guards. But what proved
to be the most useful clue of all lay in one word in
the 1934 exhibition catalogue's record of the
picture's provenance: the surname 'Blagrave'. The
puzzle was complicated by the fact that two
changes of name were involved in the Pocklington
marriage of 1769; but at last the solution emerged.

The gentleman in Stubbs's picture is Captain Samuel Sharpe Pockington, who married Pleasance Pockington in 1769 (the exact date has not yet been traced but a property settlement dated 26 May 1769, referred to in his Will, is probably a pointer to it). Both bride and bridegroom were born with different surnames. Captain Samuel Sharpe Pockington had been born Samuel Sharpe. Pleasance Pockington had been born Pleasance Pykarell, but had changed her name to Pockington as a condition of inheriting the manor of Chelsworth in Suffolk from her cousin Robert Pockington. Upon marrying her, Samuel Sharpe also assumed the name and arms of Pockington (W.A. Copinger, *The Manors of Suffolk*, III, 1919, p. 152). Copinger states that he was the son of Samuel Sharpe, surgeon, 1700–88, who is noticed in *DNB*. He appears in the 3rd Foot Guards in the *Army List* of 1769 as Captain Samuel Sharpe, having apparently first joined that regiment in 1766, and in the following year's *List* as Captain Sam. Sharpe Pockington; thereafter his name disappears from the *Army Lists*, suggesting that he resigned his commission shortly after his marriage, presumably so that he could look after the estates at Chelsworth. Pleasance Pockington died in 1774, and her husband Samuel in 1781.

Samuel and Pleasance Pockington had two sons. The elder, Robert, married Catherine Blagrave; and it was through the Blagraves that the portrait of his parents descended, after his own death (in 1840) and that of his only (unmarried) son. The Blagraves, perhaps not as well up in Pockington family history as they might have been, evidently assumed that the portrait must depict the most publicly distinguished member of the Pockington family, Colonel Sir Robert Pockington (Colonel in the 15th Light Dragoons, and Knight of the Imperial Order of Maria Theresa). In the compiler's catalogue of sporting paintings in the collection of Mr Paul Mellon KBE (Egerton 1978, p. 98), it was suggested that Stubbs's 'Charger with a Groom', dated 1798 and traditionally stated to have been painted at George III's inspection of the 15th Light Dragoons at Windsor in June 1798, might have been commissioned by Colonel (then Major) Robert Pockington; and would therefore have been another instance of Stubbs's loyalty to the families of patrons from whom he had received commissions years earlier: this suggestion now seems even more likely. Meanwhile the Pockington manor of Chelsworth in Suffolk passed to Samuel and Pleasance's second son, Henry Sharpe Pockington, and in turn to his descendents (family portraits at Chelsworth are noticed in Farrer, *Portraits in Suffolk Houses* (*West*), 1908 p. 76).

The identity of the lady behind Pleasance Pockington in the marriage portrait of 1769 remains conjectural. She seems to be not much older than the bride, but to resemble Samuel Sharpe Pockington rather than Pleasance Pockington. Samuel Sharpe Pockington's Will (PRO, Prob. II/1073) includes bequests to his three sisters, two of whom had married; perhaps this is a portrait of his unmarried sister, Frances Sharpe.

(The compiler is grateful to Mr Boris Mollo of the National Army Museum for confirming that Captain Pockington wears the correct uniform for the 3rd Foot Guards at this period; Mr Mollo notes that in 1813 this Regiment adopted the name of the Scots Guards, and adopted a uniform with buttons in threes.)

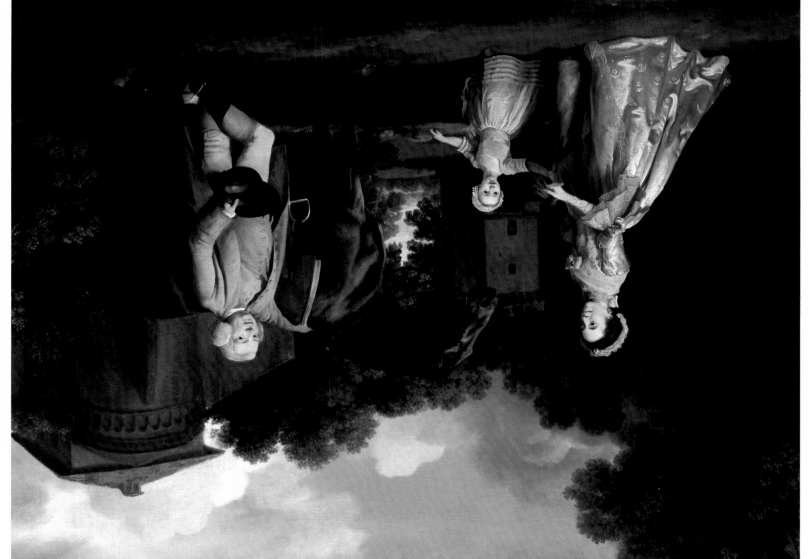

108*

THE SALTONSTALL FAMILY
dated 1769
Oil on canvas, 23 × 31 in.
(58.5 × 73.7 cm.)
Inscribed 'Geo: Stubbs 1769' lower
centre
Private Collection

PROVENANCE

. . . ; anon. sale, Christie's 8 March 1902 (70), bt.
Agnew; anon. sale, Christie's 14 June 1907 (65),
bt. Colnaghi, from whom purchased for a private
collection

EXHIBITED

Conversation Pieces, Sir Philip Sassoon's, 25 Park
Lane, London 1930 (73); *British Art, R.A.* 1934
(387, *Commemorative Catalogue* no. 164); Liverpool
1951 (5); Whitechapel 1957 (3)

The picture's early provenance is unknown. It
appeared in the saleroom early this century as 'Mr.
and Mrs. Saltonstall and daughter, of Hillingdon
Hall, Uxbridge'. It is generally assumed that the
sitters are Robert Saltonstall, his wife Isabella
Battie of Sheffield, whom he married in 1764, and
their only child Isabella, who must have been born
in 1765 or 1766 (at her death on 5 February 1829
her age was given as sixty-three). Stubbs's enamel
portrait of Isabella Saltonstall as 'Una', at the age of
sixteen in 1782, is No. 121. In the last decade or so
of Stubbs's life, she gave him considerable financial
help, and is named as co-executrix of his Will.

The Saltonstalls came from Pontefract, in the
West Riding of Yorkshire, where Isabella's
grandfather was an apothecary; his brother or son
Samuel was Mayor of Pontefract in 1751, 1766 and
1767, and his sons Robert and Thomas seem to
have moved to London about the same time as, or a
little before, Stubbs. Robert Saltonstall's Will
describes him as 'gentleman, of Warrick Court,
Holborn', where he died in 1786 and his wife died in
1791; it does not mention Hillingdon Hall, but
refers to considerable property in or near
Pontefract. Thomas Saltonstall, Freeman of the
Society of Apothecaries, lived in Holborn, but must
have had some link with Hillingdon, for he died
there in 1782 (leaving one surviving child, a
daughter born in 1772). The curious battlemented
gateway in the picture is most unlikely to have
been at Hillingdon in Middlesex, but seems (as
John Harris helpfully suggests) to derive from the
architecture of Pontefract Castle, already ruined by
the eighteenth century. The setting for the picture
may therefore be a real or allusive reference to
Saltonstall property near Pontefract. It is possible
that Stubbs's acquaintance with the Saltonstalls
began in Yorkshire, before his move to London.

109*

LADY READING IN A PARK
c. 1768–70
Oil on canvas, 24½ × 30 in.
(62.2 × 76.2 cm.)
Private Collection

PROVENANCE

. . . ; Robert Nesham, Clapham, London; his administrator's sale, Christie's 23 July 1928 (187, as 'F. Zoffany, R.A.; A lady seated under some trees, reading'), bt. Pawsey & Payne, £378; Knoedler, from whom purchased, as by Stubbs but as 'A portrait of the Princess Royal', for the present private collection

There seem to be no clues to the identification of this lady. There is a certain informality about the portrait which suggests that the sitter is well known to the artist. Could it be a portrait of Charlotte Nelthorpe before her marriage? It is difficult to pronounce on a likeness in a down-turned face; all one can say is that the lady reading appears 'not unlike' her portrait with her daughter and husband, the Rev. Carter-Thelwall (in the Holburne of Menstrie Museum, Bath).

Stubbs's painting of the trees deserves special attention.

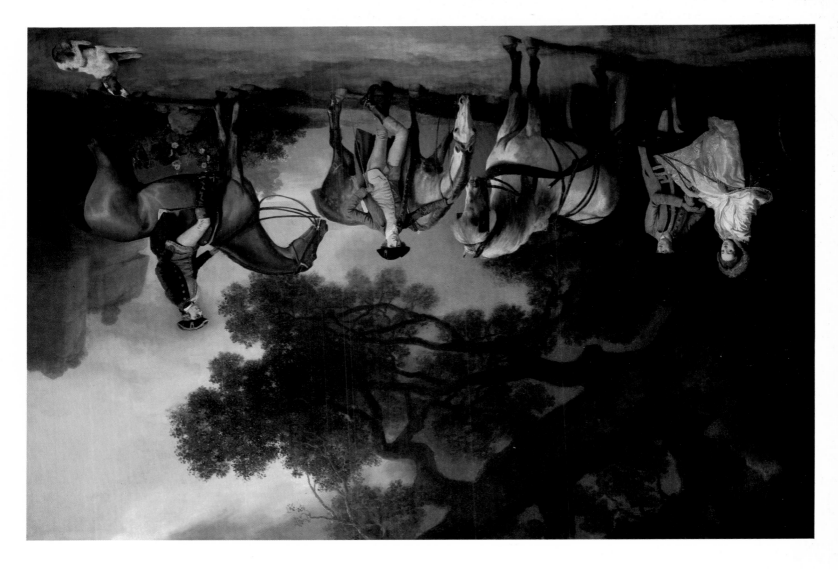

110*

THE MILBANKE AND MELBOURNE FAMILIES

c.1770

Oil on canvas, 38¼ × 58¾ in. (97.2 × 14.93 cm.)

Trustees of the National Gallery

PROVENANCE

Presumably commissioned by Peniston Lamb, (later 1st Viscount Melbourne), by descent through his daughter Emily, who married 5th Earl Cowper, and thence by descent in the female line through the Fane and Desborough families until inherited by Hon. Julian Salmond, by whom sold in 1975 to Marlborough Fine Art Ltd.; from whom, after an export licence had been refused, purchased by the National Gallery.

EXHIBITED

? Society of Artists 1770 (133), 'A Conversation'); Old Masters, R.A. 1881 (2); Animals, Whitechapel Art Gallery 1907 (37); Woman and Child in Art, Grosvenor Gallery 1913–14 (81); Conversation Pieces, Sir Philip Sassoon's, 25 Park Lane, London, 1930 (5); British Art, R.A. 1934 (401, Commemorative Catalogue, no. 166, pl. LXVI); European Masters of the Eighteenth Century, R.A. 1944–5 (110); Whitechapel 1957 (5, pl. XIX).

LITERATURE

Taylor 1971, pp. 18, 37, 38, 209, pls. 53–4; National Gallery, Director's Report, July 1975–December 1977, 1978, p. 23, repr.

The sitters are, from left to right, Elizabeth Milbanke, later first Viscountess Melbourne, her father Sir Ralph Milbanke, her brother John Milbanke and her husband Sir Peniston Lamb, who had succeeded his father as 2nd Baronet in November 1768 (he was to be given an Irish barony in June 1770, promoted to a viscountcy as Lord Melbourne in 1784 and to the English peerage in 1815).

At the age of sixteen, on 13 April 1769, Elizabeth Milbanke married Sir Peniston Lamb. Stubbs's picture was probably painted within the next twelve months; almost certainly, it was the painting exhibited in 1770 as 'A Conversation'. It was later identified as such by J.H. Anderdon, who describes the picture as 'A Lady in a tim-whisky drawn by a grey horse, a gentleman standing beside her, a gentleman standing & near the horse another gentleman on horseback, & near the horse a spaniel laid down'. If this was indeed the picture exhibited in 1770 (and the Society of Artists' exhibition usually opened in May), Stubbs may have posed the future Lady Melbourne in a tim-whisky because she was noticeably pregnant; her first child, Peniston, was born 3 May 1770 (a tim-whisky is a very light carriage drawn by a single horse, so-called because it is easy to imagine it 'whisking' along).

Of the two families at the time of the marriage, the Milbankes were of higher birth. Sir Ralph Milbanke, 5th Bart., of Halnaby Hall in Yorkshire, was head of an old Yorkshire family; he was a Member of Parliament for Scarborough, 1754–61, and for Richmond 1761–8. He married Elizabeth Hedworth, who bore him two sons and a daughter; she died on 6 July 1767, at least two years before this group was painted.

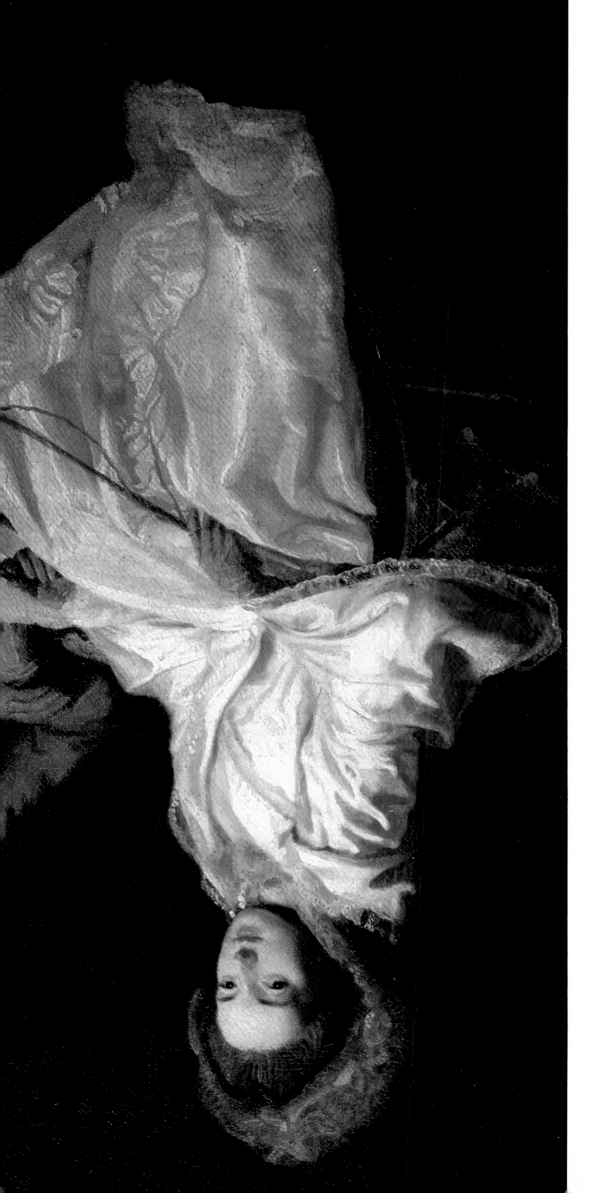

Compared with the Milbankes, the Lambs were parvenus. Their fortunes had been founded three generations earlier by Peniston Lamb, a Nottingham attorney who died leaving a fortune; his nephew and heir consolidated the family's social position by entering Parliament, buying a country seat and acquiring a baronetcy. His son Peniston Lamb (Stubbs's sitter) was an ineffectual man. He entered Parliament and sat in it for forty years, speaking only once; he devoted such energy as he possessed to drinking, hunting and gambling at faro, thereby losing much of the fortune he had inherited. Even his children seem to have regarded him with affectionate contempt, his daughter Lady Cowper later remarking, 'Papa, altho he . . . only drinks one glass of negus, manages somehow or other to be drunkish' (G.E.C.). It was his marriage to Elizabeth Milbanke which saved him from obscurity, and providentially it was her brains rather than his which were inherited by their second son William Lamb, later Lord Melbourne and a future Prime Minister.

The most powerful character in Stubbs's group was undoubtedly Elizabeth Milbanke, the future Lady Melbourne. She was energetic, level-headed, rational and above all, ambitious. 'Since to her this world was the only one, its prizes seemed to her the only ones worth having. And her whole life was given up to getting them for herself and her family. To this end she dedicated her beauty, her brains and her energy; it was for this she learned to be sagacious and smiling, tactful and dignified, ruthless and cunning' (Lord David Cecil, *The Young Melbourne*, 1955 ed. p. 14).

Even though his sitter is not yet seventeen, Stubbs manages to perceive and convey much of the future Lady Melbourne's character; significantly, her hands are firmly on the reins. She was to have numerous affairs, the most notable being with George Wyndham, third baron Egremont and, by 1784, with the Prince of Wales; she used her influence with the Prince to get her husband promoted to a viscountcy and made a Lord of the Bedchamber. Byron, nearly forty years her junior, described her as 'the best, the kindest and ablest female I have ever known, young or old . . . uniting the energy of a man's mind with the delicacy and tenderness of a woman's . . . With a little more youth, Lady M might have turned my head' (Leslie A. Marchand, *Famous in my Time: Byron's Letters and Journals*, II, 1973, p. 283).

It will be noticed that Stubbs uses virtually the same background in this picture as he does in the Pocklington group (No. 107), painted at much the same time. After the end of the 1760s, his backgrounds tend to become more generalized, and the formula of large oak plus placid water plus a few crags or a small hill takes the place of landscape with distinctive features.

David Piper observed (a propos No. 31, but the comment is equally apt for No. 110) that 'though Stubbs is in fact a leading light in that most English school, the Conversation Piece painters, one has to admit that he is the most non-conversing of them all. There is no hint of anecdote, nor cosiness; and communication between his characters . . . is vital but endlessly silent, as if some obscure but potent directive of late were at work' ('A study of horses exercising, by Stubbs', *Listener*, 9 April 1964, p. 595).

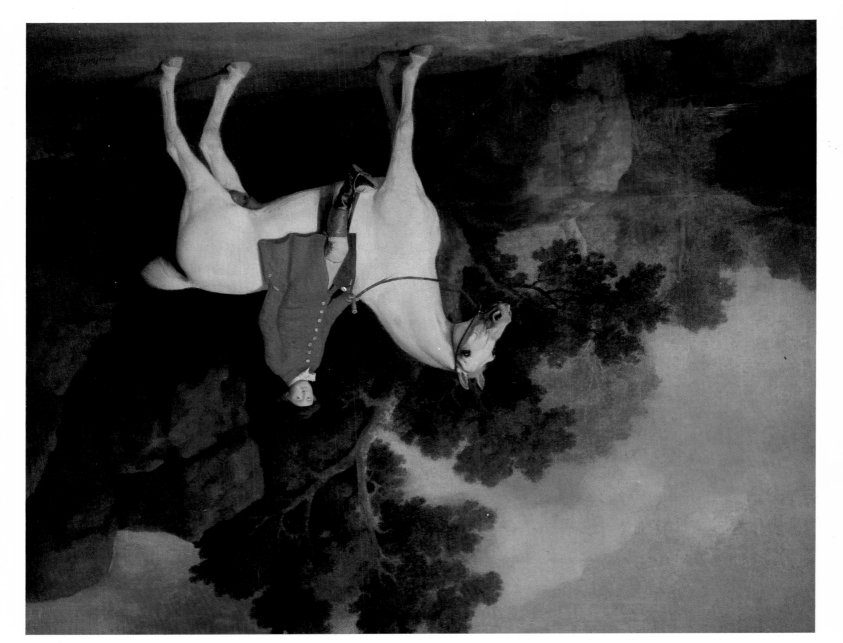

III

WILLIAM EVELYN OF ST. CLERE

dated 1770

Oil on canvas, 39 × 49 in.
(99 × 124.5 cm.)

Inscribed 'Geo: Stubbs pinxit 1770' lower
right

Private Collection

PROVENANCE
Commissioned by the sitter, and thence by
descent

The sitter is William Evelyn of St Clere, near
Sevenoaks, Kent, 1734–1813, eldest son of William
Evelyn of St Clere (1686–1761) by his second wife
Bridget, daughter of Hugh Raymond of Langley,
Kent. The sitter was M.P. for Hythe from 1768 to
1802.

Stubbs was to use the same pose for the rider as
well as for the horse in his 'Gentleman on
Horseback', signed and dated 1771, on panel,
28 × 31 in. (exh. Liverpool 1951, no. 53, lent by Sir
Raymond and Lady Evershed) though in that
picture the white horse has become a bay. More
puzzlingly, he was to use the same pose for the
horse and rider and the same immediate
background again in his own 'Self Portrait on a
White Hunter', dated 1782, painted in enamel on
Wedgwood biscuit earthenware (oval, 36½ × 27½
in., repr. p. 18.) This seems far more odd. One can
imagine Stubbs envying and so 'borrowing'
William Evelyn's splendid mount, but why should
he depict himself in the saddle twelve years later in
precisely William Evelyn's attitude, down to the
left hand thrust into the coat pocket and the
upturned toe of the left boot? Presumably Stubbs
had kept a sketch or study of the earlier portrait;
perhaps the fact that it must be difficult to paint a
self-portrait on horseback is sufficient answer to the
puzzle.

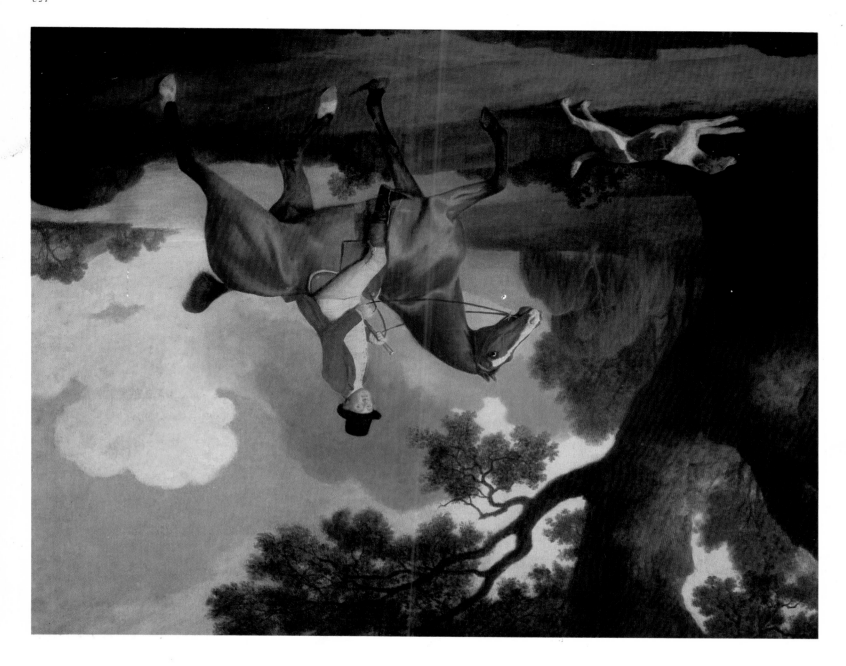

112

? SIR FREDERICK EVELYN RIDING WITH A
HOUND
dated 1771

Oil on canvas, 39 × 48¾ in.
(99 × 123.8 cm.)

Inscribed 'Geo: Stubbs pinxit 1771' lower
right

Private Collection

PROVENANCE
Commissioned by the sitter, and thence by
indirect descent (on loan c.1947–70 to Sherman
Stonor, later Lord Camoys, at Stonor Park)

ENGRAVED
by George Townly Stubbs, published 3 August
1793

The sitter's identity has not been positively
established. He is likely to be Sir Frederick Evelyn,
3rd Bart., of Wotton and Sayes Court, eldest son of
Sir John Evelyn, 2nd Bart., of Wotton M.P., and his
wife Mary, daughter of 1st Viscount Falmouth; if
so, he is the great-great-grandson of John Evelyn of
Wotton, diarist. Sir Frederick Evelyn was educated
at Eton and Clare College, Cambridge, served with
Elliot's Light Horse at the Battle of Minden in 1759
and was a member of the Jockey Club. In 1769 he
married Mary, daughter and heir of William
Turton, of Staffordshire. On his death without issue
in 1812, the baronetcy became extinct.

G.T. Stubbs's print, on which no engraved title
appears, has sometimes been called 'The Earl of
Eglinton' (e.g. by Siltzer, 1929, p. 271), a guess
probably inspired by the E branded on the
foxhound.

113*

SIR JOHN NELTHORPE, 6TH BARONET,
OUT SHOOTING WITH HIS DOGS IN
BARTON FIELD, LINCOLNSHIRE
dated 1776

Oil on panel, 24 × 28 in. (61 × 71.1 cm.)
Inscribed 'Geo: Stubbs pinx. . / 1776'
Colonel R.S. Nelthorpe

PROVENANCE
Commissioned by the sitter; by descent to
Colonel R.S. Nelthorpe

EXHIBITED
Vokins 1885 (11); *Works of Art illustrative of and
connected with Sport*, Grosvenor Gallery 1890 (99);
British Art, R.A. 1934 (336, *Commemorative
Catalogue*, no. 168, pl. LXVI); *British Country Life*,
39 Grosvenor Square 1937 (283); Whitechapel
1957 (6, pl. XVIII)

LITERATURE
Gilbey 1898, p. 167 (evidently unseen: described
as an upright picture, 49 × 39½ in.; F. Henthorn,
History of Brigg Grammar School, 1959, p. 56;
Egerton 1978, pp. 28–9

ENGRAVED
by J.B. Pratt, repr. Gilbey 1895, facing p. 14

Stubbs's portrait of Sir John Nelthorpe as a boy is
No. 27 in this exhibtiion. This picture, dated 1776,
shows him at the age of thirty-one, in the role of
Lincolnshire squire, out shooting in his home field
near Barton-on-Humber in north Lincolnshire,
accompanied by two pointers whose names are
recorded in family papers as Hector and Tinker.
The background includes a wide view of the town
of Barton-on-Humber, with the church towers of St
Mary's and St Peter's clearly visible and the
Humber estuary gleaming beyond. The village of
Horkstow lies (unseen) in the dip of the land in the
distance towards the left, three or four miles this
side of the Humber.

By 1776, the Nelthorpes, whose ancestors
included London-born goldsmiths, had been
Lincolnshire landowners for almost two centuries.
As Henthorn (op. cit., p. 6) notes, 'The family
never achieved any national fame: they were
content in the eighteenth century to live as country
squires, solid but unpretentious'. Sir John
Nelthorpe was at Eton from 1757 to 1763, and then
at Oxford (Trinity). He was wealthy enough to buy
property in London, including a house in Berkeley
Square, but seems to have settled contentedly
chiefly for country life, though by no means for a
bovine existence: the Nelthorpe papers
(Lincolnshire Archives Office) record payments in
1795, for instance, to Sir John's perfumer, hatter,
harpsichord maker, tailor, snuff-maker, purveyor
of wines and spirits and supplier of pottery
(Messrs. Wedgwood), as well as to his gunsmith,
saddler and brewer. He played a conscientious part
in local affairs; besides acting as a Governor of
Brigg Grammar School, founded by his ancestor the
1st Baronet in 1699, he was High Sheriff of
Lincolnshire in 1767 and Deputy Lieutenant three
years later. His Lincolnshire estates were increased
in 1788 by his inheritance (from an elder branch of
the family) of Scawby Hall and its lands.

Sir John Nelthorpe continued his mother's
patronage of Stubbs throughout his life. He bought
what is perhaps the original version of 'Lion and
Lioness', dated 1772. It was probably Sir John
Nelthorpe who recommended Stubbs to his
Lincolnshire neighbours the Earl of Yarborough
and Robert Vyner (see Nos. 103 and 104). On
Stubbs's visit to Lincolnshire in 1776, he painted
not only the portrait of Sir John Nelthorpe
shooting, but also a 'family picture' of Sir John
Nelthorpe's sister Charlotte and her young
daughter in a pony-carriage, with her husband, the
Rev. Carter-Thelwall, standing beside it and
Redbourne Church in the background; Sir John
Nelthorpe himself married a Charlotte Carter of
the same family (that picture, now in the collection
of the Holburne of Menstrie Museum of Art, Bath,
is not in good enough condition to travel to this
exhibition; it is repr. in Parker 1971, p. 165).

Sir John Nelthorpe owned a copy of *The Anatomy
of the Horse*, and bought many of Stubbs's own
prints; Stubbs's receipt for his subscription
towards the publication of 'Hay-Makers' and
'Reapers' is No. 171 in this exhibition. The last
commission Stubbs received from Sir John
Nelthorpe was on a further visit to Lincolnshire in
1792, when he painted 'Faddle, a Spaniel', for
which a payment of £20 is recorded in Sir John's
Farm Accounts Book.

With the threat of French invasion in 1798, Sir
John Nelthorpe raised and commanded the Brigg
Independent Volunteer Armed Association, over
eighty strong, but died the following year, in
London, having (as his daughter Frances reported)
caught cold there.

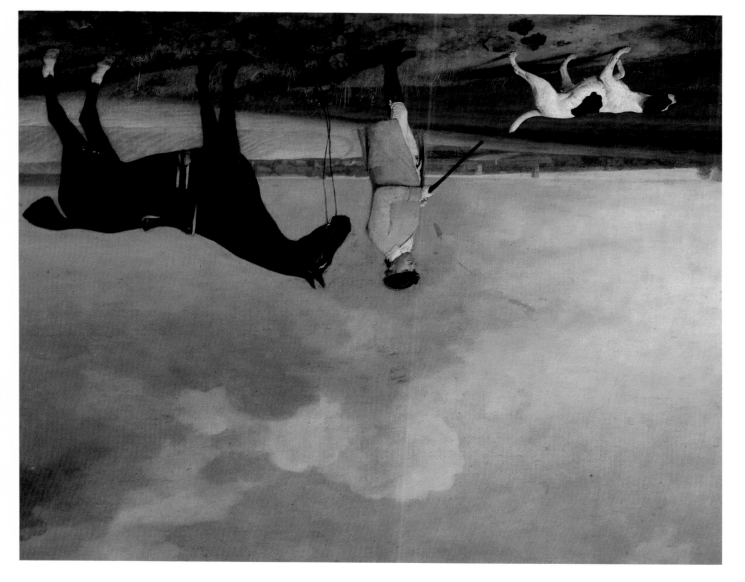

114*

VALENTINE KNIGHTLEY WITH HIS
SHOOTING-PONY, MONARCH, AND HIS
POINTER, BELL, IN BARTON FIELD,
LINCOLNSHIRE
dated 1776

Oil on panel, 32 × 39 in. (81.3 × 99 cm.)
Inscribed 'Geo: Stubbs pinxit / 1776'
lower left of centre, below loop of reins

Private Collection

PROVENANCE
Painted for the sitter; by descent to Sir Charles
Knightley, 5th Bart., Fawsley Park,
Northampton, sold by Chancellor & Sons (in a
12-day sale at Fawsley Park) 8 May 1914 (122,
as 'Sportsman with Shooting Pony and Pointer',
bt. by the father of the present owner.

EXHIBITED
English Sporting Pictures, Leggatt Brothers 1959
(35, as dated 1778)

The sitter is Valentine Knightley (1744–1796),
second of the six sons of Valentine Knightley
(1718–1754) of Fawsley Park, Northamptonshire,
and his wife Elizabeth, daughter of Edward
Dummer of Swaything, Hampshire. The
Knightleys were an ancient family, tracing their
descent to Sir Rainald de Knightley, mentioned in
Domesday Book. G.E.C. relates that the pride in
his lineage displayed by the Rainald Knightley who
was created 1st Baron Knightley in 1892 inspired
the following paraphrase of Addison's lines:

And Knightley to the listening earth
Relates the story of his birth.

The Valentine Knightley who sat to Stubbs was
born on 20 May 1744. Apart from a visit to Italy
(Horace Walpole mentions his return to England in
a letter of 15 June 1773; *Correspondence*, ed. Wilmarth
S. Lewis and others, 23, X, p. 491) he seems to have
been content with the life of a country gentleman,
playing an occasional role in Northamptonshire
affairs. He was High Sheriff of Northamptonshire in
1795, and succeeded his elder brother Lucy
Knightley as lord of the manor of Fawsley in 1791.
He died unmarried at Preston Capes,
Northamptonshire on 7 July 1796, 'at 11 o'clock in
the morning.'

The background here is virtually identical to
that in Stubbs's portrait of 'Sir John Nethorpe out
shooting . . .' also painted in 1776 (No. 113): Barton
Field in north Lincolnshire, with a view of Barton-
on-Humber and the river Humber beyond. In the
Nethorpe portrait, the background is that sister's
own home ground; but Valentine Knightley is not
known to have had any landed interests or close
family ties in Lincolnshire. It is most unlikely that

Stubbs would have presumed to use the Barton
Field background for Knightley's portrait without
the permission of Sir John Nethorpe, his faithful
patron. Perhaps Valentine Knightley was an
occasional shooting companion of Sir John
Nethorpe over this country. If so, the friendship
between them may well have been based on the old
school tie: Knightley, a year or so older than
Nethorpe, entered Eton College on 22 January
1755, Nethorpe on 11 February 1757 (ed. Richard
Austen-Leigh, *Eton College Register, 1753–1790*,
1921, pp. 316, 387).

Stubbs's studio sale included 'A black and white
spaniel, belonging to Mr. Knightley' (25 May 1807,
lot 73). This may be the picture described as
'Spaniel Dog, Signed and dated George Stubbs
1794' in the Fawsley Park sale of 1914 (124,
dimensions not given, buyer's name not recorded
and present location unknown); if so, the picture
may have been unfinished or unpaid for at the time
of Valentine Knightley's death in 1796, finding its
way only later to Fawsley Park.

Joseph Smyth of Sholebrooke,
Northamptonshire, Lieutenant of Whittlebury
Forest, painted by Stubbs (No. 32 in this
exhibition), was Valentine Knightley's uncle by
marriage.

(Information about Valentine Knightley is
drawn from Namier & Brooke, *1754–1790*, III,
1964, p. 14; G.E.C., VII, 1929, p. 344, and G.E.C.,
The Complete Baronetage, V, 1906, pp. 321–3; and
Oswald Barron, *VCH: Northamptonshire Families*,
1906, pp. 169–206. The compiler is indebted to the
help of Colin Eaton and P.I. King, County
Archivist, Northamptonshire.)

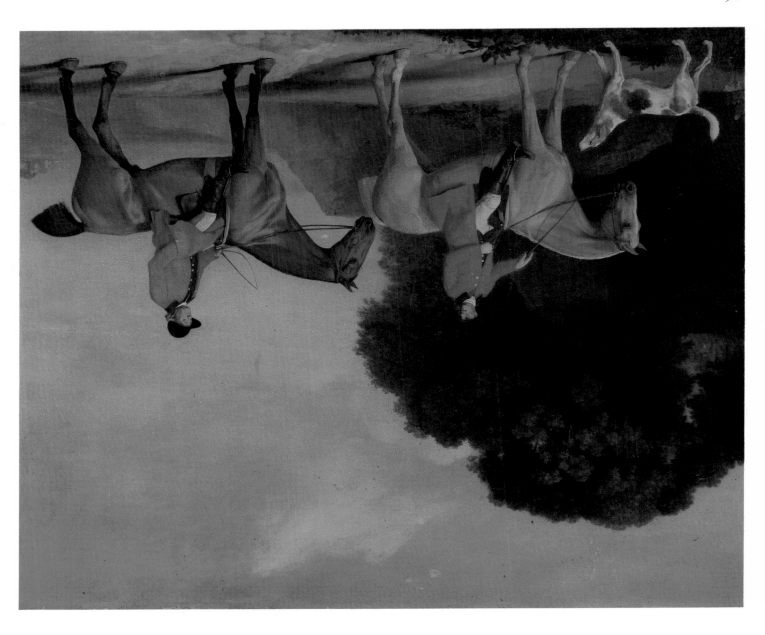

The Smith family were huntsmen at Brocklesby for four generations. Stubbs's portrait shows Thomas Smith, huntsman from 1761 to 1816, turning towards his father, who had preceded him as huntsman and was still famous for his 'erect but easy seat'. The picture is described by the elder Thomas Smith's grandson, William Smith (op. cit.: himself huntsman from 1816 to 1845): 'a most striking likeness of my grandfather, and his very attitude on horseback. They used to go to and from covert at foot's pace at that time of day, though ever so cold; this was the old man's attitude, one hand in his pocket, and resting on his thigh'.

The younger Thomas Smith started to whip in to his father when he was fourteen years old. William Smith wrote 'Hounds was my father's object alone; he was lost in any other business, but in that I believe he was quite perfect. He was born for the saddle; his form stout upwards, with bow'd legs, rather short in his person . . . The picture strikes me as a taller man. I think it is like his attitude, but not his countenance.'

William Smith adds that the elder man rides a favourite horse called Gigg, who had once come in fourth at Newmarket; the younger Thomas Smith rides Brilliant, a cream-coloured horse 'bought from the Duke of Grafton to carry Mrs. Pelham' (Sophia Aufrere, wife of Charles Pelham, later 1st Lord Yarborough, portrayed feeding chickens in one of Reynolds's most charming portraits), 'but never very good, albeit a thoroughbred'. The hound is Wonder, bred in 1770, by Tatler out of Trickster.

115*

Earl of Yarborough

THOMAS SMITH, HUNTSMAN OF THE
BROCKLESBY HOUNDS, AND HIS FATHER
THOMAS SMITH, FORMER HUNTSMAN,
WITH THE HOUND WONDER

dated 1776

Oil on panel, 32¼ × 39½ in.
(77 × 100.3 cm.)
Inscribed 'Geo: Stubbs pinxit / 1776'
lower left

PROVENANCE
Commissioned by Charles Anderson-Pelham
(created 1st Lord Yarborough, 1796); thence by
descent

EXHIBITED
British Art, R.A. 1934 (412, *Commemorative
Catalogue* no. 169)

LITERATURE
William Smith, 'Thoughts on Hunting', 1830,
published in G.E. Collins, *History of the Brocklesby
Hounds*, 1902, pp. 82–3; Gilbey 1898, p. 141

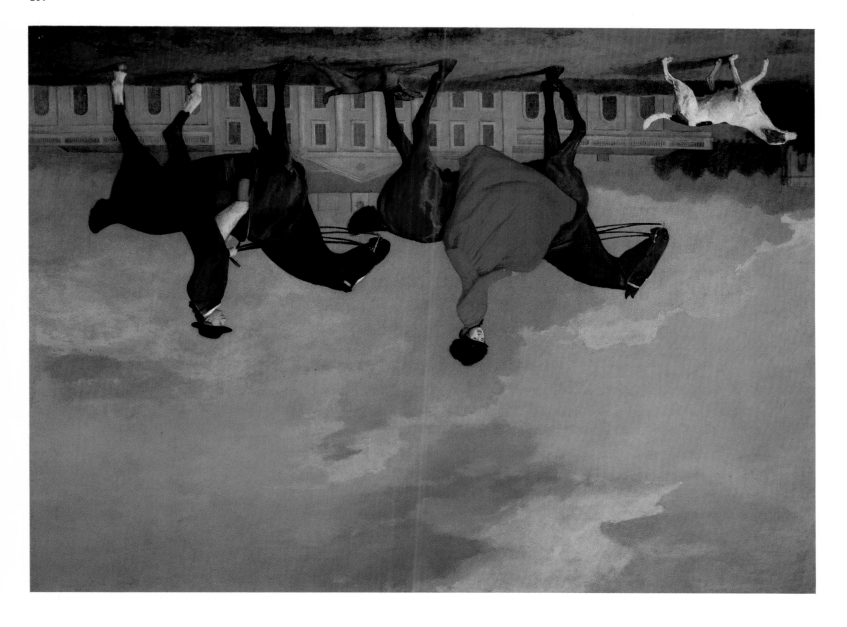

116*

JOHN AND SOPHIA MUSTERS RIDING AT
COLWICK HALL
dated 1777

Oil on panel, 39½ × 49 in.
(100.4 × 124.4 cm.)
Inscribed 'Geo. Stubbs pinxit / 1777'
beneath the nearside foreleg of Mrs
Musters's horse

Private Collection

PROVENANCE
Commissioned by John Musters; by descent to
the present owner

EXHIBITED
European Masters of the Eighteenth Century, R.A.,
Winter 1954–5 (103); Whitechapel 1957 (8, pls.
LV, XXI); *Sport and the Horse*, Virginia Museum of
Fine Arts, Richmond, Virginia 1960 (21, repr.);
British Sporting Painting 1650–1850, Arts Council
1974–5 (48)

LITERATURE
Mary Spencer, in MS notes added to Humphry's
MS Memoir; H. Wilberforce Bell, 'The
Vicissitudes of a Picture by George Stubbs',
Country Life, 26 September 1936, pp. lii–liii.

Dated 1777, the picture portrays John Musters of Colwick Hall, near Nottingham, at the age of twenty-four, with his wife Sophia, aged nineteen or twenty. John Musters was born on 7 February 1753, the son and heir of Mundy Musters of Colwick Hall, and his wife Mary, daughter of John Gray, of Newton Linford, Leicestershire; Sophia was the eldest daughter and co-heir of James Modyford Heywood of Maristowe, Devon, and his wife Catherine, daughter of Major Chiverton Hartopp of Welby, Leicestershire (her sister and Sophia's aunt Mary was the Lady Howe of Gainsborough's ravishing pink and silver portrait at Kenwood).

John and Sophia Musters were married the year before Stubbs's portrait, on 29 or 30 July 1776. That year also saw the completion of the rebuilding of Colwick Hall (as the date '1776' on its lead rainwater pipe-heads still proudly proclaims), by Samuel Stretton of Nottingham under the direction and to the design of John Carr of York. Stubbs's picture shows the south front of Colwick Hall, with its portico of four attached Ionic columns and a graceful central cupola, and with the church of St John the Baptist on the left of the picture. Accompanied by a foxhound bitch and a terrier who, according to Mary Spencer (op. cit.) was the favourite in the house', John and Sophia Musters ride out on a high embankment which protects Colwick Hall and its grounds from the river Trent, which must be imagined as flowing behind the artist's back. Pevsner's comment on the village of Colwick is that 'Church and Hall once made a famous picture by the river Trent. Now the Church is unroofed and the Hall does catering in connection with the racecourse' (*Nottinghamshire*, 1951, p. 55).

John Musters probably commissioned this picture to celebrate both his marriage and the remodelling of his house: possibly to commemorate also the fact that he was High Sheriff of Nottinghamshire in 1777. Though he had a London house (22 Grosvenor Place), John Musters was more interested in Nottinghamshire life, politics and sport than in London society. He kept a famous pack of hounds, and was also devoted to racing; he was one of the chief subscribers to the building of a grandstand (also designed by Carr of York and built by Stretton) on the original Nottingham racecourse, and he owned several racehorses, notably Orion, winner of the Gold Cup at Nottingham in 1771. The Musters family patronized the Nottingham Assembly Rooms, and gave balls at Colwick, one of them thus described in the diary of Abigail Gawthern, 8 December 1784: 'Mr. and Mrs. Musters gave a ball at Colwick; above one hundred persons there; Mr G. and myself amongst the number; a deep snow; returned at 3 o'clock'.

Behind the façade of Colwick Hall there developed, it appears, matrimonial unhappiness. Sophia seems to have preferred a metropolitan Court life to a country one. She became known as a 'beauty', and sat to Romney, Hoppner and at least four times to Reynolds, who also painted John Musters (her portrait as Hebe by Reynolds is at

Kenwood, as is the Romney; Reynolds's portrait of John Musters is in a U.S. collection). Sophia frequented Brighton as well as London; there were rumours linking her name with the Prince Regent's.

At some point (evidently within Stubbs's lifetime), John Musters became convinced of his wife's infidelity, and had her painted out of the picture. The resulting 'vicissitudes' of the picture are related by H. Wilberforce Bell (op. cit.); they can be followed in three photographs which illustrate Bell's article and are displayed here. It seems that John Musters first of all had Sophia painted out of the picture; then, as his own figure riding behind a saddled but riderless horse must have looked rather silly, he had himself painted out. Presumably Stubbs himself painted out both figures (he also painted Mrs Musters out of No. 117, substituting a sporting vicar in her place), doing it very skilfully so that the figures could be retrieved if required; but before their resurrection, John Musters evidently commissioned another artist to give some meaning to the riderless horses by inserting the figure of a groom before each, and turning one rein in each case into a leading-rein. The figures of these grooms were necessarily weedy, since Stubbs – as always – had designed his composition so compactly that there was little or no room for any additions; that Stubbs cannot have been responsible for the unhappy result is surely clear from the middle photograph. The painting was mercifully restored in 1935–6 to its original appearance.

John Musters died in London on 23 February 1827, Sophia in Brighton on 19 September 1819. One son and one daughter survived them; John, the son, married Mary Ann Chaworth, with whom in his sixteenth year Byron had fallen desperately and hopelessly in love. Both John and Sophia Musters were buried at Colwick. Sophia's monument by Westmacott is now re-erected in All Saints, Annesley, Notts.; it shows her as Resignation.

(For information in this and the following entry, the compiler is indebted to the researches and generosity of Mr John Cadman.)

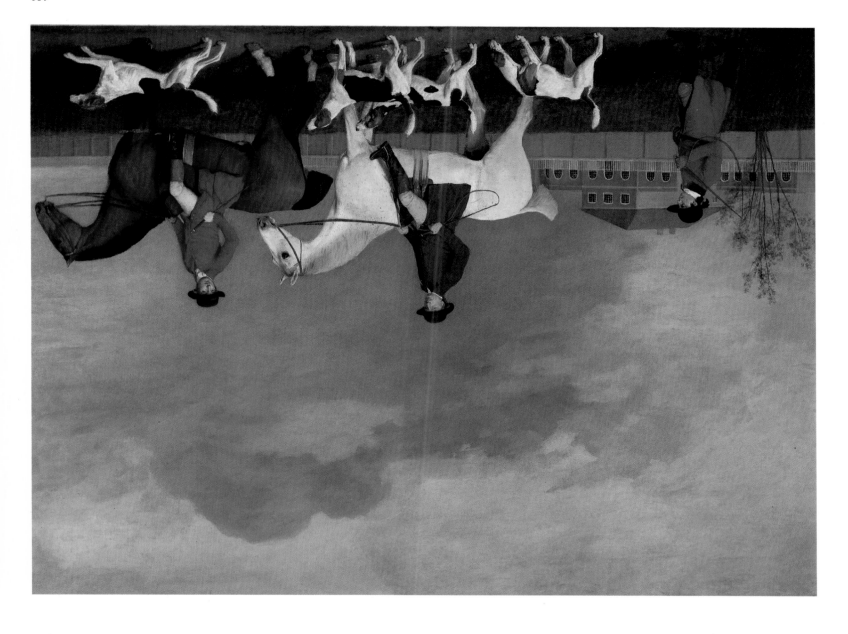

117*

JOHN MUSTERS AND THE REV. PHILIP STORY RIDING OUT FROM THE STABLE-BLOCK AT COLWICK HALL

dated 1777

Oil on panel, 39¼ × 49 in.
(100.4 × 124.4 cm.)

Inscribed 'Geo. Stubbs pinxit / 1777'
lower left

Private Collection

PROVENANCE
Commissioned by John Musters, as a double portrait of himself and his wife; by descent to the present owner

EXHIBITED
Coronation Exhibition of Portraits, Leicester Museum and Art Gallery 1937

This picture was originally, like No. 116, a portrait of John Musters with his wife Sophia. The unhappy relationship which developed between them is mentioned in the entry above. As the present owner points out, the saddle on the grey horse now ridden by Rev. Philip Story has no saddle-flap; it was originally a side-saddle, with Mrs Musters's legs invisible on its further side. In this case (unlike the 'vicissitudes' of No. 116), it was evidently Stubbs who not only painted Mrs Musters out (in this case entirely obliterating her figure) but also painted the vicar in, although, as the present owner notes, he neglected to convert the saddle into one appropriate for a man.

The Rev. Philip Story (?1748–d. 1819) became Vicar of Lockington, Leicestershire, in 1777, remaining its incumbent until his death on 9 June 1819. A tablet in Lockington parish church commemorates his long service there, and records that he married Martha Stevens and by her had fourteen children. He evidently shared John Musters's passion for fox-hunting. John Musters hunted the south Nottinghamshire country, and bred a famous pack of hounds. One of his most celebrated runs, on 16 February 1776, has become legendary.

This picture shows two friends setting off to ride to hounds, accompanied by a hunt servant and two couple of foxhounds. In the background is the stable-block at Colwick, close to the house and at right angles to it; it was designed, like the house itself, by John Carr of York and built by Samuel Stretton of Nottinghamshire. Carr's designs for Colwick extended to the kennels for John Musters's foxhounds, which were built (by Stretton), with a house for the huntsman, about a quarter of a mile away from the house. They were described in the Nottinghamshire volume of *The Beauties of England and Wales*, 1813, as 'a well constructed, and indeed even elegant, dog kennel' (p. 210). Few hunt servants lived in quarters as well designed and as commodious as those built (e.g. at Goodwood and Raby as well as at Colwick) for the hounds of a premier pack.

John Musters commissioned at least four other paintings from Stubbs: (1) a portrait of himself riding his favourite horse, Monarch, accompanied by a foxhound, dated 1777, in the same collection as Nos. 116 and 117; (2) 'A group of John Musters's Brood Mares', dated 1777 but unfinished, formerly in the collection of Mr Paul Mellon KBE (Egerton 1978, no. 86, pp. 89–90), sold Sotheby's 18 November 1981 (104), and now in a private U.K. collection; (3) and (4) two portraits of Mrs Musters's spaniel Fanny, one sold, one offered, Christie's 15 July 1983 (8–9). The last three paintings were sold from Colwick Hall in 1888.

118*

TWO HUNTERS WITH A YOUNG GROOM AND A DOG

dated 1778

Oil on panel, $32\frac{1}{2} \times 39\frac{1}{4}$ in.
(82.5 × 99.7 cm.)

Private Collection

PROVENANCE
. . . ; Earl of Carnarvon, sold Christie's 3 June
1918 (300, as 'Two horses by the edge of a lake,
with a groom wearing the Grosvenor livery . . .'),
bt. Arthurton, £300; Mrs Edward Hulton;
Partridge, from whom bt. by present owner

EXHIBITED
On loan to the Sporting Room at the Tate
Gallery from H. W. Arthurton, c.1936–9;
Liverpool 1951 (32); Whitechapel 1957 (24);
English Sporting Paintings, Partridge 1960 (65);
British Sporting Painting 1650–1850, Arts Council
1974–5 (49)

The groom's yellow livery was stated in the 1918
sale catalogue to be Lord Grosvenor's, but no
record of this painting leaving Lord Grosvenor's
collection has been traced. Other noblemen (e.g.
Lord Lonsdale) favoured yellow livery. The
background, with battlemented buildings on the
left, has not been identified.

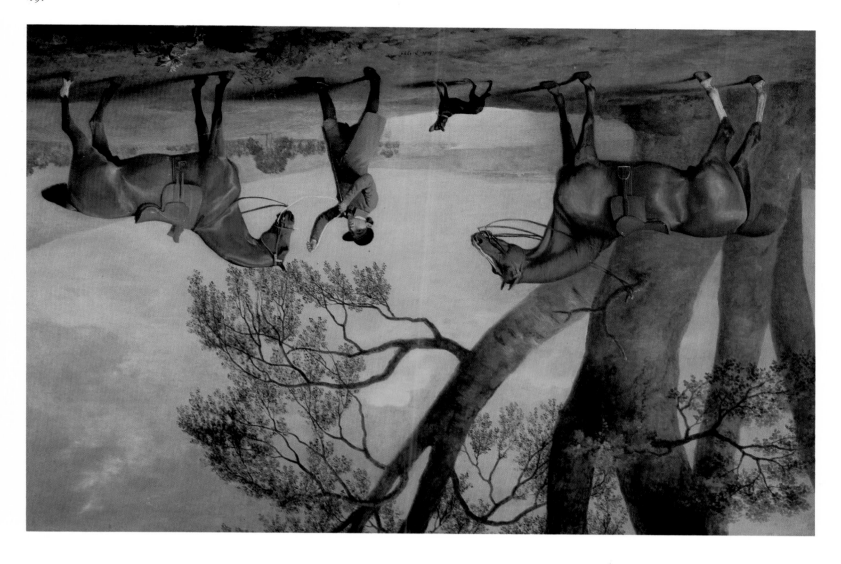

*119

**TWO HUNTERS WITH A GROOM AND A
DOG**
dated 1779
Oil on panel, 35¼ × 53¾ in.
(90.2 × 136 cm.)
Inscribed 'Geo: Stubbs p: 1779' lower
centre
Private Collection

PROVENANCE
. . . ; Comte de Greffulhe (d. 1932); sold by the
Comtesse Greffulhe and the Duc and Duchesse de
Gramont, Sotheby's 22 July 1937 (95, repr.), bt.
Lumley, £820; Leggatt Brothers, from whom
purchased by the present owner and her late
husband

EXHIBITED
British Painting from Hogarth to Turner, British
Council tour, Scandinavia 1949–50 (91);
Liverpool 1951 (46); Whitechapel 1957 (26);
*Private Views: Works from the collections of twenty
Friends of the Tate Gallery*, 1963 (106)

LITERATURE
Parker 1971, p. 94, repr. p. 95

Parker (op. cit.) observes that the dog features in
this painting not just as a pet but as a crucial link in
the design: 'take him away and the whole
arrangement splits in two. Even lower his head a
little and the movement of the design is lost, for it
depends on the poise of his head, looking upwards,
leading the eye up to the curve of the groom's arms
and through to the horse, and echoing the curved
branch of the trees beyond . . .'.

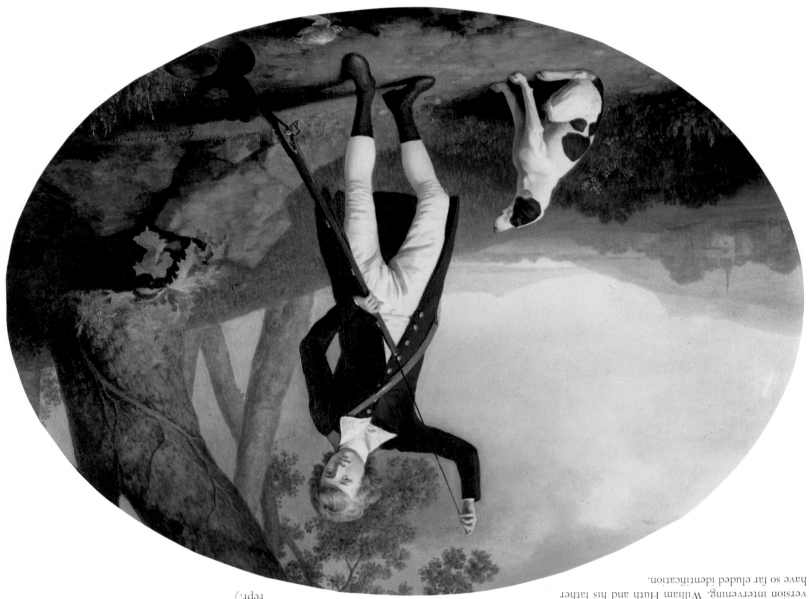

120*

PORTRAIT OF A YOUNG GENTLEMAN
SHOOTING
dated 1781

Enamel on Wedgwood biscuit earthen-
ware, oval, 18 × 24½ in. (45.7 × 62.2 cm.)

Private Collection

PROVENANCE
. . . ; Sir Walter Gilbey; his executors' sale,
Christie's, 11 June 1915 (405, as 'Partridge
Shooting'), bt. Pawsey & Payne, £115.10.0;
Tresham Gilbey, sold Christie's, 25 April 1940
(245), bt. Agnew; Ian Greenlees; Agnew, by
whom sold 1959 to Mrs Jean Garland [thence by
descent]

EXHIBITED
Royal Academy 1782 (79); *Stubbs & Wedgwood*,
Tate Gallery, 1974 (24)

LITERATURE
Humphry, MS Memoir, Taylor 1961, p. 223, no.
14; Taylor 1971, pp. 19 and 212, pl. 96

This is presumably 'the portrait of a young
Gentleman (William (?) Huth Esq[d]) son of a
Gentleman Farmer' which Humphry notes as 'the
companion size' to the portrait of Isabella
Saltonstall as Una (No. 121); each, he notes, was
'painted on Enamel from Nature', with no' oil
version intervening. William Huth and his father
have so far eluded identification.

121*

ISABELLA SALTONSTALL IN THE
CHARACTER OF UNA, FROM SPENSER'S
FAERIE QUEENE
dated 1782

Enamel on Wedgwood biscuit earthen-
ware, 18⅞ × 25⅝ in. (47.9 × 63.8 cm.)
Inscribed 'Geo: Stubbs pinxit / 1782' on
the rocks to the right, and on the back,
in brown ink, 'Isabella Saltonstall Aged
sixteen. / In the character of Una,
Spenser's Faery Queen — / From her fayre
eyes he took commandment / and ever by
her looks conceived her intent'

*Syndics of the Fitzwilliam Museum,
Cambridge*

PROVENANCE
Presumably painted for the sitter; if still in her
possession when she died in 1829, bequeathed to
her cousin, Mary Susanna Saltonstall; Sir Walter
Gilbey (not in Gilbey, 1898); his executors' sale,
Christie's 11 June 1915 (409), bt. S. Gilbey,
9 gns.; Leslie T. Good (d. 1965); his brother
Harold Good, from whom purchased by The
Syndics of the Fitzwilliam Museum, 1971

EXHIBITED
Royal Academy 1782; Whitechapel, 1957 (13);
Stubbs & Wedgwood, Tate Gallery, 1974 (25,
repr.)

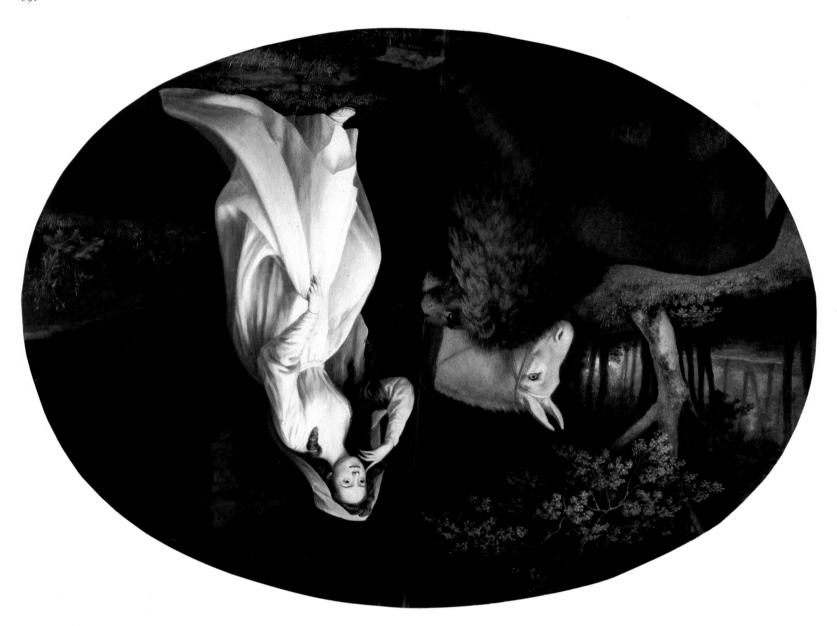

LITERATURE
Taylor, 1961, p. 211 and p. 224, no. 16; Bruce
Tattersall, *Stubbs & Wedgwood*, exh. cat., 1974,
pp. 82–3; J.W. Goodison, *Catalogue of Paintings
III: British School, Fitzwilliam Museum*, 1977,
pp. 258–60, pl. 16

The subject is taken from Edmund Spenser's *Faerie
Queene*, Book 1: 'The Legende of the Knight of the
Red Crosse or of Holinesse'. The Knight,
personifying the Anglican Church, is the champion
of Una, a virgin maiden personifying Truth, who
rides on a 'lowly Asse more white than snow'; but
the Knight is tricked into deserting her,
whereupon the role of protector is taken by a lion.
Tamed through pity for her, the lion obeys all her
commands; that is the meaning of the lines
inscribed on the back of the plaque: 'From her faire
eyes he took commandment/And ever by her looks
conceived her intent'. The omission of quotations
like this from the exhibition catalogue was one of
the grievances which Stubbs had against the Royal
Academy; a justifiable one, since the catalogue for
1782 included a quotation from the *Faerie Queene* for
a 'Cynthia' subject by Maria Cosway.

Stubbs must surely have known the treatment of
this subject by Benjamin West P.R.A., dated 1772
and engraved that year, and exhibited at the Royal
Academy in 1780 (138); it is now in the collection of
the Wadsworth Antheneum, Hartford,
Connecticut (repr.). Stubbs's treatment of Una is
closer to resembling Circe rather than the Anglican
Church.

Isabella Saltonstall, probably seen as a little girl
in the so-called Saltonstall family group (No. 108),
played an important role in the last decade or so of
Stubbs's life. She was born in 1765–6: she was aged
sixty-three at her death on 5 February 1829. She
was the daughter of Robert Saltonstall, of Warwick
Court, Holborn, 'gentleman', and his wife Isabel
Battie. She became a considerable heiress after the
deaths of her father in 1786 and her mother in 1791,
especially as two Saltonstall uncles also named her
as their heir. Her inheritance consisted of estates
in London and in Yorkshire (in and around
Pontefract), as well as securities and cash (her uncle
Robert left, for instance, £2,000 in cash as well as
property in Yorkshire: this sum was about half
what Stubbs's studio sale fetched). Miss Saltonstall
bought the estate of Hatchford, near Cobham,
Kent, where she spent the rest of her life.

Isabella Saltonstall evidently gave Stubbs
generous financial help from at least 1791 (after her
mother's death). Farington recorded on 3 June
1817 that 'a Lady had advanced to *Stubbs* a
considerable sum of money & Had a Bond of
Security which gave Her a claim to His pictures
&c. – These were sold the last week & the prices
were kept up by Her agents & many articles were
bought in. – It is understood that after Her debt is
paid there will be little left'. On 6 June 1807
Farington noted that 'Nollekens told me that when
Stubbs died there was no money in the House but
ab! £20 was owing to him by a person. His House
was mortgaged to a Lady a friend of his and He
owed Her money besides. – His pictures & effects
produced at the sale upwards of £4,000, but the
Lady had been ill advised & bought in pictures for
which high prices were bid, one in particular for
which Mr Tho! Hope bid upwards of £200 but she
could not let it go'.

The Sporting Magazine of November 1809
recorded pictures by Stubbs (among them many in
enamel) owned by Miss Saltonstall, and added that
she 'has also a great collection of his sketches', and
most of the horses Stubbs painted for the Turf
Gallery.

What happened to Isabella Saltonstall's
collection of paintings and drawings by Stubbs is a
mystery. She lived and died a spinster. Her Will
makes no mention of pictures; the two chief
beneficiaries are her cousin Mary Susannah
Saltonstall (who in fact predeceased her) and 'my
dear friend Margaret Wilson spinster now residing
with me the daughter of the late Mr. George
Wilson of Thornhill in the Co. of York': and there
the clues peter out. Isabella Saltonstall's estate was
proved to be worth 'under £45,000', a considerable
sum for those days.

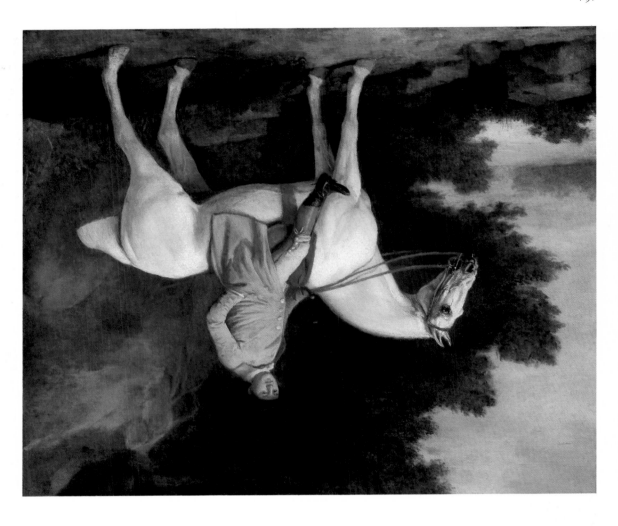

122f

A GENTLEMAN ON A GREY HORSE

dated 1781

Inscribed 'Geo. Stubbs pinxit / 1781'
lower right
Oil on panel, 23⅜ × 28 in. (59.5 × 71 cm.)

Yale Center for British Art,
Paul Mellon Collection

PROVENANCE

. . . ; Robert Nesham, his administrators' sale,
Christie's 23 July 1928 (153, as 'A gentleman on a
white horse', on panel, 23¼ × 27½ in.), bt. Ellis &
Smith, 1,000 gns.; Ackermann 1929; Mrs Robert
Emmet, Paris; Mrs St Clair Balfour, Hamilton,
Ontario; John Alastair Campbell, Alberta,
Canada, from whom purchased by Mr Paul
Mellon KBE, 1964, and presented to the Yale
Center for British Art, 1977

EXHIBITED

R.A. 1964–5 (264); Yale 1965 (176)

LITERATURE

Taylor 1971, p. 211, pl. 88; Egerton 1978, p. 92,
no. 90

The sitter's pose is a variation of that used in the
portrait of William Evelyn, 1770, No. 111, and in
Stubbs's own self portrait of 1782, reproduced here
on page 18. Taylor considers that 'The man's
features show such a strong resemblance to the
artist's, while being considerably younger, that one
is bound to consider the possibility that the picture
may represent his natural son, George Townly
Stubbs.' No certain portrait of G.T. Stubbs is
known, so this suggested identification must
remain speculative. There is certainly a lack of
pretension about the sitter which might suggest
that he was at least a friend of Stubbs's. It is worth
noting that this picture and the 'Portrait of a Lady
reading', were both in Robert Nesham's sale in
1928, though so far it is not known how and when
he acquired them. Both portraits have a private,
informal look, which suggests that the sitters
belong to a circle in which Stubbs felt at home.

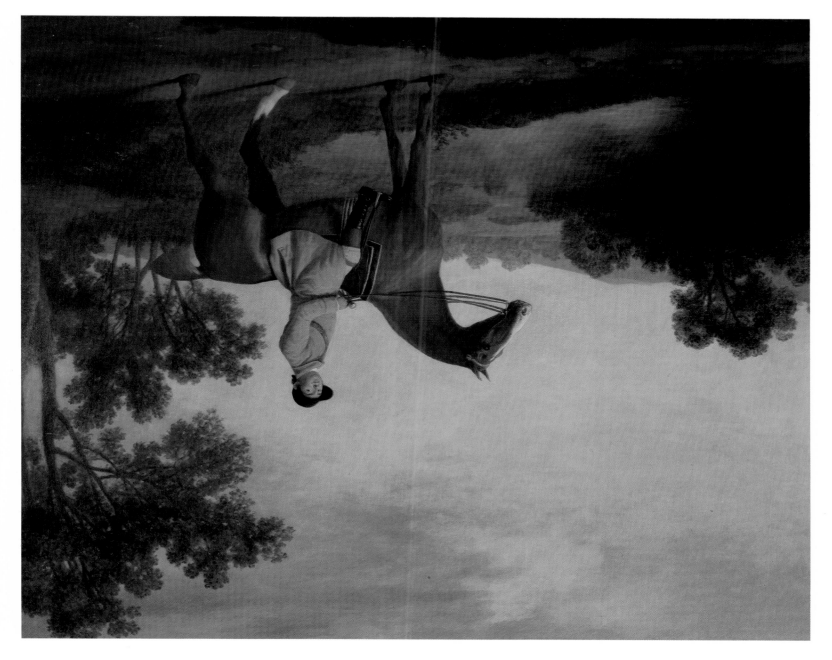

123*

THE 8TH EARL OF CARLISLE'S GROOM, WILLIAM SHUTT, RIDING HIS MASTER'S FAVOURITE CHESTNUT

dated 1773

Oil on panel, 32½ × 40¼ in. (82.5 × 102.3 cm.)
Inscribed 'Geo. Stubbs pinxit / 1773'
lower right

Castle Howard Collection

PROVENANCE
Commissioned by Frederick Howard, 8th Earl of Carlisle; thence by descent

EXHIBITED
British Portraits, R.A. 1956-7 (307)

LITERATURE
Georgina, Lady Carlisle, MS catalogue of paintings at Castle Howard, c.1805

This was exhibited in 1956-7 as 'a Huntsman on a favourite horse of the 5th Earl of Carlisle', which cannot be correct, as the 5th Earl died in 1692. It must have been Frederick Howard (1748–1825),

who succeeded as 8th Earl of Carlisle in 1758, who commissioned this painting, at the age of twenty-five. Horace Walpole described him five years later as 'A young man of fashion, fond of dress and gaming, by which he had greatly hurt his fortune; totally unacquainted with business, and though not void of ambition, had but moderate parts and less application' (*Journals*, February 1778, quoted by G.E.C.) The 8th Earl was later a sitter to Lawrence, a Whig in politics and in private life an intimate friend of Canning.

There was no equivalent of Walpole to record pen-portraits of the servants of the period; it was left to Stubbs to catch their characters. Georgina, wife of the 9th Earl, comments in her MS catalogue (op. cit.) that 'the groom is an admirable likeness'. Traditionally identified as William Shutt, and wearing the Howard livery, the groom seems to personify Yorkshire downrightness, of a sort which a young and apparently frivolous master might well respect; the 8th Earl evidently thought sufficiently highly of him to want his portrait included in his commission to Stubbs to paint his 'favourite horse'. Lady Carlisle adds 'the painter's inability to paint landscape or suffer any other artist to supply his defect, which was requested, makes this piece less valuable'. Unfortunately no correspondence survives to indicate what was 'requested from Stubbs.

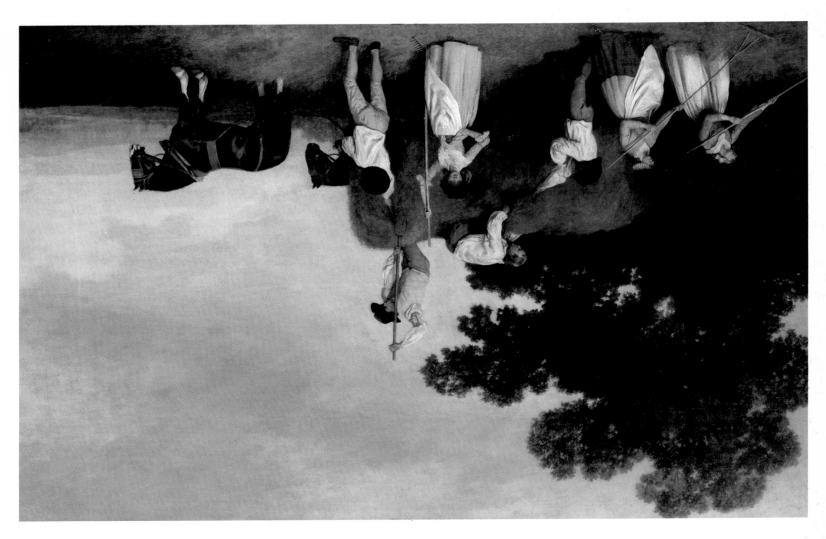

124*
HAYMAKERS
dated 1785
Oil on panel, 35¼ × 53¾ in.
(89.5 × 135.2 cm.)
Inscribed 'Geo: Stubbs pinxit / 1785'
bottom right
Tate Gallery

125*
REAPERS
dated 1785
Oil on panel, 35¼ × 53¾ in. (90 × 137 cm.)
Inscribed 'Geo: Stubbs pinxit / 1785'
bottom right
Tate Gallery

PROVENANCE
. . . Caroline Victoria Jane Downer, The Red House, Garrog, near Corwen, Merionethshire, d. 24 December 1933; by descent to her nieces, Violet and Nancy Tombs; included in the sale of The Red House and its contents, Frank Owen 13 July 1934 (? no catalogue); bt. Alderman James Conrad Cross of Liverpool, sold 1934 to Spink and Son Ltd.; Leggatt Brothers 1935; Captain Arnold Wills, by descent to Major John Lycett Wills, from whom purchased, through Leggatt Brothers and Oscar and Peter Johnson Ltd., by the Tate Gallery, 1977, with the aid of a special government grant, with assistance from The Friends of the Tate Gallery, The Pilgrim Trust, The National Art-Collections Fund, Mr Paul Mellon KBE, The Trustees of the Sir Alfred Munnings Art Museum and Bonhams, and with the help of donations from Thos. Agnew & Sons Ltd., Associated Newspaper Group, BAT Industries, BSR Ltd., The Baring Foundation, The Chase Charity Trust, Mr Algy Cluff, Editions Alecto, The Evening Standard, Fine Art Developments Ltd., The Gordon Fraser Gallery Ltd., Mr Richard Green, Mr and Mrs H.J. Heinz II, Inchcape Management Services Ltd., The Jephcott Charitable Trust, The Post Office, The Joseph Rank Trust, The J. Arthur Rank Group, Rank Hovis McDougall Ltd., Thomson Holidays, The Wolfson Foundation and countless members of the public, 1977

EXHIBITED
R.A. 1786 (94 and 77); Society for Promoting Painting and Design, Liverpool 1787 (100, as 'Harvest scene, Reapers' and 101, as 'Ditto, Haymakers'); Whitechapel 1957 (45 and 44, repr. pls. XVI and XVII); *English Painting c.1750–c.1850*, Leggatt Brothers 1963 (10, repr. and 12).

LITERATURE
Taylor 1971, pp. 19–20, 39–40, 213, repr. pls. 103 (detail 104) and 100 (detail 101); Basil Taylor, 'Farming as Stubbs saw it', *Country Life*, 28 June 1973, pp. 1858–60, repr. figs. 2 and 5; *The Tate Gallery 1976–8, Illustrated Catalogue of Acquisitions*, 1979, pp. 17–19

ENGRAVED
in mixed method by the artist and published by him 1 January 1791 (Nos. 187 and 188)

Painted in his sixty-first year, these were Stubbs's only exhibits in 1786, and his first exhibited pictures since 1782, when five of the seven works he showed at the R.A. were enamel paintings. The interval between exhibits probably reflects Stubbs's reaction to the evident lack of public enthusiasm for his enamels rather than a decline in output in that or any other medium; it may also reflect a deliberate pause in which Stubbs sought to diversify his subject-matter and make it more generally appealing to the public.

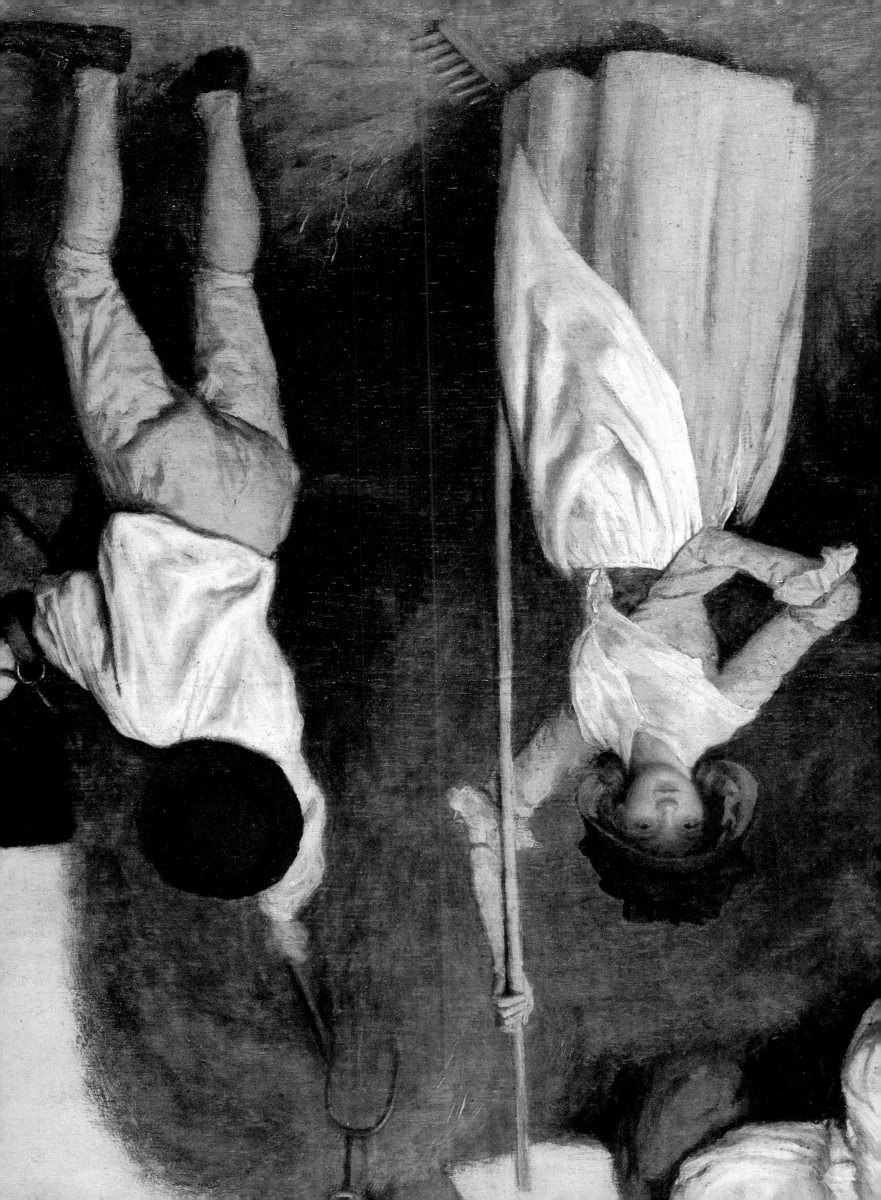

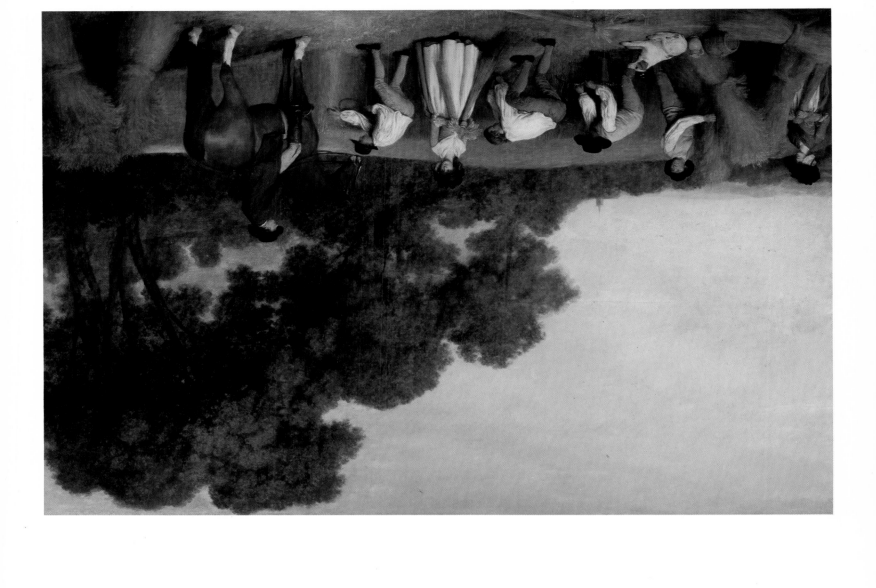

Nos. 124 and 125, both dated 1785, are Stubbs's deliberate refinements of earlier versions of the same subjects, also painted in oils, on panels of similar size, both dated 1783 (National Trust, Bearsted Collection, Upton House: repr. Parker 1971, pp. 126 and 131: not available for this exhibition. In his choice of 'Haymakers' and 'Reapers' as subjects, Stubbs may have been partly influenced by the current popularity of picturesque rural subjects by Gainsborough, Wheatley and Morland, and by some of the many illustrators of Thomson's *Seasons*. There is enough similarity between both versions of 'Haymakers' and an oval haymaking scene painted in watercolour by Thomas Hearne, and exhibited at the Society of Artists, 1783 (108) as 'A Landscape and figures from Thomson's *Seasons*' (Whitworth Art Gallery; repr. *British Watercolours from the John Edward Taylor Collection in the Whitworth Art Gallery*, 1973, p. 8) to suggest either that Stubbs and Hearne studied the same scene, or that Stubbs borrowed from Hearne the images of the girl pausing in front of the haycart with her hayrake upright, the woman raking in hay and the man on top of the haycart. Such borrowings by Stubbs from an exhibited picture by Hearne might partly explain why Stubbs did not choose to exhibit the 1783 versions of 'Haymakers' and 'Reapers'; but in any cases, Stubbs evidently realized that he could improve on the composition of his first versions of the subjects. He reorganized his subject-matter to produce, in the 1785 versions, seemingly natural and unforced groupings which are in fact controlled by a masterly sense of design. The only reasonably certain facts about the

early history of the 'Haymakers' and 'Reapers' of 1785 are that Stubbs exhibited them at the R.A. in 1786, and the following year sent them up to his native Liverpool for the second exhibition of the Society for Promoting Painting and Design (where they were copied without his consent by Charles Towne); that he announced his intention to engrave the pictures in 1788–9 (and published the engravings in 1791); and that in 1794–5 he adapted the subjects to three oval versions painted in enamel. The 1785 paintings were almost certainly in his posthumous sale but thereafter remained completely unrecorded until 1934.

Evidently 'Haymakers' and 'Reapers' were based on preliminary drawings made from nature. The first day of Stubbs's sale included 'Six studies of the Reaper [sic], and two finished drawings ditto' (17); 'A capital Drawing, the original design for the Corn Field with Reapers' (28) and 'Ditto, ditto, the original design for the Painting of the Hay Field and Men loading a Hay Cart' (30). How far such drawings related to either pair of the finished compositions, or what clues they might have contained to the precise location for the original studies, is now impossible to tell: all the drawings in Stubbs's sale have disappeared without trace. In both the 'Haymakers' and 'Reapers' of 1785, Stubbs evidently felt free to rearrange the landscape elements to suit his compositions; but that he made his original observations at first-hand is evident from the lyrical yet realistic manner with which he depicts the skilled movements of labourers reaping or stacking sheaves, raking or loading hay.

In their concentration upon direct, un-sentimental yet sympathetic observation of work in the countryside, with little or no narrative content, 'Haymakers' and 'Reapers' should perhaps be grouped with such pictures as 'Phaeton with a pair of Cream Ponies and a Stable Lad' (No. 131) and 'Lord Clarendon's Gamekeeper with a Dying Doe and a Hound' (No. 137). Many details in earlier pictures, notably the groups of grooms and stable-lads rubbing down a horse after exercise in the Goodwood 'Racing' picture of the early 1760s or in 'Gimcrack on Newmarket Heath', 1765 (Nos. 31 and 55) seem to anticipate 'Haymakers' and 'Reapers' by the dispassionate sympathy with which Stubbs portrays the skilled, intent and unselfconscious demeanour of his labourers in the fields; but these remain details in larger compositions. Only with 'Haymakers' and 'Reapers' do such figures take the centre of the stage, and occupy it as fully, though less self-consciously, as do the upper-class sitters in 'The Milbanke and Melbourne Families' (No. 110).

Stubbs painted three oval versions of the subjects in enamels: 'Haymakers' (Lady Lever Art Gallery) and 'Reapers' (No. 126), both dated 1795, are fairly closely based on the 1785 pair, though with fewer figures; 'Haymaking', dated 1794 (also Lady Lever Art Gallery) retains only the central figure of the girl from the 1785 oils, and introduces figures mowing and tossing hay. The three enamels are reproduced in Tattersall 1974, pp. 105, 107 and 109.

126†

REAPERS
dated 1795

Enamel on Wedgwood biscuit earthen-
ware, oval $30\frac{1}{4} \times 40\frac{1}{2}$ in. (77 × 102 cm.)
Inscribed 'Geo: Stubbs pi[?nxit: obscured
by frame] / 1795' lower right
*Yale Center for British Art, Paul Mellon
Collection*

PROVENANCE
Probably the item in Stubbs's studio sale, 27 May
1807 (93), catalogued as 'Landscape with Hay
Field and Hay Makers, an oval in large enamel.
This very extraordinary Performance, not only
the largest as a Painting on enamel extant, but for
finishing, beauty and perfection in all its Parts, is
a wonderful effort of ingenuity and success –
capital.'; ? Isabella Saltonstall; . . . ; Major
A.E.W. Malcolm; Mrs Malcolm, sold Sotheby's
18 November 1959 (43), bt. Colnaghi for Mr Paul
Mellon KBE, by whom presented to the Yale
Center for British Art, 1981

EXHIBITED
British Institution 1806 (56); Liverpool 1951
(63); Whitechapel 1957 (47); V.M.F.A. 1963
(327, pl. 183)

LITERATURE
Taylor 1961, p. 211, no. 21; Tattersall 1974,
pp. 106–7; Bruce Tattersall, in Egerton 1978,
no. 95, pl. 34

This is largely based on the oil painting of 1785
(No. 125), but omits two figures from that
painting, the girl in the centre of the composition
and the bare-headed labourer behind her.

Stubbs painted two slightly smaller harvest-field
subjects in enamel on Wedgwood biscuit
earthenware, both $28\frac{1}{2} \times 39\frac{1}{2}$ in., and both now in
the Lady Lever Art Gallery, Port Sunlight, there
called 'Haymakers' (with mowers), signed and
dated 1794, and 'Haycarting', signed and dated
1795. These are reproduced in Tattersall 1974,
pp. 105 and 109.

274

HORSES FIGHTING

Inscribed 'Geo:Stubbs pinxit / 1781' lower right

Paul Mellon Collection, Upperville, Virginia

Enamel on Wedgwood biscuit earthen-ware, oval, 29 × 37 in. (73.7 × 94 cm.)

PROVENANCE
Stubbs's studio sale, 27 May 1807 (96, as 'STALLIONS FIGHTING — with other Horses in a Landscape, and a Bridge in the middle distance; an oval in enamel — the spirited Action of the Animals and the splendour of the whole stamps it an unrivalled Performance';; Sir Walter Gilbey by 1898, sold by his executors, Christie's 11 June 1915 (402), bt. Williams; Victor Emanuel; E.J. Rousuck, New York; Miss Clara S. Peck, New York, by 1960; another private collection; The Sporting Gallery, Middleburg, Virginia, whence purchased by Mr Paul Mellon

KBF

EXHIBITED
R.A. 1781 (17, as 'Two horses — in enamel');
British Institution 1806 (83); *Wedgwood, A Living Tradition*, Brooklyn Museum 1948 (609);
V.M.F.A. 1960 (22, repr.)

LITERATURE
Gilbey 1898, p. 160 (as 'The Combat'); Taylor 1961, p. 224, no. 15; Tattersall 1977, pp. 98–9

ENGRAVED
by George Townly Stubbs, as a pair to *Horses Fighting* published by Benjamin Beale Evans, 1 May 1788

The subject and to some extent the horses' poses appear to have been derived from the central pair of horses in the engraving, 'Fighting Horses', by Johann Stradamus after Goltzius (repr. W. Strauss, *Hendrik Goltzius, Complete Engravings, Etchings, Woodcuts*, 1977, p. 193, no. 105).

Stubbs showed paintings entitled 'Fighting bulls' and 'Fighting Horses' at the Royal Academy in 1787 (83 and 84). 'Fighting bulls' is the picture exhibited here as No. 127, and its pair in 1787, also likely to have been in oil on panel, was probably the picture which also remained in the Hope Barton family collection until sold at Sotheby's, 2 December 1964 (17, repr.), bought by Ackermann and exhibited in that firm's annual exhibition of Sporting Paintings, 1980 (1, repr.).

The sale of Benjamin West's collection after his death, Christie's 10 June 1820, included the two prints of *Horses Fighting* and *Bulls Fighting*. They were knocked down to Henderson for ten shillings the pair.

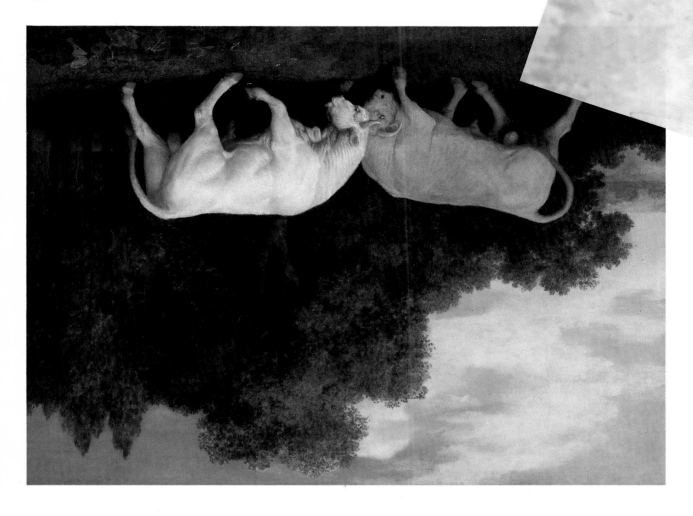

128+

BULLS FIGHTING
dated 1786

Oil on panel, 24¼ × 32¼ in.
(61.5 × 82.5 cm.)

Inscribed 'Geo: Stubbs pinxit / 1786'
lower right

*Yale Center for British Art, Paul Mellon
Collection*

PROVENANCE
J. Hope Barton, Saxby Hall, Lincolnshire, by
1868; by descent to Mrs Hope Barton de Ross,
sold Sotheby's 2 December 1964 (16, repr.), bt.
Agnew, from whom purchased by Mr Paul Mellon
KBE, 1965 and presented to the Yale Center for
British Art, 1977

EXHIBITED
R.A. 1787 (83); Leeds 1868 (1129, as 'Bulls
Fighting, painted with Wright of Derby')

LITERATURE
John Lawrence, *A Philosophical and Practical Treatise
on Horses and on the Moral Duties of Man towards the
Brute Creation*, II, 1798, pp. 248–9; Egerton 1978,
pp. 94–5, no. 92

In the R.A. exhibition of 1787, this was no. 83; it
hung with its companion, 'Fighting Horses' (95), in
the Great Room. John Lawrence, an admirer
though apparently not an acquaintance of Stubbs,
relates that contemporary critics condemned 'Bulls
Fighting' as 'tame and spiritless, because the
animals were not represented with all the fiery and
active ferocity of tygers and stallions'. Lawrence
defended Stubbs for his realism: 'the truth is, the
picture is the justest and most natural representa-
tion of a combat between those sedate and heavy
animals, the bulls, which is anywhere to be found
on canvas, and which the painter had often seen in
nature – his critics never'. Stubbs's critics may
have expected one of those snarlingly melo-
dramatic bestial combats depicted by Snyders and
later by Northcote. While Stubbs leaves little
doubt that his bulls have embarked on a combat
which will be bloody and probably deadly, there is
an instinctive, almost private quality about their
struggle which removes it from the arena of
spectacle. The restrained setting – timeless woods
and water – and the artist's unemotional
observation lend the composition a weight far more
substantial than any savagery could.

The subject may be derived from Dutch pictures
such as 'Bulls Contesting a Cow', by Paul Potter,
currently on loan to the Fitzwilliam Museum,
Cambridge.

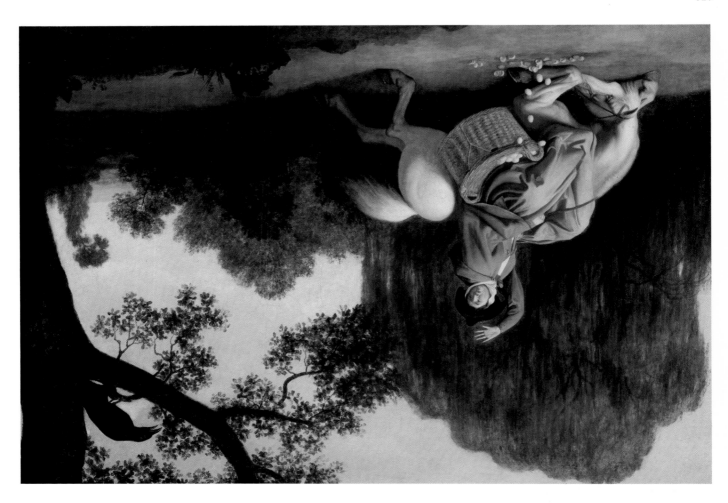

129+

THE FARMER'S WIFE AND THE RAVEN
dated 1786

Oil on panel, 26¼ × 38¼ in.
(67.2 × 98 cm.)
Inscribed 'Geo:Stubbs pinx / 1786' lower
right of centre

Collection
Tale Center for British Art, Paul Mellon

PROVENANCE
. . . ; Sir Walter Gilbey, sold Christie's 12 March
1910 (146), bt. Vokins; Tresham Gilbey, sold
Christie's 30 May 1947 (83); Walter Hutchinson,
offered Christie's 20 July 1951 (131); purchased
through Christie's by Colnaghi for Mr Paul
Mellon KBE, by whom presented to the Yale
Center for British Art, 1977

EXHIBITED
Vokins 1885 (7); *Tresham Gilbey Collection*, Ellis &
Smith 1947 (55); National Gallery of British
Sports and Pastimes 1948 (112); V.M.F.A. 1963
(323, pl. 185); R.A. 1964–5 (266); Yale 1965
(178)

LITERATURE
Gilbey 1898, p. 159; Egerton 1978, pp. 95–6, no.
93

ENGRAVED
by George Stubbs, published 1 May 1788 (No.
185)

The subject illustrates *Fable XXXVII, The Farmer's
Wife and the Raven*, in the *Fables* of John Gay, first
published in 1727. A farmer's wife rides to market,
her pannier laden with eggs; she jogs on, musing on
the profits she will make, when 'starting from her
silver dream / thus far and wide was heard her
scream' as that prophet of disaster the raven
croaks, her horse falls down, 'and her mash'd eggs
bestrow'd the way'. Stubbs's composition is based
on John Wootton's illustration, engraved by B.
Baron for Gay's *Fables*, I, 1727, p. 124.
'A capital high finished coloured Drawing of the
Farmer's Wife and Raven, from Gay's Fables' was
included in Stubbs's studio sale, 27 May 1807 (37)
but is now untraced. This is the last of three
painted versions. The first, in enamel on
Wedgwood biscuit earthenware, 27¾ × 37 in., oval,
signed and dated 1782 (in the collection of the Lady
Lever Art Gallery, Port Sunlight) was exhibited at
the Royal Academy in 1782 (120), and in the *Stubbs
& Wedgwood* exhibition at the Tate Gallery, 1974
(26, repr.). The second, in oil on panel,
34¼ × 53¾ in., signed and dated 1783, is in a private
collection.

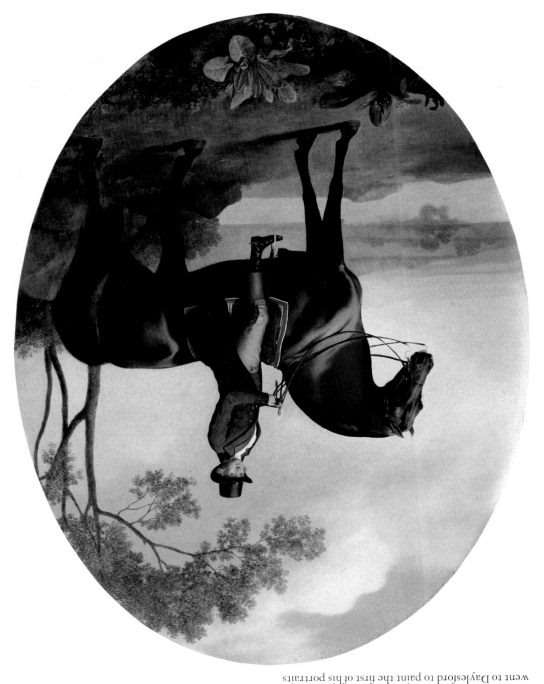

130*
WARREN HASTINGS ON HIS ARABIAN HORSE
dated 1791

Enamel on Wedgwood biscuit earthenware, oval, 37 × 28¾ in. (94 × 71.7 cm.)
Inscribed 'Geo: Stubbs / pinx 1791' lower right

Private Collection

PROVENANCE
? presumably commissioned by the sitter, remaining at Daylesford after his death; Lord Rothermere, sold Christie's 26 June 1978 (67, repr.), bt. in, later sold through Colnaghi to present owner

EXHIBITED
Warren Hastings, Dean's Yard, Westminster, December 1932

LITERATURE
Taylor 1961, p. 224, no. 19; Taylor 1971, p. 215, pl. 128; Tattersall 1974, pp. 102–3

ENGRAVED
in stipple, bust length only, by George Townly Stubbs, published (repr. A. Mervyn Davies, *Warren Hastings*, 1935, facing p. 530)

Dated 1791, this was painted when the long process of Warren Hastings's impeachment for 'high crimes and misdemeanours' committed as Governor-General of Bengal was in its fourth year; it had begun on 13 February 1788, and was to drag on until Hastings's acquittal on 23 April 1795. There had been a short lull in 1791, when a new House of Commons was elected; Burke's supporters hoped that the impeachment would be deemed to have died with the old Parliament, but Edmund Burke, chief prosecutor, pressed for its continuation. To those who thought the trial had already gone on too long, Burke replied that those who thought so were no more capable of knowing what ought to be the length of an impeachment 'than a rabbit, which breeds six times a year, is capable of judging the time of gestation of an elephant' (quoted in Michael Edwardes, *Warren Hastings*, 1976, p. 170).

Hastings was slight in build, just five feet and a half feet in height, and weighed 122 lbs. When the impeachment began, Lord Minto said he had never seen 'a more miserable-looking creature', and was sure he looked 'as if he could not live a week' (Edwardes, op. cit., p. 13). Hastings's greatest consolation during the long trial was the ancestral estate of Daylesford, Warwickshire, which had been sold out of the family in 1715 and which he managed to buy back in 1788. Stubbs probably went to Daylesford to paint the first of his portraits of Hastings (probably the version in oil on panel in the collection of the Earl of Rosebery) and his portrait of Hastings's Arabian horse (in the collection of Lord Rothermere).

Stubbs painted two versions in enamel. This one presumably remained at Daylesford after Hastings's death and that of his wife (they had no children), and was probably taken over by the new owner as part of its contents. The 'Portrait of Warren Hastings, Esq., on his celebrated Arabian, in enamel, an oval, painted in 1791' which was lot 68 on 27 May 1807, the second day of Stubbs's studio sale, was not (as Tattersall and Christie's 1978 sale catalogue state) this version but another enamel, at one time in the collection of Sir Walter Gilbey, bought at his sale on 11 June 1915 (406) by Lord Curzon and presented by him to the Victoria Memorial Hall, Calcutta, where it is still is (it is repr. in E. Rimbault Dibdin, 'Liverpool Artists in the Eighteenth Century', Walpole Society, VI, 1917–18, pl. XIX). That enamel is cracked, which is perhaps why Stubbs painted a second version on enamel: fortunately this version is in very good condition and the strong red in particular is technically a triumph.

George Townly Stubbs's stipple engraving of Stubbs's portrait of Hastings, bust-length, was published in 1793 when Hastings was still 'news'.

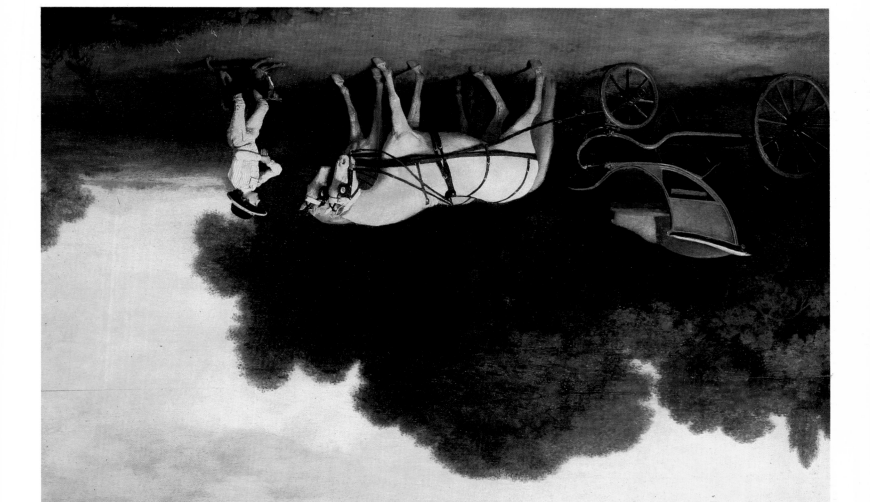

131†

PHAETON WITH A PAIR OF CREAM PONIES IN CHARGE OF A STABLE-LAD

c.1780–5

Oil on panel, 35¼ × 53½ in.
(89.5 × 136 cm.)

Tale Center for British Art, Paul Mellon Collection

PROVENANCE
. . . ; Lord Lilford; H.W. Dallison; Colonel Keown Boyd, Plaxtol, Kent; Agnew, from where purchased by Mr Paul Mellon KBE, 1961, presented to the Yale Center of British Art, 1977

EXHIBITED
Whitechapel 1957 (28); V.M.F.A. 1963 (325, frontispiece to text vol., in colour); R.A. 1964–5 (273); Yale 1965 (185)

LITERATURE
Egerton 1978, pp. 93–4, no. 91, colour plate 17

A pair of beautifully matched cream ponies wait, blinkered and wearing pale blue brow-bands, in harness to a crane-neck phaeton painted in blue, its lines picked out in gold and red and its interior painted old rose. The young stable-lad (or is he a tiger-boy, who will ride at the back of the carriage?) wears a pale blue and white striped livery jacket and gazes quietly at the ponies in his care. The only action in the scene comes from the dog crouching at his feet; though his attitude is inquisitive rather than provocative, the ponies back a little in their shafts.

Are they waiting outside a house, and for whom do they wait? It is impossible to tell, though the elegance of the carriage and the nicety with which the horses' brow-bands match the boy's livery jacket suggest that they wait for someone who deliberates about appearances. Cream-coloured ponies were very fashionable; a lady's carriage was described in 1788 as 'drawn by a pair of prancing long-tailed creams' (quoted in O.E.D., from *Papers of the Twining Family*, 1887, p. 154). In contrast to the briskness of the scene in 'The Prince of Wales's Phaeton' (No. 135), the mood of this picture is pensive and private.

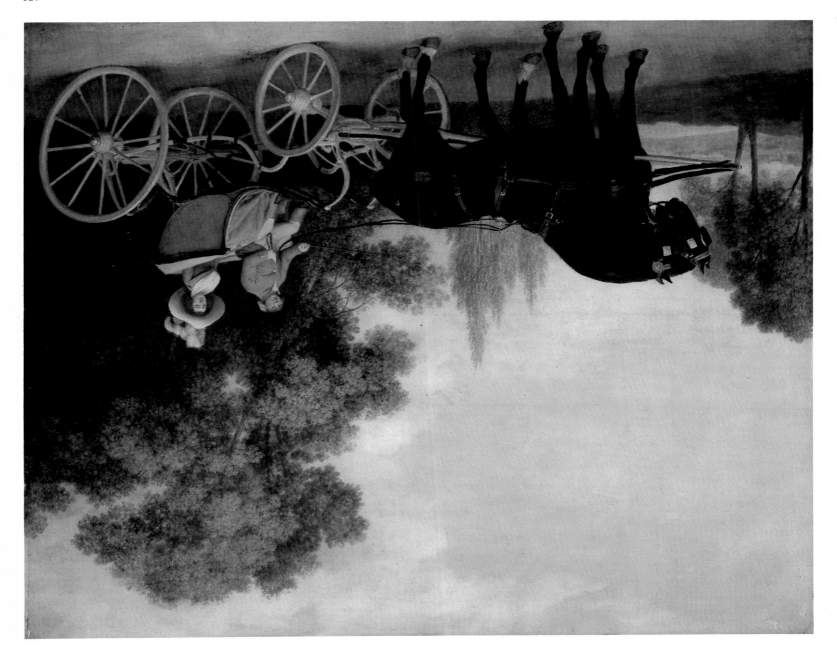

132*

LADY AND GENTLEMAN IN A PHAETON

dated 1787

Oil on panel, 32½ × 40 in.
(82.5 × 101.6 cm.)
Inscribed 'Geo: Stubbs / pt. 1787' lower
right of centre, behind nearside front
carriage-wheel
Trustees of the National Gallery

PROVENANCE
? painted for a member of the Hope family of
Liverpool, bankers; Dr Charles Coates, who had
married a daughter of S. Hope of Liverpool;
bequeathed by his niece, Miss S.H. Hope, to the
National Gallery, 1920

The sitters cannot be identified, but appear to
belong to the middle class rather than the
aristocracy. Given the provenance, one might
speculate that they are members of the Hope
family of bankers in Liverpool, and that the picture
could have been painted near Liverpool, if (as
seems likely) Stubbs returned there in 1787 to see
the exhibition at the Liverpool Academy to which
he had lent 'Haymakers' and 'Reapers' (Nos.
124–5).

The exactitude with which Stubbs observes
(almost 'anatomizes') the intricate construction of
the under-carriage and wheels deserves attention.
He must have chosen just this angle at which to
paint the phaeton because an accurate repre-
sentation of its construction posed a problem which
he wanted to solve.

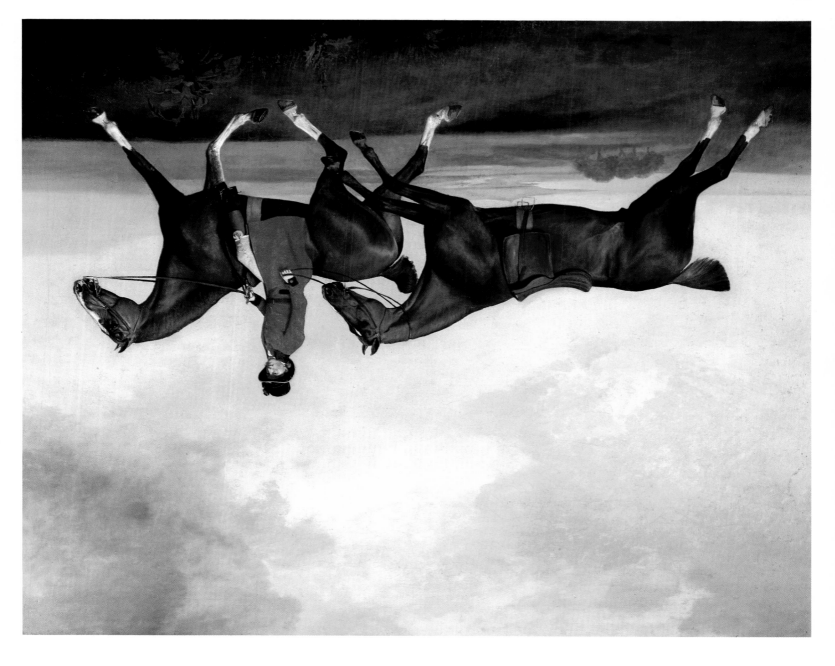

134

LAETITIA, LADY LADE
dated 1793

Oil on canvas, 40¼ × 50⅜ in.
(102.2 × 127.9 cm.)
Inscribed 'Geo: Stubbs pinxit / 1793'
lower right
Her Majesty The Queen

PROVENANCE
Presumably commissioned by George IV, when
Prince of Wales (first recorded, in store at
Carlton House, in 1816), and thereafter in the
Royal Collection

EXHIBITED
The King's Pictures, R.A. 1946 (477); *Animal
Painting*, The Queen's Gallery 1966–7 (22)

LITERATURE
Gilbey 1898, p. 125, no. 10; Millar 1969, no. 1112,
pl. 143; Stella Walker, *Sporting Art: England
1700–1900*, 1972, p. 68, pl. 27

The picture was no doubt commissioned to portray
the elegance of the Prince's chestnut horses
(probably both of the same breeding) rather than
as a portrait of Anderson, the Prince's back-groom.
Stubbs has chosen to depict Anderson riding one
chestnut and leading the other, as if he were
on an early morning ride, perhaps on the downs
beyond Brighton. The Prince was fond of chestnut
horses; he wrote to Sir John Lade from Brighton,
15 April 1792: 'I have driven every day of late the
chestnut horses wh. go better than any horses I
have belonging to me' (A. Aspinall, *The Corres-
pondence of George, Prince of Wales 1770–1812*, II,
1964, p. 247).
Millar (op. cit.) notes that William Anderson
was helper and hack-groom to the Prince of Wales
from 1788 to 1800, becoming head groom in 1807
and Groom of the Stables in 1812. Stubbs portrays
him wearing the royal livery (scarlet with blue
collar and cuffs). In the background, as Millar
notes, there is 'an extensive prospect of an open
landscape and the sea, presumably on the south
coast'. Some of Anderson's accounts of expenditure
survive (H.O.73/7). During 1793 he paid out
£196.6.3 for such expenses as board and lodging
(ten days at Windsor cost five shillings, but twelve
days at Brighton twelve shillings), travelling
expenses, lamps for the stables, 'Dose of Physic' and
other medicaments and 'Scissers'.

133*

**WILLIAM ANDERSON WITH TWO SADDLE-
HORSES**
dated 1793

Oil on canvas, 40¼ × 50⅜ in.
(102.2 × 127.9 cm.)
Inscribed 'Geo: Stubbs p:/ 1793' lower
centre
Her Majesty The Queen

PROVENANCE
Presumably commissioned by George IV (when
Prince of Wales); first recorded, in store at
Carlton House in 1816, as 'The Prince's chestnut
saddle horses, with Anderson the groom. Stubbs',
and thereafter in the Royal Collection

EXHIBITED
The King's Pictures, R.A. 1946 (484); Liverpool
1951 (54); *Animal Painting*, The Queen's Gallery
1966–7 (18)

LITERATURE
Gilbey 1898, pp. 122–3; Millar 1969, no. 1110,
pl. 140

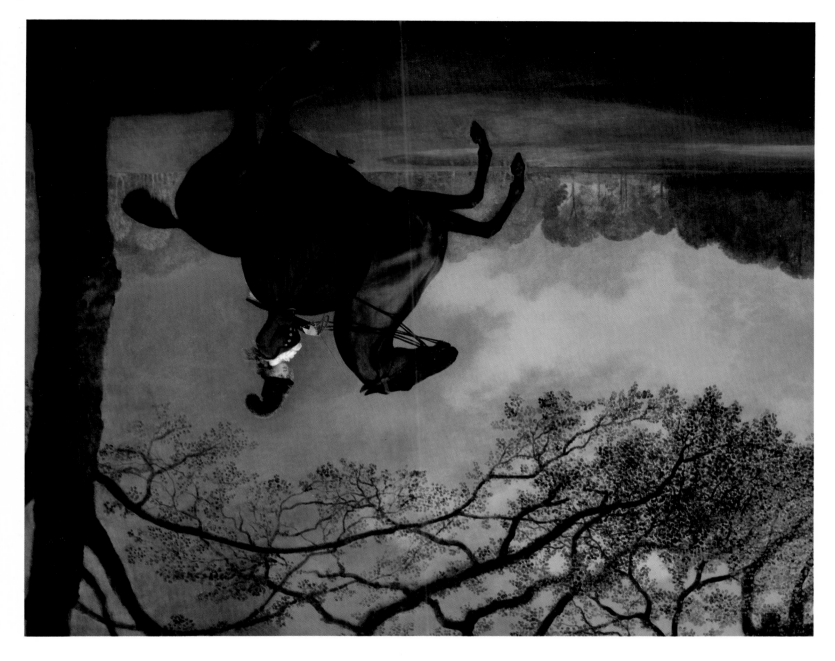

Millar notes that the sitter's identity is perhaps not precisely established, since her name is given in the earliest record of the picture at Carlton House as 'Mrs. Hill', though in the inventory of 1873 as 'Lady Lade'; but he concludes that she bears a reasonably close resemblance to Reynolds's portrait of Lady Lade, exhibited in 1785 (repr. F.K. Warehouse, *Reynolds*, 1941, pl. 252). Lady Lade was renowned for her skill in horsemanship: Stubbs's sitter certainly displays such skill. Stella Walker notes 'the prancing impetuosity of her horse and the tell-tale restraining rein for a "puller" running from bridle to saddle'. This horse's pose demands far more skill from its rider than does, for instance, the prancing horse in Stubbs's portrait of the Baron de Robeck of 1791, and its ears are dangerously laid back.

If Lady Lade had not existed, Georgette Heyer might have been thought to have invented her. As Laetitia Darby, alias Smith, she is variously stated to have been the mistress of Rann, the highwayman, and to have been at some stage under the protection of the Duke of York. The *Correspondence of George, Prince of Wales 1770–1812*, I, 1963, p. 326, note 1) or to have been picked up by Sir John Lade 'at a house in Broad Street, St. Giles's, whose inhabitants were not endowed with every virtue' (J.R. Robinson, *The Last Earls of Barrymore*, 1894, pp. 160–1). Her early liaison with Sir John Lade was no secret; when her portrait by

Reynolds (mentioned above) was exhibited at the Royal Academy in 1785 as 'Portrait of a Lady', Horace Walpole annotated his exhibition catalogue 'Mrs. Smith, mistress of Sir John Lade'. Their marriage took place in 1787.

Sir John Lade, 2nd Baronet (1757–1838), was a member of the Jockey Club and of the Four-in-Hand Club, who taught his wife to ride and drive as fast and furiously as himself. He was a sporting companion of the Prince of Wales, who purchased racehorses and carriage-horses from him, and invited Lade to hunt, shoot and occasionally to dine with him, though the ageing ex-Chancellor Lord Thurlow growled in 1805, 'I have no objection, Sir, to Sir John Lade in his proper place, which I take to be your Royal Highness's coach-box, and not your table' (Aspinall, op. cit., V, 1970, pp. 235–6).

The Prince of Wales seems to have had at least an amused tolerance and, probably, a genuine liking for the company of both the Lades. Lady Lade's notoriously bad language seems not in the least to have perturbed him: he coined a new expression, 'to swear like Lady Lade'. He seems to have remained indifferent to the censoriousness of others, and had presumably learnt not to heed the extraordinary outspokenness, on this and other matters relating to him, of the newspapers. At Brighton Pavilion in the summer of 1789, Lady Lade, eager to establish her position in society, persuaded the Prince to notice her publicly by

dancing with her: this provoked *The Times*, on 5 August 1789, to deplore the fact that the Prince should dance with 'a woman who lived in the style of a mistress to one-half of his acquaintance . . . among those acquaintances, his own brother made one of that very woman's keepers' (quoted by Aspinall, op. cit., II, 1964, p. 130, note 2). In December 1791, the Prince enclosed a ring, 'with my very best compliments to my Lady', in a letter to Sir John Lade (ibid., p. 223); but his commission to Stubbs to paint Lady Lade's portrait may have arisen from nothing more complex than his admiration for her as a brilliant horsewoman.

The Lades were frequently in financial scrapes. They had owned the lease of a London house 'opposite the Lodge in the Green Park, at the upper end of Piccadilly'; they had to sell the lease and, at Christie's on 21–23 January 1796, the entire contents of the house. Millar (op. cit.) suggests that the background in Stubbs's portrait of Lady Lade might be the Round Pond in Kensington Gardens, but it could in fact be Rosamond's Pool in St James's Park. Despite a pension of £300 per annum from the Prince of Wales received jointly by the Lades, Sir John Lade was in the King's Bench Prison for debt in 1814. Lady Lade died at Egham, on 5 May 1825, Sir John Lade, having squandered all his fortune, died in 1838; there were no children of the marriage, and the baronetcy thus became extinct.

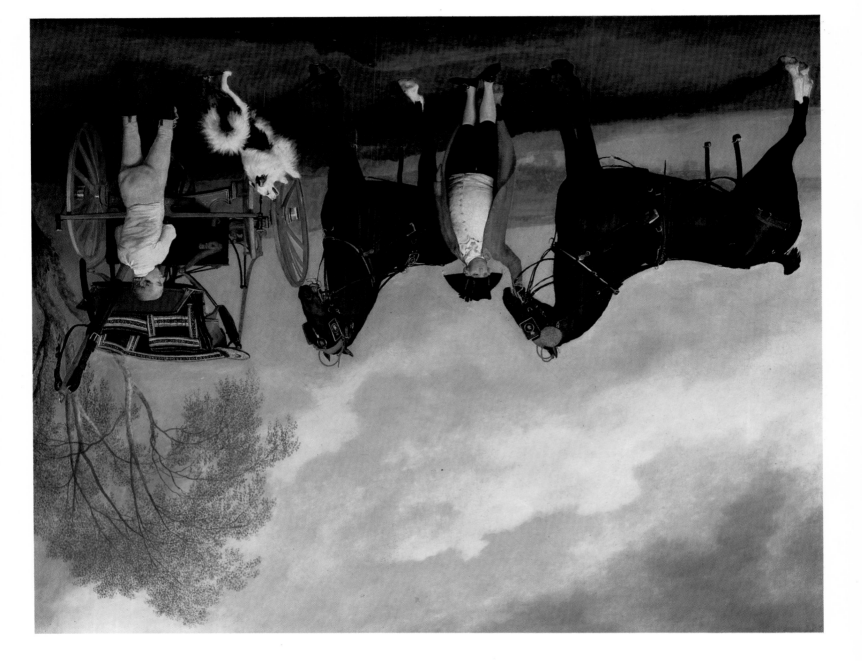

135*

THE PRINCE OF WALES'S PHAETON

dated 1793

Oil on canvas, 40¼ × 50½ in.
(102.2 × 128.3 cm.)
Inscribed 'Geo: Stubbs pinxit / 1793'
lower right

Her Majesty The Queen

PROVENANCE
Commissioned by George IV (when Prince of Wales); first recorded in store at Carlton House in 1816 as 'The Prince's Phaeton, with a pair of black horses, Thomas, the state-coachman, and a boy – Stubbs', and thereafter in the Royal Collection

EXHIBITED
The King's Pictures, R.A. 1946 (500); Liverpool 1951 (29); *Animal Painting*, The Queen's Gallery 1966–7 (23)

LITERATURE
Gilbey 1898, pp. 120–1; Millar 1969, no. 1117, pl. 142

Marylian Watney describes the phaetons of the 1790s as 'built very high, the seats being hung over the front wheels which were from four to five feet high, while the hind wheels measured up to six feet'. The under-carriage was either the straight wooden 'perch' or the superior and heavier 'crane-neck': the latter had two iron cranes with bends in them, under which the front wheels could turn, thus making the vehicle more wieldy. Both sorts (the Prince of Wales's appears to have 'perch' construction) were termed 'Highflyers', and because of their 'extreme height and consequent danger to drive, were very popular with young sporting bloods, among them the Prince of Wales' (*The Elegant Carriage*, 1961 p. 18).

The Prince of Wales evidently ordered several new carriages in the early 1790s, relying for advice on his old sporting friend Sir John Lade: his letter to Lade of 21 April 1793 thanks Lade for a report of progress on the carriages, and adds 'If you think there is anything to be done to make them easier, better or safer, I hope you will be so good as to give such directions as may be necessary' (A. Aspinall, *Correspondence of George, Prince of Wales*, I, 1963 p. 352).

In an earlier letter to Lade of 15 April 1792 (ibid, p. 247) the Prince wrote 'I am very impatient to have my phaeton out'. Probably this is the gaily-painted and upholstered Highflyer phaeton which Stubbs's picture celebrates. Stubbs paints it as if it were making its debut, on a fine morning, with Samuel Thomas, the Prince's State Coachman, in the full glory of his scarlet coat with gold collar and cuffs, supervising a young tiger-boy who raises the shaft to which a pair of magnificently matched very dark bay horses are to be harnessed. Every detail of the coach and horses is exactly observed, down to the Prince of Wales's feathers in silver on the horses' blinkers. The dog Fino (who appears again with Tiny in No. 105) joins the scene, his excited leap seeming to salute the new phaeton.

136

SOLDIERS OF THE 10TH LIGHT DRAGOONS
dated 1793

Oil on canvas, 40¼ × 50⅜ in.
(102.2 × 127.9 cm.)

Inscribed 'Geo: Stubbs p: / 1793' lower
right

Her Majesty The Queen

PROVENANCE
Presumably painted for George IV when Prince of
Wales, and thereafter in the Royal Collection

EXHIBITED
British Art, R.A. 1934 (394), Commemorative
Catalogue no. 174, pl. LXVII); *The King's Pictures*,
R.A. 1946 (495)

LITERATURE
Gilbey 1898, pp. 113–14; Millar 1969, no. 1115,
pls. 141, 145

On 29 January 1793 the Prince of Wales was
delighted to receive the news that his father the
King had appointed him Colonel Commandant of
the 10th (or The Prince of Wales's Own) Regiment
of (Light) Dragoons, the rank to be effective as
from the preceding 19 November, so that His
Royal Highness should rank above all other
Colonels.

The Prince took enormous pride in his military
rank and in the uniform that he was now entitled to
wear. Within days of his appointment, the
Revolutionary Government in France declared war
against England; the Prince who now longed to
serve abroad. Sir Gilbert Elliot reported the
Prince's impatience with his present 'inglorious
life, while his brother and all the Princes of Europe
are acting personally in their common cause',
adding 'He wishes to serve abroad and to have his
share of the glory that is going . . . He does not like
to remain at home merely as a parade officer or an
idle spectator of the great events in Europe, while
everybody else is acting a part in them' (quotations
are from A. Aspinall, *The Correspondence of George,
Prince of Wales*, I, 1963, pp. 526, 374). By 16
October 1793 the Prince of Wales reported to the
King his 'thorough attachment to the profession of
soldiering. He enjoyed occasionally camping with
his regiment, particularly when they were
stationed near somewhere congenial like Brighton:

he spent his thirty-first birthday (12 August 1793)
encamped at Brighton, taking 'a camp dinner' with
his regiment and 'seeing the line a *feu de joye*' in
his honour.

The Prince's commission to Stubbs to portray
some of The Prince of Wales's Own Dragoons was
thus a manifestation of his pride in his regiment.
Millar (op. cit.) notes that the four men in the
picture are a mounted sergeant (with his sword at
the carry), a trumpeter, a sergeant shouldering
arms and a private presenting arms, and that
Stubbs 'may have been asked to record soldiers
mounting guard or their mounted and dismounted
order for guard-mounting'. The Muster Rolls of
the 10th (or The Prince of Wales's Own) Regiment
show that they were stationed in or near
Canterbury for most of the first half of 1793, and in
or near Brighton for most of its second half. It is
possible that the Prince made his birthday on 12
August the occasion for commissioning this
picture. It is not, alas, possible to identify the four
individuals whom Stubbs portrays. The Muster
Rolls list, after the officers of the regiment, seven
sergeants, one Corporal, six Trumpeters and
seventy-two effective Private Dragoons (P.R.O.,
W.O. 12/923). Whoever they are, Stubbs has
painted them with a lively eye for detail and for
character.

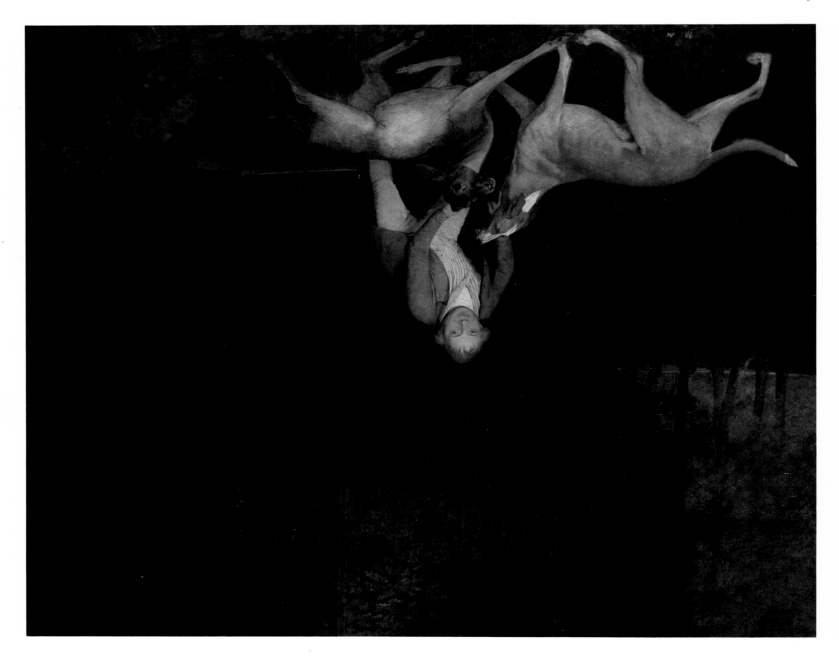

137

FREEMAN, THE EARL OF CLARENDON'S
GAMEKEEPER, WITH A DYING DOE AND A
HOUND ('A PARK SCENE AT THE GROVE
. . .')

dated 1800, exh. 1801

Oil on canvas, 40 × 50 in.
(101.5 × 127 cm.)
Inscribed 'Geo:Stubbs pinxit / 1800'
lower right
Paul Mellon Collection, Upperville, Virginia

PROVENANCE

Commissioned by Thomas Villiers, 2nd Earl of
Clarendon, The Grove, Watford, Hertfordshire;
by descent to 6th Earl of Clarendon, sold
Christie's 13 February 1920 (96), bt. Pawsey &
Payne; Agnew's; F. Whalley 1926; Spink 1927;
Leggatt 1930; Partridge, New York (exh. 1959,
10, repr.), from whom purchased by Mr Paul
Mellon KBE, 1959

EXHIBITED

R.A. 1801 (175, as 'A Park Scene at the Grove,
Watford, Herts, the seat of the Earl of
Clarendon'); *Sportscapes*, Parrish Art Museum,
Southampton, Long Island, New York 1959 (1);
V.M.F.A. 1963 (330, pl. 178); R.A. 1964-5 (272,
pl. 57); York 1965 (184, pl. 57); Yale Center 1982
(73, repr. p. 28)

LITERATURE

Taylor 1971, p. 89, pl. 132; Egerton 1978,
pp. 99-100, pl. 35; Stephen Deuchar, *Noble
Exercise*, Yale Center for British Art, 1982,
pp. 27-8

ENGRAVED

in mezzotint by Stubbs (? or by George Townly
Stubbs), published, without title, 16 October
1804 by G Stubbs: No. 24 Somerset Str. Portman
Square

Lord Clarendon was both an important and a
kindly patron during the last years of the artist's
life. In a notice of Ben Marshall in September 1826,
the *Sporting Magazine* (p. 319) compares Lord
Sonde's hospitality to Marshall to 'that given
Gilpin by the late Mr. Whitbread, and by the late
Lord Clarendon to Stubbs'. Thomas Villiers, 2nd
Lord Clarendon (1753-1824), of The Grove,
Watford, Hertfordshire, was M.P. for twelve years
(1774-1786); his only recorded speech in the
House was moving the Address on 18 November
1777, and then Walpole commented that he spoke
'very poorly' (Namier & Brooke). He kept both
stag-hounds and fox-hounds, and was a founder-
member in 1820 of the Hertfordshire Hunt. He
died unmarried in 1824, whereupon his honours
devolved upon his brother.

Stubbs was seventy-six when he painted this
picture. Not surprisingly, an elegaic note has been
detected in it; yet for all its grave poetry, the living
and the dying animals are robustly juxtaposed, and
the keeper's attitude to each is patently matter-of-
fact. The stag-hound has done the work it was
trained to do, and no more; he makes no attempt to
savage the doe. Freeman the gamekeeper has a
knife and will give the doe the *coup de grace* as
painlessly as he can. Light is dying in the wood, and
the doe will die before it goes.

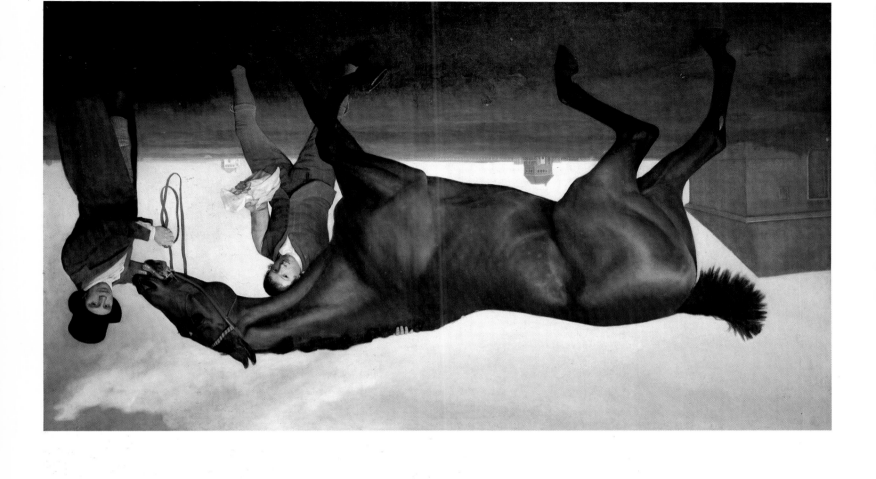

138*

HAMBLETONIAN, RUBBING DOWN
exh. 1800

Oil on canvas, 82¼ × 144⅜ in.
(209 × 367.3 cm.)
Inscribed 'Geo:Stubbs 1800' lower centre
National Trust, Mount Stewart

PROVENANCE
Commissioned by Sir Henry Vane-Tempest, and thence by descent

EXHIBITED
Royal Academy, 1800 (744); Liverpool, 1951 (42); Whitechapel, 1957 (29, pl. 1)

LITERATURE
Gilbey, 1898, pp. 173–4, repr. facing p. 174; H. Montgomery Hyde, *Londonderry House and its Pictures*, 1937, p. 17, pl. XVIII; Taylor, 1971, pp. 29–30, pl. 131; Judy Egerton, 'A Painter, a Patron and a Horse', in *National Trust Studies*, 1984 (forthcoming)

In 1799 Sir Henry Vane-Tempest, 2nd Bart., of Wynyard Park in the County of Durham, commissioned Stubbs to paint his money-spinning racehorse, Hambletonian. The baronet was then aged twenty-eight; Stubbs was seventy-five. The result was the unforgettable image which, when exhibited at the Royal Academy in 1800, bore the matter-of-fact title 'Hambletonian, Rubbing Down'. The result was not achieved without vexation: Stubbs in fact had to take the baronet to court to get paid for it.

Sir Henry Vane Tempest had inherited a modest estate from his father, Rev. Sir Henry Vane, and a vast estate from his uncle, John Tempest, whose only son had been killed in a riding accident, on

Thomas Freeman was appointed Gamekeeper at The Grove in 1772. Lord Clarendon kept a herd of deer which usually numbered three hundred and fifty to four hundred; he also had a stud-farm and bred fine bulls, favouring 'the small Indian' breed. Stubbs exhibited 'Portrait of a Mare, the Property of the Earl of Clarendon' at the Royal Academy in 1801 (201) and 'Portrait of an Indian Bull in the possession of the Earl of Clarendon' in 1802 (866). Other works by Stubbs were in the Clarendon sale in 1920, including 'A Moose', 'A Stag at a Stream' and 'A Bison', present locations unknown.

Humphry records a visit to Stubbs on 31 August 1803, just after Stubbs's seventy-ninth birthday; and reported that he 'still enjoys so much strength & Health that he says within the last Month having miss'd the stage, he has walked two or three times from his own House to the Earl of Clarendon's, at The Grove near Watford Heath, a distance of Sixteen miles carrying w^{th} him a little Trunk in his Hand?'.

condition that he should add the name of Tempest to Vane. Sir Henry Vane Tempest was now rich enough to indulge his passion for racing and gambling.

The most successful of his string of racehorses in the late 1790s was undoubtedly Hambletonian, foaled in 1792 and, like his master, northern-bred. Hambletonian had the blood of two champions in his veins; his sire was King Fergus, son of Eclipse, his dam a daughter of Highflyer. His early successes (for other owners) were in the north of England, where he won the 1796 St Leger; Vane-Tempest purchased him a few days later, in time to lead him in as the winner of the Doncaster Gold Cup.

Vane-Tempest now determined on a grand throw at Newmarket. In the spring of 1799 he matched Hambletonian for 3,000 guineas against Joseph Cookson's horse Diamond, a popular Newmarket winner. The match was run on 25 March 1799. According to the Sporting Magazine, it 'drew together the greatest concourse of people that ever was seen at Newmarket. The company not only occupied every bed to be procured in that place, but Cambridge and every town and village within twelve or fifteen miles was also thronged with visitors'. Side-betting ('very deep in the morning') was estimated at between 20,000 and 30,000 guineas, with the odds at starting 5–4 on Hambletonian.

The match was run over the Beacon Course, a nearly straight distance of just over four miles; it was all over in eight minutes. Hambletonian was ridden by Frank Buckle, Diamond by Dennis Fitzpatrick. The Sporting Magazine's commentary reported that 'Both horses were much cut with the whip, and severely goaded with the spur, but particularly Hambletonian; he was shockingly goaded'. Hambletonian made the running until the last half mile, when they ran neck and neck; but although he now seemed the more exhausted, Hambletonian 'by an extraordinary stride or two, some say the very last stride, won the match by a little more than *half a neck*'.

It was presumably soon after this match that Vane-Tempest commissioned Stubbs to paint two pictures of Hambletonian, which he himself described thus: 'One represents Hambletonian winning the race, and is a remarkable fine likeness of the horse and of Buckle the rider'. No painting by Stubbs of this subject survives. 'The other represents the horse rubbing down after the race, and is as large as life': clearly No. 138. Vane-Tempest planned to capitalize on Hambletonian's success by publishing engravings after Stubbs's pictures; on 31 May 1799 he published, in several daily newspapers as well as the *Sporting Magazine*, an *Advertisement* which stated that Stubbs had already produced two pictures of Hambletonian 'from the life'. He added, rather arrogantly, 'No artist whatever, except Mr. Stubbs, has had my permission to take any likeness of Hambletonian since he was in my possession.' This attempt to corner the market in popular prints of Hamble-tonian was snubbed by the Editor of the *Sporting Magazine*, which had already published a conventional profile portrait of Hamble-tonian after J.N. Sartorius, and now pronounced that Vane-Tempest's Advertisement 'partakes too much of puff for a gentleman's signature to accompany. The projected engravings after Stubbs never appeared. It was left to J.N. Sartorius to record the match in a popular print. The relationship between Stubbs and Vane-Tempest had gone so sour that Stubbs eventually had to take Vane-Tempest to court to secure payment for his work.

Exasperatingly, no records or reports of the case of Stubbs v. Vane-Tempest appear to have survived. All we know of it is hearsay, reported thus by Farington: 'Humphry & Lawrence told me that ab[t] 3 weeks ago they attended as witnesses for Stubbs, a trial between him & Sir H. Vane Tempest for payment of a large portrait of a Horse, for which Stubbs demanded 300 guineas. — Garrard also appeared for him. — On the other side Hoppner & Opie appeared, & the former was very violent against the claims of Stubbs, for whom, however, a full verdict was given. — It was in the Sherriffs Court' (Diary, 9 April 1801).

Basil Taylor described Stubbs's painting as 'the image of a creature enduring the aftermath of a terrible, almost sacrificial triumph of which he has been the hero', adding that Hambletonian had been so cruelly whipped and spurred that he never raced again' (1971, p. 215). Hambletonian was in fact racing, and winning, again at Doncaster in September 1799 and at York in 1800; but Stubbs undoubtedly, and very deliberately, depicts an animal which has passed through a formidable ordeal. The result is a magnificent image; but it is hardly a cheerful one. Vane-Tempest may well have wanted something which would have reflected a triumph in which he rather than the horse was the hero: something with the jockey wearing the Vane-Tempest colours, for instance, or portraying the jockey complacently riding a relaxed winner. Where were the Vane Tempest racing colours – 'lilac body, yellow sleeves and black cap'? Nowhere: in Stubbs's picture almost all the colours except for those of Hambletonians steaming flanks are greys, dull whites and browns, and the stuffs are fustian, not silk. Instead of a lithe and confidently posed jockey, the man who stands at Hambletonian's head is squat, bluff and thoroughly down to earth. Stubbs is portraying reality; would Vane-Tempest have preferred romance?

The second picture which Vane-Tempest had commissioned for Stubbs evidently never proceeded past the stage of a drawing which was exhibited at the Royal Academy in 1800 (222) in the Library, with other drawings. It is now lost, though the subject survives in the form of a version painted by James Ward, signed by Ward 'after Stubbs' and dated 1819 (also at Mount Stewart). 'Hambletonian, Rubbing Down' was hung in the Great Room, sharing the honours with, for instance, Turner's 'The Fifth Plague of Egypt'. The 'picture of the year' seems, by general consensus of reviewers' opinions to have been Lawrence's portrait of Kemble in the character of 'Rolla'. It is typical of Stubbs's worsening relationship with the Royal Academy that the numbers of his two exhibits were muddled in the catalogue. The same exhibition included Ben Marshall's portrait of Hambletonian's rival 'Diamond, with Dennis Fitzpatrick up', one of the few racehorse and jockey pictures which comes close to rivalling Stubbs (Yale Center for British Art, Paul Mellon Collection). The Morning Herald's comment on 'Hambletonian, Rubbing Down' was that 'the figure of the horse is calculated to give but a very slender idea of the swiftness of his speed; but the attendants are painted in a very masterly manner'. Hambletonian ended his days in retirement at Wynyard Park, where he is buried under a large oak tree.

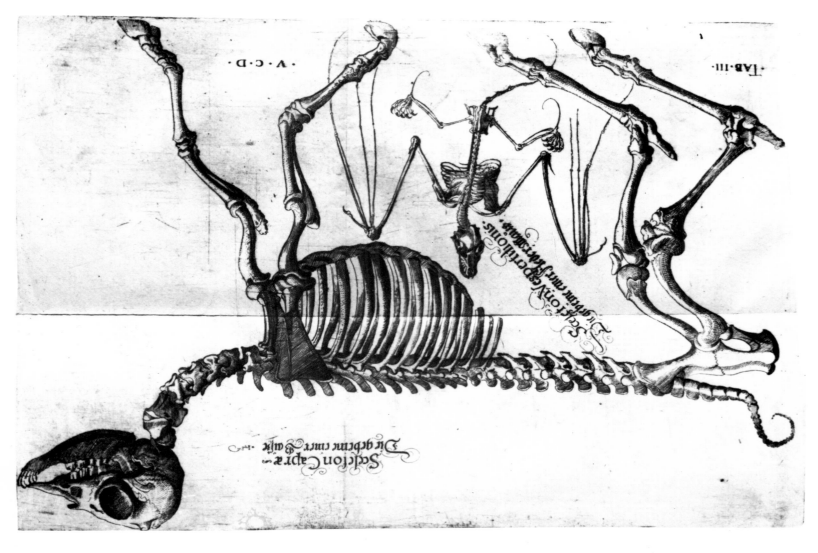

139–166 A COMPARATIVE ANATOMICAL EXPOSITION OF THE STRUCTURE OF THE HUMAN BODY WITH THAT OF A TIGER AND A COMMON FOWL

In 1795, at the age of seventy-one, Stubbs embarked systematically on the immense task of exploring and recording the comparative anatomy of the human being, the tiger and the common fowl. He was to find his self-appointed task so engrossing that an hour or so before his death (on 10 July 1806) he said that his only regret was that he had not finished his comparative anatomy.

Stubbs may have been encouraged to undertake the project in response to the exhortation with which Dr T. Cogan prefaced his translation to *The Works of the late Professor Camper on the Connexion between the Science of Anatomy and the Arts of Drawing, Painting and Statuary*, 1794: 'May we not presume . . . that some congenial mind, who unites deep skill in Anatomy with the love of Painting, will be animated to pursue the subject to a greater extent, and complete a study which professor Camper has so happily begun? Camper had already praised Stubbs's *Anatomy of the Horse* ('masterly and accurate'), but thought little of other artists' ability to draw animals, pronouncing Ridinger's animals to be 'absolutely caricatures', Paul Potter to be 'always embarrassed with the shoulder blades' and Ruini useless to the painter. Stubbs's main purpose throughout his anatomical studies was to enable himself and other painters to be more accurate.

The title of Stubbs's uncompleted work may sound bizarre. The comparison between a human and a quadruped was not new; the comparison of these with a bird was more unusual, though not unprecedented. Volchero Coiter, the first systematic exponent of comparative anatomy, had made comparisons between a pig, a deer and a parrot, and many other birds and animals, in his *Externarum at Internarum Principalium humani corporis*, 1576, a page of which is reproduced here; Camper had demonstrated the resemblance between the skeleton of a man, a dog, an eagle and a penguin.

Stubbs's choice of subjects may partly have depended on what was available. The tiger was reputedly obtained from Pidcock's menagerie; and he could of course obtain a common fowl at any

market. Obtaining the corpse of a human being was by no means easy. Here Stubbs must have had an ally in one of the big London teaching hospitals – perhaps Dr Henry Cline, lecturer in anatomy at St Thomas's and a visitor to Stubbs's studio. The only corpses anatomists could lawfully obtain were those of criminals who had been executed, but here demand always outran supply. Sir Astley Cooper at St Thomas's had established a business relationship with two 'resurrection men', or grave robbers ('a man named Murphy . . . and another named Ben Crouch'), at the rate of four guineas per cadaver.

Stubbs threw himself into the project with enthusiasm. One hundred and twenty-five drawings, many of them highly finished, some of them mere tracings for working purposes, survive. Stubbs engraved and published, 1804–6, three numbers each of five plates; he had intended to publish six. Modern anatomists level fair criticisms of, for instance, the representation of the human being's ribs, the disproportionately small heads of the tiger and the fowl, and question the value of a study which did not go deeper than the musculo-skeletal system. But as Dr William B. Ober pointed out ('Stubbs: Anatomic Artist', *Academy Bookman*, XXII, 1969, pp. 3–8), such limitations do not detract from Stubbs's great gift, 'his ability to draw what he saw and to arrange his observations in well-articulated anatomic compositions. This form of realism . . . was the product of a well-coordinated, empirical hand and eye in an age of reason. No other artist of comparable stature had so much first-hand experience in dissection nor can claim so intimate a knowledge of anatomy'.

Stubbs's manuscript text, evenly written, with his idiosyncratic reversed 'e' throughout, on paper watermarked 1796 and 1798, is probably a fair copy. Of its four volumes of text, two are in English and two in French: Stubbs may have intended to publish a French edition, as Paris was then the centre for comparative anatomical studies. There are many passages throughout which reveal Stubbs's lack of formal training in scientific language: his similes are occasionally quite homely (e.g. his note that the fourth coat of the stomach of the tiger is called *villosa* 'because when it swims in clear water, some have imagined that they saw something in it like the pile of velvet'.

The fact that the three published numbers received no critical attention and stirred small demand was not a failure personal to Stubbs; the market was after all a small one. Even Sir Busick Harwood FRS, Professor of Anatomy at Cambridge, did not progress beyond the first published number of his work on comparative anatomy, and after his death, the numerous unsold copies were sold 'for the price of waste paper nearly'. Stubbs might have been flattered to know that Sir Thomas Lawrence evidently purchased the three published numbers of *A Comparative Anatomical Exposition* . . .: what else could lot 195 in the print section of his sale at Christie's on 18 June 1830 be?: 'The Skeleton of Man, the Tiger and the Ostrich, large folio', knocked down to a print dealer named Green for five shillings?

The compiler is indebted to Lyn Koehnline, Kress Fellow in Paper Conservation at the Yale Center for British Art, for the following technical notes.

CONSERVATION OF THE DRAWINGS

Stubbs used a limited range of carefully chosen materials in his 125 studies for the *Comparative Anatomical Exposition*. Nearly all the drawings are executed in graphite, red chalk, iron gall ink, or various combinations of these three.[1] He chose papers of different weights for various types of drawings, but all his papers are of the wove variety, which was developed during the second half of the eighteenth century by James Whatman, the foremost papermaker in England. Stubbs's preference for the uninterrupted smoothness of Whatman's wove sheet comes as no surprise in view of the nature of his highly finished drawings. The grid-like texture of laid papers would have interfered with his delicate use of line and modelling. It was probably for similar reasons that Stubbs generally avoided including the area of the watermark in his drawings sheets.[2]

The majority of the drawings, eighty-one in all, were executed on very thin, strong, white wove paper. While this is not specifically a transparentized paper, it is thin enough to have been used for tracing, thus enabling Stubbs to transfer identical dimensions and poses from one sheet to another for the numerous replicas of each figure that he drew. Fourteen of the studies on this type of paper, including two in the exhibition,[3] are two-sided drawings in which the recto image is the reverse of the verso image, having been traced directly through the paper.

Forty-one of the 125 drawings are on a very heavy-weight, smooth, wove paper. These drawings include most of the finished studies, as well as a number of very rough sketches. Eight of the drawings on heavy paper, including two in the exhibition,[4] have very well-defined platemarks along their margins. These are evidence of a second method which Stubbs sometimes used to transfer the exact proportions of a figure from one sheet to another. He would begin by making a reversed-image tracing in heavy graphite or chalk. This drawing would then be passed through a printing press in direct contact with a second sheet of paper. The pressure of the press would transfer enough media to the second sheet to produce a ghostly image, which Stubbs could then complete with the details and modelling.

A great many of the drawings were subsequently mounted to secondary supports. All of the thin papers were backed with heavier paper. It is evident that Stubbs did not mount the drawings himself, as a number of these secondary supports have dated watermarks, which range from 1808 to 1818. This suggests that the drawings may have been mounted by Edward Orme, who published an edition of the completed engravings in 1817.

Earlier that year Stubbs's common-law wife, Mary Spencer, had died and all his preparatory materials for the *Comparative Anatomical Exposition* were sold. It is likely that Orme bought the drawings along with the prepared plates. Allowing for the usual lag of a few years between the manufacture and use of paper, it is reasonable to suppose that Orme had the drawings mounted shortly after he acquired them, as a routine method of making them easier to handle and store. Most of the mounting was done in an extremely careless manner, creating numerous wrinkles, puckers, and tears in the original drawings. This type of damage did not occur during the mounting of sixteen of the drawings executed on the heavier paper. These drawings were backed with a very thick, rigid, laminated paperboard, much heavier than that which would be needed for normal handling and storage. This suggests that these drawings were mounted for use in demonstration or display. All of the backing papers and backing boards are made of very deleterious materials, which have promoted considerably more discoloration and foxing than that which occurred in the drawings that had never been mounted. Nearly all of the backings were removed during conservation treatment, so that the drawings could be washed and discolorations reduced before the paper was mended and reinforced.

LYN KOEHNLINE
Kress Fellow in Paper Conservation
Yale Center for British Art

NOTES

1. Drawings B1980.1.12, B1980.1.13, and B1980.1.122 include other red-brown inks that have not been specifically identified. Drawings L1980.1.28 and L1980.1.29 include black chalk.

2. Watermarks were found in only three of the primary supports. Two of these read 1794 J TAYLOR and one reads WM ELGAR. According to Edward Heawood (*Watermarks*, Hilversum, Holland, 1957. pp. 193 and 210), John Taylor was a paper and pasteboard maker in London during the second half of the eighteenth century and William Elgar was probably a papermaker in Kent in the late eighteenth century, whose mill may have been bought by Whatman. Forty-six watermarks were found on secondary supports. Of these, forty-three were J WHATMAN or TURKEY MILLS marks and three were not identified.

3. B1980.1.13 and B1980.1.74.

4. B1980.1.33 and B1980.1.115.

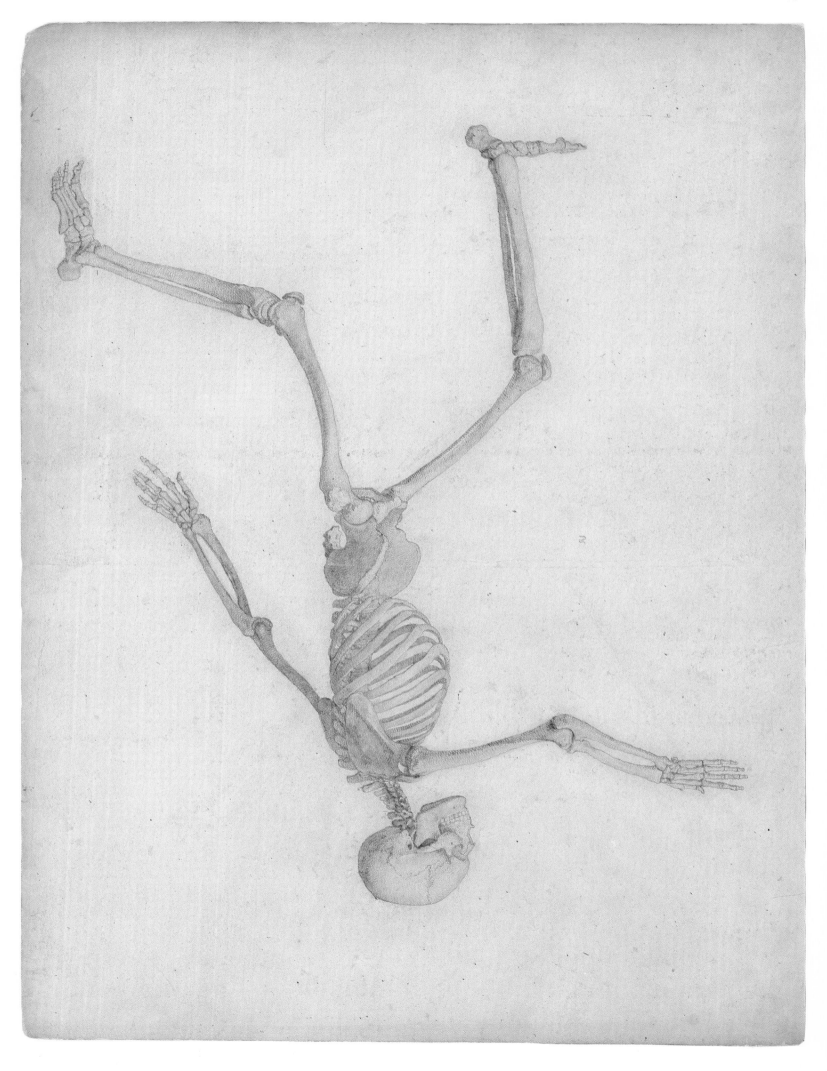

139

HUMAN SKELETON, LATERAL VIEW:
FINISHED STUDY (B1980.1.50)

Graphite on heavy wove paper,
$21\frac{1}{2} \times 16$ in. (54.5×40.6 cm.)
Yale Center for British Art

This finished drawing is close to Table III though
there are differences mainly in some of the
proportions which may have led Stubbs to reject it
for making the engraving.

140

HUMAN BEING, LATERAL VIEW, AFTER
REMOVAL OF THE SKIN AND THE
UNDERLYING FASCIAL LAYERS. FINISHED
STUDY FOR TABLE XIII (B1980.1.13)

Graphite on thin wove paper,
$19\frac{1}{4} \times 15\frac{1}{4}$ in. (48.9×38.9 cm.)
Yale Center for British Art

141

HUMAN BEING, LATERAL VIEW,
UNDISSECTED: FINISHED STUDY FOR
TABLE VIII (B1980.1.8)

Graphite on heavy wove paper,
$21\frac{1}{2} \times 16$ in. (54.5×40.5 cm.)
Yale Center for British Art

Lateral view of the human figure from the left. The
drawing has been damaged in the genital area as a
result of rubbing.

142

HUMAN BEING, ANTERIOR VIEW,
UNDISSECTED: FINISHED STUDY FOR
TABLE VI (B1980.1.6)

Graphite on heavy wove paper,
$21\frac{1}{2} \times 16\frac{1}{8}$ in. (54.5×40.7 cm.)
Yale Center for British Art

Frontal view of an undissected human figure,
highly individualized and probably based on a
particular living model. Stubbs's published plate
included front, back and lateral views of both the
human skeleton and the entire figure, but only the
lateral view of the chicken and tiger skeletons and a
plucked fowl were included as comparative
material.

143

HUMAN BEING, LATERAL VIEW, SKIN
AND UNDERLYING FASCIAL LAYERS
REMOVED: FINISHED STUDY FOR TABLE
XI (B1980.1.11)

Graphite on heavy wove paper,
21×16 in. (53.4×40.4 cm.)
Yale Center for British Art

The skin and underlying fascial layers have
been removed from a human body which is
shown frontally.

PROVENANCE
Mary Spencer; offered by her executors (? and
sold: no copy of the catalogue has been traced)
Phillips 30 April 1817, presumably bought by
Richard Wroughton (1748–d. 7 February 1822);
his executors' sale Sotheby's 3 April 1822, fifth
day's sale (1636, 'STUBBS'S COMPARATIVE
ANATOMY, 3 vol. in folio, very closely and plainly
written, with 2 portfolios, containing ONE
HUNDRED AND TWENTY-SIX BEAUTIFUL
OUTLINES AND TINTED DRAWINGS FROM
NATURE, BY HIMSELF＊＊＊ Mr. Stubbs bestowed
the labor of Twenty Years on this work'), bt. 'G',
£24.3.0.; . . . ; Thomas Bell F.R.S. (1792–1880:
the first of the text volumes bears his bookplate);
. . . ; Dr John Green of Worcester, Massachusetts,
U.S.A. (1784–1865), by whom presented to the
Worcester Public Library, Massachusetts,
1 January 1863; purchased 1981 by Mr Paul
Mellon KBE and presented to the Yale Center for
British Art, 1980

EXHIBITED
Groups of the drawings have been exhibited by
the Arts Council, 1958 and at the Tate Gallery,
1976

LITERATURE
Rediscovered Anatomical Drawings, Arts Council,
exh. cat., 1958; Terence Doherty, *The Anatomical
Works of George Stubbs*, 1974; *George Stubbs,
Anatomist and Animal Painter*, Tate Gallery, exh.
cat., 1976

144

HUMAN BEING, POSTERIOR VIEW,
PARTIALLY DISSECTED (B1980.1.33)

Graphite on heavy wove paper,
$21\frac{1}{4} \times 16$ in. (54×40.6 cm.)
Yale Center for British Art

146

HUMAN SKELETON, ANTERIOR VIEW:
FINISHED STUDY FOR TABLE I
(B1980.1.1.)

Graphite on heavy wove paper,
$21\frac{1}{4} \times 16\frac{3}{8}$ in. (54.1×41.6 cm.)
Yale Center for British Art

145

HUMAN BEING, POSTERIOR VIEW WITH
SKIN AND UNDERLYING FASCIAL LAYERS
REMOVED: FINISHED STUDY FOR TABLE
XII (B1980.1.12)

Graphite on heavy wove paper,
$21\frac{1}{8} \times 16$ in. (53.8×40.6 cm.)
Yale Center for British Art

147

HUMAN SKELETON, POSTERIOR VIEW:
FINISHED STUDY FOR TABLE II
(B1980.1.2)

Graphite on heavy wove paper,
$21\frac{3}{8} \times 16$ in. (54.3×40.5 cm.)
Yale Center for British Art

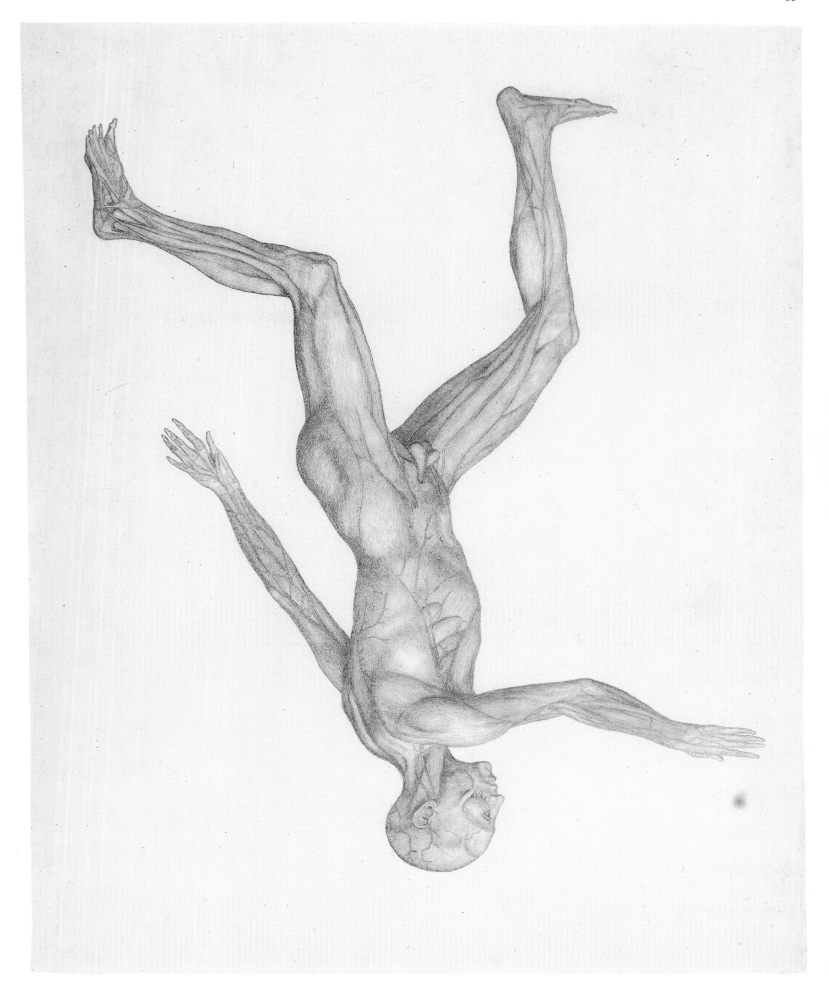

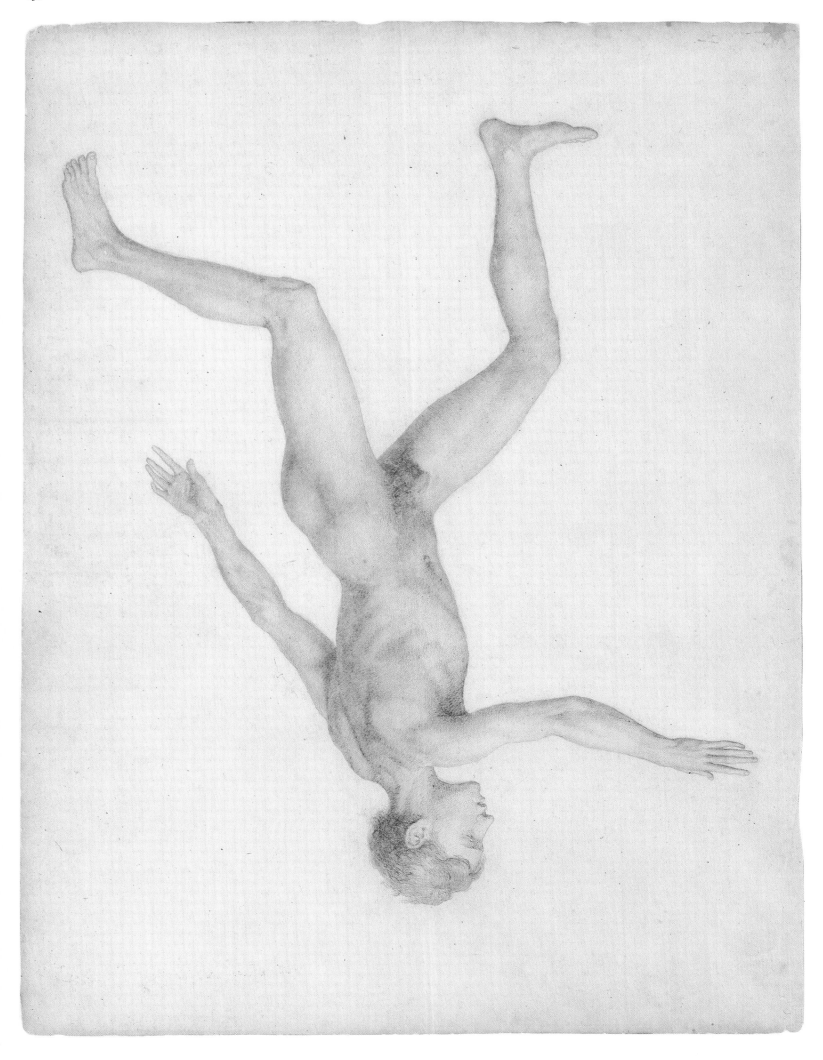

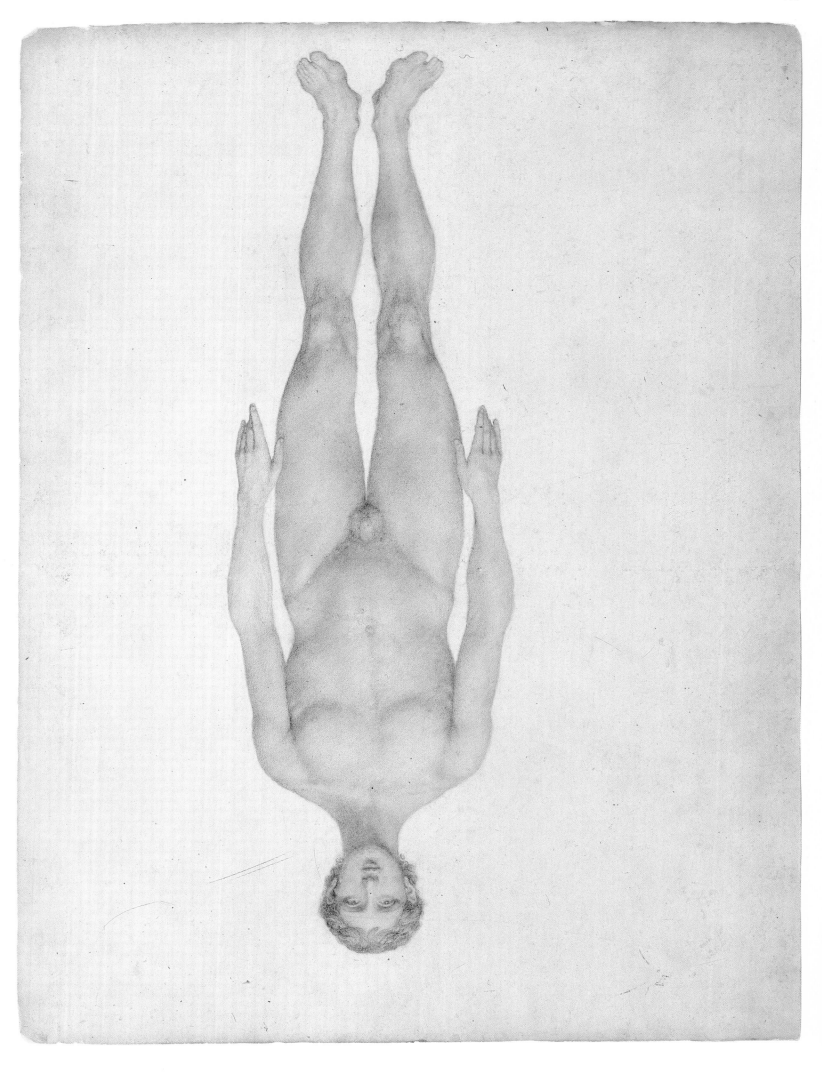

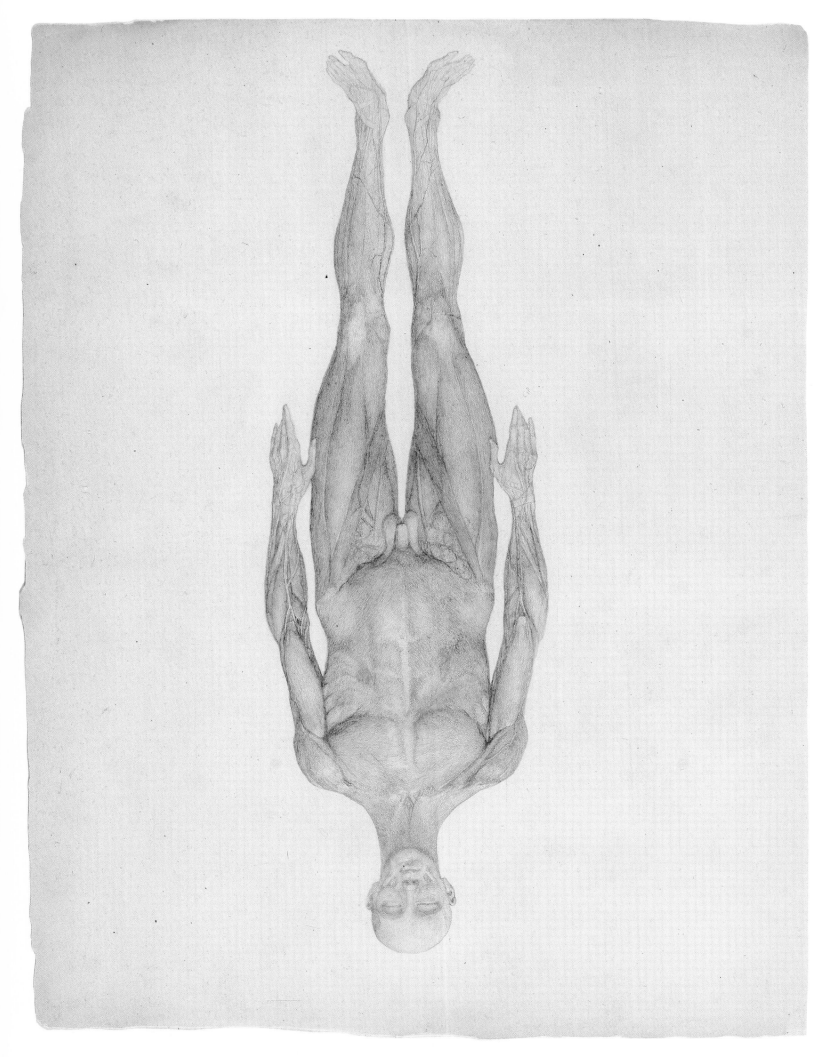

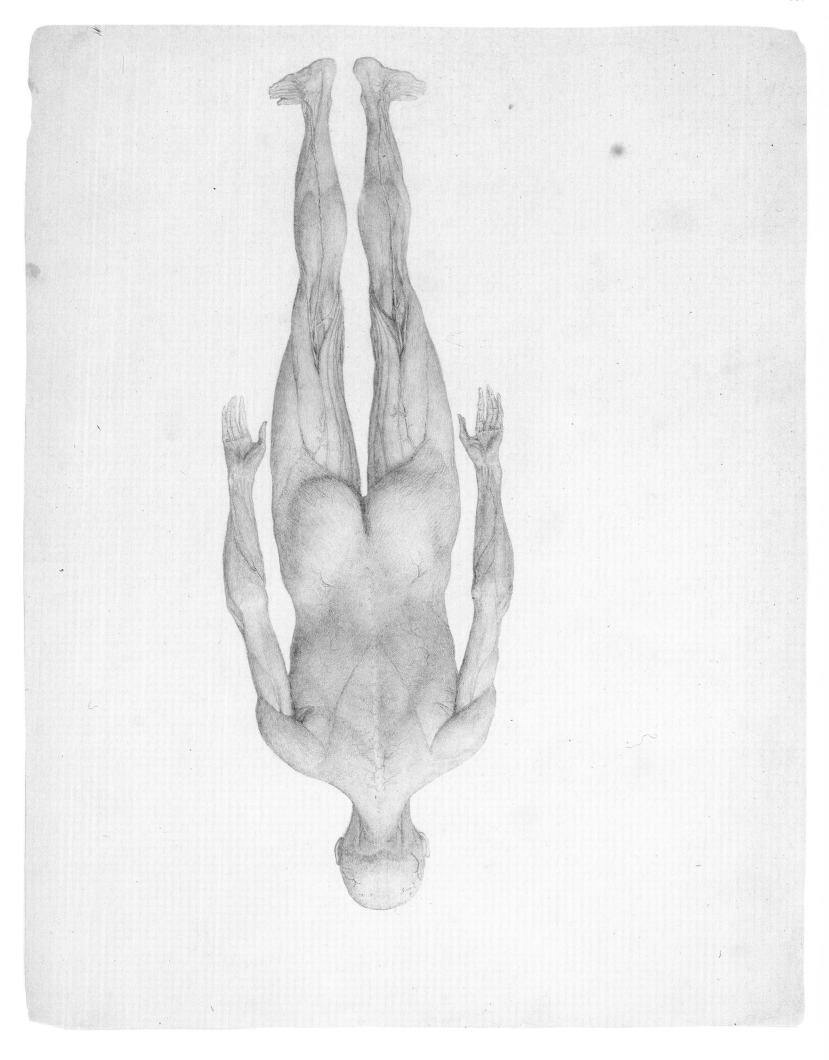

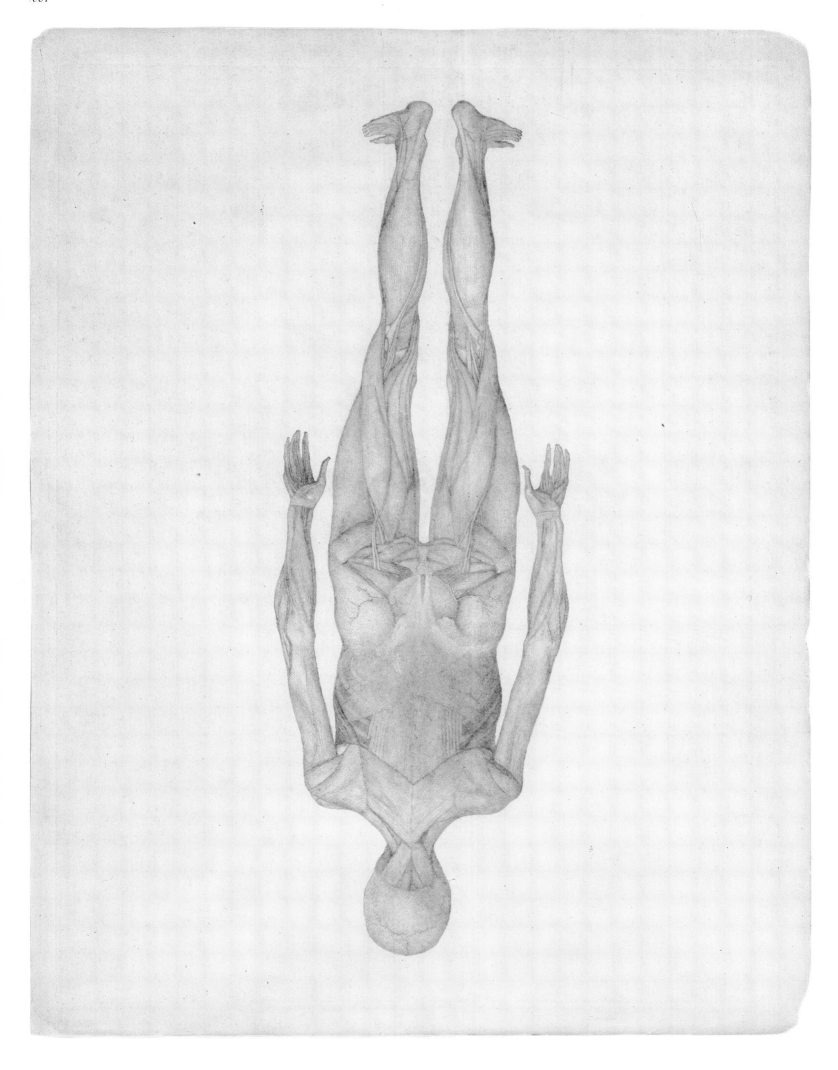

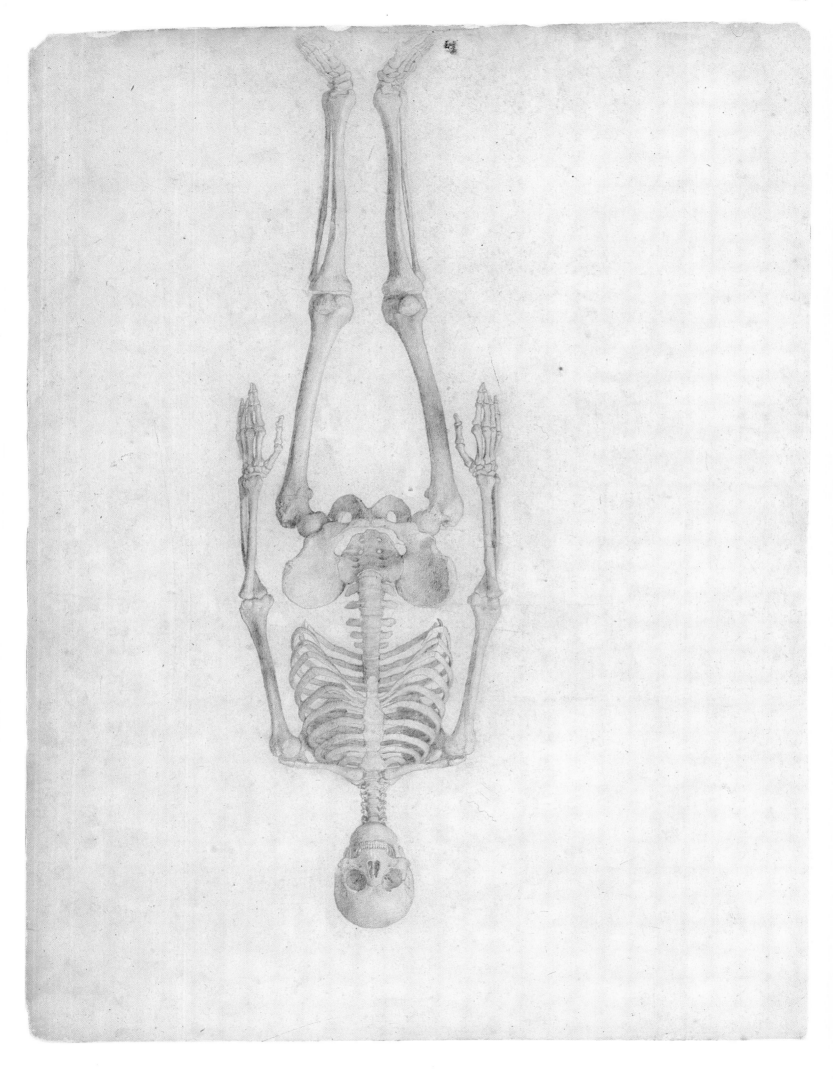

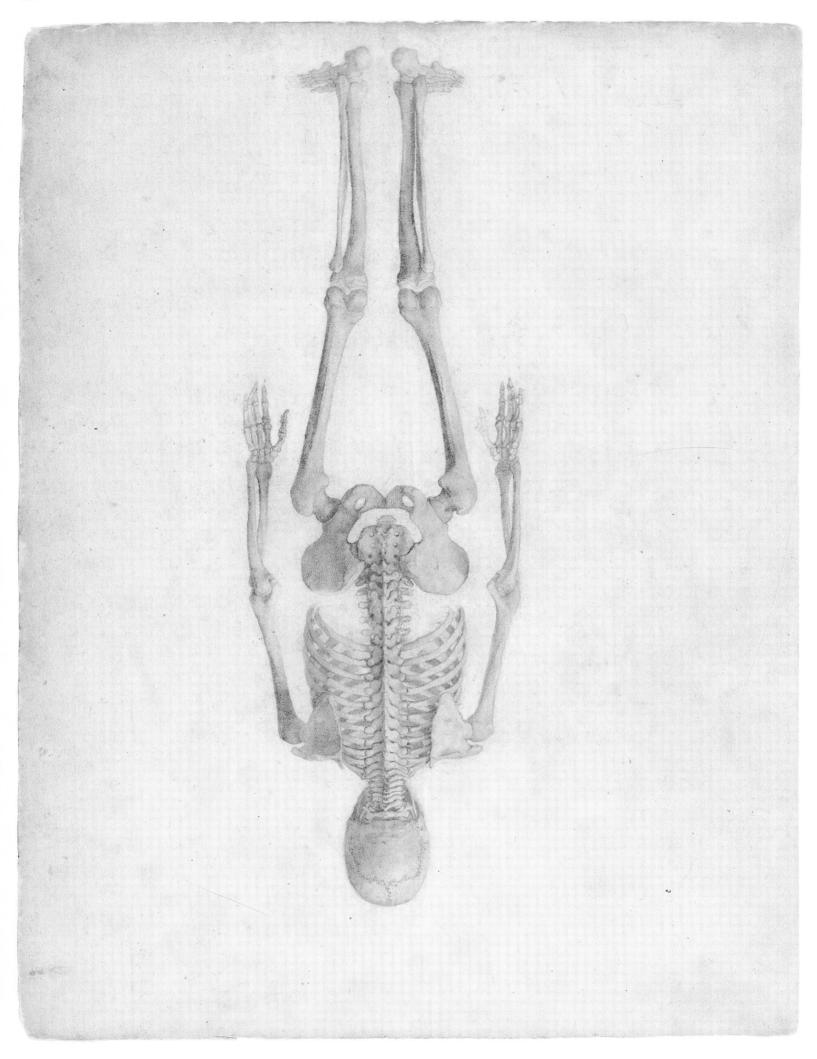

148

HUMAN SKELETON, POSTERIOR VIEW:
RIGHT ARM OUTSTRETCHED (B1980.1.61)

Graphite on thin wove paper,
$17\frac{3}{4} \times 11\frac{1}{2}$ in. $(45 \times 29.2$ cm.)
Yale Center for British Art

A finished study for an unpublished table.

149

HUMAN SKELETON, ANTERIOR VIEW,
RIGHT ARM OUTSTRETCHED (B1980.1.59)

Graphite on thin wove paper,
$17\frac{3}{4} \times 11\frac{1}{8}$ in. (45×28.2 cm.)
Yale Center for British Art

Like No. 148 this is a finished study for an un-
published table.

150

HUMAN SKELETON, ANTERIOR VIEW, IN
CROUCHING POSTURE (B1980.1.65)

Graphite on thin wove paper,
$17\frac{5}{8} \times 11\frac{1}{8}$ in. (44.8×28.2 cm.)
Yale Center for British Art

151

HUMAN SKELETON, LATERAL VIEW, IN
CRAWLING POSTURE (B1980.1.63)

Graphite on thin wove paper,
$11\frac{1}{8} \times 17\frac{5}{8}$ in. $(28.2 \times 44.8$ cm.$)$
Yale Center for British Art

152

OWL, STANDING, ANTERIOR VIEW, WITH
MOST OF THE FEATHERS REMOVED
(B1980.1.124).

Graphite on thin wove paper,
$15\frac{1}{2} \times 10\frac{3}{8}$ in. (39.2×26.4 cm.)
Yale Center for British Art

153

LEOPARD, LATERAL VIEW, WITH SKIN
REMOVED (B1980.1.94)

Red chalk with graphite on thin wove
paper,
$10\frac{1}{8} \times 13\frac{5}{8}$ in. (25.6 × 34.8 cm.)
Yale Center for British Art

154

TIGER SKELETON, LATERAL VIEW:
FINISHED STUDY FOR TABLE IV
(B1980.1.4)

Graphite on heavy wove paper,
$16 \times 21\frac{1}{4}$ in. (40.5 × 54 cm.)
Yale Center for British Art

155

TIGER SKELETON, LATERAL VIEW, IN
WALKING POSTURE (B1980.1.67)

Graphite on thin wove paper,
$11\frac{1}{8} \times 16\frac{3}{8}$ in. (28.2 × 41.7 cm.)
Yale Center for British Art

156

TIGER, LATERAL VIEW, WITH SKIN AND
TISSUE REMOVED: FINISHED STUDY FOR
TABLE IX (B1980.1.9)

Graphite on heavy wove paper,
$16\frac{1}{8} \times 21\frac{1}{8}$ in. (41.1 × 53.7 cm.)
Yale Center for British Art

157

TIGER, LATERAL VIEW: DIAGRAM
SHOWING SUBCUTANEOUS BLOOD SUPPLY
(B1980.1.74)

Graphite and red chalk on thin wove
paper, $15\frac{1}{2} \times 20\frac{1}{2}$ in. (39.4 × 52 cm.)
Yale Center for British Art

158

TIGER, LATERAL VIEW PARTIALLY
DISSECTED (B1980.1.79)

Graphite on heavy wove paper,
$16 \times 21\frac{1}{4}$ in. (40.8 × 54 cm.)
Yale Center for British Art

159

DORKING HEN, WITH SKIN AND TISSUE
REMOVED (B1980.1.121)

Red chalk and graphite on thin wove
paper, $10\frac{1}{4} \times 14$ in. (26.4×35.7 cm.)
Yale Center for British Art

Dorking Hen Body, Lateral View:
The skin and underlying fascial layers have been
removed. The Dorking breed of hen exhibits the
condition of hyperdactyly in which extra digits
occur. In this specimen there is an extra digit on the
right limb.

DORKING HEN SKELETON, LATERAL
VIEW, IN WALKING POSTURE
(B1980.1.119)

Graphite on thin wove paper,
11 × 15½ in. (27.9 × 39.3 cm.)
Yale Center for British Art

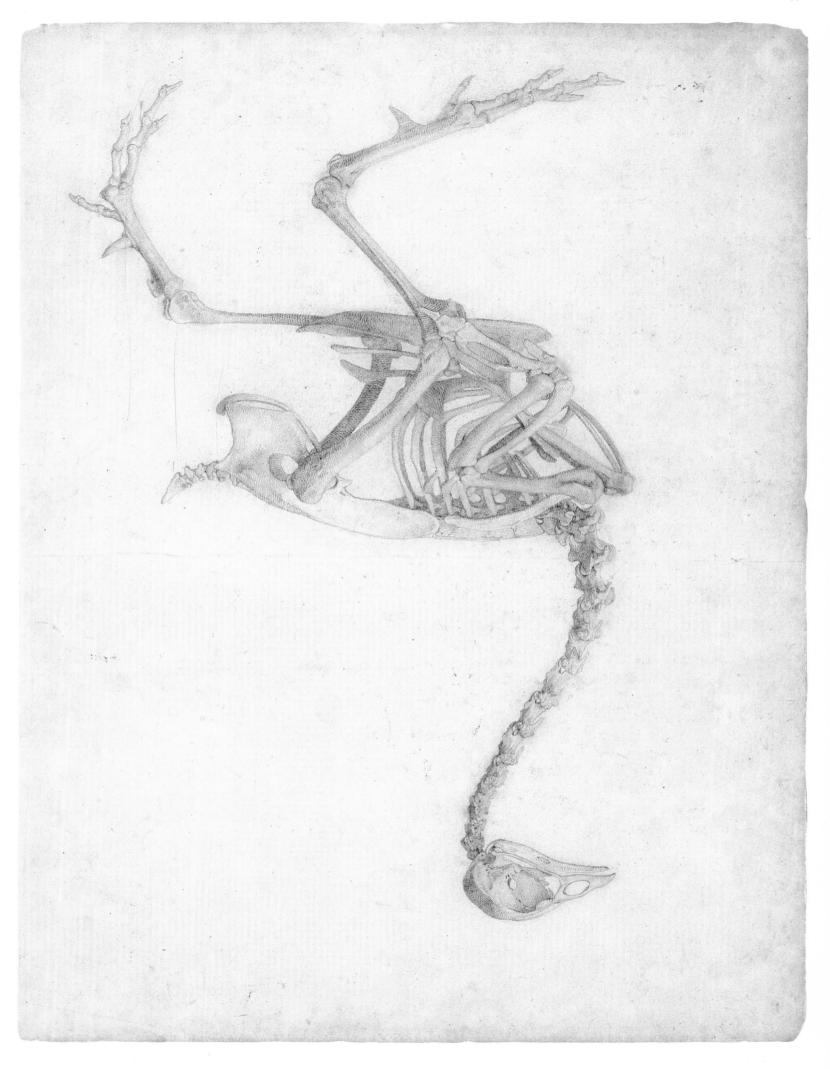

161

FOWL SKELETON, LATERAL VIEW:
FINISHED STUDY FOR TABLE V
(B1980.1.5)

Graphite on heavy wove paper,
$21\frac{1}{2} \times 16$ in. (54.5×40.6 cm.)
Yale Center for British Art

162

FOWL, LATERAL VIEW, WITH MOST OF
FEATHERS REMOVED: FINISHED STUDY
FOR TABLE X (B1980.1.10)

Graphite on heavy wove paper,
$21\frac{1}{2} \times 16$ in. (54.4×40.6 cm.)
Yale Center for British Art

163

FOWL, LATERAL VIEW WITH SKIN AND
UNDERLYING FASCIAL LAYERS
REMOVED: FINISHED STUDY FOR
TABLE XV (B1980.1.15)

Graphite on heavy wove paper,
$21\frac{3}{8} \times 16$ in. (54.3×40.5 cm.)
Yale Center for British Art

The blood supply to the head and neck and legs is
exposed.

164

FOWL, LATERAL VIEW, DEEPLY
DISSECTED (B1980.1.115)

Graphite on heavy wove paper,
$21\frac{1}{4} \times 16$ in. (54×40.6 cm.)
Yale Center for British Art

A finished study for an unpublished Table. Most of
the muscles have been removed revealing the
abdominal viscera.

165

FOWL SKELETON, LATERAL VIEW
NUMBERED AND LETTERED
(B1980.1.113)

Graphite and red chalk on thin wove
paper, $14\frac{7}{8} \times 21\frac{1}{4}$ in. (37.7×54 cm.)
Yale Center for British Art

A numbered and lettered study for the key to
Table XV.

A COMPARATIVE ANATOMICAL EXPOSITION OF THE STRUCTURE OF THE HUMAN BODY WITH THAT OF A TIGER AND A COMMON FOWL

Published in parts, 1804–6
Royal Academy of Arts, London

The great anatomical work which engaged Stubbs during the last fifteen years or so of his life was never published in full. It was to have consisted of thirty tables; only fifteen were published, in three parts, each of which contained five plates, within wrappers. Unlike *The Anatomy of the Horse*, the three parts of the *Comparative Anatomical Exposition* were published without a title page or preface, and with no explanatory text. Stubbs's text remains unpublished, in manuscript. After Stubbs's death Edward Orme republished the fifteen plates with a version of the text.

TAB. V.

OZIAS HUMPHRY : PORTRAIT OF GEORGE STUBBS, *c.*1794 Pastel, 23 × 19 in. (58.5 × 48.3 cm.) Collection Walker Art Gallery, Liverpool

The pastel portrait of Stubbs which is reproduced above (it was not available for the exhibition because of the fragility of the medium) was probably drawn about 1794, when Stubbs was aged seventy, and was at work on his comparative anatomy. Stubbs's purposefulness and energy lasted until the end of his life, but George Dance (whose earlier portrait of Stubbs is No. 5 in this exhibition) was saddened to note the physical changes which seemed suddenly to overtake Stubbs; on 25 January 1804 Farington noted in his Diary 'Dance told me He had met Stubbs & was shocked at His appearance, – so aged, – so in-jawed & shrunk in his person. –' Stubbs died on 10 July 1806, the year in which the third part of *A Comparative Anatomical Exposition* was published.

167

JOHN BURTON M.D.

AN ESSAY TOWARDS A COMPLETE NEW
SYSTEM OF MIDWIFERY THEORETICAL
AND PRACTICAL.

... *Interspersed with Several New*
Improvements; *All Drawn up and*
Illustrated with Several Curious Observations,
and Eighteen Copper-Plates

London: Printed James Hodges, at the
Looking-Glass, facing St. Magnus'
Church, London Bridge, MDCCLI.

Private Collection

The 'Eighteen Copper-Plates' are Stubbs's first
exercise in printmaking; some of them illustrate his
own dissections. His name however appears
nowhere in Burton's book. They are also the
earliest examples of Stubbs's lifelong preoccupation
with anatomy. The Humphry MS Memoir notes
that Stubbs began his anatomical studies at the age
of eight, and that later he was given advice and
instruction by 'Dr. Holt', a neighbour. The
compiler is grateful to Timothy Stevens for
identifying the latter as Dr Ralph Holt, surgeon, of
Red Cross Street, Liverpool; Mr Stevens notes
that Dr Holt appears to have specialized in
midwifery, so it is probable that Stubbs knew
something about the subject before working with
Dr Burton in York.

THE
ANATOMY
OF THE
HORSE.

INCLUDING

A particular Description of the Bones, Cartilages, Muscles, Fascias, Ligaments, Nerves, Arteries, Veins, and Glands.

In Eighteen TABLES, all done from Nature.

By George Stubbs, Painter.

LONDON: Printed by J. Purser, for the Author. 1766.

THE ANATOMY OF THE HORSE
Published 1766

Title-page; preface 'To the Reader'; 24 engraved plates, including 15 'Tables', each with a whole- or half-plate lettered and numbered key, interspersed in 47 numbered pages of text. An *Errata* slip of 24 minor corrections is found in some copies.
Page size (average):
19¾ × 25¾ in. (50 × 65.4 cm),
Platemarks: 14½ × 18⅞ in.
(37.5 × 47.9 cm), average
Tate Gallery

Twenty of the forty-two surviving drawings from which Stubbs engraved the plates for *The Anatomy of the Horse* are exhibited as Nos. 6–25, before which notes on the work for this project may be found.

Stubbs advertised the publication of *The Anatomy of the Horse* during the year before its publication, by means of a printed *PROPOSALS for Publishing by Subscription*, dated 1765. This prospectus invited subscriptions, adding 'The Price of the Book to Subscribers will be 4L. 4s. one Half to be paid at the Time of Subscribing, the other Half when the Book is delivered. The Price to Nonsubscribers will be 5L. 5s. The Names of the Subscribers will be printed at the Beginning of the Work.' No copy has been found with such a list.

Stubbs's advertisement for the publication of his engravings in 1788 (No. 171) also advertises *The Anatomy of the Horse*, still available twenty-two years after its publication. Probably Stubbs had ordered a large quantity of the text, printed by J. Purser, in 1766, printing the plates on demand.

Christopher Mendez was the first to point out, in correspondence with the compiler in 1976, that copies of *The Anatomy of the Horse* continued to be published after Stubbs's lifetime, on paper watermarked 1813 and 1815. It is not known whether these were published by J. Purser or by another publisher, working at the request of Mary Spencer when demand arose.

TO THE
R E A D E R.

WHEN I firſt reſolved to apply myſelf to the preſent work, I was flattered with the idea, that it might prove particularly uſeful to thoſe of my own profeſſion; and thoſe to whoſe care and ſkill the horſe is uſually entruſted, whenever medicine or ſurgery becomes neceſſary to him; I thought it might be a deſirable addition to what is uſually collected for the ſtudy of comparative anatomy, and by no means unacceptable to thoſe gentlemen who delight in horſes, and who either breed or keep any conſiderable number of them.

The Painter, Sculptor, and Deſigner know what aſſiſtance is to be gained from the books hitherto publiſhed on this ſubject; and as they muſt be ſuppoſed beſt able to judge, how fitly the preſent work is accommodated to their purpoſe, any addreſs to them is ſuperfluous.

As for Farriers and Horſe-Doctors, the Veterinarian School lately eſtabliſhed in France ſhews of what importance their profeſſion is held in that country; amongſt us they have frequent opportunities of diſſecting, and many of them have conſiderable ſkill in anatomy: but it were to be wiſhed that this, as well as other parts of medical ſcience, were as generally attended to by them, as by thoſe gentlemen who treat the diſeaſes and wounds of the human body. If what I have done may in any ſort facilitate or promote ſo neceſſary a ſtudy amongſt them, I ſhall think my labour well beſtowed.

I will add, that I make no doubt, but Gentlemen who breed horſes will find advantage, as well as amuſement, by acquiring an accurate knowledge of the ſtructure of this beautiful and uſeful animal.

But what I ſhould principally obſerve to the Reader concerning this my performance, is, that all the figures in it are drawn from nature, for which purpoſe I diſſected a great number of horſes; and that, at the ſame time, I have conſulted moſt of the treatiſes of reputation on the general ſubject of anatomy.

It is likewiſe neceſſary to acquaint him, that the proportions which I have mentioned in ſeveral places of the book, are eſtimated from the length of the head, as is uſually done by thoſe who have treated on the proportion of human figures; this length is taken from the top of the head to the ends of the cutting teeth, and is divided into four equal parts, each of which is again divided into twelve minutes.

a

TAB. VIII.

TAB. IX.

169

REVIEW OF THE TURF,

from the year 1750 to the completion of
the work; comprising the history of
every horse of note, with pedigree and
performance and embellished with prints
from pictures painted, and plates
engraved, by Messrs. G. & G.T. Stubbs,
London: published by Messrs. Stubbs, at
the Turf Gallery, Conduit-Street,
London, 1794
In boards, with a printed label reading
'Turf Review/No. 1' to which '& 2' has
been added in ink.
Tate Gallery

The text consists of the 'History' of those horses
whose names range from Aaron to Astraea. No
further text was issued. This copy lacks the plate of
The Godolphin Arabian which was used as a
frontispiece.

170

A FOXHOUND ON THE SCENT
engraved 1788

Graphite on paper, $3\frac{1}{2} \times 3\frac{7}{8}$ in.
$(89 \times 98$ cm.$)$
Paul Mellon Collection, Upperville, Virginia

PROVENANCE
. . . ; anon. sale, Christie's 19 November 1968
(25, repr.), bt. John Baskett for Mr Paul Mellon
KBE

LITERATURE
Taylor, 1969, pp. 39–40, fig. 7

ENGRAVED
by Stubbs in reverse direction and published by
him 1 May 1788 (No. 181)

The foxhound is taken from 'The Charlton Hunt'
which Stubbs had painted for the 3rd Duke of
Richmond twenty-eight years or so before he
published his engraving of it. There is a possibility
that the hound is called 'Soundwell', an eminently
suitable name for a hound. James Ward's Account
Book lists several small pictures by Stubbs which
he was cleaning and framing for Thomas Garle,
including the 'Rubbing Down House' studies (Nos.
52–3) and also including a picture called
'Soundwell'.

Stubbs's earliest exercise in printmaking, undertaken with some reluctance, was to etch illustrations from his own drawings for Dr Burton's treatise on midwifery (No. 167). He had first to teach himself how to etch, with some advice (according to the Humphry MS Memoir) from a house painter at Leeds who told him to cover a halfpenny with etching varnish and smoke it, 'and then with a common sewing needle stuck in a skewer he showed him how etching was to be done'. Stubbs also borrowed engraving tools from a clock maker to reinforce the etched line.

By the time he came to engrave the plates for *The Anatomy of the Horse*, published in 1766, Stubbs had evolved a far more sophisticated technique of etching and engraving; the plates took seven or eight years to complete, in the intervals of painting. They convey, accurately and harmoniously, differences between bone, cartilage and muscle, and are immediately comprehensible as well as having a beauty of their own.

There is then a gap of eleven years before the publication of the first of Stubbs's engravings after his own paintings, the 'Horse frightened by a lion' (No. 172), published in 1777, which combines etching and engraving. In the intervening years Stubbs's work had been engraved by professional engravers. William Woollett, for instance, engraved the four 'Shooting' paintings (Nos. 73–76) and 'The Spanish Pointer'; his technique influenced Stubbs's first single prints, particularly in his use of 'worm lines', which may be observed, for instance, in the bark of the tree in No. 177. Stubbs must have had a fairly close friendship with Woollett; a portrait of Woollett by Stubbs (now untraced) was in Stubbs's studio sale (27 May 1807, lot 48). Benjamin Green produced the first engraving of the 'Horse frightened by a Lion' in 1769; other engravings of Stubbs's paintings were produced by George Townly Stubbs, John Dixon, Richard Houston and others.

As Richard Godfrey observes, 'it is impossible that an artist with a consuming interest in technique . . . could have taken anything less than a keen interest in the progress of engravings after his work' ('George Stubbs as a Printmaker', *The Print Collector's Quarterly*, XIII, no. 4, 1982, p.114), and in the new techniques of stipple, aquatint and soft-ground etching which were introduced into England in the 1760s and 1770s. Stubbs began to experiment with various techniques of engraving, seeking always to achieve the effect of colour and of gradations of tone; as Godfrey remarks (p. 115), he 'gives the impression of an artist stooped over a copper plate with a small battery of tools beside him, the function of each being diverted to original and unexpected use as it came to hand'. His mature printmaking technique can only be described as 'mixed method', since it combines etching, engraving, stipple, mezzotint and occasionally soft-ground etching. The result is the achievement of the delicate balance of tones evident in, for instance, the foxhound prints.

On 1 May 1788 Stubbs published twelve prints. Some of these may have been produced years earlier. Perhaps he wished to astonish connoisseurs by publishing twelve prints at once; perhaps, as Leslie Parris suggests, he deliberately timed publication to coincide with the opening, later in May 1788, of John Hunter's museum. Whatever the reason, it appears that there was no great demand for Stubbs's prints, and consequently few impressions were printed. Like Gainsborough's contemporary soft-ground etchings, they appear to have been too sophisticated for the general public.

'PROPOSALS FOR PUBLISHING BY
SUBSCRIPTION, TWO PRINTS,
HAY-MAKERS AND REAPERS . . .'

dated London, 24 September 1788 and
including an advertisement for other
prints by Stubbs and for the *Anatomy of
the Horse*, still available twenty-two years
after its publication in 1766. The prices
quoted in the following notes are
taken from this advertisement. In this
case the Proposals incorporate a receipt
dated 20 March 1789 for the first part
of the subscription to *Hay-Makers*
and *Reapers* from Stubbs's patron
Sir John Nelthorpe (portrayed in Nos. 27
and 113).
Lincolnshire Archives Office

London 24th September, 1788.

PROPOSALS

FOR PUBLISHING BY SUBSCRIPTION,

TWO PRINTS,

HAY-MAKERS

AND

REAPERS,

TO BE ENGRAVED BY

Mr. STUBBS,

From Two Pictures of his own Painting,

That have been Exhibited at the *Royal Academy London, and Liverpool.*

SUBSCRIPTIONS Received by Mr. STUBBS, No. 24, Somerset-Street,
Portman-Square, where the Pictures may be seen.

CONDITIONS.

I. The Price to Subscribers is Two POUNDS TEN SHILLINGS for the Pair.—
Half to be paid at the time of Subscribing, and the remainder on Delivery of
the Prints which will be in the Course of the next Year.

II. The Size of each Plate is 27 Inches by 19.

Recvd. March 26 1789 of Sir John Nelthorp
one Pound five Shillings being the 1st Subscription
for one pair of Hay-Makers and Reapers, which I
promise to deliver agreeable to the above Proposals. *Geo: Stubbs*

AT Mr. STUBBS's MAY ALSO BE HAD THE FOLLOWING PRINTS.

	Inches Inches	£. s. d.
Farmer's Wife and *Raven* with its Companion the *Labourers* Size	28 by 21 Price of each	1 6 0
A *Horse* affrighted by a *Lion*, with its Companion *Tygers* at Play	19 by 15—do —— do	0 7 6
A *Lion* devouring a *Horse*, a *Horse* affrighted at a *Lion*, two *Tygers*, a *Lion*, and a *Tyger*	12 by 9—do —— do	0 5 0
A *Lion*, a *Tyger*, and two *Dogs*	8¼ by 6¼—do —— do	0 2 6
Three Prints of Single *Dogs*	5 by 4—do —— do	0 1 6
And his Book of the Anatomy of the *Horse*.	do —— do	5 5 0

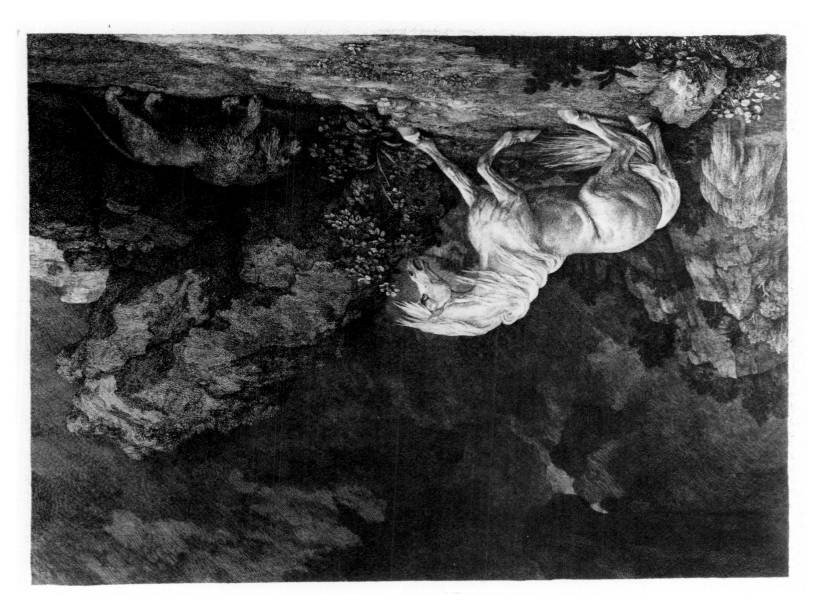

172

A HORSE FRIGHTENED BY A LION

Etching and engraving, 13⅝ × 18⅛ in.
(34.5 × 45.8 cm.); platemark,
13¾ × 18¹⁵⁄₁₆ in. (37.5 × 48 cm.)
Writing-engraving, in scratched letters,
? by Stubbs himself: 'Painted and
Engraved by Geo: Stubbs / Publish'd as
the Act directs Sep! 25 1777 by
Geo: Stubbs London.'

Taylor 1, first state of two

Engraved in reverse and with some differences from
the painting which is No. 62 in this catalogue. The
irregular contours of the rock above the lion are
repeated in the engraving, but the open space on
the further side of the horse has been blocked in by
rock faces.

Advertised by Stubbs in 1788 as 'A Horse
affrighted by a Lion', at 7s. 6d.

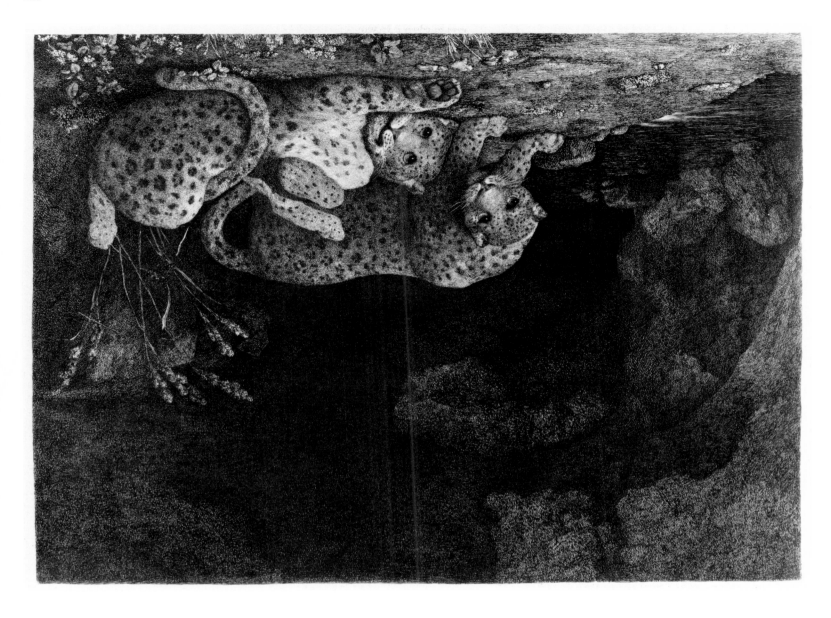

173

LEOPARDS (ENGRAVED TITLE TYGERS . . .) AT PLAY

Etching and engraving, $13\frac{1}{4} \times 18\frac{5}{16}$ in.
(34.3×46.4 cm.); platemark,
$14\frac{13}{16} \times 18\frac{3}{4}$ in. (37.3×47.6 cm.)
Writing-engraving, in scratched letters,
'? by Stubbs himself.' Painted and
Engraved by Geo: Stubbs / Publish'd as
the Act directs feb⁵ 25 1780 by Geo:
Stubbs London.'

Trustees of the British Museum

Taylor 2; Leslie Parris, *George Stubbs A.R.A.:
'Leopards at Play and 'The Spanish Pointer'*, 1974,
second state of three: Parris notes that in
addition to the two states noted by Taylor, an
earlier state, without any inscription, was sold at
Sotheby's 14 January 1971 (52, repr.).

The original copperplate is now in the collection of
the Tate Gallery. A final and limited edition of
impressions from it was printed by Iain Bain in
1974, with the John Boydell Press watermark dated
1971.

Stubbs's paintings of the subject are noted under
No. 78. As Parris notes, the engraving is closest to
the version in the collection of Countess Fitz-
william.
Offered by Stubbs in 1788 for 7s. 6d.

174

A HORSE FRIGHTENED BY A LION

Mixed method, $8\frac{15}{16} \times 12\frac{1}{2}$ in.
(22.8 × 31.8 cm.); platemark,
$9\frac{15}{16} \times 12\frac{15}{16}$ in. (25.3 × 33 cm.)
Writing-engraving: 'Painted Engrav'd &
Publish'd by Geo Stubbs 1 May 1788
N⁰ 24 Somerset Str Portman Sq London'
Trustees of the British Museum

Taylor 3, only state

From the number of impressions which survive, demand for this print must have been greater than for any other of Stubbs's prints. Its popularity and the fact that it was reproduced in the *Sporting Magazine*, 1808 (as after an enamel painting) probably explain the number of painted copies by unknown hands.
Advertised in 1788 at 5s.

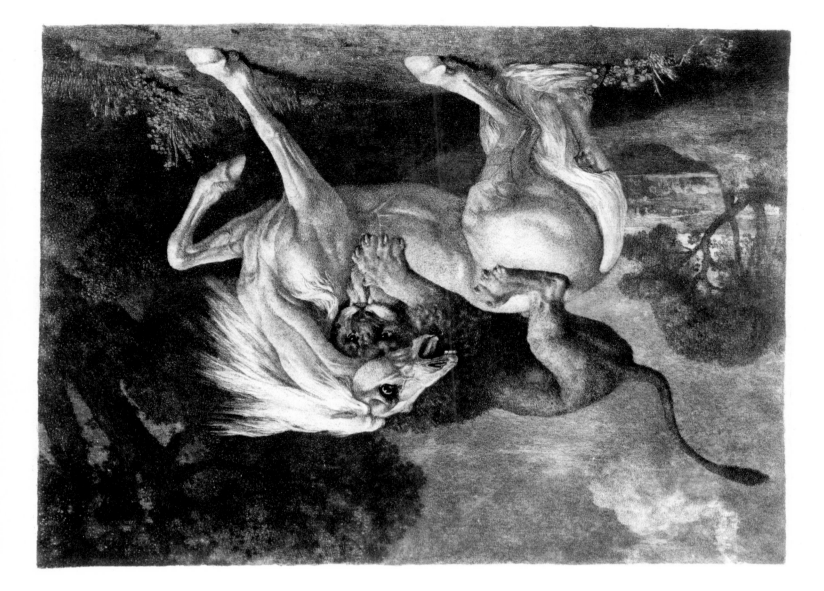

175

A HORSE ATTACKED BY A LION

Mixed method, $9\frac{13}{16} \times 13\frac{3}{16}$ in.
(25×33.6 cm.); platemark, $10\frac{7}{8} \times 13\frac{15}{16}$ in.
(27.7×35.5 cm.)
Writing-engraving: 'Painted Engravd &
Publishd by Geo Stubbs 1788 No 24
Somerset Str Portman Sqr London'

Trustees of the British Museum

Taylor 4, only state

Probably engraved after the version in oil on an
octagonal panel, No. 65 in this catalogue. A
different version of the subject was engraved by
Benjamin Green from a painting then in the
collection of Luke Scrafton (now untraced),
published 1 September 1769.
Advertised in 1788 at 5s.

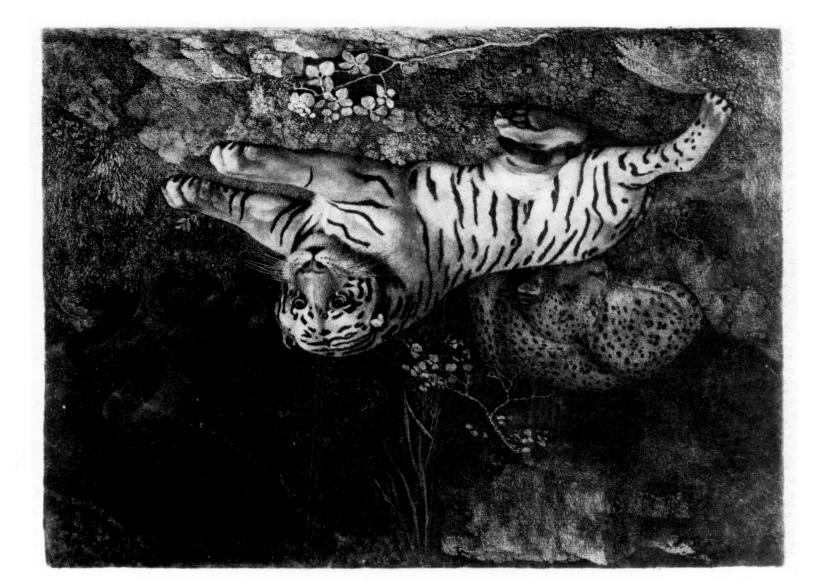

176

A TIGER AND A SLEEPING LEOPARD

Mixed method, $9\frac{1}{8} \times 12\frac{3}{16}$ in.
(23.3 × 30.8 cm.); platemark,
$9\frac{15}{16} \times 12\frac{15}{16}$ in. (25.2 × 32.8 cm.)

Writing-engraving: 'Painted, Engrav'd &
Publish'd by Geo. Stubbs, 1 May, 1788,
Nᵒ 24 Somerset Str. Portman Sq. London.'
Trustees of the British Museum

Taylor 5, only state

No painting which depicts the two animals
together survives. Stubbs may have combined the
images of the tiger from one of the three painted
versions of that subject and the leopard from No. 86
for the engraving. As Taylor notes, this must be
the print referred to in Stubbs's advertisement of
1788 as 'Two Tygers', price 5s.

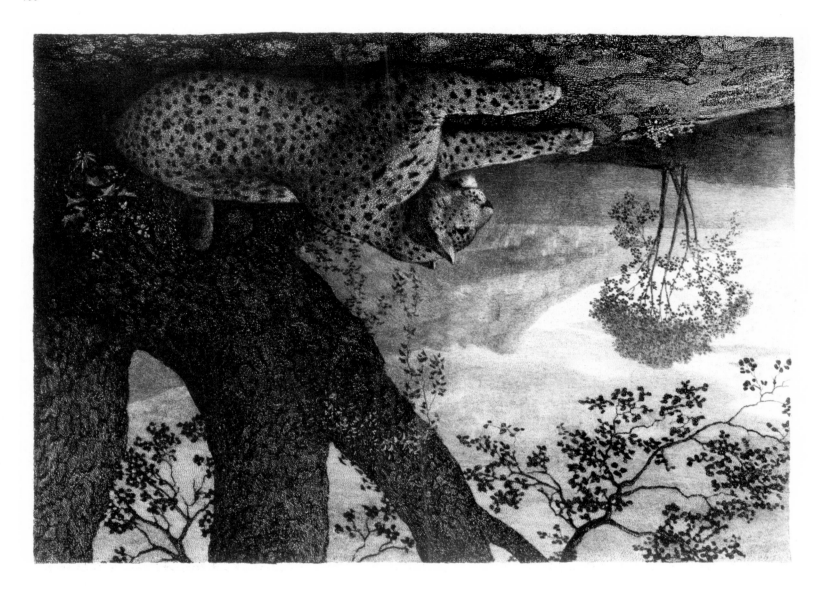

177

A RECUMBENT LEOPARD BY A TREE

Mixed method, $8\frac{7}{8} \times 12\frac{5}{16}$ in.
(22.5 × 31.3 cm.); platemark,
$9\frac{15}{16} \times 12\frac{15}{16}$ in. (25 × 33 cm.)
Writing-engraving: 'Painted Engrav'd &
Publish'd by Geo Stubbs 1 May 1788
No 24 Somerset Str Portman Sq London'
Trustees of the British Museum

Taylor 6, only state; engraved after a small
painting in enamel colours, now in a private
collection
Advertised in 1788 at 5s.; an impression fetched
£5,800 in a London saleroom in 1982.

A LION RESTING ON A ROCK

Mixed method, 8⅞ × 12⁵⁄₁₆ in.
(22.5 × 31.3 cm.); platemark,
9¹⁵⁄₁₆ × 12¹⁵⁄₁₆ in. (25 × 33 cm.)
Writing-engraving: 'Painted Engrav'd &
Publish'd by Geo Stubbs 1 May 1788
No 24 Somerset Str Portman Sq London'
Trustees of the British Museum

Taylor 7, only state

Taylor notes that no painting of the subject is now
known, though Stubbs's studio sale included
'Portrait of a Lion seated on a Rock – in enamel',
27 May 1807 (85).
Advertised in 1788 at 5s.

180

A RECUMBENT LION

Mixed method, $6\frac{7}{16} \times 8\frac{5}{16}$ in.
(16.5 × 21.1 cm.); platemark, $6\frac{15}{16} \times 8\frac{7}{8}$ in.
(17.7 × 20.5 cm.)
Writing-engraving: 'Painted, Engrav'd &
Publish'd by Geo. Stubbs, 1 May, 1788,
Nº 24 Somerset Str Portman Sq.
London.'
Trustees of the British Museum

Taylor 9, only state

A mezzotint engraved by G.T. Stubbs titled *The
Lyon* and published on 12 August 1776 shows the
lion in the same position apparently emerging from
a river or pool within a cavern.
Advertised by Stubbs in 1788 for 2s. 6d.

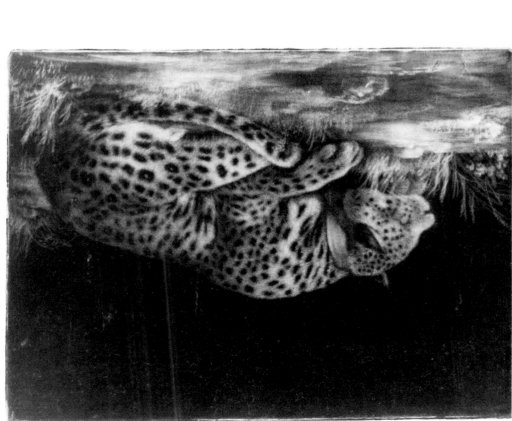

179

A SLEEPING CHEETAH

Mezzotint, work and plate size
$5\frac{15}{16} \times 7\frac{15}{16}$ in. (15.2 × 20.3 cm.)
Trustees of the British Museum

Taylor 8, as only state

This impression, proof before letters, must be
the first of two states. Taylor notes that the animal
is 'almost certainly' the cheetah presented to
George III in 1765 (No. 79). Stubbs probably
charged 2s. 6d. for this print. An impression of it
was acquired in 1981 by the Whitworth Art
Gallery, Manchester.

183

A FOXHOUND

Mixed method, $3\frac{9}{16} \times 4\frac{1}{2}$ in.
(9.2×11.5 cm.); platemark $4\frac{1}{8} \times 4\frac{15}{16}$ in.
(10.5×12.7 cm.)
Writing-engraving: 'Publish'd by Geo
Stubbs 1 May 1788'
Trustees of the British Museum
Taylor 12, only state

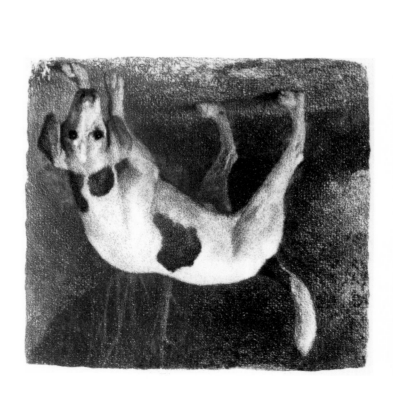

182

A FOXHOUND VIEWED FROM BEHIND

Mixed method, $3\frac{5}{16} \times 4\frac{1}{8}$ in.
(8.4×10.5 cm.); platemark, $4\frac{1}{8} \times 4\frac{15}{16}$ in.
(10.6×12.7 cm.)
Writing-engraving: 'Publish'd by Geo
Stubbs 1 May 1788'
Trustees of the British Museum
Taylor 11, only state

181

A FOXHOUND ON THE SCENT

Mixed method, $3\frac{7}{16} \times 3\frac{3}{4}$ in.
(8.9×9.5 cm.); platemark, $3\frac{3}{4} \times 4\frac{1}{8}$ in.
(9.6×10.4 cm.)
Writing-engraving: 'Publish'd by Geo
Stubbs 1 May 1788'
Trustees of the British Museum
Taylor 10, only state

For Stubbs's preliminary drawing see No. 170.
This and Stubbs's three other foxhound prints
derive from portraits of hounds in 'The 3rd Duke of
Richmond with the Charlton Hunt, No. 29.
Stubbs charged 1s. 6d. for each of the three
single foxhound prints and 2s. 6d. for the print of
two foxhounds. An impression of 'Foxhound on the
Scent' was sold for £4,950 in 1983.

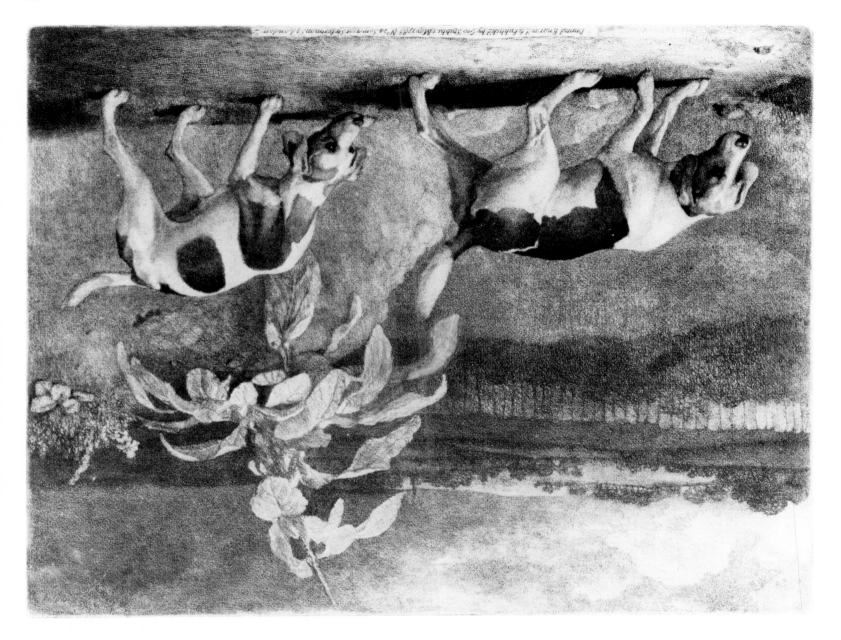

'Painted Engrav'd & Publish'd by Geo Stubbs 1 May 1788 N.o 24 Somerset Street Portman 1 London'

184

TWO FOXHOUNDS IN A LANDSCAPE

Mixed method, work and plate size
$7 \times 9\frac{1}{16}$ in. (18×23.2 cm.)
Writing-engraving within the work area:
'Painted Engrav'd & Publish'd by Geo
Stubbs 1 May 1788 N.o 24 Somerset Str
Portman Sq London'

Trustees of the British Museum

Taylor 13, only state

Godfrey notes that here and in the prints of single
foxhounds Stubbs seems to have made original and
delightful use of soft-ground etching in the
background'.

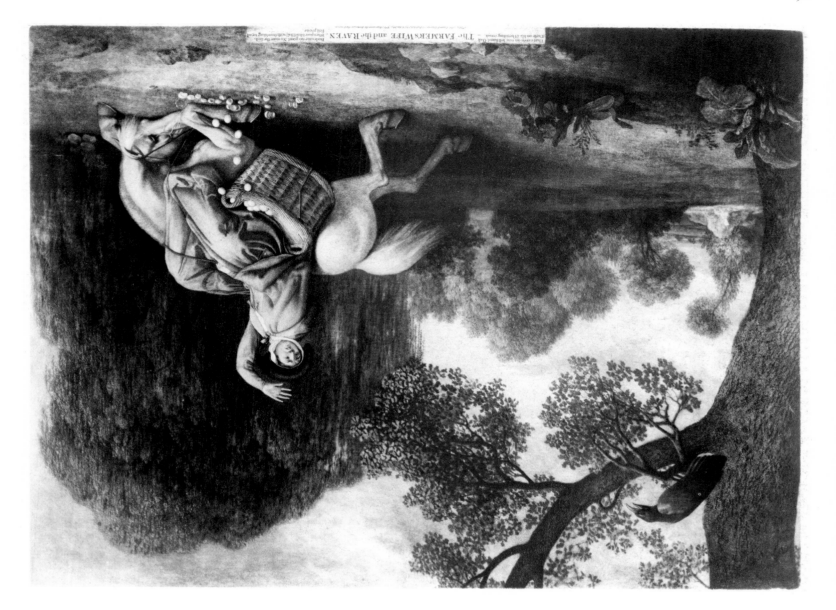

The FARMER's WIFE and the RAVEN. — The Farmer's Wife her said, 'No more me good,
Boded no good, 'No more me said, When poor blind Ball with stumbling tread
purpose

185

THE FARMER'S WIFE AND THE RAVEN

Mixed method, $20\frac{1}{2} \times 27\frac{3}{16}$ in.
(52.1×69.6 cm.), plate marginally bigger
on left and right edges
Writing-engraving: 'The FARMER's WIFE
and the RAVEN. / 1st May 1788. Painted,
Engrav'd & Publish'd by G Stubbs, Nº 24
Somerset Str. Portman Sq. London.'
This is flanked by verses from John Gay's
Fables:
left:
'That raven on yon left-hand Oak
(Curse on his ill-betiding croak)
right:
'Bodes me no good. No more she said
When poor blind Ball with stumbling
tread / Fell prone.'

Trustees of the British Museum

For paintings of this subject see No. 129. Stubbs
advertised this in 1788 as a companion to *Labourers*,
at £1. 6s. 0d. each.

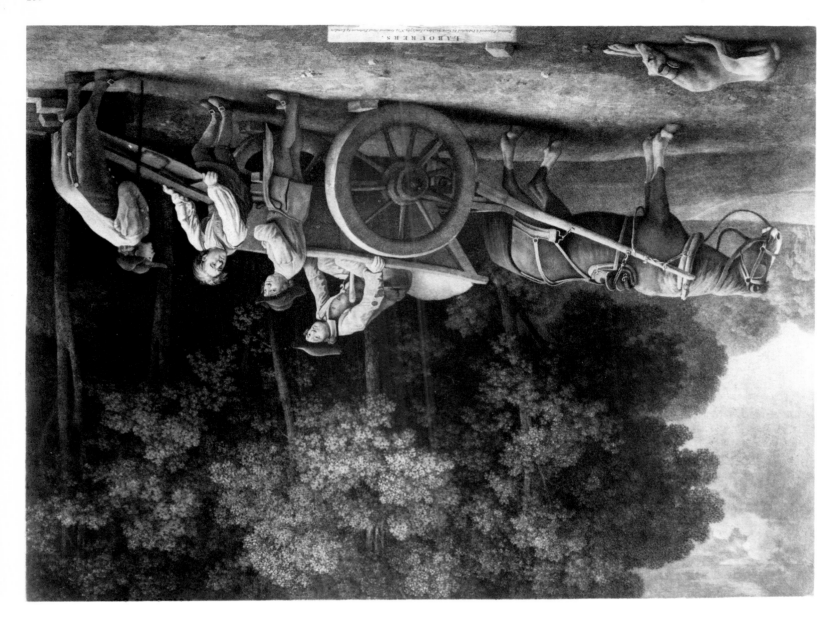

186

LABOURERS

Mixed method, work and plate size
$20\frac{5}{8} \times 27\frac{1}{2}$ in. (52.3×69.7 cm.)
Writing-engraving within the work area:
'LABOURERS. Painted, Engraved &
Published by Geo. Stubbs, 1 Janʸ 1789,
Nᵒ 24, Somerset Street, Portman Sq.
London.'

Trustees of the British Museum

Taylor 15, only state

Probably after the oil painting of 1779 (see No. 47).

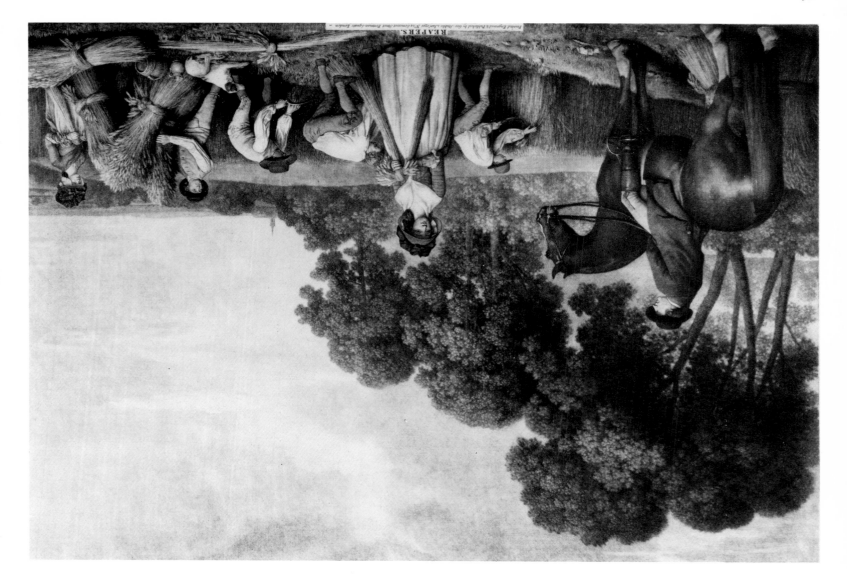

REAPERS.

Printed Engraved & Published by the Author 1 Jan.y 1791 Somerset Street Portman Square London.

187

REAPERS

Mixed method, work and plate size
18$\frac{15}{16}$ × 26$\frac{3}{4}$ in. (48.2 × 68 cm.)
Writing engraving within the work area:
'REAPERS. Painted, Engraved &
Published by Geo: Stubbs, 1 Jan.y 1791.
N.º 24 Somerset Street, Portman Square,
London.'
Trustees of the British Museum

Taylor 16, only state

After the oil painting of 1785, No. 125.

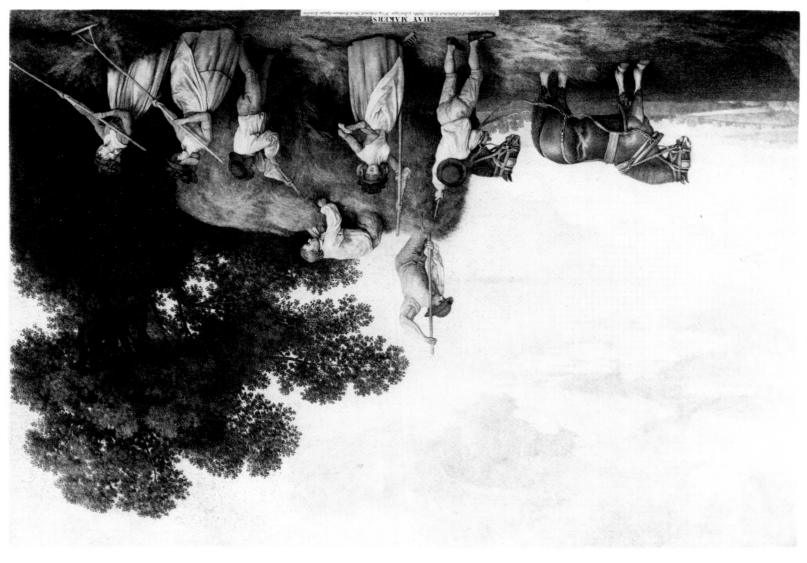

HAY-MAKERS

Mixed method, work and plate size
19 × 26⅝ in. (48.3 × 68.2 cm.)
Writing-engraving within the work area:
'HAY-MAKERS Painted, Engraved &
Published by Geo: Stubbs, 1 Jan.ʸ 1791,
Nº 24, Somerset Street, Portman Square,
London.'
Trustees of the British Museum

Taylor 17, only state

After the oil painting of 1785, No. 124.

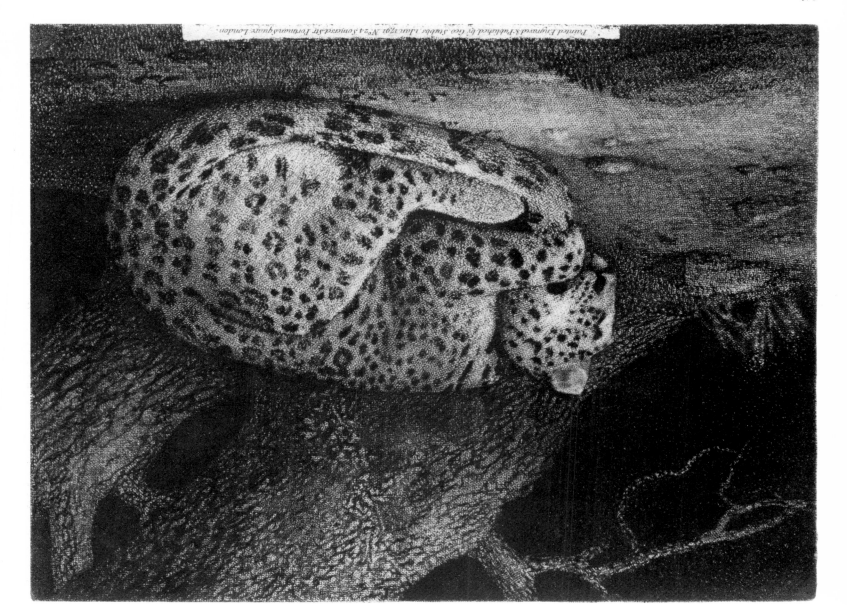

Painted Engraved & Published by Geo. Stubbs 1 Jan.y 1791. N.º 24 Somerset Str. Portman Square London.

189

A SLEEPING LEOPARD

Mixed method, work and plate size
$7\frac{1}{16} \times 9\frac{5}{16}$ in. (17.9 × 23.6 cm.)
Writing-engraving within work area, the
work having been cleared to carry it:
'Painted, Engraved & Published by Geo.
Stubbs, 1 Jan 1791, Nº 24 Somerset Str.
Portman Square, London'

Trustees of the British Museum

Taylor 18, as only state; but a proof before
letters is also in the collection of the British
Museum.

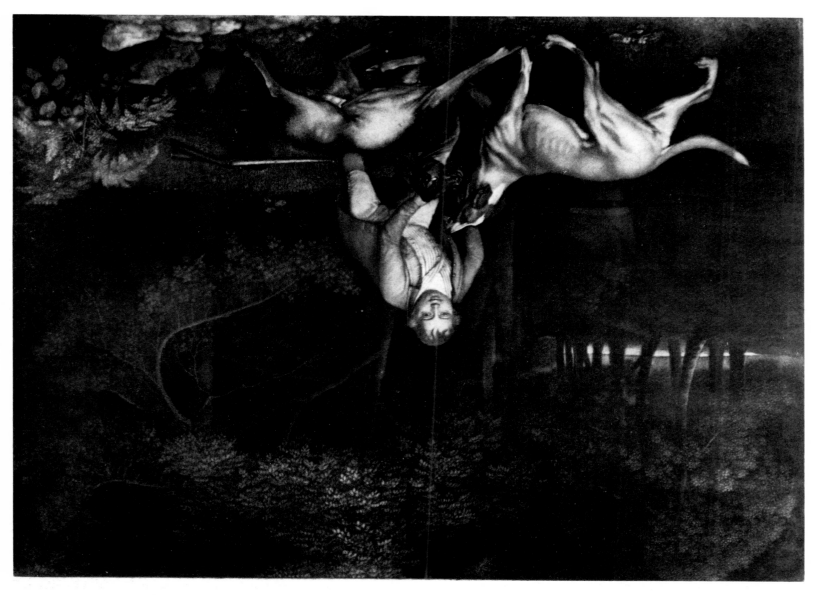

190

FREEMAN, THE EARL OF CLARENDON'S
GAMEKEEPER, WITH A DYING DOE AND A
HOUND

Mezzotint, engraved surface 14¾ × 19⅞ in.
(36.8 × 50 cm.); platemark 15¾ × 19⅞ in.
(40 × 50 cm.)
Writing-engraving: 'London. Pub:
Oct.r 16: 1804 by G Stubbs: No. 24
Somerset Str. Portman Square.'
Private Collection

Taylor 19.

After the painting of 1800, No. 137. In 1804, when
this print was published, Stubbs was aged eighty.
Several sets of his prints, individually specified,
were included in his studio sale; this was not among
any of them. Siltzer attributes it to G.T. Stubbs;
this compiler is inclined to agree with him, not only
because of its absence from Stubbs's studio sale but
also because the keeper's face seems more in G.T.
Stubbs's manner than in his father's. It may have
been a combined effort. Several copies (all now
untraced) are recorded of an autograph letter from
G.T. Stubbs, dated 1801 and addressed to various
patrons, soliciting subscriptions for publishing this
engraving, written on a printed proposal for it. See
Maggs's catalogues nos. 2385 (1925) and 1406
(1931), and the Hugo sale, Sotheby's 8 August 1877
(301). The title *Death of the Doe* appears on a reprint
published by Edward Orme on 4 June 1817.

THE FRIENDS OF THE TATE GALLERY

The Friends of the Tate Gallery is a society which aims to help buy works of art that will enrich the collections of the Tate Gallery. It also aims to stimulate interest in all aspects of art.

Although the Tate has an annual purchase grant from the Treasury, this is far short of what is required, so subscriptions and donations from Friends of the Tate are urgently needed to enable the Gallery to improve the National Collection of British painting to 1900 and keep the Modern Collection of painting and sculpture up to date. Since 1958 the Society has raised well over £800,000 towards the purchase of an impressive list of works of art, and has also received a number of important works from individual donors for presentation to the Gallery.

In 1982 the Patrons of New Art were set up within the Friends' organization. This group, limited to 200 members, assists the acquisition of works by younger artists for the Tate's Modern Collection.

The Friends are governed by a council – an independent body – although the Director of the Gallery is automatically a member. The Society is incorporated as a company limited by guarantee and recognized as a charity.

ADVANTAGES OF MEMBERSHIP INCLUDE:

Special entry to the Gallery at times the public are not admitted. Free entry to, and invitations to private views of, paying exhibitions at the Gallery. Opportunities to attend lectures, private views at other galleries, films, parties, and of making visits in the United Kingdom and abroad organized by the Society. Use of the Reference Library in special circumstances. Tate Gallery publications, including greetings cards, etc. and art magazines at reduced prices. Use of the Members' Room in the Gallery.

MEMBERSHIP RATES AS AT OCTOBER 1984

ANY MEMBERSHIP CAN INCLUDE HUSBAND AND WIFE

Benefactor £1,500. Life membership.

Patron of New Art £325 annually or £250 if a Deed of Covenant is signed.

Patron £150 or over annually. Five fully transferable guest cards.

Corporate £75 or over annually. For corporate bodies and companies. Two fully transferable guest cards.

Associate £40 or over annually. Two fully transferable guest cards.

Member £10 annually or £9 if a Deed of Covenant is signed.

Educational & Museum £8 annually or £7 if a Deed of Covenant is signed. For the staff of museums, public galleries and recognized educational bodies.

Young Friends £7 annually. For persons under twenty-six.

FOR FURTHER INFORMATION APPLY TO:
The Friends of the Tate Gallery,
Tate Gallery, Millbank, London SW1P 4RG.
Telephone: 01-821 1313 or 01-834 2742

BENEFACTORS SINCE 1958

Sir Robert Adeane
Miss H.M. Arbuthnot
Sir Richard and Lady Attenborough
Sir Nigel and Lady Broackes
Mrs P. Broke Freeman
Sir Andrew Carnwath
Mr I.O. Chance
Dr and Mrs J.D. Cohen
Lady d'Avigdor Goldsmid
Miss Mabel Davis
Mr and Mrs Gilbert de Botton
Mr and Mrs Alan Driscoll
Dr and Mrs Henry L. Foster
Mr Gordon Fraser
Mr Norman Granz
Mrs Sue Hammerson
Mr and Mrs Alex Herbage
Mr and Mrs Joseph H. Hirshhorn
Sir Antony and Lady Hornby
Mr and Mrs Anthony Jacobs
Mr and Mrs Hyman Kreitman
Mr and Mrs M.S. Lipworth
Sir Anthony and Lady Lousada
Sir Jack and Lady Lyons
Mr D.H. MacAuslan
Mr William A. McCarty-Cooper
Miss M.M. Neal
Mr and Mrs Michael Sacher
Sir Robert and Lady Sainsbury
Mr Anthony R. Shalit
Mrs Jack Steinberg
Mr John B. Sunley
The Hon. Mrs Quentin Wallop
Miss Elizabeth Willson
Mr and Mrs Terry Willson
Mr and Mrs William E. Wiltshire
Sir David and Lady Wolfson
and Benefactors who prefer to remain anonymous

HONORARY MEMBERS

Mrs Vivien Duffield
Mrs Allan D. Emil
Mr and Mrs H.J. Heinz II
Mr and Mrs Gustav Kahnweiler
Mr and Mrs Kenneth A. Levy
Mr and Mrs Paul Mellon
Mr and Mrs Henry Moore
Mr and Mrs Roy Neuberger
Mr E.J. Power

PATRONS

Mr and Mrs I. Bloomfield
Mr and Mrs Godfrey Bonsack
The Hon. Mrs George Borwick
Mrs S. Bradman
Mr Henry M. Cohen
Mrs Ruth Cohen
Mr and Mrs Raymond De Prudhoe
Baron and Baronne Elie De Rothschild
Mrs J. Epstein
Mr Norman J. Hyams
Mr Simon Karmel
Mr C. MacGonigal
Mr Robert Miller
The Hon. Peter and Mrs Samuel
Mr Eric R. Shemilt
Ms Pamela H. Stephenson
Mr and Mrs J.R.A. Townsend
Mr P.D.B. Townshend
Mr and Mrs R.F. Winkler
and Patrons who prefer to remain
anonymous

SUBSCRIBING CORPORATE BODIES

Agnew & Sons Ltd., Thomas
Alex, Reid & Lefèvre Ltd.
Allied Irish Banks Ltd.
American Express Europe Ltd.
Associated Television Ltd.
Balding & Mansell Ltd.
Bankers Trust Company
Barclays Bank International Plc
Baring Foundation, The
Benson & Partners Ltd., F.R.
BOC International Ltd.
Bowring & Co. Ltd., C.T.
British Council, The
British Petroleum Co., Plc
Cazenove & Co.
Celus Properties Ltd.
Charterhouse Group
Christie, Manson & Woods Ltd.
Colnaghi & Co. Ltd., P. & D.
Commercial Union Assurance
Coutts & Company
Delta Group Plc
Editions Alecto Ltd.
Electricity Council, The
Equity & Law Charitable Trust
Esso Petroleum Co.
Farquharson Ltd., Judy
Fine Art Society Ltd., The
Fischer Fine Art Ltd.
Fitton Trust, The
Gimpel Fils Ltd.
Greig Fester Ltd.
Guardian Royal Exchange Assurance
Group
Guinness Son & Co. Ltd., Arthur
Guinness Peat Group
Kleinwort Benson Ltd.
Knoedler Kasmin Ltd.
Leger Galleries Ltd.
Lewis & Co. Ltd., John
Madame Tussauds Ltd.
Manor Charitable Trustees
Marks & Spencer
Marlborough Fine Art Ltd.
Mayor Gallery, The
Midland Bank Plc
Moeller Ltd., Achim
Morgan, Grenfell & Co. Ltd.
National Westminster Bank Plc
Ocean Transport Trading Ltd.
Pearson & Sons Ltd., S.
Pedoka Ltd.
Phillips Petroleum Co. Europe-Africa
Piccadilly Gallery
Postcard Gallery, The
Rayne Foundation, The
Redfern Gallery
Rediffusion Television Ltd.
Roberts & Hiscox Ltd.
Roland, Browse & Delbanco
Rothschild & Sons Ltd., N.M.
RTZ Services Ltd.
Schroder, Wagg & Co. Ltd., J. Henry
Sotheby Parke Bernet & Co.
Spink & Son Ltd.
Stephenson Harwood
Sun Alliance & London Insurance Group
Swan Hellenic Tours
Tate & Lyle Ltd.
Thames & Hudson Ltd.
Tranman Trust, The
Vickers Ltd.
Waddington Galleries Ltd.
Williams & Glyns Bank Ltd.
Willis, Faber & Dumas
Winsor & Newton

INDEX

Figures in roman refer to plate numbers
Figures in italic refer to page numbers
All work by George Stubbs referred to in SMALL CAPITALS
Work by other artists referred to in single quotation marks
Single quotation marks also used for names of horses and dogs